THE PAINTER'S CHOICE

THE
PAINTER'S
CHOICE

Problems in the Interpretation
of Renaissance Art

MILLARD MEISS

Icon Editions
HARPER & ROW, PUBLISHERS
New York, Hagerstown, San Francisco, London

To my wife

FIRST EDITION

ISBN: 0–06–430068–4 (paper)

0–06–435657–4 (cloth)

LIBRARY OF CONGRESS CATALOG CARD NUMBER: 75–12290

Designed by Sidney Feinberg

Contents

Preface

The reprinting of these studies in one book is intended to serve two purposes. Some of them appeared in volumes not handy for historians of art and still less for students, to whom the new paperback edition in particular is addressed. Furthermore I believe that, united, these essays may be more meaningful than separated. Most of them explore closely related problems, or represent different approaches to the same problem, and they thus complement each other.

When selecting these essays I excluded those that are largely limited to one work of art, even though the conclusions in such instances may have been more specific. I chose instead papers that concern a group of works and that develop hypotheses which, if more questionable, are of wider application. The one exception to this plan, "A Documented Altarpiece by Piero della Francesca," is related in several ways to the three other papers on this painter that are included in the book.

The earliest essay, one of three concerned wholly or in part with Northern painting of the fifteenth century, was printed forty years ago. During this period, which began indeed even earlier with the "Madonna of Humility" of 1936, I continued to raise questions of interpretation which seemed to me difficult but fascinating. Partially divergent readings of one of the important forms—Piero della Francesca's large egg—have been presented since, but they have not persuaded me.

I hope nevertheless that by now I have attained greater objectivity about my views and that I can recognize more clearly the weaker spots in them. I

propose, indeed, to adopt a plan used by my friend Richard Krautheimer when undertaking a similar collection. Almost all the studies in this book are followed by a postscript, in which I correct a few errors, record briefly any changes of opinion, and add a word on some subsequent publications. Brief, detailed additions are occasionally inserted in the text or the notes, always in brackets. I have signaled an alteration of a paragraph or more by a starred note.

Three essays differ somewhat from the rest; their accent is more historical than interpretative. " 'Highlands' in the Lowlands" identifies a structure of landscape that was envisaged first by Ambrogio Lorenzetti, adopted thereafter by a French follower *ca.* 1400, highly developed by Jan van Eyck, and then, partly under his influence, widely exploited by early Renaissance painters in Italy. This "plateau type," as I called it, constitutes a basic form—one of many—common to the art of the period north and south of the Alps.

"Toward a More Comprehensive Renaissance Palaeography" was, and remains, the first attempt to trace the epoch-making transformation of the capital letter in Italy during the fifteenth century—a transformation that occurred not only in script but in inscriptions on buildings and in works of art. Indeed, if my hypotheses are right, sculptors, painters, and architects played a leading role in the development. Closely related to this paper is an account of a series of treatises on the method of designing capital letters—the least well-known of those treatises on the arts that were one of the striking innovations of the Quattrocento. The Italian search for general laws in the phenomenal world—in perspective and in the proportions of the human figure and of architecture—is here carried into the microcosm of the shapes and proportions of majuscules. Like contemporary architects, moreover, the author of the first of these treatises, the antiquarian Felice Feliciano, did not follow precisely his own principles of proportion when designing the illustrations of his text. On the contrary, he preferred to alter the shapes to meet the judgments of his own eye.

Most of the other articles are studies of the relation of form, subject, and meaning. By the slippery word meaning I include what others have called intrinsic significance or implications—implications of the whole work of art which the artist and his patron may or may not have intended. Such meanings are disclosed by correlating the work with modes of expression, with contemporary religious or secular thought, or with attitudes shaped by the forms

of social life. Thus my earliest paper of this kind, published in 1936 but not included in this book, explored the history and significance of the Madonna of Humility.[1] This subject was first represented when its main symbolical aspect, the relation of the Madonna to the ground, could be given vivid expression by the immediately prior development of tri-dimensional space. Since the image involved, moreover, the removal of the Madonna from her traditional throne to a lowly posture on the floor the innovation seemed related, I suggested, to the gradual replacement of feudal values by those of the bourgeoisie in the growing republican cities of Siena and Florence.

Several other essays in this book, too, find a correlation between a new subject and the character of contemporary style. Current forms, it seems, predispose the painter and his patron to the choice of a subject. Sometimes the figurative language even makes the subject possible. At the very least the subject may offer special opportunities to an imagination inclined to certain kinds of images. Thus these papers attempt to give a larger role to style and to the imagination of the single artist than they were allowed in some preceding iconographic and iconologic studies.

When exploring problems of this kind I tended to adopt two strategies. New styles and new subjects seemed to offer greater opportunities than established ones. Innovations, for one thing, are more likely to be discussed than survivals; and the response to them, the degree of acceptance, is usually telling. In the second place new subjects can often be more readily illuminated than new forms. Forms emerge to a greater degree from the mysterious recesses of the imagination, either of one artist or of several associated in a school. Novel subjects, on the other hand, were often at least formulated by the patron, whether individual or institutional. Sometimes they may be traced to the practices of a new religious group, as in the case of "the penitent St. Jerome." Simplest of all is the conformity of new subjects with texts, as we shall see in "Sleep in Venice." The identification of the written analogy, however, again represents only one phase of our inquiry. Why, we ask, was the text chosen? Such questions force us to delve into deeper meanings.

The kinds of problems with which these papers deal are posed by artistic production at all times, but they become more open and accessible in the period of the Renaissance. At that time the claims of tradition upon the patron and the artist diminished rapidly. Innovation in style and iconography seemed more desirable. Private collectors emerged, interested especially in

the new secular subjects. It was patrons who normally chose the subject, whether secular or religious, but frequently they consulted the artist. Toward the end of the fifteenth century, however, a highly esteemed master such as Giovanni Bellini could refuse to paint a subject requested by so powerful a patron as Isabella d'Este; he even eventually persuaded her to accept a theme of his own choice. He was wont, he said furthermore to her agent, to "roam at will in his paintings"—"sempre vagare a sua voglia nelle pitture."[2] Precisely this he did in certain religious paintings when he abandoned several traditional symbols for the divine spirit and replaced them with light.[3] Bellini's words show a striking awareness of his way of working, of the role of his imagination in the shaping of his pictures. His statement also confirms the remarkable degree of independence attained by artists at his time.

Not all masters enjoyed Giovanni Bellini's degree of control over his own work, but even when a subject was prescribed for them the mode of realizing it usually was not. Thus we may perhaps suppose that it was a patron rather than Jan van Eyck who selected for a painting by him the illustration of the Nativity hymn that was in part written on the frame of his *Madonna in the Church*. Perhaps patron and painter reached the decision together. In any event only Jan himself would have decided to abandon the graphic rays employed hitherto for a beam of light that passes through the stained glass to fall in pools on the floor near the Madonna.

Even the rays had not been used for very long. During the quarter-century preceding Jan van Eyck painters in France and the Netherlands had been engaged in an intensive study of luminary phenomena, and it was partly as a by-product of their discoveries that they first represented rays passing through glass windows, and thus gave visual form to a simile of the Incarnation that had been familiar to theologians for centuries. Here again, as in the instance of the Madonna of Humility, we recognize that a subject may be conditioned by the character of contemporary style. Artistic movements favor, if they do not indeed generate, some of their own themes.

The same phenomenon is illustrated by the history of the sleeping female figure. This image suddenly became popular in Venetian painting while at the same time it was rare in Florence, although the ancient myths that inspired many of these representations were no less familiar to the Florentines than to the Venetians. The image was peculiarly consonant with the formal qualities of Venetian art. The paintings seem, moreover, to convey values

that are embodied in Venetian literature, religious imagination, and indeed in the civilization of the city as a whole. Values of this kind are not easily defined, and the risks of interpretation accordingly rise. In the face of such risks we can only do what we do in studies of all kinds: use historical methods strictly, and temper them (in Panofsky's unforgettable words) "if possible by common sense."

As I was mulling over the nature of this book I rediscovered with surprise the little story that is printed below. It is clear that the author did not underestimate the strange power of art. In this instance, however, the problem of the meanings conveyed between the lines I leave gratefully to the experience and the imagination of others.

THE LOST SISTER

Once upon a time, there was a brother and sister, who had no father or mother. They lived in a little hut in a forest. The little girl took care of the house and cooked the meals, while the boy worked in the forest far from the house, cutting down trees. One day when he came home, his sister was gone. He looked everywhere and could not find her. He began to cry and just then a fairy came and told him that the dwarfs had taken his sister and would not give her up until he had carved a picture of her out of wood. He said he could not do that; but the fairy said he should try his best. He began to carve and as he was so anxious for his sister to come back, he worked all day and night. At last it was finished. And the next day his sister was there.

MILLARD MEISS,
Second Grade.
(Reprinted from *The Forge,* 1911–1912,
The University School, Cincinnati, Ohio)

NOTES

1. "The Madonna of Humility," *Art Bulletin,* XVIII, 1936, pp. 435–464.
2. Millard Meiss, *Giovanni Bellini's St. Francis in the Frick Collection,* New York, 1964, p. 33.
3. *Op. cit.,* p. 28 ff.

PART I

1

Light as Form and Symbol
in Some Fifteenth-Century Paintings

In accounts of the development of naturalism in fifteenth-century painting linear perspective is usually given first consideration. This modern emphasis on perspective has been influenced, no doubt, by the writings of the fifteenth-century artists themselves. Discussions of it occupy a prominent place in the treatises of Alberti and Piero della Francesca. These discussions were, however, motivated not only by a sense of the importance of perspective for painting but also by a desire to raise the status of the craft. Writers therefore stressed the theoretical and mathematical modes of thought necessary to it.

There is no question, of course, that the fifteenth century extended the use of perspective in painting beyond earlier periods, and that it created the theory of focus perspective together with consistent methods of applying it. But basic innovations in pictorial composition were made early in the fourteenth century in both Siena and Florence. Duccio, Giotto, Simone Martini, and the Lorenzetti succeeded in creating the illusion of space and solidity and of a world seen through a frame from a more or less fixed position. If we compare with their work the paintings of the leading masters of the first half of the fifteenth century, the advances in the rendering of light impress us scarcely less than the consequences of the application of systematic focus perspective. In the compositions of Masaccio, Domenico Veneziano, Piero, or Campin and the Van Eycks, things are largely what they appear to be from a

This article was published in the *Art Bulletin*, XXVII, 1945, pp. 43–68.

certain point of view and under certain conditions of light. The objects of painting thus acquire a new dimension, and they approximate more closely the objects of the world, the portrayal of which was a major concern of the painters of the time. Light contributes, too, a new subtlety to the personalities that appear in painting. Moving over the features of Giovanni Arnolfini or the apostles in the *Tribute Money,* it extends and deepens consciousness. Mobile and intangible, light has always seemed the natural counterpart of the mind. In nature as in art, it stirs feelings and sustains moods.

Painters of the second quarter of the fifteenth century, like those of the early seventeenth, showed a certain predilection for subjects or motifs involving light. The *Miracle of Peter Healing by His Shadow,* seldom represented in earlier art, has a special poignancy in the Brancacci Chapel. Artists delighted in painting the generation of light as one of the most enchanting of natural phenomena. In Fra Filippo Lippi's painting of the Annunciation of the Death of the Virgin the angel brings, as a symbol of death, a burning taper instead of the traditional palm (fig. 1).[1] The compositions of Jan van Eyck and the Master of Flémalle frequently include a fire: on the hearth in the *Madonna* in Leningrad and the *St. Barbara* in the Prado, and burning candles in the Arnolfini portrait, the Paele Altarpiece, the *Virgin in the Church* (Berlin), *Joseph and the Suitors* (Prado), and the *Nativity* at Dijon (figs. 6, 9, 19). In the last-named painting the sun itself is introduced.

Most of these forms appear as perfectly normal elements of a familiar setting, whether bourgeois rooms, churches, or landscapes. Almost all of them have, however, an additional connotation derived from the chief figures or action of the painting. Christian mysteries were from the very beginning explained by metaphors of light. Painters of the fifteenth century were aware of the rich repertory of religious associations investing all the familiar sources of light, and with which they might develop and extend the religious meaning of their works. Some of these images were not represented in medieval art. Others, such as the sun, appeared as graphic signs; only in the art of the fifteenth century did they assume the vivid form which had originally inspired their selection as symbols.

Warm sunlight, together with evidence of life, growth, and fertility, distinguishes the New World from the cool, gray Old World in the moralized landscapes of Mantegna (*Madonna,* Uffizi) and Giovanni Bellini (*Man of*

Sorrows, London). Similar symbolic contrasts appear in Fra Filippo's paintings of the Madonna adoring the newborn Christ Child (Berlin and Uffizi). Panofsky and Tolnay, to whom we owe our present insight into the religious symbolism of early Flemish painting, have discussed the symbolic content of the candles, and of the sun in the Dijon *Nativity.*[2] It seems possible too that the fire on the hearth has likewise a religious meaning, particularly in the panel of *St. Barbara* in the Prado. In this painting, which shows the Saint piously reading before a fire in a neat and cozy room, all the objects above the fireplace, the statue of the Trinity, the candle, the carafe, and, farther along the wall, the towel and water jug refer in one way or another to her sanctity. Of fire Berchorius (†1362) says:

> Since fire is the most noble element, its virtue is wonderfully diffused. For fire lurks secretly in all things, as is evident when two solid bodies are struck together, for then the fire breaks out, though it was not at all believed to be hidden there. Thus God is truly in all things, though invisible. . . . Indeed, we may well speak of the fire of charity, or the fire of the Holy Spirit, and especially of the fire of divine love, which is in many people who are not believed to possess it.[3]

Fascinated by light, some of the leading Flemish painters of the late fourteenth and early fifteenth centuries adopted a striking symbolic image that was current in medieval thought. Theologians and poets often explained the mystery of the Incarnation by comparing the miraculous conception and birth of Christ with the passage of sunlight through a glass window:

> Just as the brilliance of the sun fills and penetrates a glass window without damaging it, and pierces its solid form with imperceptible subtlety, neither hurting it when entering nor destroying it when emerging: thus the word of God, the splendor of the Father, entered the virgin chamber and then came forth from the closed womb (St. Bernard).[4]

Very little is told in the Gospels of the way in which the Virgin conceived and gave birth to Christ. St. John said "the Word was made flesh," and Matthew and Luke said that Mary was impregnated by the Holy Ghost. The Fathers felt it necessary to describe the miracle in greater detail, partly in order to combat heretical ideas, and partly in order to satisfy the curiosity of the faithful about these central Christian events. They declared that Mary

had received, through her ear, the Word of God in the form of a divine aspiration transmitted by the Holy Ghost. Her virginity was not affected by this miraculous insemination and she remained intact even when giving birth to Christ and forever after. Christ incarnate possessed the power of passing through material things, a power which He showed also when He rose from a closed tomb and when He moved to the apostles through closed doors. These supernatural occurrences were difficult to understand; the Fathers and their successors had recourse to metaphors and symbols. The conception was illustrated by reference to Gideon's fleece or Aaron's rod, and the birth was compared with the closed gates of Ezekiel through which only the Lord could pass.[5] Along with these similes they spoke of Christ as a light, or sometimes fire,[6] which the Virgin received and bore. The Virgin was regarded as a window through which the spirit of God passed to earth.[7] From these metaphors there was developed, in the ninth century or earlier,[8] the image of the sunlight and the glass. It possessed the advantage of symbolizing both stages of the miracle, the conception as well as the birth. In the *Biblia pauperum,* for instance, it is introduced in connection with both the Annunciation and the Nativity.[9] Its wide diffusion, if not its origin, was probably due to the prominence and the beauty of the glazed windows of medieval churches. The earlier symbols, created by agricultural peoples and inspired by natural forces such as rain, dew, and florescence, were partly replaced in the Middle Ages by an image dependent upon art.

During the eleventh and twelfth centuries the simile was used by Peter Damian, Hildebert, William of Champeaux, and St. Bernard.[10] Frequently it was interpreted to emphasize the virginity of Mary rather than the ghostly power of Christ. Thus St. Bridget, whose vision of the Nativity influenced the representation of that scene throughout Europe in the late fourteenth and fifteenth centuries, is addressed by Christ in her first revelation:

> I have assumed the flesh without sin and lust, entering the womb of the Virgin just as the sun passes through a precious stone. For as the sun, penetrating a glass window, does not damage it, the virginity of the Virgin is not spoiled by my assumption of human form.[11]

Around the twelfth century the simile was developed further under the influence, apparently, of a newer form of art. Impressed by the great stained glass windows of the cathedrals, theologians began to say: as light is colored

by radiation through stained glass, the Holy Spirit acquires human form by entering the sacred chamber or temple of the Virgin. St. Bernard, after alluding to the ray and the unbroken window in the passage quoted above, adds:

> As a pure ray enters a glass window and emerges unspoiled but has acquired the color of the glass . . . the Son of God, who entered the most chaste womb of the Virgin, emerged pure, but took on the color of the Virgin, that is, the nature of a man and a comeliness of human form, and he clothed himself in it.[12]

In the late Middle Ages the simile of the ray and the glass appears frequently in theological treatises, Latin and vernacular poems, in the mystery plays, and in hymns,[13] such as the following which was sung in the Low Countries in the fifteenth century and perhaps earlier:

> Een glas al heel dat schijnt daer door,
> Ten breket niet van der sonnen;
> So heeft ene maghet nae ende voor
> Joncfrouwe een kint ghewonnen.[14]

In several representations of the Annunciation by painters of the Netherlands in the late fourteenth and fifteenth centuries the rays, which as usual extend from heaven or God the Father to the ear of the Virgin, pass through a glass window. The earliest instance seems to be the *Annunciation* by Broederlam in Dijon, painted between 1394 and 1499 (fig. 3), in which C. Smits[15] already perceived a symbol of the Incarnation. The emergence of the rays from the glass is prominently shown just above the head of the Virgin, and the motif appears in a painting that is rich in symbolic forms, such as the "thalamus Virginis," the "hortus conclusus," and the prophets on the exterior of the building. The rays in the Annunciation are in essence symbols of the Holy Spirit, but they are usually conceived as light, and in paintings of the Annunciation, from the fourteenth century on, windows or other openings are often provided to permit their passage into the chamber of the Virgin.[16] It seems very probable then that in Broederlam's panel the divine rays which actually effect the Incarnation have a natural aspect that symbolizes and explains the miracle.

The rays likewise pass through a glass window in the *Annunciation* in the *Très Riches Heures* of the Duke of Berry, painted shortly before 1416 (fig.

4). This painting resembles Broederlam's in other ways also: in the appearance of the prophets, the posture of the Virgin, and the oblique arrangement of both figures and architecture, although the latter now has a contemporary ecclesiastical form.[17] The motif then recurs in two of the major works of the early fifteenth century, the Mérode *Annunciation* by the Master of Flémalle (fig. 2) and the approximately contemporary *Annunciation* in Washington by Jan van Eyck (fig. 5).[18] In the Mérode *Annunciation* the window, set in the wall of a domestic interior, is a small oculus. In Jan's painting the rays pass through the clerestory window of a church, accompanied by natural light which brightens the jambs. This window is filled with clear glass, unlike the one at the rear which contains the figure of Christ.

The subtle and pervasive symbolism characteristic of the work of both these painters shows itself again in the use of precisely seven rays in these representations. In late medieval painting the number of rays in the Annunciation varies greatly, from three to twelve or more. Three, symbolizing the Trinity, is perhaps the most common. Seven undoubtedly refers to the seven gifts of the Holy Ghost: wisdom, understanding, counsel, strength, knowledge, piety, and fear.[19] Christ Himself is endowed with these seven spirits, and He is sometimes shown surrounded by them in the form of seven doves, as in windows at St. Denis and Chartres.[20] The seven spirits, enumerated by Isaiah (11:1–3), are mentioned by St. John in his vision of the Lamb (Rev. 5:6) and there are seven major rays proceeding from the dove in Jan's painting of this subject in the Ghent Altarpiece.[21]

The passage of the rays through the glass is represented in several later paintings of the Annunciation, such as that by an imitator of Flémalle in the Prado,[22] Roger's Columba Altarpiece, and Jan Provost's panel in the hospital at Genoa.[23] In an *Annunciation* by the Virgo Master the rays are supplanted by a beam of light.[24] It is possible, in fact, that the conception is symbolized in certain paintings in which the rays are lacking, as they often are after the middle of the fifteenth century. In two paintings by Albert Bouts, for instance, large windows which admit the daylight are placed near the Virgin.[25] And the three windows behind the Virgin in Jan van Eyck's *Annunciation* (fig. 5) may symbolize not only the Trinity, as Tolnay has suggested,[26] but also—for a second time in this painting—the Incarnation. The radiant window alone, without a visible beam of light, may refer to the

Virgin and the miraculous conception and birth; she was sometimes called "tu fenestra vitrea sole radiata."[27]

In all the foregoing paintings the light and the glass windows seem, and are, normal elements of the interiors represented or the scenes enacted in them. Their symbolic meaning is, however, entirely consistent with other aspects of the works and with an attitude of mind shared by the painter and his audience alike.[28] In the Mérode *Annunciation* (fig. 2), for instance, the candle, the towel, the vessel, and the mousetrap all have religious significance, and the forms in Jan van Eyck's *Annunciation* in Washington (fig. 5), the lilies, the church and its murals, the zodiacal signs, and the Old Testament scenes in the pavement, are attributes or metaphors of the Virgin and the Incarnation.[29] Further proof of Jan van Eyck's intention to symbolize the Incarnation by the passage of light through a glass window is provided, I believe, by another of his panels.

In the *Virgin in the Church* in Berlin (fig. 6),[30] painted a few years earlier than the *Annunciation* and in fact the earliest of all his works, the splendor and subtlety of the painting of light is unsurpassed in Western art. A bright sun strikes through the glass in the clerestory, flickers on the jambs of the windows, spreads over the ribbed vaults, and falls in two brilliant patches on the floor of the nave. The lower part of the church is relatively dark; here the light is concentrated in the Madonna and the two glowing spots on the floor. Deeper in space the shadows are relieved by burning candles on an altar and, at the left, a sunlit portal. The flow of light through the empty church, the stillness, the rapt mood of the Virgin and her abnormal size create a sense of mystery, of a meaning beyond the immediately comprehended.

Is the wonderful radiance of the windows and the intensity of the light on the floor just behind the Virgin intended to symbolize the miraculous conception and birth of Christ? We should be uncertain were it not for the original inscription on the frame which the painting bore when it first became known to scholars. Shortly before 1855 Laborde[31] saw the panel in the collection of an architect at Nantes, one M. Nau, who had bought it for some fifty francs. He noted the inscription, and in 1869 Buerger, who came across the painting in the Suermondt Collection in Aachen, read it in essentially the same way.[32] In 1874 the painting was acquired by the Kaiser Friedrich

Museum, and shortly afterward it was stolen, only to be returned without the frame. On the lower frame appeared: FLOS FLORIOLORUM APPELLARIS.[33] Around the other three sides of the frame was written the following, which obviously has a poetic form, as I have indicated by division into verses:

> MATER HEC EST FILIA
> PATER HIC EST NATUS
> QUIS AUDIVIT TALIA
> DEUS HOMO NATUS ETCET

This may be translated:

> This mother is the daughter,
> This father is born.
> Who has heard of such a thing?
> God born a man.

These lines compose the first half of the second stanza of a medieval Nativity hymn, which begins:

> Dies est laetitiae
> in ortu regali,
> nam processit hodie
> ventre virginali
> puer admirabilis,
> vultu delectabilis
> in humanitate,
> qui inaestimabilis
> est et ineffabilis
> in divinitate.

The fifth stanza of the hymn begins:

> Ut vitrum non laeditur
> sole penetrante
> sic illaesa creditur
> virgo post et ante.[34]

This has been translated by Neale:

> As the sunbeam through the glass
> Passeth but not staineth

> Thus the Virgin, as she was,
> Virgin still remaineth.[35]

Thus the inscription on the frame proves that the painting in Berlin is not simply the usual cult image of the Madonna, but a sort of Christmas picture that contains allusions to the Incarnation and birth of Christ and the virginity of His mother. The hymn was undoubtedly a familiar one. The painter explicitly refers to it in its entirety by adding "ETCET" to the part he quoted. Because of this, and also because Jan's work shows a wide knowledge of religious texts and symbols, we are justified in supposing that he had in mind the simile in the fifth stanza and that he symbolized the virginity of Mary "post et ante" by the radiation of sunlight through the glass, more resplendent here than in any other of his paintings.

This interpretation seems confirmed by other aspects of the work. The windows are filled with clear rather than stained glass, even though they are set in a Gothic church, the characteristic features of which are described with astonishing perception, and even though Jan at other times avoided large areas of clear glass and bright light.[36] Mary, standing in the church with her Child, appears as a virgin "post partum." An allusion to her virginity at, and perhaps before, the conception is made by the representation of the Annunciation just alongside her head in the relief in the first bay of the choir screen. In the relief of the second bay appears the Coronation,[37] the final act of glorification, and just below this relief, though back in the choir, two angels sing her praises, probably in the words of the hymn inscribed on the frame. On the pinnacles of the screen is represented the Crucifixion, the major event following the Incarnation, which terminates Christ's life on earth and assures man's redemption. The Child, wrapped to the hips in a white cloth, is unusually small and relatively unformed.[38] He seems wholly dependent on His mother, and reminds us more of the Infant in the Nativity than the older, more robust and independent Christ Child of Jan's other works.[39] Are these qualities of the Child determined simply by the early date of the picture, as has been suggested, or are they expressive of extreme infancy and recent birth, in accordance with the ideas of the hymn?

The sunlight that streams into the church has still another sense in the rich and subtle context of this painting. Buerger read on the border of the Virgin's tunic: ". . . SIOR SOLE . . . HEC ES . . ."[40] and observed that this was part of the same text that is written on the frame of the Dresden trip-

tych. It appears also, in fact, on the panel of the Virgin in the Ghent Altar-
piece and on the frame of the Paele Altarpiece. It reads:

HEC EST SPECIOSIOR SOLE SUPER OMNEM STELLARUM DISPOSICIONEM
LUCI COMPARATA INVENITUR PRIOR CANDOR EST ENIM LUCIS ETERNE
SPECULUM SINE MACULA DEI MAIESTATIS

(Wisd. of Sol., 7:29, 26)[41]

[For she is more beautiful than the sun, and above all the order of the
stars; being compared with the light, she is found before it. For she is the
brightness of eternal light, and the unspotted mirror of God's majesty.]

This is Jan van Eyck's favorite text—no other is repeated in this way. Like his
paintings, it is full of images of light. It is first used in the *Madonna* in
Berlin, and here it is most closely connected with the painting, for this is the
only work in which the Virgin is actually related to the light of the sun.

The Berlin painting is both the representation of a magnificent Gothic
cathedral in which appears the visionary Madonna, preternaturally large, and
a pattern of symbols in which the image of the Virgin is surrounded by a
rather small church expressive of several aspects of her nature. We have
already referred to the light, the windows, and the reliefs; and the church
itself is one of the most common metaphors of the Virgin.[42] According to
Jan van Eyck—if we may accept as evidence the inscription on the Ypres
Altarpiece—she is the "temple of the builder; the sanctuary of the Holy
Spirit."[43] Theologians had even compared Mary, who bore the Light in her
womb, to a church filled with daylight:

Lumine plena micans, imitata est aula Mariam
Illa utero lucem clausit et iste diem.[44]

In Jan's painting, the daylight fills the church as the Divine Light filled the
womb of Mary.

Just behind the Madonna, in the first bay of the choir screen, a statue of
the Virgin and Child stands on an altar between burning candles—them-
selves symbols of the Incarnation.[45] The relationship between the sculpture
and the Virgin seems pointed. It is true that the statue is of an earlier style
(thirteenth century?) than the living Virgin. But in both groups the Ma-
donna carries the Child on her right arm, in both she wears a crown, and the

posture of the Child is remarkably similar. The Madonna is enveloped by the nave of the church, the statue by an arch of similar shape. Furthermore, at each side of the statue is a burning candle—an artificial light—while the living Virgin is celebrated at left and right by the natural light of the sun. As we contemplate these two figures in the shadowy interior we seem to witness a miracle of animation, a statue come alive. The painter and his audience would have known of similar occurrences. They had probably not heard of those in the ancient world, but they were certainly familiar with the accounts of the animation of statues of the Madonna given by many of her most ardent worshippers, including St. Bernard.[46]

For a spectator of Jan's time, the style of the church and the sculpture recalled a great Christian period, more devout and less troubled than the present. But is there latent also in the comparison of the living Virgin and the inert, outmoded statue a subtle reference to the painter's own artistic achievements, to his progress beyond his predecessors?[47] This suggestion may seem less fantastic if we recall that the mirror in the Arnolfini portrait and in a lost work[48] seems to express, beyond its other connotations, Jan's awareness of a new relation of his art to actuality. And, after all, the phrases on the Ghent Altarpiece referring to his brother Hubert and himself—"major quo nemo repertus" and "arte secundus"—are more than conventional statements. So remarkable in fact is the self-consciousness and pride which they manifest that it has increased the doubts of some scholars as to the authenticity of the entire inscription.

The church in the painting in Berlin has been identified as a free copy of St. Denis[49] or the cathedral of Ghent,[50] but, as in the case of other buildings and panoramas, Jan seems to follow no single model. Rather he composes in the style of thirteenth- and fourteenth-century Gothic. His painting is, in fact, the earliest document we possess, apart from the buildings themselves, of the actual appearance of the interior of a Gothic cathedral. Not until two hundred years after the construction of the churches themselves was a painter able to capture the qualities of space and light of their interiors. But if artists of his time in the Low Countries enjoyed debating the relative merits of the several arts, as they did in Italy, we can surmise Jan's contribution to the "paragone." He would have argued of course for the supremacy of painting, and his thesis might conceivably have been that painting is not only the one art which can truly mirror the world, but that it incorporates, in a sense, the

other arts. As proof he could point to the church, the sculpture, and the beautiful specimen of goldsmith's work in the *Virgin in the Church*.

Postscript

I doubt whether any professional task has ever given me greater pleasure than the contemplation of the group of paintings discussed above, and especially prolonged consideration of Jan van Eyck's marvelous *Madonna in the Church* (fig. 6). I am glad, therefore, that the design of the book allows this early paper to come first.

N O T E S

1. Both Mrs. Jameson (*Legends of the Madonna*, 2nd ed., London, n.d., p. 311) and H. Mendelsohn (*Fra Filippo Lippi*, Berlin, 1909, p. 88) have commented on Fra Filippo's innovation. In most paintings of this rare subject the angel gives the Virgin a palm, following the *Golden Legend* (August 15, Assumption of the Virgin). But the *Golden Legend* tells that after the angel returned to heaven, the palm held by the Virgin "shone with a great brilliance. It was a green branch, but with leaves as luminous as the morning star." In the representation of this scene in the *Maestà* Duccio added small stars to the leaves of the palm. The luminous palm branch may have suggested to Fra Filippo the use of a burning candle, a symbol customarily presented to a dying person.

2. E. Panofsky, "Jan van Eyck's Arnolfini Portrait," *Burlington Magazine*, LXIV, 1934, pp. 117–127; *idem*, "The Friedsam Annunciation and the Problem of the Ghent Altarpiece," *Art Bulletin*, XVII, 1935, pp. 433–473; *idem*, "Once More the Friedsam Annunciation . . . ," *Art Bulletin*, XX, 1938, pp. 419–424; C. de Tolnay, "Zur Herkunft des Stiles der Van Eyck," *Münchner Jahrbuch*, IX, 1932, p. 320 ff.; *idem*, *Le Maître de Flémalle et les frères Van Eyck*, Brussels, 1939.

 Tolnay's interpretation of the growth and meaning of naturalism in early fifteenth-century painting is different from that suggested above. Instead of regarding the interest in nature or reality as primary (and connected with the secular trends of the period) he believes it originated in, and was sustained by, late medieval religious conceptions. Of light he says (in his book, p. 16): ". . . the vision of interior (spiritual) light led the mystics to the contemplation of natural light, of which they—for example, Suso—sometimes give enchanting descriptions, and in this way they are the direct precursors of the painters called realists." For a point of view similar to mine, see M. Schapiro, "Muscipulum diaboli," *Art Bulletin*, XXVII, 1945, p. 183.

 Tolnay (p. 14) bases his interpretation of the Dijon *Nativity*, which includes both the sun and the candle, on the *Golden Legend*, where the two midwives appear (and speak the phrases written on the scrolls in the painting) and on a Christmas sermon of St. Ambrose or St. Maximus, in which Christmas Day is called the day of the New Sun, which shone more brilliantly than the sun on any other day of the year. The candle is not mentioned in the *Golden Legend*, and apparently not in the sermon, but it does appear, along with a reference to the sun, in St. Bridget's vision of the Nativity (1370): ". . . And while she (the Virgin) was standing there in prayer,

I saw the child in her womb move and suddenly in a moment she gave birth to her son, from whom radiated such an ineffable light and splendor that the sun was not comparable to it, nor did the candle, that St. Joseph had put there, give any light at all, the divine light totally annihilating the material light of the candle." (Quoted from the translation by H. Cornell, *Iconography of the Nativity of Christ*, Uppsala, 1924, pp. 21–22.) It seems probable that the Master of Flémalle had in mind this text, or paintings influenced by it, when painting the Dijon *Nativity*. In many representations of the Nativity influenced by the vision of Bridget Joseph holds a candle, as Cornell has shown.

3. "Cum ignis sit nobilissimum elementum, virtutem habet mirabiliter sui diffusivam. In omnibus enim rebus occulte latet ignis, sicut manifeste videtur, cum duo solida corpora invicem colliduntur, exinde enim solet ignis egredi, qui tame ibi credebatur minime occultari. Sic vere Deus invisibiliter est in omnibus . . . Vel potest dici, de igne caritatis, scilicet spiritus sancti, vel divini amoris, qui in multis est, in quibus non creditur esse." P. Berchorius, "Reductorium morale," *Opera omnia*, Antwerp, 1609, Lib. VI, Cap. IV.

4. "Sicut splendor solis vitrum absque laesione perfundit et penetrat eiusque soliditatem insensibili subtilitate pertraicit nec cum ingreditur, violat nec, cum egreditur, dissipat: sic Dei verbum, splendor Patris, virginum habitaculum adiit et inde clauso utero prodiit. . . ." Quoted by A. Salzer, *Die Sinnbilder und Beiworte Mariens in der deutschen Literatur und lateinischen Hymnenpoesie des Mittelalters*, Linz, 1893, p. 74.

5. For the patristic and medieval doctrine of the conception and birth of Christ, see G. Herzog, *La Sainte Vierge dans l'histoire*, Paris, 1908, Chaps. 1–3; Y. Hirn, *The Sacred Shrine*, London, 1912, Chaps. XIV, XV, XVII; Th. Livius, *The Blessed Virgin in the Fathers of the First Six Centuries*, London, 1893, p. 117 ff. Ernest Jones, *Essays in Applied Psychoanalysis*, London, 1923, p. 261 ff., has studied the medieval idea of the Madonna's conception through the ear from a psychoanalytic point of view.

6. For example, St. Epiphanius (Livius, *op. cit.*, p. 128); St. Fulgentius (*ibid.*, p. 138); St. Ephrem (*ibid.*, pp. 407, 426).

7. St. Fulgentius, quoted by Livius, *op. cit.*, p. 138.

8. Hirn, *op. cit.*, p. 343, refers to the use of the image in the ninth century, but cites no examples of so early a date. Salzer, *loc. cit.*, quotes as the work of Athanasius (†373) an unusually lengthy example of the simile. It appears in a text, originally Greek, entitled *Questiones aliae*, which was included in the collected writings of Athanasius (*Opera omnia*, Paris, 1727, II, p. 446). The text was rejected by Migne (*Pat. Gr.*, XXVIII, 1857, col. 790), who does not, however, assign it a date. Its interest is great enough, I think to warrant full quotation:

"Audi mysterium: Sicut domus circumsepta undique, quae habet orientem versus vitream puram et tenuissimam fenestellam, oriente sole, radii eius penetrantes vitrum et ingredientes domum totam collustrant, et rursus transeunte sole et egredientibus radiis vitrum non confringitur, sed ab ingredientibus et egredientibus repercussionibus radiorum solarium manet illaesum: ita intellegas de semper Virgine Maria. Illa enim castissima, ut domus quaedam circumsepta cum sit, filius et verbum Dei ut radius divinus ex sole iustitiae Patre descendens, qui per vitream fenestellam aurium illius ingressus sanctissimam domum eius illustravit et rursus . . . exivit, ne minime quidem foedata virginitate illius, sed sicut ante partum etiam in partu et post partum Virginem castam conservavit."

(Hear the mystery: Just as a house enclosed on all sides which has toward the east a clean thin glass window and, when the sun rises, its rays penetrating and pass-

ing through the glass brighten the whole house, and again with the passing of the sun and the withdrawal of the rays the glass is not shattered, but remains undamaged by the incoming and outgoing vibrations of the solar rays: thus you may understand the everlasting virginity of Mary. For that most chaste person, as a kind of house when (?) it is enclosed, the son and the word of God as a divine ray descending from the sun, Father of Justice, which, having entered through the glass window of her ears, has illuminated its most holy house and again . . . has gone out, without even in the least having despoiled her virginity, but just as before birth, also in birth and after birth has preserved the chastity of the Virgin.)

9. In the *Annunciation* in Utrecht, University Library, ms. 373, and in the *Nativity* in Munich, ms. Clm. 5683. Cf. H. Cornell, *Biblia pauperum*, Stockholm, 1925, p. 17.

10. Salzer, *loc. cit.* Salzer's compilation is very valuable. He does not attempt, however, a history or critical account of the simile.

11. "Assumsi carnem sine peccato et concupiscentia, ingrediens viscera Virginea, tanquam Sol splendens per lapidem mundissimum. Quia sicut Sol vitrum ingrediendo non laedit, sic nec virginitas Virginis in assumptione humanitatis meae corrupta est." *Revelationes Sanctae Birgittae*, Rome, 1628, I ("Revelations," p. 1).

12. ". . . sicut radius in vitrum purus ingreditur, incorruptus egreditur, colorem tamen vitri induit . . . sic Dei filius purissimum Virginis uterum ingressus purus egressus est, sed colorem Virginis i.e. humanam suscepit naturam humanaeque speciei decorem induit et praecinxit se." (Quoted by Salzer, *loc. cit.*)

13. Salzer, *op. cit.*, pp. 71–74, quotes a number of hymns and a great many German mystics and writers of vernacular prose and poetry. Cf. also Hirn, *op. cit.*, pp. 343–345 (Alexander Neckham, a thirteenth-century hymn, French fifteenth-century mystery play, German poem). The simile appears at the end of the text of the *Defensorium inviolatae virginitatis Mariae* in Munich, ms. Cgm. 258 (Cornell, *Iconography* . . . , p. 79) .

14. Hoffmann von Fallersleben, *Niederländische geistliche Lieder des fünfzehnten Jahrhunderts (Horae Belgicae, Part X)*, Hannover, 1854, p. 53.

15. *Iconografie van de Nederlandsche primitieven*, Amsterdam, 1933, p. 47. Smits also refers to the passage of the rays through the glass in Jan van Eyck's *Annunciation* in Washington.

16. Cf., for instance, two late fourteenth-century Florentine *Annunciations*, one in the Vatican, the other in Santo Spirito, Prato, both reproduced by G. Prampolini, *L'Annunciazione*, Milan (n.d.), figs. 18 and 19; Crivelli's *Annunciation* in the National Gallery, London; the *Annunciations* in the *Breviary of Belleville, Hours of Jeanne de Navarre, Breviary of Charles V*, all reproduced by D. M. Robb, "The Iconography of the Annunciation in the Fourteenth and Fifteenth Centuries," *Art Bulletin*, XVIII, 1936, figs. 16–18. Only a study of the original paintings would reveal whether or not there are small areas of glass in the windows of these or other representations of the Annunciation before Broederlam. In any event, the glass is prominent for the first time in Broederlam's work.

17. It might be expected that the passage of the rays through the glass would be represented in the paintings of the Boucicaut Master, who created the first complete church interior in scenes of the Annunciation; but none of his paintings shows it.

18. Both paintings were probably made around 1425.

19. See A. Didron, *Christian Iconography*, London, 1886, I, p. 423 ff.

20. Cf. E. Mâle, *L'art religieux du treizième siècle*, Paris, 1925, figs. 91, 93.

21. Seven rays appear, of course, in some other paintings of the Annunciation. See the

two Florentine paintings cited in note 16; also the *Annunciation* by an imitator of Flémalle in the Prado.

22. M. Friedlaender, *Die altniederländische Malerei,* Berlin, II, 1924, p. 192, pl. 45. The perfunctory nature of this painting is shown by the fact that only a few of the rays actually pass through the window; others strike the stone base.

 A. Liebreich, "L'Annonciation d'Aix-en-Provence," *Gazette des Beaux-Arts,* XIX, 1938, p. 65, says that the passage of the rays through the rose in the Aix *Annunciation* symbolizes the Incarnation. Judging from a photograph, I am not sure that there is actually glass in the window.

23. Friedlaender, *op. cit.,* IX, 1931, pl. 69.

24. Friedlaender, *op. cit.,* V, 1927, pl. 31.

25. Paintings in Cleveland and Berlin; cf. Friedlaender, *op. cit.,* III, 1925, pls. 50, 51.

26. "Flemish Paintings in the National Gallery of Art," *Magazine of Art,* XXIV, 1941, p. 178. Tolnay also refers to the radiant windows as symbols of Christian revelation, which Panofsky had pointed out in a somewhat different context ("The Friedsam Annunciation . . . ," *Art Bulletin,* XVII, 1935, p. 450).

27. F. Mone, *Hymni Latini Medii Aevi,* Freiburg i.B., 1853, II, no. 600. Reference should also be made to the flask partly filled with water which appears in several early Flemish paintings as a symbol of virginity. The glass is usually irradiated with light, as in the *Annunciation* in the Ghent Altarpiece (cf. Smits, *loc. cit.*). In this same painting sunlight falls on the wall alongside the Virgin.

 The flask is placed in the foreground of the *Annunciation* by Fra Filippo Lippi in San Lorenzo, Florence (see p. 26, fig. 13). Its use seems to be another instance of Flemish influence on the work of the painter who was the first in Italy to adopt the domestic interior as a setting for the Madonna (panel from Corneto Tarquinia, dated 1437, fig. 15).

28. Cf. J. Huizinga, *Waning of the Middle Ages,* London, 1937, especially Chap. XV.

29. See note 2. Also, for the Washington *Annunciation,* Tolnay in *Magazine of Art, op. cit.,* and for the symbolism of the mousetrap, Schapiro, *loc. cit.*

30. Friedlaender, *op. cit.,* I, 1924, p. 78 f.

31. *La Renaissance des arts à la cour de France,* Paris, 1855, I, p. 604.

32. W. Buerger, "Nouvelles études sur la galerie Suermondt à Aix-la-Chapelle, I," *Gazette des Beaux-Arts,* 2nd ser., I, 1869, p. 13.

33. Cf. *Kaiser-Friedrich-Museum, Beschreibendes Verzeichnis der Gemälde,* Berlin, 1906, p. 126.

34. Mone, *op. cit.,* I, p. 62, no. 49. Mone based his text on a fifteenth-century manuscript in Trier, but drawing from other manuscripts, he substitutes "factus" for "natus" in the fourth line of the second stanza. Daniel, *Thesaurus hymnologicus,* Leipzig, 1862, I, p. 320, omits the stanza which appears in part on the Berlin painting. The section of the fifth stanza dealing with the sun and the glass is quoted by Salzer, *loc. cit.*

35. J. M. Neale, *Medieval Hymns and Sequences,* London, 1857, p. 186.

36. The painter of the copy of 1499 in the Antwerp Museum (Fierens-Gevaert, *Primitifs flamands,* Brussels, 1912, I, fig. 11) inserted figures in the glass of the nave windows, and omitted the patches of light on the floor, showing that he failed to understand the meaning of Jan's composition.

37. The sixteenth-century copy in the Doria Gallery adds a third bay with a relief of the Nativity (cf. W. Weale, *Hubert and Jan van Eyck,* London, 1908, p. 135 and pl.). Weale claimed that the third bay and other peculiarities of the Doria panel must have been included in the original work (he believed the Berlin painting to be a copy). For many reasons this view is untenable.

38. W. Bode, "La Renaissance au Musée de Berlin," *Gazette des Beaux-Arts,* 2nd ser., XXXV, 1887, p. 216, commented unfavorably on the small size and poor formation of the Child.

39. With the exception of the *Madonna of the Fountain,* Antwerp, where the Child is also quite small, though more active and with a more developed structure.

40. Buerger, *loc. cit.* I have found no later record of this inscription. In the photograph here reproduced I can make out the letters . . R. . SO. ., and farther to the right, LU.

41. W. Weale, *The Van Eycks and Their Art,* ed. Brockwell, London, 1912, p. 123, note 1, says that this text was used in the little chapter at Lauds on the feast of the Assumption, in the breviary according to the use of St. Donatian, Bruges.

42. Cf. Livius, *op. cit.,* pp. 263–277.

43. "Conditoris templum: sancti spiritus sacrarium." Cf. Weale, ed. Brockwell, p. 137. If this inscription is not authentic, it probably copies Jan's original.

44. Venantius Fortunatus (7th century), quoted by Hirn, *loc. cit.*

45. J. Sauer, *Symbolik des Kirchengebäudes,* Freiburg i.B., 1924, p. 187.

46. Cf. P. Sausseret, *Les apparitions et révélations de la très Sainte Vierge,* Paris, 1854.

47. Tolnay, in *Münchner Jahrbuch,* IX, 1932, p. 324, claimed a dependence of Jan's *Madonna* on the *Virgin in the Church* by the Master of Flémalle, known by several copies (cf. Friedlaender, *op. cit.,* II, 1924, pl. 63), and in his book (*Le Maître de Flémalle et les frères Van Eyck,* Brussels, 1939, p. 24) he attributed the invention of the architectural composition to the same painter, referring to a *Presentation in the Temple* in the Pelletier Collection, Paris, which copies, at least in part, a lost work of Flémalle. Tolnay was the first to recognize the full extent of the influence of Flémalle on Jan, but the fact that the former influenced some of Jan's later paintings is no indication that he holds a priority in all the innovations that appear in the work of the two painters. Until the paintings in question can be more precisely dated there appears to be no certain way of solving the problem. But it is clear that in form and meaning Jan's painting is far richer, and that the small size of the Child, which Tolnay adduced as evidence of Jan's dependence, seems to be motivated specifically in his work and not in the painting by Flémalle.

As for the beautiful church interior in the *Mass for the Dead* in the *Milan Hours* (Museo Civico, Turin) I agree with the opinion of Dvořák, Tolnay and others, that it, and the other miniatures in this style, are not by the Van Eycks, and are not early. To the evidence which has already been accumulated in support of this view I should like to add here one comment: that the spots of reflected light, especially on the metal utensils in the *Birth of the Baptist,* are extraordinarily large and coarse, and seem to be the work of a painter who was imitating and exploiting an original observation, rather than of the originator himself. (In later publications I have not maintained this conclusion.)

48. Cf. the copy by W. van Haecht (Weale, *op. cit.,* pl. opp. p. 176).

49. K. Voll, *Die altniederländische Malerei,* Leipzig, 1906, p. 39.

50. G. Hulin de Loo, *Catalogue critique des tableaux flamands exposés à Bruges,* Ghent, 1902, pp. 2–4, 58.

2

Jan van Eyck and the Italian Renaissance

It is generally recognized that many Italian painters of the last quarter of the fifteenth century were deeply impressed by the art of the Netherlands.[1] When Giovanni Bellini began the fateful transformation of his style in the early seventies, he was undoubtedly instructed by Netherlandish panels as well as by those of Piero della Francesca. Even in Florence, the great stronghold of *disegno,* Ghirlandaio, Filippino and Piero di Cosimo were much affected by the glowing panels of Hugo van der Goes. In 1481 Ghirlandaio modeled his *St. Jerome* upon a specific work by Jan van Eyck—very probably the panel that is partly his, now in the Museum at Detroit. But the main Italian tradition in the earlier Quattrocento is usually referred to contemporary painting in the Netherlands, and above all to Jan van Eyck, only to prove utter and irreconcilable differences. For this there is much reason and impressive ancient sanction. In a well-known passage that formulated a prevalent Italian conception Michelangelo is reported to have remarked that "In Flanders they paint with a view to external exactness. . . . They paint stuffs and masonry, the green grass of the fields, the shadows of trees, and rivers and bridges . . . all this is done without reason or art, without symmetry or proportion."[2] Earlier, in 1449, the widely-travelled antiquarian Ciriaco d'Ancona made similar though more enthusiastic comments, writing of "gold

This essay was published in *Venezia e l'Europa. Atti del XVIII congresso internazionale di storia dell'arte, 1955,* Venice, 1956, pp. 58–69.

19

really resembling gold; pearls, precious stones, and everything else you would think to have been produced, not by the artifice of human hands but by all-bearing nature herself."[3] This recorded Italian view of Netherlandish painting, employing the critical concepts of antiquity, was unchallenged by any early local tradition in the North, and it has echoed down the centuries, shaping the thought even of so perceptive a critic as Roger Fry as late as 1927, when he wrote that: "On the whole we must conclude that John van Eyck's immense reputation rests mainly on his preternatural skill in reporting rather than on the importance of his imaginative attitude or on any remarkable esthetic sensibility."[4]

Now it is of course characteristic of the pictorial tradition of the Italian Renaissance, even in its moments of closest approximation to visual reality (as the astonishing vista in Domenico Veneziano's *Annunciation*), that objects in the world lose many qualities when becoming elements in a work of art. They yield part of their character to what Michelangelo and his Florentine predecessors called symmetry and proportion—in other words to an overlying image of relation and order. The long-established notion that Netherlandish painting, on the other hand, tends to preserve or duplicate the visible qualities of objects, while conveying part of the truth, does not of course attain it. If Italian painters may be said to abstract from visible reality, Jan van Eyck does not so much mirror it as enhance it, raising it to a higher power. Ciriaco d'Ancona was wrong to say that in Jan's painting or that of his followers gold really resembles gold and trees trees. The truth is that Jan gave to gold a splendor that we can all see in his panels but only he could "see" in the world. It is in *his painting* rather than in *our experience* that bronze has the more palpable hammered density, glass beads the more scintillating translucency, a mirror the cooler smoothness and the greater brilliance.*

It is furthermore not right to suppose that Jan van Eyck's fascination with single objects precluded a prominent larger order in his work. While it is true that Jan brings his eye near each of the many objects in a painting as he shapes them with his brush, his picture is not constructed from these innumerable close points of sight alone. There is a more distant viewpoint, implied by the perspective and the larger order of color, light and shape. In

* Here I have deleted a reference to a puzzling sentence by Alberti which is not relevant, as Creighton Gilbert rightly remarked to me *in litteris* years ago.

Erwin Panofsky's recent telling formula: "The great secret of Eyckian paint-ing [is] the simultaneous realization, and, in a sense, reconciliation, of the 'two infinites,' the infinitesimally small and the infinitely large."[5]

If this is true, then Jan van Eyck's actual distance from his contemporaries in Italy may not be quite so great as conventional criticism has taught us. He emerged, after all, from a tradition of painting that for nearly a hundred years had been enriched by the study of Italian art. It is true that enthusiasm for the art of Italy had been greater in France—that is to say in Paris, Dijon and Bourges—than in the Low Countries, where Jan presumably first began to form his style. But even in this region the only major pre-Eyckian panels to survive, Broederlam's altarwings, presuppose a knowledge of what we may call in some respects the "most advanced" Trecento painting—Broederlam's *Presentation,* for instance, is generally acknowledged a successor of Ambro-gio Lorenzetti's. The art of Jan van Eyck, heir to the Northern tradition, inevitably resembled in some respects Italian painting, so that the significant question is whether he struck out in a direction wholly divergent from that of his equally revolutionary Italian contemporary, Masaccio.

In a recent paper I have attempted to show that Jan van Eyck's portraits are similar in several respects to those of his contemporaries in Italy.[6] Begin-ning with the painting of 1433 in London Jan's portraits acquire an almost Italian massiveness. The faces reflect an underlying structure of bone and muscle that, as in Italian portraits, expresses the sitter's alertness, determina-tion, and even aggressiveness (fig. 8). Jan's willful *homo novus* is a close relative of his contemporaries in Italy. It is indeed not impossible that Jan developed this conception of personality and the means of conveying it by a study of some Florentine panel or drawing from the circle of Masaccio. An easel portrait would not have been the most instructive specimen of this style, because it would presumably have shown the sitter in profile, the usual Flo-rentine posture that appears, too, in surviving works by Masaccio's immediate followers. Jan could have learned most from one of those heads in Masac-cio's panels or frescoes that, like his own portrait heads, receive the light on their farther sides (fig. 7). Perhaps he had seen a form of this sort in a drawing, but we cannot wholly exclude the possibility that he had gone to Italy and perhaps even to Pisa or to Florence itself. In the late twenties he traveled constantly for the Duke, and in 1426 records speak twice of jour-neys to "distant places."

Jan van Eyck's figures, like those of Masaccio, present to us a new order of mentality, far more subtle and complex than anything visible in earlier painting. Nothing in any of the arts of the time bespeaks so decisively the beginning of a new era, which later offers us the *Moses* of Michelangelo or, in the nineteenth century, the novel. The new depth of consciousness in the figures of Jan and Masaccio is bound up with the unprecedented visualization of light. Light permits an infinitely subtle, vivid, yet imprecise variation of plane. Mobile and intangible, it has always been associated with the spirit, especially during the Christian centuries. Present in medieval art only as a symbol, light, even more than linear perspective, was the great conquest of fifteenth-century painting, a conquest in which Masaccio and Van Eyck shared equally. In the work of both light reveals a new reality *inside* man as well as around him.

Although Jan van Eyck's light is devoted more to the enhancement of color and texture and Masaccio's to the intensification of substance and space, the luminary patterns created by the two painters are often fundamentally similar. In both the Arnolfini portrait of 1434 (fig. 9) and the *Crucifixion of St. Peter* in Berlin (fig. 10), light strikes into the pyramidal space from the upper left, spreading across the immediate foreground. Behind this luminous area, through which, so to speak, we enter the picture, a band of shade extends across the space, giving way in turn to a brighter zone, so that the extension of the space is made vivid by an alternation of light and dark zones, all parallel to the picture plane. The figures, likewise more or less parallel to the same plane, are grounded, as it were, in the middle dark zone but they tend to rise into light. The space is closed behind them by a wall that is responsive to their variations in luminosity, becoming bright where they darken, and vice versa.

These two paintings by Jan van Eyck and Masaccio, with their succession of parallel planes, share other compositional qualities—a highly developed axiality, symmetry, rectangularity. In Jan's Paele Altarpiece of 1436, the figures, more massive and rounded than in the Arnolfini panel of 1434, conform to a semi-circular space defined by the arcade of a church (fig. 19). Now a circular arrangement of cylindrical figures may be found also in the painting of Masaccio—in the *Tribute Money,* for instance (fig. 52). It is a form of composition that was novel in both Italy and the Netherlands. Prior to Masaccio and Van Eyck, compositions were commonly rectilinear, the

forms parallel to the picture plane; sometimes they were triangular, as in Giotto and other Trecento masters, or convex, as in the early fifteenth century, so that the forms trailed off into space. The concave plan introduced by our two painters effects a slow, regular movement *into* space and out again. It permits both plastic compactness and spatial extension, and it imparts a grave serenity to the design. In both the Paele *Madonna* and the *Tribute Money,* the architectural members are rounded also: arches and windows, and in Jan's panel, stout columns. Now the taste for circular forms, for hemispherical plans, and for domical spaces, is widespread in Italy in the second quarter of the fifteenth century. Alberti justifies it as a natural phenomenon. "It is evident," he says, "that Nature takes delight in round things," and he refers for proof to trees and birds' nests. The occasion for these comments was his consideration of the shapes of churches and their chapels.[7] During this period symbolic values were attached to circular buildings, as Wittkower has recently shown.[8] Similarly, Filarete, Florentine but writing in Milan where the Gothic arch was still commonly employed, argues for the round arch on physiological or psychological grounds that warrant the use of round forms generally.[9]

Filarete had in mind, of course, the round arch of early Renaissance architecture, which Masaccio employs, if not clearly in the *Tribute Money* then in the *Trinity* in Sta Maria Novella. Jan van Eyck on the other hand revived the Romanesque—a style that is, after all, full of antique reminiscences. For Jan and his period, this style was charged, as Erwin Panofsky has shown, with religious significance, connoting either the world before Christ, or far-off or visionary holy places.[10] Jan's choice of Romanesque architectural members was thus motivated—as artistic choices usually were—by a conjunction of delight with the object's form and interest in its meaning. Werner Körte remarked some years ago that the Romanesque was to Jan van Eyck almost what Roman architecture was to the early Renaissance architects and painters.[11] Indeed the Romanesque seems to have attracted Brunelleschi himself in his early years.

In addition to these broad similarities of taste and of style, the paintings of Masaccio and Jan van Eyck are related with respect to perspective, linear as well as aerial, despite the fact that Jan did not attain to a one-point system. The two masters shared a conception of an objectified perspective image seen through a frame from one or two fixed points of sight, and sometimes they

drew very similar consequences from this conception. Jan's *Madonna of the Fountain* (fig. 11), for instance, resembles the mother receiving alms from St. Peter in the damaged fresco in the Brancacci Chapel (fig. 12). Both women stand majestically and hold an infant who turns his back upon the beholder as he clings to his mother's body. The reversed figure, introduced by Giotto and occasionally employed before 1425 even for the Christ Child,[12] is here given a similar form, expressiveness and importance. The concept of the objectified perspective image led Jan van Eyck to another radical innovation—the disappearance of the ground plane and of the feet placed upon it, as in the famous instance of Adam and Eve in the Ghent Altarpiece. While this frog's eye perspective, affecting the figures as well as their setting, remained exceptional in the North, Masaccio applied it to single monumental figures also just a few years earlier than Jan. He used it for the lost saints on the Carmine piers, and in another lost fresco attributed to him by Vasari. This last fresco, painted on a pilaster in the Badia, represented St. Ives of Brittany, standing, like Adam and Eve, within a niche. According to Vasari, "i piedi scortassino alla veduta di sotto."[13] Masaccio's conception is reflected in Domenico Veneziano's fresco in Santa Croce.

If, as I have suggested, the broad and obvious differences between Masaccio and Jan van Eyck do not preclude similarities, in some respects basic, would not those successors of Masaccio who shared his luminarist outlook have been attracted also by Jan van Eyck's work, provided of course pictures by him, or at least drawings of them, were accessible? About trips by early Quattrocento painters to the North we hear nothing at all. But there are fifteenth- and early sixteenth-century records of several pictures by Jan and his close follower Petrus Christus in Neapolitan, Florentine, and Paduan collections.[14] We shall, furthermore, shortly advance convincing pictorial evidence for the presence in Padua or Venice before 1455 of an Eyckian panel of the Crucifixion.

It was probably in the former of those cities that the closest of Masaccio's followers, Fra Filippo Lippi, saw an Eyckian composition that is reflected in his *Madonna* in Corneto Tarquinia (fig. 15). Fra Filippo worked in Padua in 1434, and the Corneto *Madonna* was finished three years later. Its setting, a domestic interior, is, so far as I know, unprecedented in the Italian traditions for the Madonna. In the room we see an alcove with a bed, possibly signifying the sanctified *thalamus* of the Virgin. Equally novel are the window

admitting light while disclosing a landscape, and the shutters casually opened onto the street behind. Fra Filippo has translated into the language of Masaccio and Donatello characteristic elements of Jan's Madonnas (fig. 16), his rather showy marble throne replacing Jan's canopy as a means of dignifying the Virgin.

The Corneto *Madonna* is perhaps the earliest instance in Renaissance painting of a taste for the familiar and the homely—a taste that is prominent in later works of Fra Filippo and that recurs from time to time in the Quattrocento even before the appearance of Ghirlandaio. It seems to have been stimulated at the very beginning by Eyckian painting. It was Jan's painting also that helped to form another vital aspect of Fra Filippo's style that emerged initially in the Corneto *Madonna*—the multiplication of spaces and the vivid connection between interior and exterior. Light flows into the chamber through the window and the shutters and from a source at the upper left, spreading with fluctuating intensity over the jambs and the walls, and producing a remarkably sophisticated luminary medley, somewhat drowned out, it must be admitted, by the throne. Small but quite precise clues as to the source of all this, and certainly tokens of Fra Filippo's enthusiasm for Jan van Eyck, are the glistening pearls strung over the Madonna's forehead, the gems in the large brooch pinned into her hair, the rings set with radiant stones that she wears on three fingers, the gleam of metal in the borders of her dress and in the bosses of her book. Is it furthermore simply coincidental that the very first *cartellino* bearing an inscription in Italian painting appeared in the partially Netherlandish context of this panel? Is not this crumpled paper stuck onto the throne the result of a playful delight in optical illusion inspired by the similar enthusiasm of Jan van Eyck? Is this paper not, in other words, related to the inscription carved in weathered, timeworn stone in Jan's *Leal Souvenir?*

Similar forms may be found in another early work of Fra Filippo, an unusual painting now in the Metropolitan Museum (fig. 14).[15] There the corner of a shadowy room with two windows serves to frame and to bind together for posterity a remarkably demure couple. The specification of a domestic setting, indeed of a setting of any kind, is exceptional for an Italian early Renaissance portrait, and it is bound up with an equally exceptional portrait iconography. For whereas the portrayal of man and wife, or as in the Metropolitan panel, a betrothed couple is unknown in earlier Italian easel

portraits, there are in the Netherlands examples of a couple portrayed both on two corresponding panels or joined in one field. The man and wife by the Master of Flémalle in London are certainly pendants, and Massys' panel of a money-changer and his wife seems to reflect a lost Eyckian painting of similar subject.

In another painting that Fra Filippo made not long after his stay in North Italy, the *Annunciation* in San Lorenzo, there is a glass vase that sparkles with reflections and intrigues us with its subtle complication of penetrating and reflected light (fig. 13). Like some similar forms in the paintings of Fra Angelico and Domenico Veneziano, it is scarcely conceivable without a knowledge of Jan van Eyck's paintings, and it seems indeed almost like a Flemish quotation in an otherwise essentially Tuscan text. In a fourth panel of this early period, now in the Uffizi, Fra Filippo made a basic change in the story of the death of the Virgin. According to the *Golden Legend* the angel approached the Virgin bearing a palm, and this symbol appears in Duccio's panel in Siena, one of the very few representations of this rare subject. Fra Filippo, however, put into the hand of the angel a burning taper, a radiant object that, though differently painted, recurs over and over again in panels by Jan van Eyck and the Master of Flémalle (fig. 1).[16]

It was, as we have suggested, in Padua or Venice around 1433–1434 that Fra Filippo Lippi first studied the painting of Jan van Eyck. In the same region and at just about the same time Jan's art was apparently discovered by the first major painter of the Quattrocento who originated in the North. As Roberto Longhi has pointed out,[17] Domenico Veneziano's relatively early tondo in Berlin contains recollections of the luminous, particularized world of Jan van Eyck. Guided perhaps by Domenico's enthusiasm, his pupil Piero della Francesca became fascinated with the same art. In Piero's panel now in Urbino the Madonna, like Fra Filippo's at Corneto, appears in the room of a house (fig. 17). The niche with a jar and a basket of fresh linen on its shelves is a familiar feature of the interiors of Eyckian paintings, and the view into a second room reminds us of the famous scene of the birth of the Baptist in the Hours now in Turin. Only the panels of Jan van Eyck, moreover, such as the *Virgin in the Church* in Berlin (fig. 6), could have inspired the pools of warm sunshine that lie on the wall and the window jambs, streaked by the shadows of the mullions. Piero's wonderful gray and white palette, characteristic of his last phase, and his imposing design for the fig-

ures, with its flatness and repeated verticals, strike us as utterly un-Eyckian. But the way in which only sections of several objects, such as the door and niche, fall within the frame recalls Jan's method of enframing his compositions (fig. 16). Even the angels and the Virgin in Piero's panel are only partly visible. The method of "incomplete" representation is common to both painters and in both it is bound up with a highly developed optic mode.

Piero painted the Urbino *Madonna* near the end of his career. For him at this time the art of Jan van Eyck provided more than an occasional pictorial episode; it touched the very core of his style. In all the late works light becomes more vital than shape. The interaction of light with the color and texture of surfaces is analyzed at closer range. The world is portrayed with an almost Eyckian visual intimacy. This is evident in the subtle fluctuation of the light over the soft flesh of the Urbino Madonna, in the glistening necklaces of the angels, and the astonishing glints in their hair. In his late works Piero displays even more prominently than earlier large, still bodies of water in which adjacent forms are reflected, as in a mirror. These limpid ponds are equivalents in nature of the glass mirrors in Jan van Eyck's interiors.

Mirror-like too is the shining armor of the Count Federigo in the Brera Altarpiece (fig. 88). This luminous painting is full of the refulgent metal and jewels that Jan van Eyck loved to paint. It is not only in qualities of light or color however that this work recalls Van Eyck. The setting is a church, as in Jan's altarpiece of 1436 for the Canon van der Paele (fig. 19). With this altarpiece Piero's panel shares in addition the curved plan, the prominent rug below the Madonna and, curiously enough, even the donor kneeling on the Madonna's left rather than on her right. Both paintings imply that the spectator is within the interior of the church.[18] Perhaps Piero had seen a drawing of this picture or a similar painting by Jan, or possibly, once again, the same ideas were simply "in the air" at the same time in two different places. The precise nature of such relationships is often impossible to determine, but there can be little doubt about some aspects of the history of another form that appeared simultaneously north and south.

In both of Piero's portrayals of the triumphal processions of the Count and Countess of Urbino a wagon, curiously rustic, moves along a flat narrow eminence far above the plain below. This is a form of composition which we may call the "plateau type." It combines two large planes at very different levels, the upper one in the picture representing the lower in the illusory

space. It was specially favored by Tuscan artists, since it provided a means of combining figures and landscape that maintained or rather increased the primacy and the independence of the figures while giving them a universal reference. Piero gave it its typical form in an early work made around 1450, the panel of a donor and St. Jerome in the Venice Academy. The composition was widely used during the third quarter of the Quattrocento, appearing for instance in Pollaiuolo's *Labors of Hercules* or Baldovinetti's *Madonna* in the Louvre.

Now it is a very interesting fact that the fully developed plateau composition appeared in the work of Jan van Eyck around the same time or even earlier than in Italy. Jan introduced it in several pictures: the *St. Barbara* in Antwerp (fig. 23), a lost *Crucifixion* (as we shall see), and, in a related interior-exterior combination, in the *Rolin Madonna* (fig. 50). Nothing reveals to us more vividly the deep kinship of Jan van Eyck with Italian Renaissance art than his use of this composition. Though it was, moreover, well established in his work, it did not prove congenial to his successors in the Netherlands, who preferred to immerse man in the world of nature rather than to elevate him above it.[19] Of all the fifteenth-century Netherlanders only Petrus Christus, who inherited Jan's workshop, followed him in the frequent use of the developed plateau type. His enchanting little Berlin *Madonna* (fig. 20) shows a combination of interior-exterior like the *Rolin Madonna,* but, as usual with Christus, more open and airy.

The combination of interior-exterior originated by Jan van Eyck may occasionally be found in Italy, also, and particularly in Padua, which we have already recognized as a sort of Eyckian outpost. It was adopted by Mantegna for his *Death of the Virgin* in a form similar to the Madonnas of Eyck and Christus (fig. 21). He employed the purely landscape version for his *Madonna of the Rocks* (fig. 22), giving it a design astonishingly like Jan van Eyck's *St. Barbara* painted about twenty years earlier (fig. 23). It is true that Mantegna's *Madonna* is anticipated in Italy by Madonnas such as Giovanni di Paolo's in Boston and Jacopo Bellini's in the Louvre. The paintings by Mantegna and Eyck, however, are so extraordinarily alike that the resemblances need scarcely be itemized: the curved shape of the plateau, the high point of sight, the posture of the main figures, the forward inclination of the head of each, the demure countenance, and the massive vertical form rising behind. Among the figures inhabiting the plain below there are even masons

at work in corresponding places in the two compositions. The problem of whether Mantegna had actually seen a copy of the *St. Barbara* is better considered after we have discussed still another instance of his relationship with Jan van Eyck.[20]

Throughout the fifteenth century the plateau composition had a special significance in one subject that we have not yet considered—the Crucifixion. It was partially developed in the Eyckian diptych in the Metropolitan Museum. It then appeared in typical form in a *Crucifixion,* certainly by Jan, that is known only from copies, two of them panels, an unfinished one in the Museo Civico, Padua, and the other in the Cà d'Oro, Venice (fig. 25). The earliest and best copy however is a miniature in the so-called *Heures de Milan* now in Turin (fig. 27). Jan shows soldiers on the declining slope of the mountain; they have completed their work and are quietly riding single-file down the hill toward Jerusalem. Many of them are visible in a bright little field before the gate of the city.

Whereas later Netherlandish painters, for reasons of taste, rejected Jan van Eyck's plateau composition for the Madonna and other subjects, traditional ideas of Golgotha's site led to the acceptance of his design for the Crucifixion and occasionally for events such as the lamentation under the Cross that were believed to have occurred in the same place. Similar designs for the Crucifixion are numerous not only in the Netherlands but, more important for our present purpose, in Italy. To begin with, the copy of Jan's *Crucifixion* now in Padua is probably Italian, and a panel of related design in the Academy, Venice is stylistically connected, at least as far as the figures are concerned, with Squarcione and the early Mantegna, and it is probably Paduan about 1460 (fig. 24).[21] Here, precisely as in Jan's composition, the soldiers ride down the hill, though the painter compromises by representing two or three of them looking back at the scene—a matter of some interest to which we shall shortly return. Down below the riders are again visible in the sunny open space, and in the city rises a forest of those towering hexagonal structures resembling the Mosque of Omar that represent Jan van Eyck's idea of the Temple of Jerusalem. The city in the panel in Venice has been shifted backwards and to the right, making room for a watery valley and distant mountains such as appear in the *Crucifixion* in the Metropolitan Museum. St. John wrings his hands in a fashion similar to Jan's figure, though his palms are turned inward, and behind the Virgin in both paintings there is a group

of three or four mourning women. Given the probable connections of both this panel and Jan's original *Crucifixion* with Padua, it should perhaps not surprise us greatly that the great Mantegna himself felt the spell of the same model. We have already speculated about his susceptibility to Eyckian compositions, and in his predella in the Louvre painted between 1454 and 1459, he adopted the hill with departing soldiers (fig. 28). He traces the file of figures downward and then up again along a rocky road to the city, now higher and more distantly situated.

Still another leading Italian master who was, at least briefly, in Padua became fascinated with Jan van Eyck's *Crucifixion*. In an unfinished and damaged but very beautiful panel that entered the Fitzwilliam Museum in Cambridge in 1947, Cosimo Tura adopted the main structure of Jan's design, including many elements that had not appeared in the panels of Mantegna or his presumed Paduan follower: a single cross without the thieves, the Virgin and St. John alone in the foreground, and the city restored to the same relative place (fig. 26). The grief of the Virgin is conveyed by a similar tense hand-clasp, and most remarkable of all, Tura's St. John wrings his hands in a very unusual way—palms outward over his head. This is precisely the gesture of the woman, probably the Magdalen, in the group behind the Virgin in Jan's painting.

Jan van Eyck's plateau *Crucifixion* combined with the departing soldiers was disseminated, chiefly by Mantegna, throughout North Italy. Its appearance in Matteo di Giovanni's *Crucifixion* in Cleveland is another instance of the transmission of Lombard forms to late Quattrocento Siena, effected mainly through Gerolamo da Cremona. The composition was adopted also by Antonello da Messina in his panel of 1475 now in Antwerp, probably made in North Italy (fig. 49).[22]

The conception basic to all these Crucifixions of a martyrdom accomplished and the resumption, by some people at least, of the routine of daily life, began to transform traditional ways of representing other events also. In Mantegna's beautiful *St. Sebastian* in Vienna, for instance, made shortly after the Louvre *Crucifixion,* the saint's body has been riddled with arrows, and the bowmen, small but conspicuous, walk away along the road in the distance. All these departing figures, first conceived by Jan van Eyck, remind us of compositions such as the Adoration of the Magi in which *approaching* figures are represented. In early examples of them, such as Bartolo di Fredi's

panel in the Siena Gallery, we find a form of so-called "continuous" representation, in which the main actors are represented several times, but even when this continuous form is abandoned and there is simply a long line of approaching figures—as in Mantegna's Uffizi *Adoration of the Magi*—a distinction should still be made from the composition introduced by Jan van Eyck. Whereas in these paintings of the Adoration the figures all move *toward* Christ, in a common act of devotion, Jan's *Crucifixion* calls forth no such universal response. The figures below the cross, limited to the grieving Mother and disciples, do express a singleness of sentiment, but the death accomplished, the soldiers and other witnesses move imperturbably away from the scene to resume, apparently unchanged, their daily business. For them the Crucifixion is an ordinary event, an execution without special meaning. Though an indifference of this sort is exhibited earlier by the three soldiers who cast lots for Christ's garments, they are specific, traditional figures without the broad reference of Jan's. The death of Christ on the cross, far from darkening the sun and the moon, scarcely affects the tenor of life of a multitude of visible people. Never before was the event immersed so deeply in the flow of time.

Such a conception would not, we should suppose, be received with equal enthusiasm everywhere. Its diffusion in North Italy, while occasioned by the presence there of Jan's panel, is a consequence of a local artistic taste. We might expect that so temporal a conception would be acceptable in Siena also,[23] but not in Florence, where indeed it was exceedingly rare. I do not recall it there in the Crucifixion, though in a beautiful panel of *St. Sebastian* painted in 1475, about fifteen years after Mantegna's, Botticelli did introduce the departing executioners.

The fact that Piero della Francesca, Fra Filippo, and apparently even the most antiquarian of Quattrocento masters, Mantegna, found the study of Eyckian works rewarding tells us something important about the style of the painters on both sides of the Alps. For while alert artists may occasionally be stimulated by works of an utterly different character, the kind of influence that Jan van Eyck's paintings exerted upon Piero della Francesca and Fra Filippo implies certain substantial affinities of style. In some respects indeed —the massiveness and articulation of his forms, the structure of his compositions with their semi-circular plans and geometric patterns of light and shade and the use of the plateau design—Jan seems closer to Masaccio and his

followers than to fifteenth-century painters in the Lowlands. Masaccio and Jan van Eyck, furthermore, are related historically, as well as stylistically; they hold similar positions in the development of Western painting. After the initial impact of their radically new styles had been felt, the influence of each tended to decline until the late fifteenth century. Then just when Michelangelo and other painters were looking more intently at the frescoes in the Brancacci Chapel, Memling, Massys and others inaugurated a sort of Eyck revival in the Netherlands. And it is especially illuminating that this reversion to Van Eyck coincided with the first introduction of Italian Renaissance forms, as in Memling's *Madonnas* in Vienna or the Uffizi. These painters themselves, then, sensed a certain kinship between Jan van Eyck and the Italian Quattrocento.

The art of Jan van Eyck defies classification in terms of our established historical concepts. Too remote from antiquity to be considered a true Renaissance art, it nevertheless must be judged to have a near or para-Renaissance character. Like Masaccio and his followers in Italy, Jan opened a new era in the North. All references to modern painting in the Netherlands, from Vasari, Guicciardini and VanMander on, rightly begin with him. In Italy the great pictorial divide between the Middle Ages and what follows had two peaks—Giotto and Masaccio—but in the North there was really only one. Even the painting of the seventeenth century, of Vermeer for instance, seems not very remote from him. And quite apart from a magical light and color Jan established durable patterns of vision. One of his early paintings, now known only through copies (one in the Metropolitan Museum—fig. 29), represented the Way to Calvary in the same locale as the *Crucifixion* that we have considered. The procession, including Christ, moves out from the city gate across the sunny open space that we had previously seen from above. Here we look up to Golgotha where the cross is being prepared, and our eyes move over the town to a distant range of mountains. All of this conveys a sense of movement in space and progression in time that is enhanced by the curling compositional plan. In the hands of Pieter Bruegel this scene becomes a vast panorama, but it is simply a more populous and more complex rendition of Jan's design (fig. 30). Bruegel enhances the sense of a recurring event already conveyed by Jan's composition. The movement past Golgotha into the landscape beyond is made more compelling, chiefly by the streaming clouds. And on the road outside of town up which crowds are climbing some

people heed neither Christ nor his surging procession and return imperturbably to their homes. In this way Bruegel, developing Jan van Eyck's ideas, makes the passion of Christ an episode in a greatly varied human world. He symbolizes continuity in this world, and the cyclical nature of life and history, by the windmill pointedly set on a crag. Almost a hundred years later another master in the Netherlands, still connected with the same tradition and quite reminiscent of Jan van Eyck and Masaccio in the grandeur of his form and light, returned to the same ideas (in a picture in the National Gallery, Washington). Giving them now an entirely secular character, Rembrandt painted the mill alone, its blades mysteriously still, but set above a curving mole, a turning road, and a winding stream.

Postscript

Already before 1936, when studying the Madonna of Humility, I tried to scale the wall—a considerable Alp—that had been raised between Italian and North European art of the fourteenth and fifteenth centuries. At first, with the encouragement of Erwin Panofsky, I watched for the diffusion of Italian Trecento forms, and then I realized that the Northern painters themselves began in turn to contribute to what seemed more and more like a collective evolution. The paper printed above contains some observations on this second aspect of the interchange. It was a lecture, delivered in a principal Italian "port of entry" for Northern culture—Venice. The paper is obviously rather discursive and fragmentary, but some of the suggestions in it were developed in later studies, especially in the one that follows immediately.

The surprising conclusion that Mantegna learned from the "ultramontani" has not received the attention I think it deserves, partly no doubt because the minute illustrations in the original publication did not make visible what I was talking about.

Among the growing number of more recent studies of this kind I would cite: R. Weiss, "Jan van Eyck and the Italians," *Italian Studies,* XI–XII, 1956, pp. 1–21; K. Bauch, "Bildnisse des Jan van Eyck," in *Studien zur Kunstgeschichte,* Berlin, 1967, pp. 79–122; J. Pope-Hennessy, *The Portrait in the Renaissance,* New York, 1966, p. 54 ff.; and, in the field of sculpture, C. Eisler, "The Golden Christ of Cortona and the Man of Sorrows in Italy," *Art Bulletin,* LI, 1969, pp. 107–118, 233–246.

NOTES

1. The footnotes added to this lecture have been limited to essential information, such as the identification of quotations. The writer intends to publish elsewhere extended and more fully documented versions of several sections of the lecture.
2. Francisco de Hollanda, *Four Dialogues on Painting,* tr. A. Bell, London, 1928. See E. Holt, *Literary Sources of Art History,* Princeton, 1947, p. 208.
3. This passage is quoted by Erwin Panofsky, *Early Netherlandish Painting,* Cambridge, Mass., 1953, p. 2.
4. *Flemish Art,* New York, 1927, p. 18.
5. *Op. cit.,* p. 181.
6. "Nicholas Albergati and the Chronology of Jan van Eyck's Portraits," *Burlington Magazine,* XCIV, 1952, pp. 138–146.
7. *X Libri de architectura,* Book VII, Chapter 4.
8. *Architectural Principles in the Age of Humanism,* London, 1949, pp. 1–28.
9. *Trattato d'architettura,* Book VIII (ed. W. von Oettingen, Vienna, 1890, pp. 271–273).
10. *Op. cit.,* p. 134 ff.
11. W. Körtte, *Die Wiederaufnahme romanischer Bauformen in der niederländischen und deutschen Malerei des 15. und 16. Jahrhunderts,* Leipzig, 1930.
12. As Northern forerunners of Jan's averted Child cf. the Madonna in an *Horae* of 1415 (Berlin, Staatsbibliothek, Germ. 42, 4⁰, fol. 284v) or, still earlier, the Madonna in the *Belles Heures,* fol. 26 v (J. Porcher, *Les Belles Heures de Jean de France, duc de Berry, Paris,* 1953, pl. XXIX).
13. *Le Vite,* ed. Milanesi, Florence, 1878, II, p. 290. A *sotto in su* had already been employed for scenes by Ambrogio Lorenzetti in his *Legend of St. Nicholas* in the Uffizi, and in the North, by the Limbourg Workshop in the *Belles Heures,* fol. 16 (Porcher, *op. cit.,* pl. XVII).
14. Cf. Panofsky, *op. cit.,* pp. 151 note 3, 189, 203 notes 5 and 6, 354, and L. Scheewe, *Hubert and Jan van Eyck,* The Hague, 1933, pp. 48–51.
15. Cf. also a *Madonna* by a follower of Fra Filippo in the Accademia Carrara, Bergamo, no. 324.
16. See above, pp. 4, 12.
17. See "Presenza di Masaccio nel trittico della neve," *Paragone,* III, 1952, p. 13.
18. The vaulted chamber with a niche that surrounds the Madonna and saints in a panel in the collection of Count Vittorio Cini in Venice may be intended to represent a chapel (fig. 18). This panel is the work of that attractive follower of Fra Filippo, Masaccio, and Donatello whose inventive, restless, and impish paintings are now generally, but I think wrongly, considered early works of Fra Filippo himself. Thus there may have appeared in the circle of Fra Filippo (who placed the Madonna in a domestic interior) the second of the novel settings for the Madonna that Jan van Eyck and the Master of Flémalle introduced into Netherlandish painting. [Although the style of the Cini panel still seems to me problematic, for some time I have preferred to ascribe it to Fra Filippo himself.]
19. Inasmuch as Roger van der Weyden's *St. Luke* is altogether Eyckian in character it is no exception to the above generalization. [See below, p. 51.]
20. Apparently the *St. Barbara* itself remained in the Lowlands. See S. Sulzberger, "La Sainte Barbe de Jean van Eyck," *Gazette des Beaux-Arts,* XXXIV, 1948, pp. 289–293.

21. I pointed out its Eyckian connection several years ago (see E. Panofsky, "The Fried-sam Annunciation and the Problem of the Ghent Altarpiece," *Art Bulletin,* XVII, 1935, p. 471 n. 75, and *Early Netherlandish Painting,* p. 235, fig. 292). I feel doubtful about Longhi's attribution of the panel to Nicola di Maestro Antonio ("Cale-pino Veneziano, II," *Arte veneta,* I, 1947, p. 185).

22. Antonello's early Sibiu *Crucifixion* shows the plateau composition and horsemen on a road in the plain, but not yet the departing soldiers (fig. 48).

23. For instance, the panel by Matteo di Giovanni in the Cleveland Museum mentioned above.

3

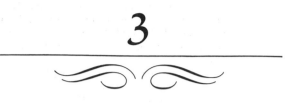

"Highlands" in the Lowlands:
Jan van Eyck, the Master of Flémalle and
the Franco-Italian Tradition

The pictorial tradition inherited by the early Netherlandish panel painters was initiated, if one may fix a precise point in an ever-changing evolution, in the late thirteenth and early fourteenth centuries in Italy. The fundamental stylistic innovations of the Italian artists of that time were accompanied, as is generally the case in history, by no less fundamental iconographic innovations. While normally these two kinds of transformation are closely interrelated, it is often possible to distinguish between them, especially when a phase of one precedes the other in time. In some instances the creation of new forms seems to have been the condition for the appearance of the new iconography. While a subject represented in Christian art usually depends upon a concept or image described in a text, the impulse to illustrate that text, and sometimes indeed even the possibility of doing so, may be provided by the appearance of new forms. It is difficult to isolate and to weigh the motives involved, but the broad evolution of forms often does condition or even stimulate the representation of a new religious image. To that extent iconography may be a product, we might even say a by-product, of the history of form; subjects may have a pre-history in "morphology."[1]

One of the most novel, most audacious, and most influential images, introduced in the *stil nuovo* of Trecento Italy was the Madonna of Humility.[2] Throughout the earlier centuries of Christian art the Madonna had been

This article was published in *Gazette des Beaux-Arts*, LVII, 1961, pp. 273–314.

represented enthroned, or majestically standing, and in Gothic art she was crowned as the Queen of Heaven. The concept of a humble Madonna, close to the earth yet for that very reason exalted in spirit, was formulated by the great Franciscan, Bonaventura, in the thirteenth century. Several decades passed, however, before this image was given visible form in art. It was only after a ground plane extending into space had replaced the ground line of earlier painting that figures seated on the ground could be vividly portrayed. The Madonna of Humility, created around 1325 presumably by Simone Martini, exalted the Virgin by associating her with the Woman of the Apocalypse at the same time that it lowered her from her throne to a cushion on the floor. It is noteworthy that the apocalyptic aspects of the subject, symbolized by the sun, stars, and moon, were suppressed in most of the images made in the great middle-class cities of Florence and Siena. There mystical exaltation was forgone in favor of simplicity, forthrightness, humility.

These qualities were, at the same time or even earlier, attributed to the Virgin and to the saints in other subjects. The Madonna of Humility is in fact only one instance of a fundamental change in the conception of the sacred figures.[3] The movement to abandon thrones for the floor or ground assumed such proportions that even the venerable figure of God the Father, elevated and remote in high medieval art, could squat on a cushion in the doctrinal image of the Trinity while Christ stands and the Dove hovers overhead (fig. 33).[4] This figure, in a Dutch bible of around 1400, represents the ultimate penetration of the new conception, for the figure who had always been represented highest has become the lowest. It is evident that this new iconography corresponded to a deep change in religious and social outlook, and we can readily understand that its most striking manifestation, the Madonna of Humility, quickly became immensely popular, spreading over the whole of Europe.

In the course of the fourteenth century two important variants of the original composition were introduced. One may be called the garden variant, in which the setting becomes the *hortus conclusus* or closed garden of the Song of Songs. The other is a domestic version, in which the previously nondescript space, enclosed by a low wall, becomes a room into which even St. Joseph may sometimes be introduced, transforming the Madonna of Humility into a sort of Humble Holy Family (fig. 34).[5] All these versions of the Madonna of Humility were eagerly adopted in France and in the Nether-

lands, beginning in the last quarter of the fourteenth century.[6] The Master of Flémalle took up the domestic type in his London *Madonna,* developing the rudimentary interior into a contemporary chamber, suppressing apocalyptic and supernatural symbols, substituting a fire screen for a halo, and increasing the intimacy of the representation by bringing both the Virgin and the beholder close to the picture plane (fig. 32).[7] The almost oppressive proximity and physicality of the figures is relieved only by the view of the city outside the window. This view suggests, at the same time, that the Virgin, though seated lowly, is in a room high above the streets of the town, mysteriously higher than the visible gate and buildings. Thus in these new, naturalistic, secular terms the Master of Flémalle seems to allude to the paradox of lowliness and elevation, conveyed more by symbols in the original Madonna of Humility.

This allusion is lacking in a related *Madonna,* now in the Hermitage, painted by the Master of Flémalle later in his career.[8] Similarly the act of suckling, symbol of *Maria Mediatrix,* and the book and chalice have disappeared, so that what is enacted in this beautiful chamber is nothing more than Mary warming her hand at the fire before beginning to diaper the Child. The point of sight is close and high, as though the beholder were standing, or at least seated above the floor on a chair, while the Virgin and Child are below him.

The humble Virgin seated in her garden was no less appealing to the Master of Flémalle than the Madonna crouching on the floor of her house. One of his portrayals of this subject was more or less freely copied in a panel in the Müller Collection in Brussels, which increases the size of the traditional symbol of the moon at the Virgin's feet to such a degree that, in this naturalistic context, it looks like a scythe employed to cut the grass.[9] A *Madonna* in Berlin omits all the apocalyptic symbols, while the rays, usually emanating from the Virgin as a symbol of the sun with which she is "clothed," now move toward her from the two upper corners of the space (fig. 31). This painting, in Flémalle's early style, shows softer forms and a more tender sentiment than we know in the work of the master himself, and it seems to me the work of the same painter in Flémalle's immediate circle who was responsible for the large panel in the Kress Collection.[10]

When Jan van Eyck places the Madonna in a garden, as in the panel in

Antwerp, she does not crouch in the grass like her predecessors in Italy and the North (fig. 11). Rapt in contemplation of her Child, she stands majestically. Behind her two fluttering angels raise a splendid cloth of honor, which frames her figure and isolates her completely from nature. The constriction and closure of the space convey vividly the idea of the *hortus conclusus.*

In Jan's splendid interiors, whether ecclesiastical, as in the Berlin, Bruges, and Dresden *Madonnas,* palatial, as in the *Rolin Madonna* (fig. 50), or domestic, as in the so-called *Lucca Madonna* (fig. 16), there was no place for a Virgin Mary seated humbly and informally on the floor. She is given an imposing throne, and even when the room becomes simple and plainly domestic, as in the *Lucca Madonna,* a brocaded canopy rises above her, establishing a ceremonial formality reminiscent of Italian Renaissance images of the same time.[11] A comparable formality may be seen in the Melbourne *Madonna,* which, though not by Jan van Eyck, is no doubt a free copy after a lost work of his.[12] The Virgin is seated lower in the space upon a couch, but the canopy again ennobles her, and she is the peak, so to speak, of a great pyramid of drapery.

A saint, as opposed to the Madonna with the Christ Child, may sit on the ground in an Eyckian painting, and without even a cushion below her, but the lowliness is transcended in a manner wholly unparalleled in the work of the Master of Flémalle. St. Barbara in the Antwerp panel (fig. 23), like the Melbourne *Madonna,* is sustained by a great mass of drapery, and indeed the presumed original of the Melbourne *Madonna,* likewise holding a book, must have looked remarkably like the exquisite saint in Antwerp. As a consequence, furthermore, of a bold compositional innovation St. Barbara is seated on a curved plateau, a sort of promontory high above a plain, on which diminutive masons busily construct her tower. This novel composition was created only by rejecting two long-established medieval conventions.[13] One, that position in the picture plane was determined by religious significance, the more important figure or form being the higher. This convention was already challenged by the introduction of the Madonna of Humility, and indeed the great expressiveness of this image was based upon the strength of the convention with which it failed to conform. The *St. Barbara,* in the second place, violates the late medieval pictorial convention that what is higher in the plane of the picture is also higher in the illusory space. This

convention was already disregarded, as we shall see, in the view out of the window in the Mérode Altarpiece; in the *St. Barbara* it is decisively reversed. What is literally above the saint is—apart from the great tower—lower in the perspective space. By means of this genial compositional device, perhaps the most important introduced in the fifteenth century, the humble saint is elevated above the world, perched on her promontory like some fifteenth-century stylite.

Jan van Eyck and the Master of Flémalle made very different decisions, then, about the posture of their main figures and the place of these figures in space. These diverse intentions are apparent not only in the representation of the Madonna and saints but in other subjects as well. In the *Annunciation,* for instance, Jan van Eyck placed the Virgin on her knees before a lectern,[14] a posture that was introduced in the early Trecento,[15] adopted in France by a follower of Pucelle,[16] and developed by an immediate predecessor of Jan, the Boucicaut Master, who strove similarly for a formal and monumental art.[17] The Master of Flémalle, on the other hand, again prefers the floor, or a level very close to it, in the Mérode triptych; he squeezed the Virgin in between a table and a bench as if to suggest that "in the beginning was the furniture," and then came Our Lady. The Virgin occasionally takes to the floor already in Italian Trecento Annunciations,[18] and whereas the posture is rare in paintings made in France for the Valois courts it was adopted more frequently in representations produced in the Flemish towns.[19]

While the central chamber of the Mérode triptych is crowded and closed —even the large windows are half-shuttered—the windows in the workshop of St. Joseph offer a view onto a square. The workshop seems to be very high, like the room of the London *Madonna,* but the corresponding space on the other side of the *Annunciation* is a courtyard, continuous with a city square lying beyond the wall. Perhaps this difference of level is intended to differentiate between the sacred and the secular realms, but in this naturalistic context both it and the shifting point of sight are confusing. The addition of Joseph as carpenter to the *Annunciation,* which is unprecedented, was partly motivated no doubt by the interest, in this manufacturing town, in his carpenter's craft. It was certainly stimulated by the growing cult of the saint,[20] and this in turn was due in part to a bourgeois wish to complete the family. This wish had earlier been manifest in the Tuscan towns where, as we have seen, Joseph was added to the Madonna of Humility, and even full-fledged Holy

Families in a domestic interior were introduced, the first in Christian art (fig. 34). In the scene of the Nativity Joseph is roused from his sleep and takes part in the action or contemplates the event.

Of the two painters, Jan van Eyck and the Master of Flémalle, the latter was more attached to tradition. The Madonna of Humility and the figures related to it, which the Master of Flémalle enthusiastically accepted and developed, are more characteristic of the period 1325–1425 than of the subsequent years. The Madonnas of Jan van Eyck, on the other hand, resemble rather more closely the Madonnas of the Quattrocento, and this connection with Renaissance art becomes more evident in the themes to be discussed below. The diverse tastes of Van Eyck and Flémalle, which led them to diverse traditions or to different aspects of the same tradition, are probably in part the consequences of activity in different social spheres. The Master of Flémalle, very probably identical with Robert Campin, apparently maintained a shop in the cloth-weaving town of Tournai. His art has the forthrightness and solidity of the townspeople, whose lives and crafts it seems to reflect. Jan van Eyck, on the other hand, worked early in his career for the Count of Bavaria and Holland, and then became the chief painter of the Duke of Burgundy. His innate inclination toward formality, refinement, and intellectuality was no doubt promoted by the patronage of this great metropolitan court.

The novel kind of composition visible in the *St. Barbara* in Antwerp (fig. 23), which we may call the plateau type, was employed by Jan van Eyck for other subjects also. Its use was fraught with especially interesting consequences in the representation of the Crucifixion. A painting of this scene in his diptych in the Metropolitan Museum, an early work which shows the type only partly realized, was followed by the fully developed form in a lost *Crucifixion* preserved for us in several copies, the best of which is a miniature in the famous manuscript now in Turin (fig. 27).[21] The Virgin and St. John stand at either side of the cross on an elevated plane; the three Maries appear near its farther edge, while the soldiers ride down the slope to a city in the valley below. The city is characterized as Jerusalem by exotic buildings, especially by polygonal structures reminiscent of the Mosque of Omar. This way of representing the Crucifixion is so familiar to us from numerous later examples that at first we do not recognize what a remarkable innovation it was.

Contrary to a common belief the site of Christ's crucifixion was not described in the Gospels as a mountain; it was called simply the place of the skull, *Golgotha* in Hebrew and *Locus Calvariæ* in Latin. From the sixth century, however, the conception of a mount of Calvary was firmly established. In early medieval art, which still preserved reminiscences of late antique landscapes, a mountain or two was sometimes represented behind the cross,[22] and in an eighth-century *Crucifixion* in Sta Maria Antiqua the Virgin and St. John stand on a rocky ledge while a hill rises behind each (fig. 35). In later medieval art the cross was elevated on a single rock, or at most on a mound,[23] and the mountainous site began to be described more fully again only in Italian painting of the fourteenth century after the development of perspective space and of landscape. This fact, like the history of the Madonna of Humility to which we referred above, reminds us that religious images are often made vivid in art only when forms appropriate to their realization have been created, and this in the course of an evolution that may have very little connection with the intensity with which the particular religious images are regarded. It was not, in other words, chiefly the desire to locate Calvary on a mountain that stimulated painters to master the third dimension, and with it landscape, in painting. And it is significant that advances in the representation of the mountain were made chiefly by the Sienese who, of all early Trecento painters, were most concerned with the portrayal, in *all* representations, of a more natural scale and extended space.

Already in the *Maestà* Duccio placed the cross near the top of an inclined plane on which he distributed the figures.[24] While this composition results in a greater elevation of Christ it diminishes the importance of the chief mourners, the Virgin and St. John. Now in fourteenth-century painting generally both height and depth are created by one or more similarly inclined planes, so that when the Sienese painters Pietro Lorenzetti[25] and, around the middle of the century, Barna strove for a more imposing hill the size of the figures had to be proportionately reduced, and the despair of John and the Virgin became less conspicuous episodes in the milling throng around the crosses (fig. 38). Barna was also one of the first painters, if not the very first, to envisage the falling slope on the far side of the hill; a soldier on horse and two on foot appear upon it.[26] But it is evident that the portrayal of Calvary as a hill conflicted, because of the requirements of scale and perspective, with the traditional prominence of the Virgin and St. John and their paradigmatic

display of grief. Painters were faced with alternatives that were not, and could not be, supplanted in the reactionary Italian style of the second half of the fourteenth century.

The terms of a solution, it is true, had been offered before the middle of the century by important developments in other subjects. It seems to have been Ambrogio Lorenzetti who in his famous fresco in the Town Hall in Siena, painted in 1338–1339, first imagined a kind of landscape different from the single inclined plane, or two or more parallel inclined planes, that moved both up and inward from the lower frame of the painting. Animated by the wish to connect a view of the environs of Siena with a view of the city itself, and to maintain just outside the gate the scale of the figures established inside it, he continued a street of the city through the gate and then showed its descent into a valley below (fig. 37). Townspeople, hunters, and farmers travel up and down the hill, and the valley is alive with rural activity. The hill in the immediate foreground, the plain below and the distant hills are not all seen from the same point. One point of view is centered on the figures just outside the gate; the four men below them on the slope in front of the road are represented in smaller scale even though they are closer to the beholder. Ambrogio's fresco is however not only the first extensive landscape in post-classical art but the first landscape in which the farther reaches, though on the wall actually *above* the hill in the foreground, are, in the illusory space, below it. Ambrogio has taken the revolutionary step of reversing conventional principles of pictorial projection.*

Ambrogio's large fresco remained for about seventy-five years the most advanced landscape in Italian art. Not long after it was created, Italian painters became preoccupied with other values not conducive to its development or even imitation. For advances in the art of landscape painting we must turn to northern France, and to the work of the French and Netherlandish masters active there.

In northern Europe, as in Italy, the traditional Crucifixion showed the Virgin on one side of the cross, St. John on the other. Alongside them often stood a few other figures. What we may call the "modern" history of this scene (as, indeed, of most other scenes) begins around 1325 in the tiny Book

* I have here deleted a reference to a landscape in the Siena Pinacoteca that I reproduced as "Ambrogio Lorenzetti?" Examination of the back of the panel out of the glass case in which it has always been kept proves that it is, as several scholars, including myself, had suspected, a fragment. F. Zeri, "Ricerche sul Sassetta," in *Quaderni di Emblema*, 2, Bergamo, 1973, p. 29 ff.

of Hours by Jean Pucelle now in the Cloisters in New York.[27] The beautiful *Crucifixion* shows, as is well known, a remarkable assimilation of the style and the very figure postures of a painting by Duccio or his circle. The cross, though not raised as high as in many Ducciesque panels, is still set on a small rocky knoll. In a miniature by a remarkable follower of Pucelle (perhaps Netherlandish) in a Missal in the Bodleian Library, Douce 313 (fig. 36), the illuminator vies with the panoramas that were, we have seen, introduced into Sienese painting of the second quarter of the century, chiefly by Pietro Lorenzetti and Barna (fig. 38). Most of the distinctive features of these scenes are visible in the miniature: the steeply ascending hill, the soldiers on horseback, the Virgin swooning in the crowd, the men contesting Christ's garment. The extended space and the great throng of people indicate, as the source of this composition, a large Italian altarpiece or fresco rather than a portable panel, and indeed among surviving works it resembles most closely a fresco in the Benedictine Monastery at Subiaco (fig. 39). At the right in this fresco there is a pair of horses very similar to the pair in the miniature, one in profile with arched neck and the other seen, in accordance with a newly acquired capacity for perspective projection, from the rear. At the left in the fresco two men blow trumpets, a rare action in the Crucifixion,[28] but undertaken in the miniature by a man who rides wildly into the scene. The fresco, by Meo da Siena or a close follower, reflects a Lorenzettian composition, probably by Ambrogio,[29] to judge by the costumes and the oriental and other exotic facial types. Perhaps this lost model was the miniaturist's source also, though, more than the painter of the fresco, he translates it back into a Ducciesque idiom. The pug-nosed, square-bearded old man, for instance, in the extreme lower right of the miniature is wholly Ducciesque.

The panoramic scene in the Douce Missal brought the representation of the Crucifixion in France or the Netherlands in the second quarter of the century to the stage it had attained earlier in Tuscany. For many years thereafter in France, as in Tuscany, there was no further advance in the portrayal of the site. Innovation in this respect would depend upon renewed progress in landscape painting, and that occurred in France with the execution, close to the end of the century, of the Book of Hours for Jean de Berry now in Brussels. In miniatures in this remarkable book the terrain extends inward and upward to unprecedented distances, and the hills are often crowned with greatly diminished buildings.

Impressive though these landscapes are, they owe their effect to an extended application of established principles rather than to the introduction of new ones. One miniature, however, is based upon a radically new idea (fig. 42). The foreground of the *Entombment* consists of a narrow brown plane that extends beneath the figures and the sarcophagus and then rises into a rocky hill behind them. In the center, behind St. John, the flat light-green area between the two high crags appears to be far below the figures because the buildings, trees, and other forms at its further limit are so greatly reduced in size.[30] The painter, whom I believe to be Jacquemart de Hesdin, had difficulty in executing his new design, especially with the shape of the light gray conical mountain behind Joseph of Arimathea. The painter was unable to envisage clearly the movement of the plane from the relatively high foreground to the low distance. He almost certainly had no model for this passage in the painting of the Lorenzetti, who masked the transition from foreground to distance, and it was only some twenty-five years later that Jan van Eyck was able to cope successfully with this problem.

It seems possible that in a painting now lost Jacquemart de Hesdin utilized the kind of composition visible in the *Entombment* for the Crucifixion itself. His creation of a Crucifixion of this type is suggested by a miniature in a small Book of Hours in the British Museum, which has a Bourges calendar and was thus produced for or in the capital of Berry, in other words, in Jacquemart's headquarters (fig. 40). The manuscript has three remarkable miniatures close to Jacquemart in style; one of them is, as I showed many years ago, a copy of a *Madonna* by the author of the paradigmatic landscape, Ambrogio Lorenzetti.[31] In the *Crucifixion* the Virgin and St. John are seated alongside the cross on the brow of a hill, which overlooks a low-lying knoll and, still farther away, a mountain. After a century of development a Crucifixion has been created in which the event is enacted on a mountain and in which, at the same time, the chief mourners retain their age-old prominence.

This fateful combination has been made possible by locating the landscape behind rather than in front of the cross and by portraying declining or sunken planes rather than inclining ones.

The sequence of planes in the miniature is designed with greater clarity and assurance than in the *Brussels Hours* (fig. 42), and the painter has imagined more vividly the invisible declining slopes of the hills. In the distance a man drives along, away from the religious event, a laden ass, the sort

of genre group visible in Ambrogio's great fresco but the first ever intro-
duced, so far as I know, into the Crucifixion. For all these reasons the minia-
ture presupposes a somewhat later stage of Jacquemart's style than the *Brus-
sels Hours*.[32]

From Jacquemart's Brussels *Entombment* and the little miniature in Lon-
don to the *Crucifixion* by Jan van Eyck copied in the Turin manuscript (fig.
27) is a long step, but it seems clear that Jacquemart's compositions provided
the basic structure for Jan's. On the other hand the genial idea of transform-
ing nondescript buildings into the city of Jerusalem, and casual inhabitants of
the landscape into departing soldiers, is entirely Jan's. Plateau and valley,
though distant from one another, are thematically joined. For the first time in
the representation of the Crucifixion the landscape is clearly charged with
specific iconographic significance.

In this respect Jan's composition is approached by a tiny *Crucifixion* in a
Book of Hours in the British Museum (fig. 41). It is a late work of the
Boucicaut Master, full of a vibrant luminosity that was itself meaningful for
the formation of Eyckian style. Far behind but not really below Golgotha, the
roofs, spires, and domes of a city glisten in the crepuscular light. Possibly the
painter intended to represent Jerusalem, but the buildings, which are not
exotic, do not permit an identification. Across the plain in the middle distance
two groups of soldiers move toward Golgotha. These soldiers are, so far as I
know, innovations in the history of the Crucifixion, but people in a landscape
approaching the sacred figures may be seen in Italian Trecento representa-
tions of another scene, the Adoration of the Magi.[33] In a ruinous painting of
the Crucifixion itself in San Clemente in Rome, the first example of the
plateau type in Italy, some soldiers, placed just over the brow of the hill, as in
Barna's fresco, move or look upward toward the event (fig. 43). This re-
markable fresco, so reworked that only the preparatory drawing for it is
entirely reliable, was painted by Masolino toward 1430. It was thus con-
ceived apparently close in time to the original *Crucifixion* by Jan van Eyck,
but the two works were probably independent of one another. Despite their
similarity as panoramic Crucifixions they differ in one respect which, though
it may seem insignificant at first, is really of great importance. In the *Cruci-
fixion* by Masolino, as in the one by the Boucicaut Master, and as indeed in
the *Adoration of the Magi* by Bartolo di Fredi, all the figures outside the
main space move toward it or at least look at the event enacted there. If they

are not stirred by religious devotion they are at least concerned with the central event. In Jan van Eyck's painting the Crucifixion calls forth no such universal response. The six figures near the cross lament the death, the Virgin and St. John with conspicuous restraint, the four women behind with great abandon. But the soldiers and other witnesses move imperturbably away from the scene to resume, apparently unchanged, their daily business.[34]

The magnificent design of the *Crucifixion,* which Jan may have employed more than once but which is preserved in its classic form in the copies we have cited, was perhaps the greatest compositional invention of the fifteenth century. I cannot, in any event, think of another transformation of a traditional subject in that period which fascinated so many painters in such widely separated places, and which had so enduring an effect upon the mode of representation of the scene. It was, to be sure, the plateau composition itself that impressed Jan's era most, and it was not in the Netherlands itself that the plateau design had its greatest vogue. The Master of Flémalle moved toward it, but indecisively. It is quite consistent with the essence of his art that he enthusiastically lowered his figures onto the floor, but did not feel an equal enthusiasm about elevating them above the world. [Small sections of a low-lying landscape or cityscape may be seen through the windows of his London *Madonna* (fig. 32) and the right wing of the Mérode Altarpiece.] The painter represented similar relatively subordinate landscapes in the Aix *Madonna,* in a *Deposition* painted around 1430 but known only in a copy, and perhaps also in a *Crucifixion,* to judge from a more or less free copy by Gerard David in the Thyssen collection of a lost Flémallesque painting of this subject.[35] It is noteworthy that the figures in this painting are arranged in a close, self-sufficient design that is unrelated to the landscape, and it may indeed have been Gerard David rather than the Master of Flémalle who added to the foreground figures elements of the Eyckian landscape. The procession away from the cross is, as often, suppressed, partly because it posed problems of perspective, but perhaps even more because as an idea it was not understood, or, when understood, it was judged unorthodox and offensive.

Thus even a modest Flemish illuminator, after having decided to adopt the composition of the great Jan, was bold enough to criticize him (fig. 44). The last rider in this little miniature performs an act that all of Jan's conspicuously avoid: he turns around to look up at the cross. And in a second

Crucifixion in another section of the same manuscript that contains the close copy of Jan's composition, the section burnt in Turin, the Flemish illuminator dealt more radically with his model, eliminating the departing figures and restoring the traditional emphasis on sorrow and conversion (fig. 45).[36] These two miniatures remind us that as historians we make a mistake if we assume that lesser artists lack judgment and independent purpose, and that their departures from models created by greater masters are the consequence simply of ineptness.

It is a striking fact that Jan van Eyck's new form for the Crucifixion was more greatly admired outside the Netherlands than in it. In several parts of Europe major artists, who knew drawn or painted copies if not a work by Jan himself, reproduced with great sympathy one or another aspect of the model. Its essential structure is reflected in the *Crucifixion* in Berlin by Konrad Witz or a related painter of the Upper Rhine or the general region (fig. 46). In this beautiful painting the landscape, impressive for its spacious luminosity, lacks specific iconographic significance; it provides a sort of quiet, prolonged resonance for the sad event. A deep marine view, originally introduced (into the *Flight into Egypt*) by Jacquemart de Hesdin, may be seen again in a *Crucifixion* in Sibiu, an early work by Antonello da Messina (fig. 48). Nor is it only the landscape in Antonello's painting that resembles the one in Berlin; the style of the figures does likewise, to such an extent that we must suppose a connection between the two works, either direct or through a common source. There are, furthermore, elements of Antonello's *Crucifixion* which, though lacking in the Berlin *Crucifixion,* may originate in Jan van Eyck's (fig. 27). The road below the mountain with figures moving casually away from it is a diminished version of Jan's radical idea, and the mourner burying her face in her hands is copied from a corresponding woman, probably one of the Maries, in Jan's painting.

In two later representations of the Crucifixion, both dated 1475, Antonello used the plateau composition again, and he approximated the Eyckian design much more closely by placing only the Virgin and St. John at the sides of the cross in the foreground.[37] In the Antwerp painting, furthermore, he represented soldiers in the plain below, all but one riding away from the hill (fig. 49). What is not Eyckian, however, and is indeed lacking in all the other descendants of the Eyckian composition, is the representation of the Virgin and St. John kneeling or seated on the ground.

In the Kingdom of Naples and Sicily, in which Antonello worked, Netherlandish style was highly valued, and already in the forties King Alfonso had acquired paintings by Jan van Eyck himself.[38] No *Crucifixion* is recorded among them, but undoubtedly other works by painters of the Lowlands were owned in the region at the time.[39] North of Naples, the great Tuscan painters around the middle of the century clearly did not share Antonello's enthusiasm for Jan van Eyck's *Crucifixion*. If they knew it they no doubt regarded the populous landscape, the departing figures, and the great "Häusermeer" as indecorous distractions from the dramatic action.

There may be a partial exception, however, to this Tuscan diffidence. A plateau and a deep panorama, including a large body of water, may be seen in the *Crucifixion* and other panels painted in 1446–1447 by Giovanni Boccati for the predella of his altarpiece now in the Perugia Gallery.[40] Boccati employed a very similar composition in other representations of the Crucifixion, as in the Cà d'Oro and in the Cini Collection, both in Venice (fig. 47). The design may be influenced by Masolino's fresco in San Clemente as well as by an Eyckian model, but it probably does not, in any event, derive directly from a Northern prototype, for the style of these paintings by Boccati, especially of the Perugia predella, owes much to Domenico Veneziano, who was, we know, in Perugia in 1438. Domenico's *Adoration of the Magi* in Berlin presupposes a study, undertaken in the Veneto no doubt, of early Netherlandish painting. The landscape, lying at a lower level than the figures, is encyclopedic, and it includes numerous travelers moving in both directions on a road. It is probably no accident that the plateau composition with an extensive landscape appeared in the work of three painters greatly influenced by Domenico: Boccati, Piero della Francesca and Baldovinetti.[41] Domenico, indeed, may have been the chief disseminator of the form in central Italy. [He would probably have brought it from the Veneto.]

In the Veneto, and particularly in Padua, Jan van Eyck's *Crucifixion* was known, admired, imitated. Here, indeed, its basic principles were quickly applied to representations of other subjects. One *Crucifixion,* painted by a follower of Mantegna, shows a landscape and buildings exceptionally close to the Eyckian model (fig. 24).[42] Many of the figures, on the other hand, derive either from Mantegna's Louvre *Crucifixion* (fig. 28) or from another version of the Eyckian composition by this great Paduan admirer. The fact that both Mantegna and his follower knew an Eyckian painting and that the

latter captured some of the pictorial qualities of its landscape proves that an early copy of Jan's *Crucifixion,* or the original itself, was in Padua or Venice by about 1455.[43]

It would have been only one of a little but fateful group of Eyckian works that were recorded in this region, at least in the early sixteenth century. Several Italian painters, Fra Filippo Lippi, Domenico Veneziano, Piero della Francesca, and Mantegna drew various conclusions from these and other Netherlandish works, as I have suggested elsewhere.[44] It may be that the same Eyckian *Crucifixion* that so deeply impressed Mantegna induced Antonello, upon arrival in Venice in 1475, to shift from his earlier Witz-like composition of the Crucifixion to the form visible in the two panels dated 1475 (fig. 49). The dependence upon the famous Eyckian model of Antonello's Antwerp as well as London panel probably thus answers the question often put as to whether this panel was painted in Sicily or in Venice.

Perhaps it was the representation of the Crucifixion, which according to a traditional belief actually occurred on a hill, that first led Jan van Eyck to the plateau composition. But that it was a form essentially congenial to his art is proved by his use of it again in the *St. Barbara* of 1437 (fig. 23), and earlier, about 1435–1436, in the *Madonna with the Chancellor Rolin* in the Louvre (fig. 50). Here he introduced what may be called the interior-exterior variant of the type, in what is perhaps his boldest design. Though the Boucicaut Master anticipated the composition to some extent,[45] only a very imaginative, self-confident artist would have dared in 1435 to spread so brilliant a panorama between the Madonna and a worshiper. To preserve the unity of the religious event from this sparkling distraction the Child is extended toward Rolin, and the Chancellor, like an Italian condottiere, fixes the Madonna—clearly not the Child—with an intent, aggressive glance. The splendid colonnaded hall is made to appear remote in time—the architecture is Romanesque—and detached in space. The elevation of the hall, effected we may infer by a hill, but a hill still greater than one sees along the river, is actually not explained. The great height in or very close to the city remains mysterious.

Movement from the interior to the exterior space is promoted by the flagged floor, the central band of which is carefully exposed along its entire length. A flight of steps leads into a garden, in which grow the symbolic lilies, and another flight leads to the battlement. At this central point in the

design the painter introduced two laymen, who turn their backs to the event in the foreground (fig. 50). One even bends over the battlement to look down at the view, encouraging the beholder of the painting to do likewise. Now spectators within paintings, even at some distance from the main action, are not novelties. In Byzantine and Western medieval art, for instance, a servant in an antechamber eavesdrops on the Annunciation or the Visitation. Spectators increase in number and in importance in fifteenth-century paintings, as in the *Purification of the Virgin* in the *Très Riches Heures,*[46] but they are concerned with the religious story. Jan van Eyck's two men, however, like his soldiers in the *Crucifixion,* turn their backs on the event. In both the *Crucifixion* and the *Rolin Madonna* these figures mediate between the sacred zone of the foreground and the great world beyond. But whereas the soldiers have a narrative connection with the Crucifixion the two men are, so far as I can see, thematically altogether independent. With the possible exception of a tiny nude youth in, significantly, a Lorenzettian landscape[47] they are the first figures in the history of painting who are entirely preoccupied with a view. Audaciously profiting from the unnatural height, they are fascinated by the panorama that it reveals.

None of Jan's contemporaries and successors shared either his artistic aims or his boldness sufficiently to develop the novel ideas in the *Rolin Madonna.* Petrus Christus, in the most beautiful of his panels (in Berlin), elevated a palatial hall to a dizzying height, but he omitted the sightseers entirely (fig. 20). In his *St. Luke Drawing the Virgin* Roger van der Weyden, in an Eyckian mood, adopted many of the elements of Jan's composition but nevertheless felt it necessary to alter their significance essentially.[48] While employing the same kind of flagged floor he covered it precisely at the center where Jan had left it visible. The size and attractiveness of the landscape is greatly reduced. By various adjustments the two sightseers are pulled back, so to speak, from the outer world toward the religious scene, and, most significant of all, they are transformed into a simply dressed elderly man and woman. We have the impression that they are related to the Virgin, perhaps Joachim and Anna[49] who have tactfully stepped out of doors so as not to distract their daughter while Luke does her portrait.[50]

Those aspects of the *Rolin Madonna* upon which we have touched are not independent innovations called forth by this subject alone; they have the deepest connection with Jan van Eyck's mode of pictorial imagination. He is

not only the most acute and passionate analyst of visual appearances in his century, but more than anyone else he found symbols for this intense visual activity, alluding to it, in other words, by iconographic equivalents. The famous convex mirror in the Arnolfini portrait, which coolly reproduces the entire scene, may be described as a symbol of the painter's eye. Similarly the man bending over the parapet in the *Rolin Madonna* is, like the painter, captivated by the landscape—both Jan's and God's.

The juxtaposition in Jan's plateau compositions of large figures in the foreground, half or more as high as the painting itself, with minute forms in the distance corresponds to the simultaneity in his single forms of the infinitely large and the infinitesimally small, as Erwin Panofsky has described it.[51] At the moment when the natural world acquired an unprecedented richness and variety, the sacred figures themselves were lifted out of it. In a world newly committed to space and time the plateau offered a place above it yet not entirely disconnected from it. For it is this natural world, understood no doubt as God's creation, that gives the Madonna and saints a universal reference.

The perfection of the plateau composition was an accomplishment of Jan van Eyck, and it had a central place in his art, but it became scarcely less important to other fifteenth-century painters, especially in early Renaissance Italy, where we might not have expected so basic a similarity with his work. This is not the place to trace the history of the plateau composition in Italy, nor to estimate the role in it of indigenous tendencies as distinct from Eyckian influence.[52] The large fact is that, with a less particularized landscape, it appears commonly in Quattrocento painting in a highly developed form after about 1450. Piero della Francesca's early *Donor Kneeling before St. Jerome* (fig. 51), one of the first Italian examples of the perfected design, shows at the same time a remarkable iconographic and compositional similarity with the *Rolin Madonna.* Piero employed the plateau again, in the late sixties, for the representation of triumphal processions, aspiring now to a more comprehensive emulation of the art of Jan. The "plateau portraits" of the Duke and Duchess of Urbino on the obverse of these panels in the Uffizi remind us of the juxtaposition of the head of the Chancellor and the landscape in the painting in the Louvre.[53]

The basic structural similarity of these Eyckian and Italian compositions, evident despite all their stylistic differences, is an interesting historical fact.

Indeed the plateau type is only one of the aspects of Jan's art that connect him with contemporary painting in Italy. The two great pictorial styles of the fifteenth century, which we differentiate by concepts of "Late Gothic" and "Renaissance," are normally brought together only for contrast. But the plateau composition, though perfected by the greatest of Netherlandish masters, was not very popular in the Netherlands itself except for the scene of the Crucifixion, and it was Italian painters who exploited it most. It became indeed one of the most distinctive formulas of early Renaissance painting.[54]

If we consider the diffusion of the plateau type in the fifteenth century in what I can only call—without intending to pun—a longer perspective, and set it in the context of what preceded it in the fourteenth century and what followed in the sixteenth, we recognize that in Trecento painting the terrain was not sufficiently extended to suggest a removal of the figures from it. In the sixteenth century, on the other hand, the passion of the Quattrocento for encyclopedic description of the world had abated, and landscape acquired so high a degree of generality that the figures, now very large in scale, could be set in it without diminishing their stature. It is true, too, that there are signs outside the sphere of painting of a quickened delight of the fifteenth century with long views. At that time merchants and nobles, who spent more time in the country than their predecessors, added open loggias to their hilltop villas from which they might enjoy the panoramas spread below them. When building the villa at Careggi around 1434 for the Medici, Michelozzo designed in one wing a colonnaded porch called a *belvedere*, one of the first examples of a kind of structure that became common in the following years.[55]

Though the plateau composition is related to contemporary values and practices of this kind it has no doubt a deeper meaning in the painting of the time. The fourteenth century, we may recall, had humanized the sacred figures and had brought them down to earth, both figuratively and literally, especially in the Madonna of Humility and related compositions (figs. 31, 33, 40). It endowed them with qualities of simplicity, familiarity, even homeliness. In the fifteenth century, a desire to exalt man produced a reaction against this trend. The central figures were elevated on thrones of increasing height. And, as the pictorial world became less distinguishable from the actual one, the figures often were lifted out of it.

The figures were elevated to an eminence that provides, it seems, a visual symbol of the high estate of man envisaged by the early humanists. Perhaps

the Italian painters intended a place something like the one to which man, or at least the spirit of man, is assigned in Florentine Neo-Platonic thought. The spirit exists, Marsilio Ficino said, between time and eternity and between finite space and infinity, possessing in each category qualities of both limits.[56] We have seen that elevation on a plateau reduces the significance of time and space. The plateau itself seems to be between the world and heaven, while its inhabitants, though physically men, have the permanence and often the immobility of Ficino's angels.

Postscript

A couple of discursive sections in the original article which were later developed elsewhere have been deleted.

The last paragraph is of course highly speculative. I do not believe I would have written it today.

A colleague suggested to me that fifteenth-century painters favored the plateau simply because it rescued them from the problem of regular diminution from foreground to background—a problem which would, he believes, have given them trouble. Already in the second decade of the century, however, French painters—particularly the Boucicaut Master (fig. 41) and Paul de Limbourg—had mastered the direct extension of the ground plane deep into space. Occasionally Fra Filippo Lippi demonstrated that he had no difficulty with a deep, flat terrain, marked at certain distances by low walls (*Nativity* and *Adoration of the Child,* Uffizi).

Jan van Eyck's depiction of what I described as symbols for his own keen perceptiveness (the two men contemplating the view in the *Rolin Madonna*) is surely related to his awareness of the novel nature of his art (see Chapter 1, p. 13).

In my earlier text, now Chapter 2, Mantegna's *Death of the Virgin,* painted in the sixties, is described as the first fully developed Italian example of the interior-exterior version of the plateau type (fig. 21). At that time I overlooked an example definitely painted before 1453, the miniature of the *Congress of the Order of the Crescent* (Paris, Bibl. de l'Arsenal, ms. 940)—a miniature which I had published in 1957 (*Mantegna as Illuminator,* color pl. opp. p. 6). Here, as in Netherlandish precedents (fig. 27), there is even an averted figure on the plateau outside the hall who faces the deep landscape

lying below. All of this, scarcely an inch high, is painted with astonishing *bravura*. As I observed in an appendix (not reprinted here) to my article of 1960, the first appearance in this miniature of the interior-exterior version (and the first example of the plateau type itself in all of North Italy) adds weighty evidence to my conclusion that a great painter designed this miniature. The novel conception, like other aspects of the painting, is far beyond the capacity of the lesser artists to whom the miniature has sometimes since been tentatively ascribed. It is significant, too, that the second example of the plateau composition in North Italy appeared in a Mantegnesque miniature— *Guarino presenting his translation of Strabo to Giacomo Antonio Marcello,* in the manuscript of 1459 in the Bibliothèque Rochegude, Albi (Meiss, *op. cit.,* pl. opp. p. 36). The venturesome painter of the *Congress* introduced a second, unprecedented, type in another miniature—the upturned head in the portrait of Marcello, the earliest example of this type, derived from antiquity, in Italian portraiture. Again it was Mantegna who next adopted this type, a few years later in his portrait in Berlin.

Who was the painter of these full-page miniatures? Although I was not entirely certain in 1957, as I stated in my preface, I saw no alternative to Mantegna, but I would have been wiser to add a question mark. I do not feel that I fully understand these miniatures even now. Very perceptive observations about them have been made recently by Giles Robertson (*Giovanni Bellini,* Oxford, 1968, p. 17 ff.), who concluded tentatively that the author is either an exceptionally Mantegnesque Giovanni Bellini (as he inclines to believe) or an exceptionally Bellinesque Mantegna (as I had suggested). Could the mysterious miniatures have been designed by Mantegna and painted by Bellini? They were both very young and might have collaborated in this way.

NOTES

1. See Chapter 1.
2. M. Meiss, *Painting in Florence and Siena After the Black Death,* Princeton, 1951, p. 132 ff.
3. *Op. cit.,* pp. 149–151.
4. For this Dutch bible see E. Panofsky, *Early Netherlandish Painting,* Cambridge, Mass., 1953, I, p. 98.
5. A Second Sienese Trecento *Holy Family,* reproduced as fig. 2 in the original publication of this article, was sold by Frederik Muller and Co., Amsterdam, in the Ante Mimara Sale, November 9–12, 1954. The painting measures 56 x 25 cm.

6. On the diffusion of the image in France, which was wider than Panofsky later main-tained (*op. cit.,* I, p. 128) see the examples cited by Meiss, "The Madonna of Humil-ity," *Art Bulletin,* XVIII, 1936, p. 450, which could be multiplied many times. One of these manuscripts was cited by Pächt, "Panofsky's *Early Netherlandish Painting,*" *Burlington Magazine,* XCVIII, 1956, p. 115.

7. The chalice, though painted on a strip that has been added to the original painting, may be a copy of an original form. See Panofsky (*op. cit.,* I, pp. 163–164, II, fig. 203), who accepts my classification of this painting as a Madonna of Humility despite the "technical objection" of M. Davies that the Virgin is seated on a very low footrest rather than on the floor (*National Gallery Catalogues, Early Netherlandish School,* London, 1945, p. 17). In the Italian Humility Madonnas, indeed, the Virgin is quite commonly raised a little above the floor, usually on a cushion.

8. Panofsky, *op. cit.,* II, fig. 211.

9. *Ibid.,* fig. 226.

10. *National Gallery of Art, Paintings and Sculpture from the Kress Collection,* Washing-ton, D.C., 1951, p. 168. The copy of the Mérode *Annunciation* in the Musée des Beaux-Arts at Brussels is similar in style but seems weaker.

11. See, for instance, the Madonnas of Humility from the circle of Fra Angelico in the Pinacoteca, Turin and the Rijksmuseum, Amsterdam (*Mostra delle Opere del Beato Angelico,* Florence, 1955, pls. 25, 42). On the tendency of the Quattrocento to ennoble the representation see Meiss, *Painting in Florence and Siena After the Black Death,* pp. 139–140.

12. That the Melbourne *Madonna* (*ibid.,* fig. 243) was not painted by Jan van Eyck became clear to me upon examination, together with Professor Panofsky, of the analysis of the inscription undertaken by the Centre National de Recherches "Primi-tifs Flamands" in Brussels, under the direction of Paul Coremans, and upon study of the photographic details of the painting that were made at the Centre. The similarity of the Virgin Mary to *St. Barbara* in Antwerp only throws into relief the inferiority of the former.

13. I identified the plateau composition and outlined its history in a paper published in 1956, now Chapter 2 of this book.

14. *Annunciations* in Washington and in the Ghent Altarpiece.

15. The Virgin kneels first in the *Annunciation* in the Arena Chapel.

16. Oxford, Bodleian Library, Douce 313, fol. 5v. In original publication of this article fig. 7.

17. For example, *Boucicaut Hours,* and Paris, Bibl. nat., lat. 1161 (Panofsky, *op. cit.,* II, figs. 60, 74).

18. See Meiss, *Painting in Florence and Siena After the Black Death,* p. 149, n. 71.

19. See for example the *Annunciation* in Paris, Bibl. nat., lat. 1364, with a calendar for Tournai, to which Panofsky has called attention (*op. cit.,* II, fig. 145).

20. See M. Schapiro, "Muscipula Diaboli," *Art Bulletin,* XXVII, 1945, p. 182 ff.

21. For the later copies in the Cà d'Oro and the Museo Civico, Padua, see fig. 25 and Panofsky, *op. cit.,* I, p. 235, II, fig. 291. The attribution of the panel in the Cà d'Oro by A. Châtelet ("Les Enluminures Eyckiennes des manuscrits de Turin et de Milan-,Turin," *Revue des arts,* VII, 1957, p. 161) to "Hand H" or the painter of the diptych in the Metropolitan Museum (Jan van Eyck, in my opinion) seems to me quite un-tenable. For the panel in the Metropolitan Museum see Panofsky, *op. cit.,* II, fig. 301.

22. See especially the *Crucifixion* in the Rabula Gospels (C. R. Morey, *Early Christian Art,* Princeton, 1953, fig. 126). I am grateful to Dr. David Wright for reminding me of this example.

23. As, for instance, in the *Codex Egberti* (Trèves, Bibl. de la Ville, ms. 24, fol. 84v; F. X. Kraus, *Codex Egberti,* Freiburg i.B., 1884, pl. 50).
24. R. van Marle, *Development of the Italian Schools,* The Hague, II, 1924, fig. 28.
25. *Ibid.,* fig. 234.
26. The horse is clearly represented on an invisible *ascending* plane. Heads or half-length figures placed over a hill, but without any sense of the plane on which they stand, appear frequently in Byzantine painting (mosaics in the Duomo at Monreale, for example) and in painting of the fourteenth century, especially the second half (see for example the *Crucifixion* in the Missal illuminated before 1394 at Avignon, Paris, Bibl. nat., lat. 848, fol. 152v. Leroquais, *Les sacramentaires et missels,* Paris, 1924, pl. 65).
27. *The Hours of Jeanne d'Evreux,* New York, 1957, pl. 14.
28. A trumpeter or two appear in the throng at the right of the cross—not the left, as in the painting discussed above—in several Riminese *Crucifixions:* Pinakothek, Munich (Van Marle, *op. cit.,* IV, 1924, fig. 140); Liechtenstein Collection (*ibid.,* fig. 179); Musée de Moulins (*Orangerie des Tuileries. De Giotto à Bellini,* Paris, 1956, pl. IV); Wedells Collection, Hamburg. A trumpeter appears on both sides of the cross in a Bolognese miniature of *ca.* 1350 (L. Ciaccio, *L'Arte,* X, 1907, reprod. on p. 108).
29. Possibly the large fresco by Ambrogio in the chapter room of S. Agostino, Siena, mentioned by Ghiberti (*Lorenzo Ghibertis Denkwürdigkeiten,* Berlin, 1912, p. 41).
30. A somewhat less developed plateau composition appears in the *Flight into Egypt* in the *Brussels Hours.*
31. "The Madonna of Humility," *Art Bulletin,* XVIII, 1936, p. 450, fig. 18.
32. An adequate model for the miniature might have been something like the beautiful Lorenzettian landscape in the *Allegory* in the Pinacoteca, Siena.
33. See the *Adoration of the Magi* by Bartolo di Fredi (Van Marle, *op. cit.,* II, 1924, fig. 318).
34. See above, p. 29. In the background of the Master of Flémalle's early Dijon *Nativity* a few figures move along the roads, mostly away from the scene of the birth but without any evident relationship to it.
35. Panofsky, *op. cit.,* II, figs. 209, 229, 230. An early instance of the plateau in the circle of Roger is the *St. Catherine* in Vienna (*ibid.,* fig. 308).
36. P. Durrieu, *Heures de Turin,* Paris, 1902, fig. 20. For another example of the many Flemish representations of the Crucifixion influenced by Jan van Eyck's composition see the *Crucifixion,* fol. 241 in a Book of Hours from the Bening workshop now belonging to H. P. Kraus, New York. Here, however, the soldiers are already before the city, and two women and a man walk *toward* the cross.
37. J. Lauts, *Antonello da Messina,* Vienna, 1940, pls. 36, 42. Antonello used the plateau again around the same time for a *Man of Sorrows* (*ibid.,* pl. 49).
38. See R. Weiss, "Jan van Eyck and the Italians," *Italian Studies,* XI, 1956, p. 9 ff.
39. Alfonso of Aragon had a painting attributed to Roger (Panofsky, *op. cit.,* I, p. 2 n. 7) and the *Death of the Virgin* ascribed to Christus now in the National Gallery, Washington, came from the Santocanale Collection in Sicily.
40. Van Marle, *op. cit.,* XV, 1934, fig. 3, pl. opp. p. 6. See fig. 4 for a later, similar *Crucifixion* by this painter. F. Zeri, "Il Maestro dell'Annunciazione Gardner," *Bollettino d'arte,* XXXVIII, 1953, p. 130, observed a connection of Boccati's work with Domenico Veneziano and Jan van Eyck, but he cites as an Eyckian model the *Crucifixion* in the Metropolitan Museum rather than the one reflected in the miniature (figs. 27, 29).
41. Fresco of the Nativity in the SS. Annunziata (Van Marle, *op. cit.,* XI, 1929, fig. 164)

and *Madonna* in the Louvre (*ibid.*, pl. opp. p. 264). For Piero della Francesca see below, p. 29.

42. See Chapter 2, p. 26 ff.

43. G. Vitzthum ("Ein Stadtbild im Baptisterium von Castiglione d'Olona," *Festschrift zum sechsigsten Geburtstag von Paul Clemen,* Düsseldorf, 1926, p. 401 ff.) argued that the view of Rome by Masolino in the Baptistry, probably of 1435, was influenced by the cityscape of the *Crucifixion*. This view, tentatively accepted by Panofsky (*op. cit.,* I, p. 235), is difficult to evaluate; if it is correct then the Eyckian *Crucifixion* was of course in Italy by 1435. But in the landscape of Masolino's *Crucifixion* in S. Clemente, Rome (fig. 43), painted in the late twenties, there are small groups of buildings conceived similarly to those in Castiglione d'Olona. We are thus brought back to a time perhaps before the creation of the Eyckian *Crucifixion* itself, though of course the Metropolitan *Crucifixion* by Jan is much earlier, and Masolino may have seen a similar early Eyckian work.

44. See p. 29 f.

45. Panofsky, *op. cit.,* II, fig. 78.

46. P. Durrieu, *Les Très Riches Heures de Jean de France, Duc de Berry,* Paris, 1904, pl. XXXIX.

47. This figure in the *Cityscape,* Pinacoteca, Siena, is not visible in a reproduction. See G. Rowley, *Ambrogio Lorenzetti,* Princeton, 1958, I, p. 75 n. 2, who cites the figure as evidence that the painting is of the fifteenth century. [F. Zeri (*loc. cit.*) now ascribes this panel, which he has proved is a fragment, to Sassetta.]

48. Panofsky, *op. cit.,* II, fig. 313.

49. The identification with Joachim and Anna was proposed by A. Schmarsow, *Robert van der Kampine und Roger van der Weyden,* Leipzig, 1928, p. 86 (I owe this reference to the kindness of Colin Eisler). Panofsky, *op. cit.,* I, p. 253, speaks of St. Anne and St. Joseph.

50. In the Boston panel, which is in my opinion by Roger himself, the old man is pointing at the view. In the Leningrad copy, which omits many details, this gesture is lacking. The figure of the man pointing was adopted by the Master of the View of Sainte-Gudule in his painting in the Musée Diocésain, Liège, which as a whole derives from Roger's *St. Luke.* (See *The Detroit Institute of Arts and the City of Bruges, Flanders in the Fifteenth Century,* Detroit, 1960, p. 134 and color plate.)

51. Panofsky, *op. cit.,* I, p. 3.

52. A brief résumé may be found above, p. 29 ff. A noteworthy early example of the plateau, not yet fully developed, is Sassetta's *Marriage of St. Francis to Poverty* in Chantilly, which belongs to an altarpiece executed in 1437–1444, around the time when Domenico Veneziano was painting in Perugia. Sassetta's design still, however, reflects to a considerable extent Gentile da Fabriano's landscapes. There are also more or less distant low-lying landscapes in the predella of Fra Angelico's *Annunciation* in the Gesù, Cortona, and in the frescoes in the Chiostro degli Aranci, Florence, painted in 1436–1439.

53. Still more relevant to Piero's portraits are the half-length figures against the landscape and the sky in Roger's Braque triptych (Panofsky, *op. cit.,* II, fig. 333).

54. Though the plateau composition is identified especially with the Quattrocento, it was employed in the sixteenth century also. See the *Crucifixion* by Paolo Veronese in the Louvre (R. Palluchini, *Veronese,* Bergamo, 1953, p. 103); *Crucifixion* by Cranach (H. Posse, *Lucas Cranach d. A.,* Vienna, 1935, fig. 35). Among Flemish representations of the Crucifixion see Detroit, Institute of Arts, no. 128 (*ca.* 1550).

55. Stegmann and Geymueller, *The Architecture of the Renaissance in Tuscany*, New York, n.d., pls. 51, 53. See also the article "Belvedere" by P. O. Rave in *Reallexikon zur deutschen Kunstgeschichte*, II, 1948, kindly called to my attention by William S. Heckscher.

56. See P. O. Kristeller, *The Philosophy of Marsilio Ficino*, New York, 1943, p. 98 ff.

PART II

4

Masaccio and the Early Renaissance: The Circular Plan

Though Masaccio's *Tribute Money* is generally believed to communicate an important truth about Christianity and the Church as well as the new Florentine culture, the story that it tells is, on the face of it, not very significant (fig. 52).[1] In more than a thousand years of Christian art this "fable puérile," as it has been called, which is told by Matthew alone,[2] was represented on a large scale only once before the Brancacci Chapel.[3] Nor did it prove more interesting later,[4] for most of the scenes called the Tribute Money illustrate another passage in the Gospels.[5] Almost all the rather rare predecessors of the Brancacci fresco are to be found in full cycles of Gospel illustrations in manuscripts. Sometimes the story was reduced to the universally appealing scene of Peter catching a very big fish, the more remarkable because of a coin in its mouth (fig. 54).[6] On occasion, especially in Byzantine manuscripts, the successive moments of Matthew's story are portrayed, as in the Brancacci Chapel: the collectors of tribute request it of Peter, Christ decides to pay it even though it is not due and instructs Peter to go fishing, Peter catches the providential fish and then gives the coin—a stater—to the collectors (fig. 53).[7] Though one or two Byzantine miniatures anticipate the fresco by showing Peter's gesture echoing Christ's at the moment of command, they could

This article was published in *Studies in Western Art. Acts of the Twentieth International Congress of the History of Art,* Princeton, 1963, II, pp. 123–145.

have provided little else because, apart from the stylistic gulf between them, Masaccio has given the story a different emphasis and meaning.

Historians have always been puzzled by the selection of this passage in Matthew for one of the large fields of the Brancacci Chapel.[8] I have been intrigued by the simultaneity of the monumental depiction of the payment of a tribute with the inauguration in Florence in 1427, after long debate, of a new tax, the famous *catasto,* the first graduated income and property tax.[9] This tax was instituted at a time of financial crisis during the Milanese war, and by launching it the Florentine oligarchy imposed a heavy tax upon itself as well as upon other social groups. Felice Brancacci belonged to the party that opposed the tax,[10] and the fresco refers to tribute properly exacted not of "citizens" but of strangers. But though the financial crisis and the *catasto* may conceivably have affected the donor's choice of the Tribute Money and its place in the chapel, they could not really have been of great consequence for the painter's conception of his work. That would seem to have been enriched far more by an interpretation of the Gospel story by St. Augustine, or by one of the innumerable theologians who follow him. The passage, in one of Augustine's sermons, is brief, but everything he wrote was carefully read by theologians at all times, and the humanists of Masaccio's time turned with special interest to him and to the other Fathers. Augustine seemed to them a precursor, and his writing "a part of the rediscovered ancient litera- ture itself."[11]

In a sermon on Matthew St. Augustine stresses the fact that, in the ac- count in the Gospel, Christ decided to pay tribute although rightfully it is exacted not from "the children of the kings of the earth" but from strangers. He paid for himself and for Peter, "for Me and thee," even though nothing was due. And then, in one of those bold similes characteristic of him, Augus- tine equates Christ's payment of the coin with the payment of his life. Ad- vancing a concept that became fundamental to the understanding of Christ's death, and that was refined by later theologians such as Anselm in his *Cur Deus Homo,* Augustine says: "If He had not paid what was not due, He would never have made us free from what was due."[12] Augustine adds that Christ honored Peter by selecting him as his agent; Peter paid for him.[13] Thus the event becomes a symbol of redemption and of the designation of the Church as a means of accomplishing it.

It is only in this light that we begin to find an adequate answer to the

question of the prominence of this unusual episode among the frescoes. In the Brancacci Chapel the Tribute Money, which has become a symbol of the Passion, comprehends the establishment of the Church also. Thus it conveys in a different guise the idea normally expressed by the Gift of the Keys.[14]

In Masaccio's painting the catching of the fish, so conspicuous in earlier representations, becomes secondary, while the decision to pay and the election of Peter have been transformed into one of the sublime compositions in Christian art.[15] The grandeur and drama of this central event are in part due to the arrangement of the figures in what may broadly be defined as an arc. At the center of this arc stands Christ, and almost all the figures, equidistant from him, look toward him. There is, of course, no perfectly regular geometric form. Masaccio varied the arrangement for a multitude of reasons that I shall not attempt to specify—suffice it to say that the sides of the arc are rather flattened. At the left, furthermore, the painter has placed two rows of apostles, Peter and John in front, paralleled by Andrew (?) and his three companions behind. Masaccio has imposed this double barrier just where there is a double thrust from within the circle outward, and its use, therefore, proves one of the functions of the semicircular plan. It serves to promote not only an unprecedented psychological concentration but the physical unity and dominance of the figures—a fundamental Florentine requirement—now threatened anew by an unlimited space that otherwise might engulf them. Other plans, such as a rectangle or, in perspective, a trapezoid, might also have served to link the figures together, but they would participate to a much greater degree in spatial recession. Only an arc permits a regularly graduated movement into and out of space from two points close to the picture plane.

Masaccio's use of the semicircular plan was, therefore, bound up with his concept of a spatial continuum and his introduction of systematic focus perspective. Many Trecento paintings also of course possessed a third dimension and therefore an unambiguous plan in space, but these plans did not frequently assume a geometric form, and when they did the circle was not common among them. Its occasional use in the fourteenth century was connected with two different factors. On the one hand, it was associated, as we shall see, with certain subjects. On the other hand, its use for these and a few other subjects was affected by the broad movements of style: it appeared somewhat more frequently in the first half of the century, and again from about 1390 on,[16] but rarely in the third quarter.[17] This chronological dis-

tribution conforms to the changing conceptions of figure and space in the Trecento, as I described them some years ago.[18]

Masaccio began to develop the circular composition in two paintings executed before the *Tribute Money*: *St. Peter Baptizing,* in the Brancacci Chapel, and the *Adoration of the Magi* in the predella of the Pisa altarpiece, painted during 1426 (fig. 56). In both paintings there is only approximately a quarter circle, and the central figure, with whom the others are engaged, appears at the left margin.

Masaccio was probably familiar with a few large-scale rounded compositions painted in the earlier fifteenth century. Two or three shallow examples by Lorenzo Monaco were visible in Florence,[19] and a more highly developed design in the altarpiece by Gentile da Fabriano that was set up in that city in 1423 (fig. 57). The composition of the main field, an Adoration of the Magi, is, like Lorenzo Monaco's representation of the same subject now in the Uffizi, based on two semicircles or ellipses, one behind and above the other. But in this instance, as in other paintings of the time, the curve is the reverse of Masaccio's.[20] Tangent to the picture plane, the arc curls back into space at both sides; indeed, in this period before the introduction of systematic perspective, the space is largely created by the overlapping and diminution of the figures in these convex arcs. This "Late Gothic" design, as we may call it, was still preserved in the thirties in some of the reliefs of Ghiberti and in the early work of Domenico Veneziano.[21] It is inherently centrifugal whereas Masaccio's inverted form is decisively centripetal.

In this respect the *Tribute Money* was anticipated by the composition of a painter who impressed Masaccio deeply, Giotto. In the *Last Judgment* in the Arena Chapel Christ hovers before the apostles, who are seated on a bench that curves forward at the extremities. Giotto's design is novel for this subject, but in closely related themes it has very old, indeed probably Graeco-Roman, antecedents.

In Early Christian art the representation of Christ and the apostles normally was given a curved plan. The figures are arranged in semicircles in paintings in the catacombs, in gold glass,[22] and in reliefs (fig. 58).[23] The group frequently appeared on the curved surface of a half-dome, as in the mosaic around 400, horribly restored, in Santa Pudenziana, Rome.[24] It has long been supposed that this composition derived from a pagan representa-

tion, and in an illuminating article George Hanfmann has recently proposed that the late antique representation of Socrates and six disciples, as it appears in the fourth-century mosaic at Apamea on the Orontes, may be the specific source (fig. 59).[25] The connection is especially evident when, as in SS. Pietro e Marcellino and other paintings in the catacombs, Christ is accompanied by only six apostles (fig. 55). The pagan and Christian representations are related not only in composition, especially with regard to the curved plan, but also in meaning, for Christ as the teacher of truth was identified with Socrates.

The representation of Socrates and his six disciples, in turn, seems to be a version of an older pagan theme, the Seven Sages.[26] The Sages, as we see them in a first-century mosaic in the Villa Albani, Rome, which probably reflects a design of the fourth century B.C., are seated on a semicircular bench, a common feature of the ancient *scholae* (fig. 60).[27] The Sages are differentiated from each other spatially and with regard to posture. They take positions freely on or near their bench, and the action of each is distinctive. The Socrates mosaic implies a diminution of these values of individuality; in it we recognize, as Hanfmann observed, the geometry and the regularity of late antique art. It was this late antique development, beginning in the third century A.D., that could produce a design for a theme such as Christ with a group of apostles who are significant far more for their likenesses than their differences. What is important is their common mission rather than their single character or contribution.

Although there are thematic differences between the representations of the Seven Sages, Socrates and his disciples, and Christ and the apostles, they all celebrate teaching and learning, and their semicircular plan had no doubt come to be associated with the perfection and the universality of the intellect. This range of meaning was also communicated by the composition when it was adopted for a series of related subjects in Early Christian and Byzantine art. When Moses "teaches" the learned men, as in the fifth-century mosaic in Santa Maria Maggiore, their bench is semicircular;[28] and it has this form in medieval, especially Byzantine, representations of Christ instructing the Doctors (fig. 62).[29] In these themes, as in the representation of an ecumenical council in the ninth-century Byzantine *Homilies* in Paris (fig. 61), the connection with the tradition of the *scholae* is especially close. The relationship

is evident also in the form given to Pentecost; in the *Homilies,*[30] for example, and in the mosaic in Monreale (fig. 63) the figures are seated in an arc.[31]

We are tracing, in all these related themes, a tradition passing from antique to Early Christian and Byzantine art. A Gothic representation of, for instance, Christ among the Doctors, as in *Queen Mary's Psalter* (fig. 64),[32] is remote from this tradition, just as the medieval schoolroom[33] lacks the hemicycle of the ancient *schola.* The curved plan reappears, on the other hand, in the beautiful fresco fragment at Assisi of Christ teaching, one of the early works, I suspect, of Giotto (fig. 65). Here, as in the other closely related frescoes of this cycle, we seem to observe a revival of Early Christian as well as late antique forms.[34] There is, moreover, good reason to believe that in Early Christian representations in Rome of Christ among the Doctors a half-dome rose above Christ.[35] Large elements of this composition are retained in the Arena Chapel, though the bench has become rectangular, while a few years later, in the fresco by a follower of Giotto in the Lower Church in Assisi, the arrangement of the figures is adjusted to a tripartite Gothic building.[36]

In all of these representations of the teacher and the taught the figures are seated. Occasionally, however, the apostles stand, as early as the fourth century in the Catacomb of Domitilla, or on the somewhat later silver casket in San Nazzaro Maggiore, Milan.[37]

It seems probable that this tradition of circular compositions proved suggestive to Masaccio when he faced the problem of representing Christ and the apostles in a relationship that would convey broad doctrinal and ecclesiastical ideas. He was probably attentive to these compositions, in any event, because of his preference for a semicircular plan, a preference already manifested in two earlier works; but their meaning made them especially relevant at the moment. It was, in other words, the connotation of the semicircular composition, which since antiquity was associated with intellectual and spiritual values, that made it appropriate for an interpretation of the miracle of the stater as an *exemplum* of the teaching of Christ and of the attainment of salvation through him and his Church.

The *Tribute Money* is a landmark in Western art not only for its perspective, its light and shadow, and its astonishing human insight, but for its compositional form as well. While this composition would seem to be linked

with a tradition extending back into antiquity, it differs from its predecessors in two respects. The placement of the tax collector tends to transform a semicircle into a circle, and the idea of circularity is strengthened by the appearance of Christ at its approximate center. In all the earlier compositions we have cited the main figure appears within an arc, at its middle point, whereas Masaccio moved Christ forward in space to the center of a circle. This important change is of course conditioned by the new conception of perspective space, and the vanishing-point for the fresco is in fact in Christ's head.[38]

Because of its circularity, or near-circularity, and its marked center the plan of the *Tribute Money* may be linked not only with the representative tradition already identified but with more general ideas about the special nature of the circle that have a long history in Western thought. For centuries the circle had been regarded as the perfect geometric form; it was employed to convey ideas ranging from the ideal city to the universe, with the ruler or God, as the case may be, at the center.[39] These conceptions were widely diffused in the Quattrocento. Just a few years earlier than the painting of the Brancacci Chapel Leonardo Bruni, describing his beloved city in his *Laudatio urbis florentinae,* envisaged its plan as four concentric circles, at the center of which stood the Palazzo Vecchio.[40] In his commentary on Dante, Cristoforo Landino said that God proceeds from himself to himself, like a circle without beginning and without end.[41]

The circle of perfection was of course current in late antique and medieval imagery. In an appropriate subject in Roman painting even a ground plan could assume this form; the figures in the *Council of Ascanius* in the *Vatican Virgil* form a ring.[42] In one Carolingian painting, the Bible at San Paolo fuori le mura, Rome, Pentecost, which is semicircular in Byzantine art, is given a rhombic plan, with the Virgin at the center.[43] Haloes, mandorlas, and similar attributes are normally round in medieval art, and circles appear commonly in *schemata.*[44] These cosmological patterns, however, as well as the circular symbols, lie flat in the picture plane. It was the development of tridimensional pictorial space in late Dugento and Trecento art that provided the condition for a revival of the circular or semicircular plan. Thus, in the representation of the Ascension, the hemicycle of the apostles in Early Christian and Byzantine art was developed to a full circle; the earliest surviving example seems to be Jacopo di Cione's panel now in the National Gallery,

London,[45] but the originator was no doubt an earlier and stronger master, possibly close to Giotto. In the second quarter of the century a Sienese painter, perhaps Simone Martini or one of the Lorenzetti, created a new design for the Assumption by, so to speak, turning a circular choir of angels into space, so that they compose an aerial ring around the Madonna as she soars to heaven.[46] It is not surprising to observe that this beautiful conception was disregarded in the third quarter of the century,[47] nor that it was adopted with enthusiasm by Masaccio's followers, as we shall see.

Though the circular plan began to appear in Trecento painting, its great diffusion came with the Early Renaissance. At that time architects were perhaps even more interested in it than painters. Ideas about the mathematical structure of the universe, and about the revelation of God in the symbol of the circle and the center, constitute the basis of Alberti's thought about churches. These ideas were expressed toward 1450 in his treatise on architecture, and similar conceptions underlie the great interest in centrally planned, domed buildings manifested earlier by Brunelleschi, Michelozzo, and others, as R. Wittkower has emphasized.[48] It was held by many people, Francesco di Giorgio informs us, that the altar should be placed at the center of the plan of such buildings, because the center of a circle is "unico e assoluto," like God.[49] Models for round structures were found in late antique or Early Christian buildings—Santa Costanza, Santo Stefano Rotondo, and the Pantheon. According to no less authoritative a text than the *Golden Legend,* the Pantheon was given a circular plan to symbolize the eternity of the gods.[50] Masaccio seems to have associated the *Tribute Money* with a compositional tradition in the figure arts that was established in late antique and Early Christian times.

Among architects it was Brunelleschi who showed the first pronounced symptoms of what has been called the "hantise de la circularité.[51] Apart from the *cupolone* of the Cathedral, he was affected by it in the mid-twenties when designing the Old Sacristy of San Lorenzo, toward 1430 in the project for the Pazzi Chapel, and again in 1434 in the plan for Santa Maria degli Angeli, which we can approximate in a drawing by Giuliano da Sangallo.[52] In Santo Spirito he rounded the chapels in the aisles. Michelozzo maintained the trend in the forties by his plan for the tribune of the Annunziata.[53]

To my knowledge it has not hitherto been observed that these designs may occasionally give a purer mathematical form to what earlier had been

conveyed by figurative iconography. In medieval domes that are borne on ribs
the number of these members is normally, for structural as well as artistic
reasons, eight or sixteen. In the mid-twenties, in the Old Sacristy, Brunel-
leschi used twelve ribs,[54] and this highly exceptional number permits us to
speculate that the ribs and the twelve "lights" might refer to the apostles,
who are actually present on the bronze doors. This dome, or the similar one in
the Pazzi Chapel designed perhaps toward 1430 (fig. 66), bears a notable
resemblance to domical mosaics such as the *Pentecost* at San Marco (fig. 67),
itself apparently one of the copies of a lost composition in the Church of the
Apostles in Constantinople.[55] The possibility of a real connection between
mosaics of this kind and Brunelleschi's domes is increased by the fact that the
twelve ribs and twelve round windows of the Pazzi dome, while radiating
from a luminous center, that is, from pure spirit, actually extend toward
roundels of the twelve apostles that Luca della Robbia made for the walls
below. If there is a real connection between a design such as the *Pentecost* at
San Marco and the Pazzi cupola, it strengthens our thesis of a connection
between the Pazzi Chapel and the *Tribute Money*.

It should be added that the mosaic at San Marco is one of two kinds of
medieval, and especially Byzantine, designs that display actually in three
dimensions the compositions that we have seen projected on the surface of
paintings and relief sculptures. The second kind is the representation, quite
common, of Christ, the Virgin, and the apostles on the curved surface of the
apse.[56]

It has long been believed that Masaccio learned linear perspective from
Brunelleschi. We may add now that the painter and the architect shared a
tendency to symbolize basic Christian conceptions by centralized plans. Given
the scantiness of our knowledge, it is useless to speculate on the precise
interrelationship of the two artists in this sphere during the mid-twenties.

The great formulator of these ideas, Leone Battista Alberti, was probably
not in touch with Masaccio and Brunelleschi in the twenties. He took his law
degree in Bologna in 1426–1427, and then he seems to have gone to Rome,
though he may have paid a brief visit to Florence in 1428.[57] Probably he did
not know Brunelleschi before the latter's journey to Rome in the year 1432 or
1433.

The proposal to connect the composition of the *Tribute Money* with an
Early Christian and Byzantine representational tradition on the one hand and

a trend in contemporary architecture on the other may seem to load it with too much freight. There can be no doubt, however, that the fresco embodies at least a formal principle that was fundamental to Masaccio's art. We have seen it announced in the *Adoration of the Magi* and *St. Peter Preaching,* and it was further developed in his only large work after the *Tribute Money,* the fresco below it, representing the raising of the son of the prefect of Antioch (fig. 68). This fresco, left unfinished by Masaccio, was completed by Filippino Lippi a half century later in a more or less comprehending fashion.

The story selected for this lower fresco, told in the *Golden Legend,*[58] was even more rarely represented than the Miracle of the Stater. There exist, it seems, only two earlier examples, one in a Spanish retable and the other in a predella of Jacopo di Cione's altarpiece for San Pier Maggiore, Florence;[59] clearly, Masaccio could not have made much use of them. In his fresco he placed the scene of resuscitation of the dead youth directly underneath the central episode of the *Tribute Money.* The ring of witnesses of the miracle, which was mistakenly continued as a straight row by Filippino, repeats the circle of the apostles. St. Peter stands near the center, to be balanced by the revived youth nearby. At the right, where Peter has received his first bishopric, the curve of the compositional plan curls into reverse, and the praying figures form a semicircle before him.[60] Unlike convex circles by Masaccio's predecessors, this one is closed by a wall.

This fresco, so similar in composition to the *Tribute Money,* is related to it also in meaning. Physical resuscitation refers to spiritual salvation—the lowered glances suggest that Masaccio's youth would have been smaller, perhaps more "soul-like"—and the bishopric of Antioch, which Peter held for seven years, foretells that of Rome.

If, as seems quite possible, the relief of the Ascension of Christ and the Gift of the Keys to St. Peter, in the Victoria and Albert Museum, was originally on the altar of the Brancacci Chapel, an approximation of the circular plan with a characteristic iconography appeared in the Chapel for the fourth time (fig. 69).[61] It is only an approximation, for so regular and slow-paced a design was uncongenial to Donatello, who valued strong currents of movement in his compositions and passionate, spasmodic figural actions. He greatly lowered the point of sight and inverted the semicircle, so that the open ends trail into the distance, as in Gentile da Fabriano. Even then the

composition, now usually dated toward 1430, is the only one of its kind in Donatellos' oeuvre. Perhaps the example of Masaccio induced him to try it in the Brancacci Chapel, though it is also true that, as I have observed above (p. 69 f.), the apostles had already been arranged in a ring in a Trecento painting of this subject. In any event, circularity in the Ascension became normal in the fifteenth century, appearing, for example, in a panel by Fra Angelico in San Marco,[62] in the lunette by Luca della Robbia of 1446–1451 for the Cathedral of Florence,[63] in a drawing by Jacopo Bellini,[64] and in the triptych by Mantegna in the Uffizi.[65]

This is not the place to deal with the large theme of the history of the circular or semicircular plan after the Brancacci Chapel, in later fifteenth-century painting and sculpture. Enough, however, must be said to consolidate our estimate of the significance of Masaccio's contribution in this respect to the art of the Renaissance. The composition, often now fully circular, was used, first of all, for subjects within the traditional range of meaning, such as Christ preaching to the apostles, one of the many designs of this kind employed by Fra Angelico in the second quarter of the century (fig. 70).[66] More reminiscent of the *Tribute Money* is the scene of a small but very impressive silver plaque in the Louvre showing Christ Healing the Woman Possessed (fig. 72). In it the cognate plans in painting and in architecture meet, because the ring of figures is placed before a huge, centrally planned church. This church, as Sanpaolesi has pointed out, is similar to the part of the Old Sacristy built first, while other forms in the plaque reflect the work of Donatello in the same sacristy.[67]

The circles of figures on which we have concentrated so far are all terrestrial, but we have observed a tendency to apply the same principle to the apostles in heaven as early as Giotto's *Last Judgment,* and in Lorenzo Monaco's *Coronation* in the Uffizi it begins to govern the host of witnesses. It was Fra Angelico, however, who gave exemplary form to the heavenly circle in the beautiful *Coronation* in the Uffizi that he designed, I believe, in the early thirties (fig. 71).[68] The saints and angels are all illuminated by the radiance of the central figures, a kind of naturalistic version of the enlightenment of the apostles at Pentecost. This conception, advanced again by Angelico during the thirties on terra firma, in the *Coronation* in the Louvre,[69] was probably preceded by an *Assumption* in the Gardner Museum (fig. 73).[70]

This painting was no doubt inspired by the Trecento Sienese design that we have discussed (p. 70), but Angelico's ring of angels is seen from below instead of from above: the spectator thus looks up at the ascending figures. Later painters, such as Botticini in his *Coronation* in London,[71] sought to give this composition a still more vivid cosmological character by increasing the throng of figures.

While in the Quattrocento, as earlier, circular or semicircular plans were employed for a certain range of subjects, their use as the century advanced was increasingly freed of traditional iconographic considerations. Religious or cosmological meanings seem frequently less explicit, and interest in the form itself appears to have become more determining. The later history of the circular plan is, in other words, bound up to a greater extent with the history of style. Semicircles and more or less well-defined arcs began to be used for the plans of a variety of subjects during the second quarter of the fifteenth century. We see them emerging in the *Sacra Conversazione* around the mid-thirties in Fra Angelico's Annalena altarpiece;[72] and twenty years later, in the impressive panel for Bosco ai Frati, the same painter set behind the ring of figures the cognate architectural element, the dome or at least the half-dome. Domenico Veneziano adopted a rounded plan for the figures in his altarpiece now in the Uffizi.

The painter to whom the compositions of the Brancacci Chapel meant most was Masaccio's greatest and most intellectual follower. On the walls of the choir in Arezzo he spread his version of the double curvature of the *Raising of the Prefect's Son,* freer now of its old connotations and given a new dimension by, on occasion, setting the arc perpendicular to the picture plane (fig. 74).[73] Piero was most concerned with this kind of design during the middle years of his career. As a phenomenon of style the "hantise de la circularité" was rooted in both personal taste and the more collective judgments of a time. While, on the one hand, as we have said, it was widely diffused in the second quarter of the Quattrocento, it was not found congenial even at that time by every artist: Donatello, for example, avoided it, except in one work. In his frescoes in the Baptistry at Castiglione d'Olona, particularly the *Dance of Salome,* which is triangular in plan, Masolino carried into the thirties the taste of an earlier time, a more Gothic taste, we might say. For if the circular composition is an equivalent of the centrally planned, domed church, the rapid reach of Masolino's compositions into

depth and height is reminiscent of Gothic architecture, despite his Renaissance details.

In the third quarter of the century, apart from so special a case as Piero della Francesca, this "neo-Gothic" trend again became dominant. In the work of Ghirlandaio as well as Botticelli, for instance, we no longer see the semicircular plan of Masaccio and Fra Angelico but a trapezoid or a triangle with an apex lying in distant space.[74] Once again perspective is employed to represent a flight to infinity. It was Leonardo who, in his *Adoration of the Magi* of 1481, opposed to the excitement of this kind of rushing recession the concentration and balance of centripetal circularity. This became fundamental to Raphael and the High Renaissance, and indeed to all later classical arts. It is familiar to us in Raphael's designs for the tapestries,[75] and still more in the central part of the *School of Athens* and in the *Disputa*. In the *Disputa* (fig. 75) the greater regularity of the heavenly circle conveys the superiority and universality of the Christian order. These frescoes may be considered Renaissance versions of the classical and Early Christian themes of the scholar and the school with which our discussion began.

The revival of the semicircular or circular plan was primarily an Italian phenomenon. Compositions of this kind remained uncommon in North European painting until the later fifteenth century, though Jan van Eyck, always exceptional, approximated them in his *Paele Madonna* (fig. 19).[76] In the diffusion of the type old representational meanings and more purely formal intentions interact. We have observed, especially, that the circular plan and perspective projection are interdependent: the latter provides a method for the projection of the former, and the former provides a structure to maintain the unity and dominance of the figures, threatened by the latter.

Both the circular plan and focus perspective, furthermore, stem from a conception of mathematical order in art and in the world. Such a conception was of course not foreign to the Middle Ages. But in medieval art geometry tends to be either merely symbolical or merely practical (as in Villard de Honnecourt), whereas in Renaissance art it is identified with the structure of representation and it is the sign of a nascent scientific understanding of the world. Indeed, what Masaccio had initiated with focus perspective and a geometric ground plan is extended to other forms by his greatest successors, Uccello, Domenico Veneziano, and above all Piero della Francesca. For them mathematical order is displayed not only by the method of projection and by

circular plans, but by the salient geometry of the objects that fill this space, including human beings themselves. In these works culminates a major, and to us nowadays very meaningful, aspect of Renaissance art.

Postscript

This account of the connotations of the circular plan in Quattrocento painting is so concise that it may be difficult to read. The symbolic meaning of the design in earlier art seems to me to emerge with great clarity, whereas in the course of the fifteenth century iconographic significance merges to a greater extent with formal values, and not frequently is outweighed by them. Within the limits of the present essay I have been able only to sketch this interplay. The study should be extended and refined—but that would mean a much larger article, or rather a sizable book!

NOTES

1. Kurt Weitzmann and David Wright generously responded to my questions about Early Christian and Byzantine art; I am grateful to them for valuable comments and for the loan of photographs and reprints.
2. 17: 24–27. The characterization of the story in the text above is that of L. Réau, *Iconographie de l'art chrétien,* Paris, II, 1957, p. 321
3. The scene, very damaged, appears in the large fresco cycle of the late thirteenth century in San Piero a Grado near Pisa. Peter is seated on a rock removing a coin from a fish; a soldier extends a hand for payment, while another figure (Christ?) stands nearby. This cycle seems to reflect the representation of the legend of St. Peter that was in the forecourt of Old St. Peter's (P. d'Achiardi, "Gli affreschi di S. Piero a Grado," in *Atti del Congresso internazionale di Scienze storiche,* VII, 1950, pp. 193–285). Grimaldi's drawing, which shows only the mosaics of this cycle still preserved in his time, does not include this story (J. Wilpert, *Die römischen Mosaiken und Malereien,* Freiburg i.B., I, 1916, pp. 399–400). The scene may have been included also in an area of the frescoes of Sant'Angelo in Formis that is now ruinous (F. X. Kraus, *Die Wandgemälde von Sant'Angelo in Formis,* Berlin, 1893, p. 33 and pl. III). The second rare scene in the Brancacci Chapel, St. Peter healing by his shadow, is represented at San Piero a Grado, though a symbolical ray of light, but no shadow, is visible (G. Kaftal, *Iconography of the Saints in Tuscan Painting,* Florence, 1952, fig. 913).
4. Though there are a few later representations, for example, in the left wing of the triptych in the Cathedral of Malines by Rubens, and Mattia Preti's painting in the Galleria Nazionale, Rome (see A. Pigler, *Barockthemen,* Budapest, I, 1956, p. 295 ff.).
5. Matthew 22: 15–22. See the painting by Titian in Dresden, M. Preti in S. Demetrio ne' Vestini (*L'Arte,* XLI, 1938, p. 267, fig. 7), and many other examples listed by Pigler, *op. cit.,* I, pp. 330–332. Earlier representations may be found in Florence, Bibl. Laur., Plut. VI, 23, fol. 87 (Byzantine, 11th century), at S. Piero a Grado, and in the *Bible moralisée* (A. de Laborde, *La Bible moralisée,* Paris, IV, 1921, pl. 734). See also *Queen Mary's Psalter,* ed. G. F. Warner, London, 1912, pl. 240. Réau, *op. cit.,* II,

p. 321, incorrectly says that this subject was not represented until the sixteenth century.

6. In the mid-thirteenth-century *Bible moralisée* (Brit. Mus., Harley 1527, fol. 33) Christ is seated at the left while Peter, in the center, holds rod and fish, and gives the stater to the collector (Laborde, *op. cit.,* III, 1913, pl. 504). The text of the *Bible moralisée* transforms the differentiation in the Gospels between the children of the kings of the earth and the strangers into a contrast between the poor and the mundane wealthy, asserting that the latter should be taxed, not the former.

 For ancient Greek antecedents of the miracle of the stater see the story of Orpheus as fisherman and related myths (R. Eisler, *Orpheus—The Fisher,* London, 1921, pp. 104–106).

7. In addition to the miniature reproduced see Paris, Bibl. nat., gr. 74, fol. 35 (*Paris, Bibl. nat., Evangiles avec peintures byzantines du XI^e siècle,* Paris, 1908, pl. 30). This sequence was copied in the mid-fourteenth century in British Museum, Add. 39627, fol. 53 (B. Filov, *Les miniatures de l'évangile du roi Jean Alexandre à Londres,* Sofia, 1934, pl. 24). More abbreviated representations may be found in: a Lectionary in San Giorgio dei Greci, Venice, fol. 101v; Paris, Bibl. Nat, gr. 923, fol. 311v; Florence, Bibl. Laur., Plut. I.56, fol. 9; an ivory in the Museum, Liverpool; Antwerp, Musée Plantin-Moretus, M.17.4, fol. 25.

 The scene of St. Peter distributing alms turned out to be strangely relevant because not many years later we hear of Felice Brancacci, in exile and poor, receiving alms from Pope Eugenius IV (Vespasiano da Bisticci, *Memoirs,* tr. W. G. and E. Waters, London, 1926, p. 28).

8. What we know about artists and the choice of subjects in commissioned cycles in the fifteenth century does not, I think, support the belief that Masaccio himself selected subjects for the Brancacci Chapel, and even decided to substitute the Tribute Money for the Gift of the Keys, a view held by R. Longhi ("Fatti di Masolino e di Masaccio," *Critica d'Arte,* v, 1940, p. 175) and H. Lindberg, *To the Problem of Masolino and Masaccio,* Stockholm, 1931, I, pp. 153–154.

 K. Steinbart, *Masaccio,* Vienna, 1948, p. 54, says that the *Tribute Money* reflects the intention of Pope Martin V to reestablish the authority of the Church. By representing the finding of a coin in the mouth of a fish, it also refers to the new maritime interests of Florence, which were promoted by Felice Brancacci.

9. F. Schevill, *History of Florence,* New York, 1936, pp. 345–346. For a recent review of the matter, with important new emphases, see U. Procacci, "Sulla cronologia delle opere di Masaccio e di Masolino tra il 1425 e il 1428," *Rivista d'Arte,* XXXVIII, 1953, pp. 16–31.

10. I owe this fact to the generosity of Ugo Procacci.

11. P. O. Kristeller, "Augustine and the Early Renaissance," *Review of Religion,* VIII, 1943–1944, p. 393 ff. For the connection between Ghiberti and the patristic interests of the humanists see R. Krautheimer, in collaboration with T. Krautheimer-Hess, *Lorenzo Ghiberti,* Princeton, 1956, p. 169 ff.

12. "*Invenies ibi staterem,* hoc est, quatuor drachmas, *da eis pro me et te.* Quid est, *Pro me et te?* Ipse Christus, Petrus, Ecclesia Christi, Ecclesiae quatuor Evangelia. Mysterium latebat: Christus tamen tributum non debitum persolvebat. Sic persolvit et mortem: non debebat, et persolvebat. Ille nisi indebitum solveret, nunquam nos a debito liberaret" (Augustinus, Sermo CLV, in Migne, *Pat. lat.,* XXXVIII, col. 845).

13. Chrysostom also emphasizes the selection of Peter at this time. A great honor was paid him, he says, first by the collectors who approached him rather than another apostle, and then by Christ, who said that the coin was paid for Peter as well as for himself. Chrysostom's understanding of the main point of the story, however, differs

from Augustine's and is more common. For him the miracle of a coin-bearing fish is proof of Christ's divinity (Homil. LVIII, 2, 3, in *A Library of the Fathers, The Homilies of St. John Chrysostom,* Oxford, 1854, II, pp. 786–788).

14. See below, p. 72.
15. The description by F. Antal must be considered quite eccentric: "The action is treated almost as a mere piece of secular reporting . . ." (*Florentine Painting and Its Social Background,* London, 1947, p. 308).
16. In the early part of the century: *Last Judgment* in the Arena Chapel (see above, p. 73); Ambrogio Lorenzetti, *Presentation in the Temple,* Uffizi, and *Madonna and Saints,* Pinacoteca, Siena; Bernardo Daddi, central panel of the San Pancrazio altarpiece, Uffizi. At the end of the century, in the circle of Agnolo Gaddi: *Pentecost,* Museo Bandini, Fiesole; *Burial of Adam,* choir, Sta Croce; *Annunciation to Zacharias,* Castellani Chapel, Sta Croce (R. Salvini, *L'arte di Agnolo Gaddi,* Florence, 1936, pls. 8, 19, 26a).
17. The exceptional examples, such as Jacopo di Cione's *Ascension* in London (see below, p. 69f), can perhaps be explained by the strength of the traditional symbolism.
18. *Painting in Florence and Siena After the Black Death,* Princeton, 1951.
19. *Coronation of the Virgin,* Uffizi (R. van Marle, *Development of the Italian Schools,* IX, 1927, fig. 109, see below, p. 73); *Adoration of the Magi,* Uffizi (*ibid.,* pl. opp. p. 152); *Meeting at the Golden Gate,* Sta Trinita, Florence (*ibid.,* fig. 104).
20. See the *Flight into Egypt* in the predella of Gentile's altarpiece; also the *Adoration of the Magi* and the *Meeting at the Golden Gate* by Lorenzo Monaco cited in the preceding note.
21. The Joseph panel, for instance, in the *Gates of Paradise,* and Domenico Veneziano's *Adoration of the Magi* in Berlin.
22. Wilpert, *Roma sotterranea. Le pitture delle catacombe romane,* Rome, 1903, pls. 96, 126, 148, 177a and b. See the gold glass of the fourth or fifth century, now on loan from Pusey House, in the Ashmolean Museum, Oxford (kindly called to my attention by Dr. Wright).
23. W. F. Volbach, "Frühmittelalterliche Elfenbeinarbeiten aus Gallien," in *Festschrift des Römisch-Germanischen Zentralmuseums in Mainz,* Mainz, I, 1952, pp. 44–53.
24. See also the fifth-century mosaic in the apse of Sant'Aquilino, Milan (Volbach, *Frühchristliche Kunst,* Munich, 1958, pl. 138).
25. "Socrates and Christ," *Harvard Studies in Classical Philology,* LX, 1951, pp. 205–233.
26. *Ibid.,* pp. 209–212; G. W. Elderkin, "Two Mosaics Representing the Seven Wise Men," *American Journal of Archaeology,* XXXIX, 1935, pp. 92–111; O. Brendel, "Symbolik der Kugel," *Mitteilungen des Deutschen Archaeologischen Instituts,* LI, 1936, fig. 2.
27. Another copy of this design is a mosaic at Torre Annunziata (see the preceding note). For the *scholae* see G. T. Schwarz, "Les scholae et le forum d'Aventicum," *Bulletin de l'Association Pro Aventico,* XVII, 1957, p. 13 ff. (kindly called to my attention by Andreas Alföldi).
28. Wilpert, *Die römischen Mosaiken . . . ,* II, 2, p. 776, and III, pl. 16
29. For this ms. see K. Weitzmann, "Narrative and Liturgical Gospel Illustrations," in *New Testament Manuscript Studies,* ed. M. Parvis and A. Wikgren, Chicago, 1950, p. 158, pl. 16. See also the mosaic in the north transept of San Marco; the *Hortus Deliciarum* (Wilpert, *op. cit.,* II, 2, fig. 345); the *Homilies of Gregory of Nazianzus* (H. Omont, *Miniatures des plus anciens manuscrits grecs de la Bibliothèque nationale,* Paris, 1929, pl. 35).
30. Omont, *op. cit.,* pl. 44.
31. Beginning with Early Christian art, the table in the Last Supper was frequently round

or half-round, and these were, in fact, common shapes of dining tables at the time. See C. R. Morey, *Early Christian Art,* 2nd ed., Princeton, 1953, p. 112, figs. 120, 174, and, for the *agape,* fig. 52. For Byzantine and Italian examples of the twelfth through the fourteenth centuries, including the Lorenzettian fresco in the Lower Church at Assisi, see E. Sandberg-Vavalà, *La croce dipinta italiana,* Verona, 1929, figs. 159, 160, 170, 173, 174. For the actual use of the round or sigma-shaped table see G. M. A. Richter, *Ancient Furniture,* Oxford, 1926, p. 139 ff., and A. A. Barb, "*Mensa Sacra,* the Round Table and the Holy Grail," *Journal of the Warburg and Courtauld Institutes,* XIX, 1956, p. 40 ff.

32. See also Brit. Mus., Add. 47682 (W. Hassall, *The Holkham Bible Picture Book,* London, 1954, fol. 17v); Brit. Mus., Harley 1527, fol. 13 (Laborde, *op. cit.,* III, 1913, pl. 484).

33. Representations are especially numerous in Bolognese illumination and in reliefs on the tombs of professors at the University of Bologna. See, for example, M. Salmi, *La miniatura italiana,* Rome, 1955, pl. XIV; R. van Marle, *Iconographie d l'art profane,* The Hague, 1931, I, figs. 359, 360.

34. This has often been pointed out; for recent observations in connection with the Isaac scenes see Meiss, *Giotto and Assisi,* New York, 1960, pp. 11–19.

35. In the now fragmentary scene in the fresco cycle in San Giovanni a Porta Latina, which preserves many elements of the Early Christian cycles in Rome, Christ is seated under an arch, or more probably a half-dome (Wilpert, *op. cit.,* IV, pl. 252–255).

36. O. Sirén, *Giotto and Some of His Followers,* Cambridge, Mass., 1917, II, pl. 96. Thereafter, in the fourteenth century, rectangular plans tend to prevail (Barna, Collegiata, San Gimignano; Giusto, Baptistery, Padua).

37. Wilpert, *Roma sotterranea . . . ,* pl. 193; Volbach, *Frühchristliche Kunst,* pl. 111.

38. It is all the more extraordinary that this head was executed by Masolino. According to Procacci (*op. cit.,* p. 8), it was the last of the heads to be painted.

39. The literature is vast. See D. Mahnke, *Unendliche Sphäre und Allmittelpunkt,* Halle, 1937, p. 144 ff., and M. H. Nicolson, *The Breaking of the Circle,* revised ed., New York, 1960. Also H. P. L'Orange, *Studies on the Iconography of Cosmic Kingship in the Ancient World,* Oslo, 1953, p. 9 ff. (kindly called to my attention by E. H. Kantorowicz). For the continuation of these ideas in the Middle Ages and the Renaissance, see G. Poulet, "Le symbole du cercle infini dans la littérature et la philosophie," *Revue de métaphysique et de morale,* 1959, p. 257 ff. For architecture see R. Krautheimer, "Introduction to an 'Iconography of Mediaeval Architecture,'" *Warburg Journal,* V, 1942, p. 9 ff.

40. See the summary of this passage in H. Baron, *The Crisis of the Early Italian Renaissance,* Princeton, 1955, I, pp. 169–170. Bruni's visualization is connected with a very old tradition (see L'Orange, *loc. cit.*).

41. Poulet, *op. cit.,* p. 263.

42. *Fragmenta et picturae Vergiliana codicis Vaticani latini 3225,* Rome, 1930, Pict. 49. See also Charles the Bald and his court in the Carolingian Bible, Paris, Bibl. Nat., lat., 1, fol. 423 (W. Köhler, *Die Karolingischen Miniaturen,* Berlin, Plate vol. I, 1930, pl. 76.

43. See A. Grabar, "Le schéma iconographique de la Pentecôte" (in Russian), in *Seminarium Kondakovianum,* Prague, II, 1928, pl. XXV, no. 2.

44. See, for instance, the cosmological fresco by Pietro di Puccio in the Campo Santo, Pisa (*Camposanto monumentale di Pisa: Affreschi e sinopie,* Pisa, 1960, pl. 99). In general see Pseudo-Dionysius, *De hierarchia caelestis,* ch. 7; M.-T. d'Alverny, "Les pérégrinations de l'âme dans l'autre monde d'après un anonyme de la fin du XIIᵉ siècle," *Archives d'histoire doctrinale et littéraire du moyen âge,* XIII, 1942, p. 239 ff.; J. Baltru-

šaitis, *Cosmographie chrétienne dans l'art du moyen-âge,* Paris, 1939. In the *Adoration of the Lamb* by the Van Eycks the angels are disposed in a circle, and again in the *Paradise* in San Marco from the workshop of Fra Angelico (Pope-Hennessy, *op. cit.,* fig. XXXI).

In the apse of S. Lupolo, Capua, there was a representation of the Holy Ghost at the center of two circles, all suspended above fourteen saints. The painting is known from a line engraving in Michele Monaco, *Sanctuarium Capuanum,* Naples, 1630, pl. opp. p. 136, kindly called to my attention by Ernst Kitzinger.

45. Van Marle, *op. cit.,* III, 1924, fig. 279. This circular arrangement of the apostles in the Ascension does not, however, seem to follow Early Christian and Byzantine precedents. See E. DeWald, "The Iconography of the Ascension," *American Journal of Archaeology,* XIX, 1915, pp. 277–319.

46. Meiss, *Painting in Florence and Siena,* fig. 22.

47. *Ibid.,* pp. 21–22.

48. *Architectural Principles in the Age of Humanism,* London, 1949, pp. 1–9, 18–20. In Alberti's *De re aedificatoria* see especially Book VII, ch. 4, where he asserts that the preference for round forms is manifested by Nature herself.

49. Wittkower, *op. cit.,* p. 11.

50. Jacobus de Voragine, *Legenda aurea,* ed. Th. Graesse, Bratislava, 1890, p. 719 (De omnibus sanctis): "Fundamentum autem ipsius templi sphericum jacitur, ut ex ipsa forma Deorum aeternitas demonstretur." This interesting passage was called to my attention by Erwin Panofsky.

51. E. Panofsky, *Galileo as a Critic of the Arts,* The Hague, 1954, p. 25.

52. G. C. Argan, *Brunelleschi,* Milan, 1955, fig. 78.

53. W. Lotz, "Michelozzos Umbau der SS. Annunziata in Florenz," *Mitteilungen des Kunsthistorischen Instituts in Florenz,* V, 1940, p. 402 ff. L. H. Heydenreich, "Die Tribuna der SS. Annunziata in Florenz," *Mitteilungen des Kunsthistorischen Instituts in Florenz,* III, 1930, p. 268 ff., showed that the design follows the Minerva Medica.

54. Argan, *op. cit.,* figs. 49, 50. On Italian domes, including Brunelleschi's, see numerous papers in *Atti del Primo Congresso nazionale di Storia dell'Architettura,* Florence, 1938, especially L. Crema, "Romanità delle volte Brunelleschiane," pp. 130–131, though the choice of twelve ribs is not discussed. This volume was kindly called to my attention by David Coffin.

55. O. Demus, *Die Mosaiken von S. Marco in Venedig, 1100–1300,* Baden, 1935, p. 18, pl. 2. See also the closely related mosaic in Hosios Lukas (E. Diez and O. Demus, *Byzantine Mosaics in Greece,* Cambridge, Mass., 1931, fig. 7) and the mosaics with the apostles in the domes of the two baptistries in Ravenna (Morey, *op. cit.,* pls. 165–166). See also K. Lehmann, "The Dome of Heaven," *Art Bulletin,* XXVII, 1945, p. 27.

56. For example, the Cathedral of Cefalù (O. Demus, *The Mosaics of Norman Sicily,* London, 1949, pl. 1).

57. See R. Krautheimer, *Lorenzo Ghiberti,* Princeton, 1956, p. 318.

58. *Golden Legend,* Feb. 22, ch. 44 (The Chairing of St. Peter at Antioch).

59. For the predella by Jacopo di Cione see G. Kaftal, *Iconography of the Saints in Tuscan Painting,* Florence, 1952, fig. 913. A second representation may be seen in a retable in the Rusinol Collection, Sitges (C. R. Post, *A History of Spanish Painting,* Cambridge, Mass., II, 1930, fig. 185).

60. This group is anticipated to a degree in a fourteenth-century miniature representing the Chairing (Bibl. Vat., vat. lat. 8541, fol. 10), and in Jacopo di Cione's predella of the San Pier Maggiore altarpiece (K. Steinweg, "Die Kreuzigung Petri des Jacopo di Cione in der Pinacoteca Vaticana," *Rendiconti della Pontificia Accademia Romana di Archeologia,* XXX-XXXI, 1957–1959, fig. 3).

61. H. Kauffmann, *Donatello,* Berlin, 1936, p. 69, originally demonstrated the connection of the relief with the Carmine, and J. Pope-Hennessy, *Donatello's Relief of the Ascension,* London, 1949, proposed that it was made for the Chapel; H. W. Janson, *The Sculpture of Donatello,* Princeton, 1957, p. 94, agrees that this was probably the original destination.

62. *Fra Angelico da Fiesole. Klassiker der Kunst,* 2nd ed., Stuttgart [1924], pl. 199. This composition was approximated in a painting in the style of Lorenzo Monaco (*Ascension* in the Vatican).

63. J. Pope-Hennessy, *Italian Renaissance Sculpture,* London, 1958, pl. 45.

64. V. Golubew, *Die Skizzenbücher Jacopo Bellinis,* Brussels, 1912, I, pl. 68.

65. E. Tietze-Conrat, *Mantegna,* New York, 1955, pl. 50.

66. In this instance the execution is by an assistant.

67. P. Sanpaolesi, *La Sacristia Vecchia di S. Lorenzo,* Pisa, 1950, pp. 6–7, where the plaque is dated *ca.* 1427–1435. Janson, *op. cit.,* II, p. 131 n. 5, places it in the second half of the century, while R. Longhi, "Fatti di Masolino e di Masaccio," *Critica d'Arte,* v, 1940, pp. 161–162, fig. 23, attributes it to Brunelleschi himself.

68. This brilliant panel from Sta. Maria Nuova, which fuses painted light with the actual refulgence of tooled gold better than any other Quattrocento painting I know, was in my opinion designed by Fra Angelico, though executed in part by assistants. M. Salmi (*Il beato Angelico,* Spoleto, 1958, p. 100) is of the same opinion, while J. Pope-Hennessy (*Fra Angelico,* New York, 1952, p. 173) attributes this "loosely organized circular design" to Angelico's follower, Zanobi Strozzi. Fra Angelico again used the circle in heaven for the fresco of the Coronation in S. Marco (*ibid.,* pl. 91).

69. Pope-Hennessy, *ibid.,* believes that the painting in the Louvre was executed in part by Domenico Veneziano and that it was the model for the *Coronation* from Sta Maria Nuova. The Louvre *Coronation* is, I believe, one of the few works in which Fra Angelico was thrown off his stride by strenuous efforts to keep up with the innovations visible around him.

70. This enchanting *Assumption* appears over a duller and weaker *Dormition* in which the hand of an assistant is evident (as Salmi, *op. cit.,* p. 101, also believes). The entire painting has been given to Z. Strozzi by Pope-Hennessy (*op. cit.,* pp. 199–200).

71. *National Gallery, Illustrations, I, Italian Schools,* London, 1923, pl. 32.

72. Other major examples are Domenico Veneziano's altarpiece in the Uffizi and Piero's in the Brera (fig. 88).

 Fra Angelico, great partisan of the circular plan, disposed the apostles in a ring in the panel of the Washing of the Feet in San Marco (*Klassiker der Kunst,* pl. 192). It is worth noting that he introduced a round building in the *Preaching of St. Nicholas,* Perugia (*ibid.,* pl. 83).

73. Piero's concern with curved plans, including arcs perpendicular to the picture plane, was already manifest in the early *Baptism* in London and continued to the late altarpiece in the Brera (fig. 88).

74. See, for example, Ghirlandaio's *Calling of Peter and Andrew* in the Sistine Chapel, his *Resurrection of the Child* in the Sassetti Chapel, Sta Trinita, Florence, or his *Adoration of the Magi* in the Uffizi. Among Botticelli's works see the tondo of the Adoration of the Magi in the National Gallery, London.

75. See *St. Paul Preaching in Athens* (*Klassiker der Kunst,* pl. 140).

76. In illumination of the first quarter of the century see, for example, in the Breviary at Châteauroux, ms. 2, the *Last Supper* (by the Bedford Master) and the *Ascension* (by the Boucicaut Master); in the *Cité de Dieu,* Walters Art Gallery, ms. 770, fol. 252, *Christ, the Virgin, and Saints in Heaven* (atelier of the Boucicaut Master).

5

A Documented Altarpiece by
Piero della Francesca

When a panel representing a saint by Piero della Francesca (fig. 77) emerged from obscurity and passed into the Frick Collection in 1936,[1] it was generally recognized to be part of a polyptych of which two other leaves were known, a *St. Michael* in the National Gallery, London (fig. 76), and a saint usually called Thomas Aquinas in the Poldi-Pezzoli Museum, Milan (fig. 78).[2] For reasons of style, the panels in London and Milan have always been dated late in Piero's career, at the end of the sixties or in the early seventies.[3] The only attempt to provide "external" evidence for their date, and also for their place of origin, was made some time ago by Tancred Borenius. In a footnote to a book review published in 1916,[4] he remarked that the saint in Milan is not Thomas Aquinas, as was commonly supposed, but the popular Augustinian Nicholas of Tolentino, and that the panel, therefore, was probably part of an altarpiece painted in accordance with a commission given to Piero in 1454 by the church of Sant'Agostino in Borgo Sansepolcro. Subsequent writers on Piero have completely ignored Borenius' suggestion, but further investigation, with the additional evidence provided by the panel in the Frick Collection, can, I believe, transform it from hypothesis into fact. This study involves a reconstruction of the polyptych as well as a consideration of other late works by Piero and the possibility of their relationship with paintings by Jan van Eyck.

This article was published in the *Art Bulletin*, XXIII, 1941, pp. 53–68.

Reference to a painting by Piero della Francesca in Sant'Agostino, Borgo Sansepolcro, was first made by Giorgio Vasari: "Nel convento de'frati di Santo Agostino (in Borgo Sansepolcro) dipinse la tavola dello altare maggiore, che fu cosa molto lodata."[5] The painting to which Vasari referred was, until the later nineteenth century, believed to be a panel representing the Assumption of the Virgin which stood on the high altar of Sant'Agostino.[6] Recently this work passed into the Pinacoteca of Sansepolcro (fig. 79). The inclusion of this panel in the oeuvre of Piero seemed confirmed when, in 1885, Gaetano Milanesi published a document of commission to Piero for a painting for the high altar of Sant'Agostino, and also a payment to the painter in 1469 for this work.[7] A few scholars, such as Lanzi and Rosini,[8] had already doubted, however, that the panel could have been painted by Piero; and Cavalcaselle,[9] with his usual acute perception, ascribed the work to a minor Umbrian master, either Gerino da Pistoia or, more probably, Francesco di Città di Castello, also called "Il Tifernate."[10] Thereafter no student of the Italian Quattrocento attributed this mediocre painting to Piero himself, but a compromise with the older opinion was sometimes attempted. Adolfo Venturi,[11] for example, observing quite correctly that certain parts of the work, especially the low wall with panels of serpentine and porphyry, are reminiscent of Piero, suggested that the altarpiece was actually the one allocated to Piero, but that it was executed by the youthful Perugino, then supposedly an assistant in Piero's shop. Borenius[12] criticized Venturi's hypothesis by pointing to the fact that whereas the *Assumption* is now, and almost certainly always was, a single panel without any "wings," the commission clearly calls for a polyptych (*tabulam que est de tabulis compositam*).[13] Despite this indication, and the fact that the commission does not specify the subject, the authors of several recent monographs on Piero state that the documents of 1454 and 1469 refer to an *Assumption of the Virgin*.[14] Borenius further remarked that three of the four saints in the foreground of the *Assumption*—Francis, Clare, and Louis of Toulouse—are Franciscan, and that the iconography would therefore preclude the execution of this work for an Augustinian church. He suggested[15] that, inasmuch as the church in question passed, in 1555, from the Augustinian Order to the Clarissan, the nuns brought the *Assumption* with them from their former house in Sansepolcro (Monastero della Strada),[16] and placed it on the high altar of their new church. The Augustinians, on the other hand, may have taken their

altarpiece to their new church, the Pieve di Sta Maria,[17] which, from 1555 on, was dedicated to S. Agostino.

The style, date, and subject of the *Assumption* in the Pinacoteca at Sansepolcro conclusively eliminate it as the painting made by Piero between 1454 and 1469 for Sant'Agostino. But the panel apparently provides nevertheless a clue to the problem of the work which Piero *did* execute for this church. For the *Assumption* contains one form which seems inharmonious with the late Quattrocento and Peruginesque elements that compose its style. The richly plastic low wall seems to reflect a different taste from the ferny or spider-like trees and the brittle surfaces and incisive linearity of the saints. Likewise its delicately shaded areas of white and its marble inlays are quite uncongenial to the sombre tones of the figures and the cool green-blue of the Peruginesque landscape.[18] The wall does indeed, as Venturi remarked,[19] recall Piero, but not so much the sarcophagus in Piero's *Resurrection,* to which he referred, as the wall in the panels in London, Milan, and New York (figs. 76–78). The author of the *Assumption* very probably knew these panels, and since he was a minor painter who in all likelihood did not travel widely, his imitation of one of their forms in a work made for Sansepolcro would seem to indicate that Piero's panels were once in that region also.

If Piero's altarpiece was originally in the neighborhood of Sansepolcro, can we specify the church for which it was made? Borenius suggested, as we have already mentioned, that the saint in the Poldi-Pezzoli Museum is not Thomas Aquinas but Nicholas of Tolentino. Students have continued, however, to call him Thomas,[20] and the only illustration which accompanies the discussion of this saint in Künstle's *Ikonographie der Heiligen*[21] is the figure in the Poldi-Pezzoli Museum. There are, to be sure, reasons for identifying the saint in Milan with the great Dominican scholar. He is dressed in gray-black, he carries a book, he is distinguished by a luminous symbol which might be the sun, and his ample proportions do justice to the known facts of St. Thomas' girth. The sum of these qualities and attributes is insufficient, however, to produce St. Thomas, because he invariably wears a Dominican habit[22]—a black mantle which opens in the front disclosing a white tunic— whereas the habit of the saint in Milan is clearly Augustinian. It is the usual Augustinian black or dark gray[23] cowled tunic with no opening down the front,[24] and, most telling of all, it is drawn together at the waist by a black leather girdle fastened with a metal (here silver) buckle. This leather belt is

the most distinctive feature of the Augustinian habit; it was, in fact, one of the articles of apparel enjoined upon the friars by a bull of Pope Gregory IX in 1241 for the very purpose of readily distinguishing them from members of other monastic orders, especially the Franciscans.[25] It appears in all representations of Augustinian friars, and Augustine himself, when portrayed as a bishop, frequently wears it under his cope.[26] There is a legend, too, that Augustine wore the black habit and the leather girdle at his baptism,[27] and the winding of the girdle around him is sometimes represented in art.[28]

The saint in Milan is undoubtedly Augustinian, and as a member of that order he can only be Nicholas of Tolentino. Nicholas, the most popular Augustinian saint after the founder himself,[29] is usually represented with a book and always with a luminous symbol which refers to the star that shone over Tolentino at his birth (fig. 84).

The attributes, then, which seemed to refer to Thomas Aquinas are actually those of Nicholas, except for the stoutness of figure. In the Early Renaissance, however, ample proportions and even plumpness cannot readily be associated with any single saint. In this period artists, and especially Piero in his later works, tended to individualize saints not only in accordance with traditional characters, but with respect also to a single contemporary model. Furthermore the fifteenth century, at least until about 1460, was not generally sympathetic to the ascetic ideal. It valued, and projected images of, full-bodied, physically powerful men; and among the sacred figures, where physical strength was traditionally lacking, it favored those who achieved a tangible triumph through cunning and courageous action. Thus David, among the masculine figures, and Judith, among the feminine, were very frequently selected for representation. Even monks, such as Nicholas of Tolentino, who had been revered for their abstemious life and the triumph of their spirit over a painfully weak body, acquired comfortable weight and vigor (fig. 84). These ideals are highly developed in the later works of Piero della Francesca, whose Saints Anthony and John the Baptist in the Perugia Altarpiece (fig. 80) and Francis in the Brera panel (fig. 88) have the robust stature of a great hero of the period, Hercules, and whose Nicholas of Tolentino could be confused with the notoriously corpulent Thomas Aquinas.

The presence of Nicholas of Tolentino in Piero's altarpiece assures us that it was made for an Augustinian church,[30] and we have already seen that there is some reason to believe that this church was in the region of Borgo

Sansepolcro. Before attempting to specify further the place for which the panels were made, it is necessary to determine their order in the altarpiece.

In the lower left-hand corner of the Frick panel (fig. 77) there appears a block of brownish marble which covers part of the saint's right foot. A section of the upper surface of this plinth has been scraped bare of paint, and the vertical boundary of this section at the right can be traced, by means of a rather faint line and differences of surface on either side of the line, upward over the marble floor and into the extreme lower left part of the saint's drapery, and then diagonally off in a straight line to the left edge of the panel.[31] These lines compose the profile of a second block of marble which rested upon the first, and even the line of junction of the vertical and horizontal planes of this block is visible. Whereas the lower block overlaps the saint's foot, this one overlapped a bit of the drapery and a considerable section of the white wall behind. These marble plinths are clearly the terminal sections of a construction—almost certainly the base of a Madonna's throne—which extended from the lost central panel of the altarpiece into the adjacent panel at the right. The base of the Madonna's throne in Piero's altarpiece in Perugia (fig. 80) shows a similar extension.[32]

The saint in the Frick Collection, then, stood at the right of the lost central panel of the polyptych, and he turns slightly to the left in deference to the central figures, who were very probably the Madonna and Child. On the opposite side of the central image stood St. Michael. The floor on which Michael now stands, composed of geometric flagstones instead of the veined marble which appears in the other two panels, is not the original one. This is indicated by the character of the present surface, and also by the perspective. For just as Piero employed a single source of light for the entire polyptych, so also one would expect him to have used a single viewpoint; and the perspective of the marble blocks in the Frick panel, together with the arrangement of the veins of the marble in the floor of this and the Milan panel, prove that he did. The orthogonal strips in the floor of the St. Michael are, however, projected in accordance with a central point of view for this panel alone. Through the repaint on the floor there is still partially visible, even in a photograph[33] a group of lines corresponding to those in the painting in the Frick Collection. The lower plinth, which in this panel has been completely scraped away or painted out, overlapped part of the decapitated dragon, and

when the plinth was later removed, the dragon was extended farther to the right. This addition to the dragon may possibly have followed an outline by Piero himself, for in the Frick panel the part of the saint's foot that is overlapped by the plinth is visible through the marble, and was therefore laid in by Piero before he painted the plinth—interesting evidence of his working method.[34] The original existence of the marble blocks in the lower right corner of the London panel is also proved by the effect of their restoration (in the reproduction) upon the design of the work. They fill a compositional void in this section: they balance the lashing tail of the dragon, and they provide a broader base for the figure and for the sword and dragon's head above.

St. Michael is turned a little to the right, corresponding to the turn of the Frick saint toward the left. Both these figures are enframed by a pair of pilasters on the wall behind, which are scarcely visible in the Frick panel because of damage and also because they are partly covered by the drapery of the saint. In the panel of St. Nicholas of Tolentino, only one pilaster is visible, along the frame at the right. This position of the pilaster, together with the slight turn of the saint toward the left, proves that the panel was originally placed at the right of the Frick saint, and was the extreme right leaf of a five-leaved polyptych.

The document of commission, dated October 4, 1454, does not specify the subject of the polyptych to be painted by Piero, although it refers to a prior agreement, embodied in writing, as to the images and figures to be represented.[35] The contract does, on the other hand, name the donor. The altarpiece was ordered by Angelus Johannis Simonis Angeli of Borgo, *ex devotione et p(ro) satisfact(i)o(n)e voluntatu(m) Simonis sui oli(m) fr(atr)is et d(omi)ne Johan(n)e oli(m) uxoris dicti Simonis ac sue ip(s)ius d(i)c(t)i Angeli cog(na)te . . .* and also . . . *p(ro) a(n)i(m)a d(i)-*

* This extract, as well as those that follow, is taken from a transcript of the document made by Dr. Gino Corti for Hannelore Glasser, who has kindly permitted me to publish them. The document is included in the doctoral dissertation of Professor Glasser, *Artists' Contracts of the Early Renaissance*, Columbia University, 1965. See Florence, Archivio di Stato, Notarile. Rogiti di Mario di Matteo di Angiolo de'Fedeli dal Borgo San Sepolcro, F. 179 (1454–1455) c. 116. In my original article I utilized, and reprinted, Milanesi's transcription of 1885 (see n. 7), but he omitted words and phrases now included in Corti's text, especially the important last word in the extract above, "cognate." Curiously, that word is also missing in the reprinting, after correlation with the original, of the entire document in E. Battisti, *Piero della Francesca*, Milan, 1971, II, p. 222. There are other small differences from Corti's version.

c(t)i oli(m) sui fr(atr)is et d(i)c(t)e sue cognate et sua(rum) et suor-(um) p(re)decess(orum). . . .

Now it was common practice at this period to introduce the patron saint of the donor of an altarpiece in a prominent position in the work itself, usually in the most favored and most important place—at the Madonna's right hand. This position in our altarpiece is allotted to *Angelus* Michael, who was very probably the patron saint of the principal donor, Angelus of Borgo. Furthermore, the figure in London bears on a band of his armor at the waist, the inscription: ANGELUS·POTENTIA DEI·LUCHA.* The use of *Angelus* and of this phrase instead of the usual *Sanctus Michael* would seem to indicate a desire to record specifically, and to honor, the name of the donor.

Angelus had perhaps another—a third—referent. For under the high altar of the present Sant'Agostino in Sansepolcro is buried the body of the Beato Angelo Scarpetti.[36] Angelo Scarpetti, a contemporary of Nicholas of Tolentino, was the most revered friar in the history of the Augustinians in Sansepolcro.[37] His life, distinguished by faith, humility, and chastity, and by the performance of several miracles, led to the growth of a cult immediately after his death, *ca.* 1306. He was buried in old Sant'Agostino, and when the monks moved to their new church in 1555 his remains were taken along and buried under the high altar. Although the place of burial of the Beato in old Sant'Agostino, at the time when Piero painted his altarpiece, is not specified, the selection of the high altar in the new church, together with the age and importance of the cult, render it likely that in the old church also he lay under the high altar.[38]

Our panels meet the specific and partly unique requirements and conditions of the commission of 1454 so completely that there can remain, I believe, no doubt that they were made in accordance with it.[39] The establishment of this connection between the panels and the commission does not provide new facts of great significance for the study of Piero della Francesca, but it does illuminate to a greater or less degree a number of different problems. The payment of 1469, as well as the commission of 1454, was given to Piero alone; no mention is made of an assistant. The documents

* D. S. Robertson, "The Inscription on Piero della Francesca's *St. Michael*," *Burlington Magazine*, XCV, 1953, p. 170, proposed that the word is MICHA for Michael. M. Davies, "Some Notes on Piero della Francesca's *St. Michael*," *Burlington Magazine*, CIX, 1967, p. 28 ff., observed that LUCHA, and indeed the entire inscription, has been much retouched.

therefore do not, to say the least, strengthen the recently revived hypothesis that a second painter executed one of the panels, the St. Michael, and even proclaimed his independent authorship by inscribing his name at the conclusion of the tribute to the archangel. According to this hypothesis, the very puzzling LUCHA which follows ANGELUS·POTENTIA DEI is the signature of Luca Signorelli, at that time supposedly an assistant in Piero's shop.[40] This identification was, however, already rendered highly dubious by the absence of any tangible traces of Signorelli's style in this panel, and also by the improbability of the insertion of an assistant's signature in one panel of an altarpiece, and in so unusual a place within the panel.

Two of the five panels of the polyptych are lost. The central one, as we have said, almost certainly contained a Madonna and Child.[41] [The drapery along the right edge of the panel of St. Michael and on the step, disclosed by the recent cleaning (fig. 86), might indicate another subject. See the Postscript.] Inasmuch as the altarpiece was made for an Augustinian church, the extreme left wing probably represented St. Augustine himself. The identity of the saint in the Frick panel, who stood originally on the Madonna's right, is not clear. The combination of the book, the bare feet, the mantle (red) and tunic (green) indicates an apostle. But which one? Among Piero's repertory of saints, the only one who resembles the Frick figure closely is the apostle at the extreme right in the Brera altarpiece, and his identity likewise is problematic (fig. 88).[42] In the later fifteenth century, and particularly in the late work of Piero, which, as we shall mention again, shows such a strong tendency toward free individualization and portraiture, it is extremely hazardous to identify saints on the basis of traditional facial types. The closest physiognomic relative of the Frick saint is, in fact, not even the figure in the Brera panel, but King Solomon in the Arezzo frescoes (figs. 81 and 82), who has the same face, but certainly does not represent the same figure. In the solution of this problem of identity, the document of commission may be of some assistance. For Angelo of Borgo ordered the altarpiece not only for his own salvation, but in accordance with the wishes, and for the souls of, Simone his deceased brother, Giovanna his sister-in-law, and his forebears, chief among whom would be his (and Simone's) father. Since his father was named Giovanni, and his sister-in-law Giovanna, we might expect to find St. John in the second most important place in the polyptych, at the Madonna's left. And

the Frick saint, who stood in this position, might represent St. John the Evangelist. St. John commonly wears a red mantle over a green tunic, and though he usually carries a pen in his right hand, he is sometimes represented without it, reading a book.[43] [Perhaps, however, the saint represents Simon Zelotes, name saint of Angelo's brother and Giovanna's late husband. But neither color nor any attribute confirm this identification.*]

The polyptych which Piero painted for Sant'Agostino thus consisted of St. Augustine (probably), St. Michael, the Madonna and Child (almost certainly), the apostle in the Frick Collection, and Nicholas of Tolentino, in that order. The frames of the three extant panels are modern but it is clear that the panels were originally surmounted by round arches, supported by Renaissance pilasters and capitals, which divided the panels from one another. As a polyptych, the altarpiece employs a form which had been generally superseded in Florence many years earlier. In the thirties and forties, Fra Angelico, Fra Filippo, and Domenico Veneziano had drawn the saints together into a single undivided space, and together with this spatial unification, had introduced a psychological one.[44] The sacred figures now commune with one another in a much more explicit and overt manner, so that these altarpieces may be described as the earliest examples of the *Sacra Conversazione* in Italian painting. Piero's failure to keep pace with the Florentine development in this respect in the Sant'Agostino Altarpiece might conceivably have been due to ignorance of it; for, after a stay in Florence around 1439, this greatest of living Italian painters apparently never again returned, curiously enough, to that center. On the other hand, the new form had already been introduced before 1439 by Fra Angelico in the Annalena Altarpiece and by Fra Filippo in his panel for Santo Spirito. The conservatism of the design of the Sant'Agostino Altarpiece is probably explained by the fact that, as the document of commission states, the panels had been prepared at

* See the Postscript. In my original article, based on Milanesi's incomplete transcription which omitted the word "cognate" (see above, p. 87, extract and footnote) neither I nor my adviser, the Latinist Dr. E. Claflin of Columbia University, drew the right inferences about Giovanna, and we married her to Angelo after the death of his brother. In 1955 Mirella Levi d'Ancona (*The Frick Collection, An Illustrated Catalogue,* New York, XII, 1955, p. 65) and in 1961 M. Davies (National Gallery Catalogues, *The Earlier Italian Schools,* London, 2nd ed., 1961, p. 331 f.) rightly doubted this reading. They both proposed that the Frick saint would probably represent St. Simon rather than St. John. C. Gilbert, in his *Change in Piero della Francesca,* New York, 1968, p. 86 f., does not cite these prior observations, and even attacks the "inertia" of scholars for accepting an identification which had, as we have just seen, been challenged in the most obvious places.

the order of the patron before Piero signed the contract and perhaps, then, without his advice.*

In the case of the Perugia Altarpiece, which has Gothic frames, he must, I believe, have submitted to the wishes of the donors in selecting panels of this shape, or, more likely, he agreed to use panels which they already had on hand. He accepted, furthermore, other conditions which made the finished work, with its combination of Gothic and Renaissance forms, its two predellas (not shown in fig. 80), its varying depths, and its enormous "gable," the strangest and most puzzling altarpiece of the Quattrocento.[45] He attempted, however, to deny the compartmentation of space produced by the polyptych form by placing the saints at different depths and behind one another, by giving them a common floor on which to stand, and by extension of the base of the Madonna's throne into the wings.

Because Piero's work seems, on occasion, to be determined to an unusual extent by the requirements and conditions of a commission, one more difficulty is added to the problem of the chronology of his paintings. The Sant' Agostino Altarpiece must have been in every way a more consistent and more impressive work than the one in Perugia, partly because in the latter Piero, probably dissatisfied with the limitations imposed upon him, allotted a much greater share of the painting to assistants. Although the saints in the Sant'Agostino polyptych are each placed in a separate panel and not grouped two by two as in the partly subdivided wings of the Perugia Altarpiece, a greater spatial continuity behind the frames is achieved by the further development of several devices introduced into that work. The floor, as in the Perugia Altarpiece, is continuous, and the base of the Madonna's throne, which is larger and higher in our polyptych, extends further into the adjacent panels, overlapping part of the dragon and the foot of the Frick apostle. The spaces are, moreover, welded together by a beautifully designed low wall which rises behind the saints.[46] This form, which Fra Angelico had introduced on a smaller scale but for a similar purpose in his polyptych in San Domenico, Cortona, does not appear in the Perugia Altarpiece, where indeed its prominent horizontality would have contrasted too strenuously with the vertical movement of the Gothic frame. Although the saints of our polyptych show a

* Corti's transcript makes this explanation the most likely because it includes a phrase omitted by Milanesi: "Et ultra et(iam) dederu(n)t et assignaveru(n)t d(i)c(t)o mag(ist)ro Petro d(i)c(t)a(m) tabula(m) sic pinge(n)da(m) et ornanda(m) et figura(n)da(m), q(ue) est de tabulis c(om)posita(m) et laborat(am) de lignamine in d(i)c(t)a sacristia soluta(m) et facta(m) fieri et fabricari p(er) d(i)c(t)um Ang(e)lum sub d(i)c(ti)s i(n)tent(i)o(n)ib(us)."

greater freedom and individuality of movement than those in Perugia, they
are also part of a larger pattern which transcends the single panel. The
contour of St. Nicholas of Tolentino, who is a terminal figure, is firmly
closed at the right; his sleeve forms an arc which swings toward the left (i.e.,
the center of the altarpiece) and which is repeated, on a larger scale and with
more resonance, by the right contour of the apostle and by a large fold of his
drapery. The same motif is developed inversely on the opposite side of the
central panel by the arms of St. Michael. Furthermore, St. Nicholas is bal-
anced bilaterally to a greater extent than the apostle, whose pose and book
(which is shifted from the vertical axis of the panel) direct us decisively
toward the left. Space within the figures deepens as one passes from St.
Nicholas to the apostle, presumably climaxed by an even greater depth
within the central panel. This lateral progression toward the center of the
altarpiece is accompanied by a kind of ascension and by an increase in the
intensity of expression of the figures. The area of focus in the panel of the
apostle, who raises his book and lowers his head, is higher and more concen-
trated than in the panel of St. Nicholas.[47] The greater elevation is prepared
and enhanced by the diagonal relation of the forearms and hands of St.
Nicholas. A similar ascension, as well as an increase in depth, is developed in
the Perugia Altarpiece. In this work it is accomplished by the slightly greater
height of the two innermost saints and by relationships of hands and haloes.
The inclination toward the center, however, culminates not in the Madonna
and Child but in the beautiful half-dome of the throne. The Madonna ap-
pears, anticlimactically, below it. Her weary, uncertain pose detaches her
from it and from the design of the altarpiece as a whole. In the Sant'Agos-
tino polyptych, on the other hand, the large plinths raise the throne very
much higher, undoubtedly so that the central figures can appear at the apex
of movements generated in both wings of the altarpiece.[48]

　　As we have mentioned above, the Sant'Agostino polyptych shows a
higher and more consistent development of certain qualities of design than
the Perugia Altarpiece. The greater elevation of the central figures, the more
individual behavior of the saints, integrated at the same time into a pattern
embracing the entire altarpiece, tend to indicate that the Sant'Agostino polyp-
tych was designed later. Neither one of these altarpieces quite prepares us for
the remarkable work that Piero painted for the Duke of Urbino in the early
seventies. This altarpiece, now in the Brera (fig. 88), was not made for a

burgher or a church in a small Umbrian town, but for the prince of one of the most brilliant and cosmopolitan courts in Italy. In it Piero overleaped all intervening stages in the development of the altarpiece in Florence and created a new design which influenced profoundly the later history of the *Sacra Conversazione,* especially in the Venetian school.[49] The only earlier paintings which resemble it, so far as I know, are a fresco representing S. Giovanni Gualberto enthroned amidst saints and *beati,* painted by Neri di Bicci in San Pancrazio in 1454/5, and possibly reflecting a lost work by a greater master, and Fra Angelico's altarpiece for Bosco ai Frati, wherein this painter's usual canopied throne has been so greatly enlarged that it resembles the domed apse of a church. In the Brera Altarpiece Piero abandoned, in favor of a single rectangular panel, the polyptych form which he had pre-served for so many years—perhaps he *had* to abandon it if the Duke of Urbino, as donor, was to be represented in the same scale as the saints, and in a very prominent position—and he brought the Madonna, saints, and donor together in the crossing of a Renaissance church. For the first time in an Italian altarpiece a church is introduced as the setting for the Madonna and saints. The relation of the figures to the architecture is the reverse of the one that obtains in the Sant'Agostino polyptych, where the figures themselves tower like half-domes above a low wall which is introduced for the very purpose of enhancing their stature. The monumentality of the figures in the Brera panel is to some extent absorbed by the even greater monumentality of the church, and the new design involves, therefore, a partial loss of the heroic individualism of the saints of the Sant'Agostino polyptych.[50]

Despite the great differences in general design between these two altar-pieces, they are related in many ways—especially in the similar taste that informs the architecture, and the close resemblance between the wonderfully delicate details in the two works. The capitals are very similar, and the palmettes and other ornaments in the frieze of the polyptych reappear in almost identical form in the dome. These relationships, among others, sug-gest that the execution of the Sant'Agostino polyptych did not precede by a great many years the altarpiece for the Duke of Urbino.

The three extant panels of the Sant'Agostino Altarpiece represent men of different ages, and we cannot fail to be struck by the way in which Piero, whose style is distinguished by generalizations of various kinds, has charac-terized them, so that, beyond their other connotations, they suggest a cycle

typifying the ages of man. St. Michael is a youth. He is the most forthright
and the least complex of all three. He has just been victorious in a fight, and
he stands before us alert and tense, his head high in pride and defiance. St.
Nicholas also looks out at the spectator, but analytically and with reserve.
Carrying his large figure with quiet confidence and assurance, he represents a
successful man in middle age. The apostle is an old man. Unaware of his
audience and completely detached from the events around him, he stands
inactive, rapt in grave contemplation of the contents of his book.[51]

Partly, perhaps, in order to develop the characterization of St. Michael as
a militant youth, Piero has represented him in an unusual way. Instead of
showing the saint, in the traditional manner, with his lance in the mouth
of the dragon, Piero selected the moment just after he had cut off the head of
the beast. In one hand he holds the head, in the other the sword. This motive
for St. Michael seems to have been created in Tuscany in the fourteenth
century (fig. 83), probably on the basis of analogy with other figures such as
David (fig. 85) or even Perseus, who perform an act of decapitation and
display the head as a symbol of victory.[52] In this new type of St. Michael, the
lance is replaced by the sword, a shorter weapon with implications of a
struggle at closer range and of a more immediate physical contact. The saint
himself has hacked off the head, picked it up, and carries it as a trophy in his
hand. Piero has furthermore dressed the saint as a Roman soldier, with
cuirass and lambrequins, an armor which he introduced also in the battle
scenes at Arezzo and in other paintings.[53]

While each of the saints of the Sant'Agostino polyptych has a typical
character with respect to personality and age, one of them shows in a remark-
able way the tendency toward individualization and portraiture which
emerges in Piero's later style. In richness of physiognomical detail and depth
of expression, St. Nicholas is one of the most highly developed portraits that
had been painted up to that time in Quattrocento Italy (fig. 78). For a
comparable work of this or an earlier date, one must turn outside Italy to the
Netherlands, and particularly to Jan van Eyck. The resemblances between the
head of St. Nicholas and the portrait of Niccolo Albergati[54] or of Jan de
Leeuw (fig. 8) suggest the possibility that Piero may have seen and studied a
similar work by Jan. This possibility becomes more considerable not only
because of Piero's connection with the Duke of Urbino, who showed an
unusual interest in Flemish painting and who actually was said to have

possessed a panel by Jan van Eyck,[55] but also because other late works by Piero likewise contain forms that recall Jan's paintings.[56] Piero's panel formerly in Sinigaglia and now in the Ducal Palace at Urbino represents the Virgin and Child in a domestic interior, a setting for this group which was common in the North (figs. 16, 17).[57] The composition of the Brera Altarpiece (fig. 88) probably reflects Jan's paintings, especially the Paele Altarpiece of 1436 (fig. 19).[58] In the Brera panel, as in the *Sinigaglia Madonna,* the analysis of color and light, especially in the armor of the Duke and in the rich materials and precious stones—never before introduced in such number in Piero's work—draws his art still closer to that of Jan and his followers.

Similar coloristic and luminary refinements are evident in the Sant'Agostino polyptych—in the gleaming metal and glistening jewels of St. Michael's armor,[59] or the golden border of the apostle's tunic. These qualities, together with the portrait character of St. Nicholas and the form of the ornamental details of the wall, which we have discussed above, prove that the polyptych, which was contracted for in 1454, was for the most part painted in the sixties, not very much earlier than the Brera panel and the *Sinigaglia Madonna,* and around the time of the latest frescoes at Arezzo, which were finished by 1466. This is perhaps supported by the fact that, though the polyptych seems to be mentioned as a finished work in the document of 1469, Piero had not yet received all the money due him.[60]

The polyptych, furthermore, contains signs of the dissolution of that remarkable synthesis which Piero had developed in the fifties in such works as the *Meeting of Solomon and Sheba* (fig. 74), a synthesis based on Domenico Veneziano's method of designing in color and light, as well as on Masaccio's rationalization of space through perspective and Uccello's rationalization of form through stereometry. Piero combines values of color, light, and volume in a composition which unfolds planimetrically as well as spatially with equal density and richness. In his later paintings, certain of these qualities are developed at the expense of others, light and color design at the sacrifice of formal pattern. The figures are no longer woven into a complex interplay of volumes, but tend to be placed frontally, in a regular and almost monotonous alignment.[61] They become more massive and plastic, as though they were molded rather than painted, and the rhythmic movement of forms is diminished. The very even distribution of interest over the entire design of the earlier works is now modified by the emergence of

accented sections or details, and there is a tendency toward individualism of figure and what might be called particularism of object.

But through these changes Piero maintained his ideal of a composed and confident mankind, exalted by physical and intellectual vigor, and a firm will to move rationally through an intelligible world. Piero had inherited this vision from the great Florentines of the second quarter of the century; in the sixties, the time of the painting of the Sant'Agostino polyptych, it remained vivid for him alone. The world, as shown in painting, tended to become unfathomable or forbidding, and the people in it violent or pathetic, tense with melancholy emotion or mystical rapture.

Postscript

Although the principal hypothesis of this paper depended in considerable measure upon close observation of the surface of paintings in London and Milan that were inaccessible during the war I nevertheless decided, with youthful rashness, that the evidence provided by photographs was sufficient, and I consigned the text to the press. I was lucky.

First of all, when communication was re-established at the end of hostilities I learned that Roberto Longhi, in the second edition of his *Piero della Francesca,* the preface of which was dated 1942, briefly connected the three panels of saints with the Sant'Agostino commission. (Curiously, in 1943 I submitted another article to the *Art Bulletin* on the role of Masaccio and Masolino in the Brancacci Chapel, but in this case I withdrew it to await one more visit to Florence. The end of the war made accessible an article by Longhi on the same subject, with virtually the same division of hands—"Fatti di Masolino e di Masaccio," *Critica d'arte,* V, 1940.)

When infrared and X-ray photographs of *St. Michael* in London could be made, they confirmed the presence of two steps similar to those in the Frick panel, and thus proved the correctness of the reconstruction (see M. Davies, National Gallery Catalogues, *The Earlier Italian Schools,* London, 1961, pp. 428–433).

In 1947 Kenneth Clark completed the reconstruction of the side panels of the polyptych when he discovered the *St. Augustine* in Lisbon (fig. 87—see "Piero della Francesca's St. Augustine Altarpiece," *Burlington Magazine,* LXXXIX, 1947, pp. 205–209).

So far events fell out as predicted; but there was one surprise. X rays of the lower part of the London panel showed not only the steps but, on the lower one, some richly ornamented drapery which later cleaning uncovered (fig. 86). Furthermore, a band of blue drapery appeared along the right edge of the panel, at the level of the upper part of the parapet (see M. Davies, "Some Notes on Piero della Francesca's *St. Michael*," *Burlington Magazine,* CIX, 1967, p. 28 ff.). These details suggested to him that the subject of the central panel was not, as I had thought most likely, a Madonna enthroned, but a Coronation of the Virgin, as Professor Mirella Levi d'Ancona had suggested earlier (*The Frick Collection, An Illustrated Catalogue,* New York, XII, 1955, p. 63 ff.). P. Hendy, *Piero della Francesca and the Early Renaissance,* New York, 1968, p. 124, inclined to the same view. In the most thorough study of the entire problem E. Battisti, *Piero della Francesca,* Milan, 1971, II, p. 43 f., argued, persuasively I believe, for the improbability of a Coronation and the likelihood of a Madonna enthroned with two standing angels.

The cleaning of the damaged and repainted *St. Michael* and the discovery of the *St. Augustine* have proved there is a wider range of style within the polyptych than I could recognize in 1941. The saints to the right seem earlier, as most scholars believe, and the Frick panel may be the earliest of all.

Battisti's recent highly informative account of the altarpiece (*op. cit.,* p. 37 ff.) includes two new and interesting observations about the identity of the Frick saint. He favors John the Evangelist because Giovanna and Angelo were the two *living* donors. He agrees that the Frick saint *looks like* St. John (see above, p. 89 f.), and he adds that if the uncommon St. Simon were intended he would have been identified by an attribute or in some clear manner. Colors are not decisive indicators in an identification of this kind, but Gilbert (*Change,* p. 87 f.) disregards them entirely when asserting the complete similarity of a figure of St. Simon who wears a light (yellow?) mantle —a color St. Simon wears also in Nardo's fresco in the Strozzi Chapel and in Lorenzo Salimbeni's panel in the Pinacoteca, Sanseverino.

My article has been reprinted here without the two appendices. One was devoted to Milanesi's (incomplete) transcription of the documents, now superseded by Gino Corti's transcription, from which the essential passages have been extracted above, and by the entire texts printed by Battisti (*op. cit.,* II, pp. 222, 228). The discussion in the other appendix of the relation to the

altarpiece of three smaller saints then in the Liechtenstein and Lehman Collections was indecisive. I identified the saints in the Liechtenstein (now Frick) Collection as Augustinian, one as St. Monica and the other probably the Augustinian of Sansepolcro discussed in the article above, Beato Angelo Scarpetti (see also *Renaissance News,* IV, 1951, p. 28).

NOTES

1. This study was facilitated by an invitation of The Frick Collection extended to me and my graduate students at Columbia University to work, in the Collection itself, with one of the early Italian paintings. I wish to thank the Collection for this privilege and also for permission to reproduce the copyright photographs of the panel by Piero. Many of the problems which arose could not have been solved without the great resources of the Frick Art Reference Library. I am indebted for several valuable observations to two members of my class, Miss Morna Crawford and Mr. Charles Le Clair.

2. The panels in the Frick Collection and in London each measure 52¾ by 24½ inches (for the *St. Michael* in London, cf. *The National Gallery, Catalogue of Pictures,* London, 1921, p. 106). The panel in Milan measures 53½ by 23⅕ inches (1.36 by .59 m.; cf. *Catalogo del Museo Poldi-Pezzoli,* Milan, 1911, no. 598).

 All three of the panels were at one time in Milan. One is still there. The *St. Michael* was formerly in the Fidanza Collection in that city, and then in that of Sir Charles Eastlake (cf. *Catalogue of the National Gallery, loc. cit.*). When the third panel passed into the Frick Collection, it bore on the back a seal with the Austrian double eagle and a medallion in the center containing the letters FI (probably Francis I of Austria, 1804–1835). The incomplete inscription ADEMIA around the circumference of the shield can be completed, by comparison with similar shields, as G.R. ACADEMIA DI MILANO. A second shield on the back of the panel contains two oval cartouches surmounted by a count's coronet and on either side a small lion rampant. This has been identified almost certainly as the shield of a Spanish ducal entail, and although the charges on the dexter cartouche are almost entirely defaced, those on the sinister one belong to the Dukes of Cardona (eighteenth century). Just before the panel was acquired by the Frick Collection it belonged to the Von Miller family in Vienna (Molly, August, and Arthur von Miller owning it in succession). For this information on the history of the Frick panel, and for the identification of the shields, I am indebted to the Director of the Frick Collection, Mr. Frederick Mortimer Clapp.

3. Cf. R. Longhi, *Piero della Francesca,* London, 1930, p. 113; R. van Marle, *Development of the Italian Schools,* The Hague, XI, 1929, p. 86.

4. *Burlington Magazine,* XXIX, 1916, p. 162 n. 4.

5. G. Vasari, *Le Vite,* 1st ed. of 1550, republished by C. Ricci, Milan, n.d., II, p. 72; 2nd ed. (1568) edited by G. Milanesi, Florence, 1878, II, p. 493.

6. M. Vedova Pichi, *Vita di Piero della Francesca,* Florence, 1835, p. 20; L. Coleschi, *Storia della Città di Sansepolcro.* Città di Castello, 1886, pp. 179–180 (Coleschi says that Milanesi also believes the *Assumption* to be the work of Piero, but others gave it to Perugino); J. Passavant, *Raphael d'Urbin,* Paris, 1860, I, p. 394; E. Marini-Franceschi, *Piero della Francesca,* Città di Castello, 1912, p. 75.

7. *Il Buonarroti,* Serie III, vol. II, Quaderno V, 1885, pp. 141–142, and Serie III, vol. II, Quaderno VII, 1887, p. 218.
8. L. Lanzi, *Storia pittorica dell'Italia,* Venice, 1837, III, p. 152; G. Rosini, *Storia della pittura italiana,* Pisa, III, 1841, p. 38. Rosini referred the *Assumption,* quite correctly, to the school of Perugino, although he believed it to be the panel cited by Vasari. Milanesi himself, in a note in his edition of Vasari, published a few years before the documents (*Le Vite,* Florence, 1878, II, p. 493 n. 3), said that without the testimony of Vasari one would believe the *Assumption* to be the work of a follower of Perugino.
9. J. Crowe and G. Cavalcaselle, *A History of Painting in Italy,* ed. T. Borenius, London, V, 1914, p. 18.
10. The attribution to Francesco da Castello is accepted by U. Gnoli, *Pittori e miniatori nell'Umbria,* Spoleto, 1923, p. 120, and questioned by Van Marle, *op. cit.,* XIV, 1933, p. 450 n. 1. O. H. Giglioli, *Sansepolcro,* Florence, 1921, p. 52 calls the panel "Umbro-Tuscan." On Francesco da Castello, cf. also W. Bombe in Thieme-Becker, *Künstler-Lexikon,* VI, 1912, p. 150.
11. *L'Arte,* XIV, 1911, p. 53 and *Storia dell'arte italiana,* Milan, VII, part 2, 1913, p. 460 and fig. 349. L. Venturi, in *Piero della Francesca,* Florence, n.d., pp. 27 and 78, said that the *Assumption* was allocated to Piero but painted by others.
12. Borenius, *loc. cit.*
13. Except for the significant phrase quoted above, the documents speak of the work simply as a "tabula," a term used to designate an altarpiece of wood, whether or not it consisted of more than one panel.
14. Longhi, *op. cit.,* pp. 136, 140, 148, 157; W. Waters, *Piero della Francesca,* London, 1901, p. 50; F. Witting, *Piero dei Franceschi,* Strassburg, 1898, p. 4; also Van Marle, *op. cit.,* XI, 1929, p. 6.
15. Crowe and Cavalcaselle, *op. cit.,* V, 1914, p. 18 n. 2.
16. For the history of the Clarissans in Sansepolcro, cf. Coleschi, *op. cit.,* p. 179.
17. For the removal of the Augustinians, cf. Coleschi, *loc. cit.*
18. A wall of this character does not, of course, appear in any of Perugino's numerous representations of the Assumption, nor indeed in any of his works of whatever subject.
19. Venturi, *loc. cit.* The pose and expression of St. Louis in the *Assumption* also recalls Piero.
20. With the sole exception, so far as I know, of B. Berenson, *Italian Pictures of the Renaissance,* London, 1932, p. 455. The saint is also called Thomas Aquinas in the recent catalogue of the museum: F. Wittgens, *Il Museo Poldi-Pezzoli,* Milan, 1937, pl. 15.
21. Freiburg, i. B., 1926, pp. 558–559.
22. Cf., in addition to the very numerous Quattrocento representations of Thomas Aquinas, the collection of examples in P. L. Ferretti, *San Tommaso d'Aquino,* Turin, 1923. C. Künstle, *loc. cit.,* pp. 558–559, was troubled by the absence in the Milan figure of the typical Dominican habit, and attempted to account for it by claiming that the saint wears the robe of a professor. In addition to what is to be stated above about the dress, it should be observed that in the painting by the school of Fra Angelico which represents St. Thomas teaching (*Fra Angelico, Klassiker der Kunst,* 2nd ed., Stuttgart [1924], p. 151), the saint wears the Dominican habit. Künstle explains the leather belt by claiming that "St. Thomas" here wears the miraculous protective girdle which, according to the legend, was given to him by angels. This reference does not account for the specific form of the girdle, which is Augustinian.
23. Piero avoids black, and uses dark gray for this habit, as well as for other Augustinian habits which will be discussed later.

24. This habit was stipulated for the Order at the Chapter of 1256. Cf. E. A. Foran, *The Augustinians,* London, 1938, p. 169. T. Borenius, "Prof. Venturi on Quattrocento Painting," *Burlington Magazine,* XXIX, 1916, p. 162, said that the white lining of the cowl of the saint in Milan is unusual, but it seems, on the contrary, to be quite common in the representation of Augustinian monks.

25. Cf. R. P. Hélyot, *Dictionnaire des ordres religieux,* Paris, 1847, I, col. 294.

26. Cf. the polyptych by Giovanni di Paolo, Metropolitan Museum, New York; panel by Botticini, Academy, Florence (Van Marle, *op. cit.,* XIII, 1931, fig. 280).

27. Cf. Foran, *loc. cit.*

28. Cf. a late fourteenth-century fresco in the Eremitani, Padua, reproduced in *Revista d'arte,* XII, 1930, p. 360.

29. Nicholas died in 1306 and was canonized in 1446 (cf. Künstle, *op. cit.,* p. 464). Before the canonization, however, he was commonly represented with a halo (cf., for example, Taddeo di Bartolo, panel in the Palazzo dei Priori, Volterra).

30. Nicholas of Tolentino is usually represented in Augustinian altarpieces, but very rarely in altarpieces of other Orders.

31. The panel in the Frick Collection, like the other two extant panels of the altarpiece, has suffered considerable damage from the accidents of time and from repainting. Remarks on the present condition of the panels are made elsewhere in this paper, but any attempt at a precise account of the nature of the damage would necessitate a long and intricate description. It is useful to mention in the instance of the Frick panel, however, that very little original paint is left in the lower part of the wall behind the saint, and that only faint traces of the marble inlay between the pilasters are visible. Furthermore, the outermost molding of the upper frame of these inlays has at some later period been decorated with a continuous bead and reel motif which is carried over, and obscures, the abacus of both pilasters. In the figure, the most conspicuous area of damage and repaint is found in the horizontal folds of the mantle, just below the hands and the book.

32. In Piero's Misericordia polyptych in Sansepolcro, two figures extend from the central panel into the adjacent ones at the right and left.

33. I have not seen the panel itself since discovering these lines, and since the beginning of the war it has been completely inaccessible. The inked lines which appear in the reproduction (fig. 76, and also in fig. 77) have been made in accordance with the following scheme: unbroken lines represent lines which are in great part visible; lines composed of dashes represent lines which are only partly visible; the dotted lines are not visible at all. The dotted line representing the top edge of the upper block in fig. 76 (this edge is not visible in a photo of the panel) has unfortunately been inked in slightly too high.

34. Piero apparently preferred to work with an entire foot rather than a part, even though only a part would show in the completed painting. On the other hand, it is possible, though not likely, that he decided to introduce the plinth only after he had painted the figure of the saint.

35. This document has apparently not been preserved.

36. Giglioli, *op. cit.,* p. 4.

37. Cf. *Enciclopedia italiana, s.v.* "Angelo Scarpetti" (vol. III, p. 304); J. Lanteri, *Postrema saecula sex religionis Augustinianae,* Tolentino, 1858, pp. 60–61; and, most important, *Acta apostolicae sedis, commentarium officiale,* Rome, annus XIII, vol. XIII, 1921, pp. 443–446.

38. If there actually is a B preceding ANGELUS it might conceivably refer to Scarpetti. This B has not been included in previous records of the inscription (cf., for example,

The National Gallery, Catalogue of Pictures, London, 1921, p. 106). It seemed visible in a photograph of the painting, and in a courteous reply to my request for a rereading of the inscription a member of the staff of the National Gallery now quite independently reports its existence. [M. Davies, National Gallery Catalogues, *The Earlier Italian Schools,* London, 2nd ed., 1961, p. 428, states that infrared and X rays demonstrate only a decorative mark at this point. See the same author in "Some Notes on Piero della Francesca's *St. Michael,*" *Burlington Magazine,* CIX, 1967, p. 31.]

39. We know of no other commission for an altarpiece given to Piero by an Augustinian church.

40. This explanation of the LUCHA was tentatively proposed by Cavalcaselle (*Storia della pittura in Italia,* Florence, 1898, VIII, p. 274). Recently Longhi (*op. cit.,* p. 168) has stated that Berenson's attribution of a group of Madonnas to Signorelli's early years "may perhaps provoke a fresh examination" of this theory. The *Madonnas* in Boston, Oxford, and the Villamarina Collection in Rome which Berenson ascribes to the youthful Signorelli ("An early Signorelli in Boston," *Art in America,* XIV, 1926, p. 105), attributions which have been accepted by Van Marle (*Development of the Italian Schools,* The Hague, XVI, 1937, p. 5 and figs. 1–2), are certainly not all by the same hand, and should any one of them actually be an early Signorelli, then it would be just as difficult to attribute to him the St. Michael in London.

 The explanation of LUCHA which immediately presents itself is that it refers to the author, not of the painting, but of the phrase ANGELUS·POTENTIA DEI which precedes it. This phrase does not, however, appear in the most likely places, the Gospel of St. Luke or Acts. I should add that one passage in Luke, which was called to my attention by Prof. Meyer Schapiro, is often brought into relation to St. Michael and to the verses in the Apocalypse (12:7) which speak of Michael's struggle with the dragon. This passage is Luke 10:18–19.

 The letters LUCHA extend to the very edge of the right contour of the figure, and this suggests the possibility that the word is not intended to be complete, but contains additional letters rendered invisible by the revolution of the plane. What this word could be, however, is equally a puzzle.

41. The *Madonnas* in Oxford and Boston by followers of Piero (cf. Berenson, *op. cit.*) both show a wall with marble panels behind the figures similar to the one in our polyptych, and therefore probably derived from it. In the *Madonna* in the gallery at Modena painted by Cristoforo da Lendinara in 1482 (cf. Venturi, *Storia,* VIII₃, fig. 391), a painting clearly dependent in many ways on a late work of Piero, the throne is raised on a large, severely geometrical stone base, and is perhaps related in this respect to the lost central panel of our polyptych or to a similar late work by Piero.

42. He has sometimes been called St. Andrew (cf. Longhi, *op. cit.,* p. 168, and Witting, *op. cit.,* p. 138). Van Marle, *op. cit.,* XI, p. 88, identifies him as John the Evangelist. Piero's St. Andrew in the Misericordia Altarpiece wears a mantle and tunic of somewhat different colors. The mantle of the Brera saint is rose, the tunic green (the same colors are used for the Frick saint), and the tunic contains an ornamented border in both panels. The only notable difference between the two figures is that whereas the hairline of the Frick saint recedes deeply over the temples, the Brera saint has a bald pate. The identity of the saint in Milan might be solved if one could discover the patron saint of the Duke Federigo d'Urbino, or the saint under whose care he placed himself between 1470–1475. For the figure in the Brera panel, standing closely behind the Duke and looking down (though not directly at him), seems to show some special relationship with him. This hypothesis of a special relationship is perhaps strengthened if we recall the old opinion that this panel was an ex-voto of Federigo,

ordered on the occasion of the birth of a male heir and the death of his wife in 1472 (cf. L. Pungileoni, *Elogio storico di Giovanni Santi,* Urbino, 1822, p. 53). If this is true, then the Madonna and Child would contain a reference to the Countess Battista and her son, and the prominent position of the Baptist at the Madonna's right would be due to his relationship to the Countess Battista. The saint in the corresponding position on the right, who so closely resembles the Frick saint, would thus be the patron of the Duke.

43. For another example of St. John reading, see the altarpiece by Cossa in the Gallery at Bologna. As mentioned in note 42, Van Marle has identified as John the Evangelist the saint in the Brera panel who resembles the Frick figure.

44. Fra Angelico: Annalena Altarpiece, *ca.* 1435 (*Fra Angelico, Klassiker der Kunst,* 2nd ed., pl. 56); panel for the high altar of San Marco, now in the Museo di San Marco, *ca.* 1440 (*op. cit.,* pl. 144); altarpiece for Bosco ai Frati, *ca.* 1450 (*op. cit.,* pl. 172). Domenico Veneziano: altarpiece in the Uffizi, *ca.* 1445. Fra Filippo Lippi: panel for Santo Spirito now in the Louvre, 1437-*ca.* 1443. The new form is the product of an evolution which began in the later fourteenth century and in which even a non-Florentine painter like Gentile da Fabriano participated (cf. his panel in the Staatliche Museen, Berlin-Dahlem, which, however, contains recollections of the Gothic division in the two trees which separate the Madonna from the saints).

45. Some problems with respect to the present form of the Perugia altarpiece remain to be investigated. There is, however, evidence to prove that the *Annunciation* (but not in its present stepped-pyramid form?) was originally placed over the triptych, and A. Aubert ("Bemerkungen über das Altarwerk des Piero dei Franceschi in Perugia," *Zeitschrift für bildende Kunst,* N.F. X, 1898–1899, p. 263) and W. Weisbach (Review of W. W. Witting, *Piero dei Franceschi. Eine kunsthistorische Studie, Repertorium für Kunstwissenschaft,* XXII, 1899, pp. 72–77) have shown that the two predellas belonged to the altarpiece originally.

46. It is a curious and interesting fact that while Antonello da Messina's San Cassiano Altarpiece (1475) was influenced by Piero's Brera panel, his triptych in Messina two years earlier (1473) resembles Piero's Sant'Agostino polyptych in two ways: the platform of the Madonna's throne extends into the wings, and a continuous low wall rises behind the figures.

47. [Piero designed *St. Augustine* in Lisbon as a pendant to *St. Nicholas.* The verticals are emphatic, and the hands complete the symmetry of the diagonals.]

48. A thorough analysis of Piero's design, in all its complexity, lies beyond the scope of this paper. Certain forms—for example, the horizontal halo of the apostle compared with the inclined halo of St. Nicholas—function as counter-motifs to the patterns and rhythms which we have discussed.

49. For the influence of Piero's panel on the Venetians, and for comments on the development of the altarpiece in the Quattrocento, cf. J. Wilde "La pala di S. Cassiano," in *Jahrbuch der Kunsthistorischen Sammlungen in Wien,* N.F. III, 1929, pp. 70–72.

50. In this aspect of the design of the Brera Altarpiece is probably to be found the chief reason for the relative lack of interest in it of the Florentine painters, for the Florentines usually tend to subordinate the setting or environment to the figure.

51. This recalls Alberti's interest in typifying the demeanor of man at different ages: "Siano i movimenti ai garzonetti leggieri, jocondi, con una certa demostratione di grande animo et buone forze. Sia nell huomo movimenti con piu fermezza ornati, con belli posari et artificiosi. Sia ad i vecchi loro movimenti et posari stracchi, non solo in su due piè, ma ancora si sostenghino su le mani" (Leone Battista Alberti, *Della pittura,* ed. H. Janitschek, Vienna, 1877, p. 129).

"The movements of youths should be light, pleasing, with a certain show of high spirit and strength. The movements of man should be imbued with greater firmness, with graceful and practiced postures. The movements of old men should be weary, and they should support themselves not only on two feet, but also with their hands."

52. For a Trecento example of this type of Michael, cf. the beautiful panel by the shop of Orcagna in the collection of Mr. Philip Lehman, New York City (fig. 83). Cf. also St. Michael in a polyptych by Pietro da Montepulciano in Potenza Picena (Van Marle, *op. cit.*, VIII, 1927, fig. 161). For medieval and Renaissance representations of Perseus cf. Panofsky and Saxl in *Metropolitan Museum Studies*, IV, 1933, figs. 22–24c, and Jacopo Bellini's drawing in the Louvre (V. Golubew, *Die Skizzenbücher Jacopo Bellinis*, Brussels, 1908, II, pl. 44).

53. As Professor Erwin Panofsky has pointed out to me, the function of the shoulder straps of the Roman cuirass or *lorica* (cf. C. Daremberg-E. Saglio, *Dictionnaire des antiquités grecques et romaines, s.v.* "lorica") has apparently not been understood in the London panel. They do not (as in antiquity) support the *lorica*, which itself passes over the shoulders, but are merely metal bars affixed to it.

 Mr. Stephen Grancsay has kindly informed me that he believes that armor imitating the antique was occasionally made in the fifteenth century.

 Piero's St. Michael was imitated by Lorenzo di Alessandro da Sanseverino in a polyptych in the Pieve at Serrapetrona (cf. Van Marle, *op. cit.*, XV, fig. 29). Signorelli's paintings of St. Michael often followed Piero's example with respect to armor (cf. his altarpiece in the Uffizi, Van Marle, *op. cit.*, XVI, 1937, fig. 56, and in the Metropolitan Museum, Van Marle, *op. cit.*, XVI, fig. 32) and the Sienese painters of the late fifteenth century frequently adopted parts of it (cf. Neroccio, triptych in the Pinacoteca at Siena, Van Marle, *op. cit.*, XVI, fig. 161, and Pacchiarotto, triptych in the same place, Van Marle, *op. cit.*, XVI, fig. 285). The Florentines generally gave the saint armor of the usual contemporary form.

54. Indicative of the difference between an Italian and a Flemish painter—even when their styles seem to converge—is the fact that St. Nicholas resembles even more closely Jan's silver-point study for the painting (Dresden, Kupferstichkabinett), which contains less detail than the painting and in which the volumes are more prominent and the light and shade broader.

55. Vasari, *Le vite*, ed. Milanesi, Florence, 1878, I, p. 184: "Giovanni da Bruggia mandò al duca d'Urbino Federico II (sic!) la stufa sua." Cf. also on this panel W. Weale and M. Brockwell, *The Van Eycks*, London, 1912, p. 197 n. 1.

 Certain other Italian centers (especially Naples) were also interested in Flemish painting, but only Urbino, so far as we know, provided work for a major Flemish painter—Joos van Gent—for any considerable length of time. It is scarcely necessary to mention here the well-known fact that the hands of the Duke of Urbino in Piero's Brera panel were painted—or possibly repainted—by a master whose style contains many Flemish elements.

56. Stylistic resemblances between Piero and Jan van Eyck have been alluded to especially by Longhi, *op. cit.*, pp. 104, 117.

57. [Almost all of three paragraphs on the relation between Piero's late works and Flemish painting have been deleted because their content is contained in Chapter 2 above, within a larger context. My earliest discussion of this relationship, however, appeared in this article in 1941.]

58. Cf. also the Dresden triptych, and the Berlin *Madonna in the Church*, although in the latter, an early work, no saints are represented (fig. 6).

59. The golden inscription around the waist of the saint recalls the even more resplendent inscriptions on the figure of God in the Ghent Altarpiece.

In connection with these relationships between the late work of Piero and the style of Jan van Eyck, the resemblances of Piero's *Nativity* in London with the Portinari Altarpiece painted for Florence by Hugo van der Goes should be mentioned. The wide interval in Piero's *Nativity* between the frame and the figures, and between certain figures, recalls Hugo's panel. The child in the London painting is unusually small and infantile for Piero, and the way in which the Madonna's mantle is wrapped around her may perhaps be related to Hugo's painting.

60. [A marginal note in the document of 1469, transcribed by Corti, shows that Piero was owed some money after that date. Battisti, *op. cit.,* II, pp. 38, 228, agrees that, as I said above, the painting was completed.] Several students, including Milanesi himself, erroneously regard the payment of 1469 as a *final* payment. Cf. Milanesi, in Vasari, *Le Vite,* Florence, 1878, II, p. 493; Venturi, in *L'Arte,* XIV, 1911, p. 53; Crowe and Cavalcaselle, *Storia della pittura in Italia,* Florence, 1898, VIII, p. 203.

61. Cf. the Brera and Sinigaglia panels, and the *Nativity,* National Gallery, London.

6

Ovum Struthionis: Symbol and Allusion in Piero della Francesca's Montefeltro Altarpiece

Everyone familiar with the altarpiece by Piero della Francesca in the Brera has been fascinated by the egg that appears in the apse (fig. 88). Among all the forms in Quattrocento painting it is peculiarly attractive and enigmatic, like the smile of Mona Lisa. Hanging before the dark curve of the shell, it catches the warm light that flows into the church, and a segment of its receding surface that lies in shade is brightened by reflection from the white marble beyond. Though it is suspended on a slender chain, it looks rather like some small radiant meteor that has moved into the church and hovers, motionless, over the Madonna. It lies exactly on the central axis or, we might say, the meridian, of the picture, and its latitude is about midway between the top of the shell and the Madonna's head. The two vertical spaces that it thus measures are approximately equal to those that extend from the dais to the Child, from the Child to the Virgin's head, and from the top of the shell to the summit of the vault, so that, however small and free, it is firmly set in a system of five regular divisions.

The luminosity of the egg and its position in the painting give it a magnetic power, and this is enhanced by its geometric shape. It approximates

This paper, read before the Annual Meeting of the College Art Association in January 1952, was published after a considerable delay in *Studies in Art and Literature for B. da Costa Greene,* Princeton, 1954, pp. 92–101. A short "Addendum Ovologicum" appeared at the same time in the *Art Bulletin,* XXXVI, 1954, p. 221 f.; it has seemed preferable to add its contents at two points in "Ovum Struthionis."

in regularity those five bodies that Piero, adopting Platonic beliefs, conceived to be basic to all natural appearance. Its shape is in fact approached by the ovoid head of the Madonna and other figures, and it is echoed by the curvatures of the vault, the apse, and the circle of saints and angels below. At the same time the egg is a kind of equivalent of the Madonna and Child, for it is a central form enveloped by the vertically paneled wall of the apse as the Madonna is encircled by the surrounding saints and angels. For each mural panel, moreover, there is one figure. This broad correspondence of forms above and below is continued in details; the ridged scroll of the shell, for instance, resembles the banded cap of the Madonna. The entire composition is in fact divided vertically into two almost exactly equal parts, and one cannot escape the impression that in developing these two parts Piero was guided by the conviction expressed in his treatise that the visible objects of the world attain perfection on the level of geometric form.

The egg is a larger object than it at first appears to be, for, hanging in the recesses of the interior, it is much diminished by the perspective. Its actual height, calculable by the ratio of diminution of other forms in the composition—a calculation that is entirely legitimate in the case of so mathematical a painter as Piero—is around six inches.[1] [The following paper, p. 131, shows that the egg is still larger, eight and a half inches or even more.] The egg cannot then have been laid by a chicken. It is in fact too large for any bird except the largest of them all, the ostrich, whose eggs range from six to six and a half inches in length.[2] Many years ago, indeed, Schmarsow and Witting identified it as such,[3] though the suggestion seems to have escaped the more recent writers on Piero. The artist himself could undoubtedly have seen this goliath among birds, and presumably also its eggs, in several princely zoos. In the late fourteenth century one of these captive creatures served as a model for drawings by masters in the circle of Giovannino dei Grassi.[4]

But why should Piero have given so peculiar a prominence in his painting to the egg of this exotic bird? Its geometric shape was no doubt congenial and even profoundly meaningful. But neither shape nor philosophical content alone would have secured so prominent a place for an object in a Quattrocento church interior. The nature of fifteenth-century art would lead us rather to suppose that, as in the instance of the flames that Campin and Jan van Eyck liked to paint, or the fruits of Crivelli, there was a conjunction of enthusiasm for the object's form with interest in its Christian reference.

The ostrich egg was from early times an object of wonder and awe. In primitive cosmologies it symbolized the creation, and it served in burial customs in Mycenae, Latium, and Etruria.[5] The large eggs were given a part, too, in the Christian cult. They were preserved in church treasuries, and during the Renaissance as well as the Middle Ages actual or simulated specimens were incorporated in reliquaries.[6] Most important for our present purpose, they were suspended in churches (and also in mosques, where the practice persists to the present day).[7] Durandus, in the *Rationale divinorum officiorum*, tells us that "in some churches two eggs of ostriches and other things which cause admiration, and which are rarely seen, are accustomed to be suspended: that by their means the people may be drawn to church, and have their minds the more affected. Again, some say, that the ostrich, as being a forgetful bird, 'leaveth her eggs in the dust': and at length when she beholdeth a certain star, returneth unto them, and cheereth them by her presence. Therefore the eggs of ostriches are hung in churches to signify that man, being left of God on account of his sins, if at length he be illuminated by the Divine Light, remembereth his faults and returneth to Him, Who by looking on him with His Mercy cherisheth him."[8]

The egg of the ostrich, clear white, smooth, perfect in shape, and surprisingly large, always proved to be a source of wonder and delight.* It was taken to be a striking symbol of the cosmos and, more forcefully than less exotic eggs, it conveyed ideas of birth and rebirth. There were, in addition, three principal aspects of the relation of the enormous bird to its eggs that suggested other connotations. According to an influential passage in the Book of Job[9] the ostrich deposited its eggs in the sand and then left them (as it may actually do for a period during the heat of the day). This habit gave the bird an unfavorable reputation, sometimes stressed by quotation from Matthew 10:37: "He who loves father and mother more than me is not worthy of me."[10] Berchorius and, in the sixteenth century, Ripa compare with the ostrich those parents who do not love, or who abandon, their children.[11]

On the other hand this waywardness, mentioned also by Durandus, was balanced—and in the late Middle Ages overshadowed—by three positive aspects of the myth. First, the ostrich consults the heavens before laying eggs

* The following paragraphs have been revised by the inclusion of material published in the Addendum of 1954, by the reordering of the presentation, by the reattachment of a misplaced note and by the correction of the interpretation of an inscription in Eysenhut's block book, and by the addition of new evidence.

and it does not proceed until it can see the star Vergilius or the constellation
of the Pleiades (fig. 91). The Physiologus, the Bestiaries and Durandus say
that man, like the ostrich, should lift his eyes to heaven for divine illumina-
tion.[12] As an Italian Bestiary puts the thought, after a reference to the star
and to the eggs hatched by the sun, "Questo castruzo mostra che noi devemo
sempre levare li nostri ochi al zielo, laudando Dio. . . ."[13]

The other moral and spiritual qualities of the ostrich concern the hatch-
ing of its eggs. In the fourteenth century or earlier an anonymous writer said
that the large egg should be understood as Christ while the warm sand that
hatched it was the Virgin Mary.[14] More common was the belief that the eggs
were hatched by the sun—an occurrence that, as we shall see presently, was
interpreted as a simile of the miraculous birth of Christ effected by the True
Sun. The legend of the power of the sun was contained in the older versions
of the Physiologus, whereas the later versions from the thirteenth century
transferred this power to the bird itself. In other words, the ostrich hatched
its eggs merely by peering at them.[15]

Along with the legend of the sun this myth of the generative eyes entered
the encyclopedias of Vincent of Beauvais and of Albertus Magnus, although
the latter questioned its truth.[16] Beginning in the thirteenth century religious
poetry compared the miraculously effective glance of the ostrich with the
protective compassion of the Virgin or—elss frequently—Christ. Around
1275 Konrad von Würzburg formulated this simile vividly:

> mit der gesihte kan der struz
> sin eier schone brüeten:
> also wil uns behüeten
> din ouge erbarmekeite vol;
> uns armen ez bewachen sol,
> und ist entslozzen über uns.
> der güete und der genaden runs
> gat von dir, keiserinne wis.[17]

Konrad perhaps wrote his *Goldene Schmiede,* which was widely read, to
increase interest in the completion of Strasbourg Cathedral.[18] Although soon
afterward, in 1293, Hugo von Langenstein transferred the same simile to
Christ,[19] later poets followed the *Goldene Schmiede* in maintaining the asso-
ciation between the hatching of ostrich eggs and the Virgin Mary. Thus in
1455, in the *Goldene Tempel,* Hermann von Sachsenheim wrote:

Recht als der struss sin jungen
Git leben in der bruot,
Soltu mir synn und muot
Erwecken und enbörn[20]

In the religious treatises of the late thirteenth and fourteenth centuries
that coordinated events in the New Testament with types from the Old as
well as from ancient and natural history, the ostrich usually was given a
place. In the most widely diffused of these typological texts, the *Speculum
humanae salvationis,* the great bird, but not with its egg, appeared as a
symbol of salvation.[21] Two somewhat later treatises, however, agree in re-
turning to the theme of the eggs hatched by the sun and they present this
phenomenon as a type of the virginal birth of Christ. As far as we know, this
comparison was first made between 1351 and 1358 by Ulrich, abbot of the
Cistercian monastery of Lilienfeld, in his *Concordantiae caritatis.*[22] Ulrich,
quoting Isidore of Seville's description of the eggs laid in the sand and
hatched by the sun, construed the extraordinary event as a type of the Nativ-
ity, employing symbols reminiscent of the earlier Anonymus Trecensis cited
above.[23]

Half a century later Franciscus de Retza, in his *Defensorium inviolatae
virginitatis Mariae,* formulated the idea succinctly: "Si ova struthionis sol
excubare valet, cur veri solis ope virgo non generarat." Franciscus, a learned
Dominican friar who was professor of theology at the University of Vienna
and delegate to the Council of Pisa, intended his treatise to serve as a decla-
ration of the devotion of his Order to the Virgin Mary—a declaration that
was especially significant at a time when the Dominicans, contrary to the
Franciscans, bitterly opposed the idea of the immaculate conception of the
Virgin herself.[24] As an institutional document of this kind the treatise circu-
lated among at least the houses of the Dominican Order. Although only a
few manuscripts before *ca.* 1472 are known there seems to have been a
Netherlandish or Rhenish edition in block book about 1450,[25] which served
as the model for books of this kind published by Walther in Nördlingen in
1470 and by Eysenhut in Regensburg in 1471.[26] When movable type became
available the treatise was printed immediately, in 1475–1480 at Würzburg
and in four other editions before 1500, ranging from Speyer and Basle to
Saragossa. A French translation was printed at Rouen in 1514.[27]

Like the *Concordantiae* and the *Defensorium,* the other texts containing

the images of the natural sun hatching the eggs of the ostrich as a symbol of the *Sol verus* and the Incarnation seem all to have been written in northern Europe, and particularly in Germany, even though they were occasionally published elsewhere. Italian texts are conspicuously lacking; it is not clear, at the same time, that Italian literature has been studied in the same way as Northern. We do know, however, that the simile had crossed the Alps and was displayed south of the Brenner Pass, on the main thoroughfare between northern Europe and eastern Italy. The *Defensorium* is the subject of a group of frescoes in the cloisters of the Cathedral of Bressanone (Brixen), probably painted in the third quarter of the century. In one fresco the sun shines on three ostrich eggs while the mother bird gazes upon them (fig. 95). One of the eggs is hatching, as in the block book of Eysenhut (fig. 92), and indeed, apart from the presence of a true ostrich in the fresco instead of the goose in the woodcut, the two representations and their inscriptions are remarkably similar. They are undoubtedly related, perhaps through a common model.[28]

Although the legend of the eggs of the ostrich has not been shown to be prominent in late medieval Italian literature Italy provides evidence of another kind—evidence that, so far at least, is not paralleled in the North. The practice described by Durandus of hanging ostrich eggs in churches can be traced to the region in which Piero della Francesca worked. In the early fourteenth century some ostrich eggs were hanging over an altar in the very center of Florence. Among the records of the Baptistry there is the following: "1338. Ova di struzzolo pendenti sopra l'altare di S. Giovanni si rassettino e pulischino."[29] The symbols probably refer to the miraculous birth of the Baptist (Luke, 1).

Whereas in this instance the large eggs were hanging over the altar of the Baptist all but one of another series of records concern altars or chapels dedicated to Mary as the virgin mother of Christ. First of all, for the high altar of the adjoining Cathedral of Florence, we have the following records:

1445, Febbraio 27.
Angelo Nicolai degli oriuoli, i. VI s. III fp., sunt pro parte solutionis armature unius ovi marmoris pro contrapeso fiendo pro lanpadibus que retinentur ante altare maius. (Stanz., G, c. 77.)

1445, Aprile 23.
Angelo Nicolai degli oriuoli, i. LV fp., sunt pro resto sui magisterii in ornando unum ovum qui est ante altare maius. (Stanz., G, c. 81^t.—Cfr. B. serN., VI, c. 6^t.)

1447, Settembre 6.
(Spese minute apartenenti alla sagrestia deono dare) I. I s. XIII p. portò
Michelozo di Bartolomeo per raconciare l'novo (*sic*) dello struzolo all'altare
mag(i)ore portò chontanti. (Quad. di cassa, X, c. 7ᵗ.)[30]

Probably all these three records refer to one egg. Made of marble, it
served as a counterweight for the lamps hanging over the high altar. It was
undoubtedly fixed to the same rope or chain that supported the lamps, but on
the opposite side of the pulley from the lamps themselves. Thus it helped
balance the weight of the lamps when they were raised or lowered. Normally
it would hang at some distance above the floor, perhaps at the same height as
the lamps themselves. The fact that it served a practical purpose would
obviously not have precluded a symbolic meaning; such meanings were nor-
mally recognized in all objects used in medieval churches, including even the
wax of candles or of lamps which lacked so fixed and special a form as the
ostrich egg.[31]

The high altar of Santa Maria del Fiore was dedicated primarily to the
Virgin Mary.[32] The high altar of the Cathedral of Siena, likewise dedicated
to the Virgin, displayed an ostrich egg also—in fact, two of them. They were
described in the extraordinary records of the contents of the Cathedral that
we possess from precisely the period that concerns us. These records were
compiled at intervals from 1420 to 1482. No less than eleven detailed inven-
tories survive. Of these only one, of 1482, has been published in extenso; one
(1467) was translated into French long ago, and to a few I have not even
found a reference.[33] Each of the successive inventories is clearly related in
character and sequence to its predecessor, but frequently the wording varies.
Thus in the document of 1423 we read, at the end of the description of the
high altar, "e due huova di sturzo dinanzi per adornezza d'esso altare."[34] In
the inventory of 1435 this becomes: "et due huova di struzo dinanzi al detto
altare atachate ad alto."[35] The quality of "adornezza" ascribed to the egg
does not, of course, exclude symbolical meaning. In medieval texts, including
Durandus, even crucifixes and the vessels of the Mass were described as
"ornaments."

The texts always relate the eggs to the altar as a whole; they were "at-
tached above it"—possibly to the baldachin or canopy over the *Maestà* of
Duccio, which was the largest and most important object on the altar. They
were, in any event, hanging; the inventory of 1439 states: "et due uova di
sturzo pendenti. . . ."[36]

Dr. Wolfgang Lotz, whom I have discovered to be a fellow oologist, has kindly pointed out to me that an "huovo di sturzo" hung in another part of the Cathedral: "Uno huovo di sturzo cierchiato d'actone, attacchato da chapo dinanzi alla decta arliquera."[37] This chapel was apparently the left of the three in the sacristy, nearest the hospital, and the relic that was celebrated in the panels of the "arliquiera" in it, painted in 1412 by Benedetto di Bindo, was a sliver of the True Cross.[38] The egg, as a symbol of rebirth and resurrection, might have been associated with this relic, but we cannot be sure, for the chapel preserved also numerous other relics of the Virgin as well as of Christ.[39] Furthermore, the Virgin has a principal role in the two large frescoes in the chapel, painted around 1410–1412. They represent her image as intercessor carried in the procession of Pope Gregory during the plague and Augustus' vision of the Madonna in the sky—the Aracoeli.[40]

If there is some uncertainty about the connotation of the ostrich egg in the sacristy there can be none about two others in the Cathedral—not to mention the two hanging before the high altar. The inventories describe the contents of twenty chapels; two of these twenty were adorned with ostrich eggs.

> La chapella di sancto Sano. Uno altare con la tavola dipenta con l'Annuntiata di nostra Donna et due altre fichure dallato, cioè sancto Sano et sancta Margarita, . . . con un huovo di sstruzzo attachato a chapo detta chapella.[41]

> La chapella di sancto Vittorio. Uno altare con tavola dipenta della Natività di Christo, con due fichure dallato, . . . et uno huovo di ssturzo appichato sopra al detto altare.[42]

The altarpiece of the Annunciation was the one by Simone Martini and Lippo Memmi now in the Uffizi; the altarpiece of the Nativity, painted probably by Andrea di Bartolo in 1406, has apparently been lost.[43]

Although the other eighteen chapels were dedicated to the remaining patrons of Siena and to other saints, and the altarpieces represented scenes from the life of the Virgin and/or Christ, only the two associated with the Annunciation and the Nativity displayed an ostrich egg.[44] The connection with the Incarnation is thus clearly demonstrated. The presence or absence of the great eggs cannot be a coincidence; given the number of chapels, the mathematical chances for a random coordination are extremely slight. The pattern of distribution, determined by the dedication of the altar and the

representation on it rather than by the saint, thus conforms strikingly with the central symbolism of the ostrich egg that we have traced in texts. The eggs are usually emblems of exceptional hatching and birth, a sign in nature of the miraculous conception and birth of Christ.

Piero's panel in Milan is not the only Quattrocento painting that exhibits an ostrich egg, nor is it the earliest. A white ovoid object the size of an ostrich egg appears in Mantegna's San Zeno Altarpiece (fig. 96) and in several other North Italian *Madonnas* under Mantegna's influence, such as Benaglio's in San Bernardino, Verona and Butinone's at Isolabella (fig. 97). The egg appears also in Montagna's *Madonnas* in the Brera and in the Museo Civico, Vicenza, Fogolino's in Amsterdam (fig. 108) and Buonconsiglio's in Vicenza.[45] In the earlier of these paintings the building in which the egg is suspended is not actually a church; it is a kind of aedicula, as in the San Zeno Altarpiece, or a portico or an arch. The relationship of the egg with the Madonna is not as pointed as in Piero's panel because it is fixed just above a lamp and because it is in some instances surrounded by objects of similar shape and texture—fruits, such as lemons and apples, vegetables (chiefly squashes, gourds, and cucumbers), pearls, and wooden or glass beads. In fact, in these paintings the egg takes its place as one of the globular forms, hard, polished, and brightly colored, which are characteristic of many styles of the third quarter of the Quattrocento, particularly in Padua and Lombardy. Like the egg, several of these objects convey, at the same time, symbolic meanings. That the ostrich egg in Mantegna's San Zeno Altarpiece may have some special connection with the Madonna and Child is indicated by the fact that in his *Madonna della Vittoria* in the Louvre a coral charm is similarly suspended over their heads.

In two North Italian paintings the context of the ostrich egg varies from that of the preceding group of Madonnas. In a painting by Marziale in the National Gallery in London the egg and the lamp appear above the Infant Christ, with Mary alongside, but in a scene of the Circumcision.[46] In a Ferrarese painting in San Petronio, Bologna, sometimes ascribed to Ercole, the egg alone hangs over St. Jerome—author of a highly influential text on the Virgin Birth.[47]

No relation to this subject can be discerned in three other paintings. In an altarpiece of S. Bernardino in the Brera from the immediate circle of Mantegna, dated in the sixties, a comparatively small egg is fixed to a lamp that

hangs over the head of the saint.[48] A curious picture by Vittore Carpaccio in the Academy in Venice (fig. 101) relates a vision of Francesco Antonio Ottoboni, prior of Sant'Antonio di Castello in Venice. The prior, while kneeling before an altar, sees the martyrs of Ararat, each carrying a cross and moving in procession into his church. The building, which was destroyed in 1807, is represented in great detail. Three large ship models appear high above the floor, and the altarpieces are so carefully described as to be precisely datable. On the rope supporting the largest lamp, which hangs in the center of the nave, is suspended an enormous ostrich egg, much as in the Mantegnesque paintings discussed in the article. There are five additional eggs, somewhat smaller but no doubt intended as those of an ostrich, on another lamp hanging in the nave. This lamp, which is exceptionally heavy, is suspended from a winch that facilitates lowering when additional oil was required. The winch is operated by a rope that is tied around a column. Lamps of less weight were customarily suspended from a pulley, as in Montagna's large altarpiece in the Brera.

The half-dozen eggs fixed to the lamps are apparently not the only ones visible in this church. They are rounded out almost to an even dozen by those hanging from the *parco* or nave screen along with other votive offerings.

An ostrich egg is fixed to each of the lamps hanging in the church painted by Lorenzo Lotto *ca.* 1523–31 in a predella of his altarpiece now in the Pinacoteca at Jesi (fig. 104). Others hang among the votive offerings around the tomb of St. Agatha. Like the votive eggs in Carpaccio's picture and, indeed, like Piero's, they are unmounted and are suspended on cord, a chain or wire.[49] This display reminds us of the document describing the sale of ostrich eggs as offerings just outside the church of Notre-Dame in Paris.[50] The ostrich egg that appears in the frescoes in the Cappella di San Brizio in the Cathedral of Orvieto must again have another meaning (fig. 102).[51] Hanging in the embrasure of the arch over the window, below Christ in the *Last Judgment,* it may well refer to Resurrection.

Like many other objects that appeared frequently in churches and in art the egg of the ostrich served several purposes and embodied several meanings. In all of them there lurked wonder at its size and delight with its color and shape—in other words, an aesthetic response.[52] Comparative rarity, too, was part of its attraction. When fixed to the rod or chain supporting a lamp it may have served a practical function: to keep rodents away from the oil.

Often it was accompanied, however, by a flat disk that was equally effective, and the consistent use of the egg as a deterrent of rodents is sometimes still more decisively denied by the insertion over it of simulated leaves that facilitate rather than prevent access to the oil (fig. 108).[53] One document, concerned with the marble egg over the high altar of the Cathedral of Florence, ascribes to it, as we have seen, the function of counterweight to the lamp. This practical purpose, however, does not exclude religious connotations any more than it would in the instance of the lamp itself. Lamps, of course, not only provide necessary light in dark spaces but they, and even each of their parts, bear symbolical meanings.[54] Durandus said: "The lamp in the church is Christ. . . . Or the light in a church may denote the apostles and other doctors. . . ."[55]

Hanging in the churches the large eggs were intended to increase the attendance, please the curious, remind them of divine mercy and encourage them to return to the *via veritatis*. Sometimes the eggs referred more specifically to the compassion of Christ, but more often of the Virgin. Occasionally, as in the Orvieto fresco, they seem to refer to rebirth or resurrection, or they are associated, for reasons not clear, with a saint. Most often, however, in both texts and practice the ostrich eggs conveyed ideas of the miraculous conception and birth of Christ.

The egg in Piero's altarpiece, hanging in a small church above the Virgin and Child, thus conforms with the central tradition of the object's symbolical meaning. Symbols always acquire a precise and full range of significance in a specific context. At the same time Piero, more than any other painter, delighted in the play of light on the smooth, white shell, and we understand fully why he would not have wished to interrupt the regularly turning planes by a metal mount nor by attaching it to a lamp. Thus it was partly for visual pleasure that Piero gave the ostrich egg a special prominence, but we should inquire, nevertheless, whether it does not have additional connotations, related especially to the donor.

The ostrich itself, first of all, was an emblem of the Count (from 1474 the Duke) Federigo, who is present in the painting. It inhabits friezes in Federigo's palace or the borders of manuscripts illuminated for him, (fig. 94) standing proudly, bearing in its bill a horseshoe or sometimes an iron nail or an arrowhead.[56] Here the bird exhibits quite another distinction: it was generally believed to be a sort of avian sword swallower, capable of digesting

metal (fig. 93).⁵⁷ Princes frequently selected it as an emblem because of this exemplary *spiritus durissima*. They also valued it for its feat of hatching eggs by peering at them, which signified the ability of a leader to inspire his followers by word and look.⁵⁸ Leonardo noted the belief that the ostrich was "for armies, the food of commanders. It extracts nourishment from iron; hatches eggs by its gaze."⁵⁹

The egg in Piero's panel is thus the egg of a Federican bird, and, like the bird, it may have a personal meaning. It is in fact only one of several forms that suggest that the painting was inspired by two of the most important events in Federigo's life, the long-awaited birth of a son and heir, and the death of his wife, to whom he was deeply attached, some six months later.⁶⁰ Federigo and Battista Sforza were married in 1460, and in the succeeding decade Battista had borne eight daughters. With each successive feminine arrival, anxiety and disappointment grew sharper at the court of Urbino, until in 1471 the desperate Countess offered her life in return for a son. She went to Gubbio to pray to St. Ubaldo, patron of the city. While there she dreamed of another bird, a phoenix. After perching in a tree for thirty-six days it flew up to the sun and disappeared in flames.⁶¹ Shortly afterward Battista conceived, and late in January 1472 gave birth to a son—named in recognition of the intervention of the saint, Guido Paolo Ubaldo. On July 6th, not long after the prophetic dream and the celebration of the birth, the Countess died.*

The ostrich egg, symbol of a supernatural birth, may perhaps allude to the exceptional, and in the eyes of contemporaries, not wholly natural birth of Federigo's son. The egg may also refer, as it frequently did, to a departed, though not in this instance an indifferent, mother, and to one (the Count) who forgets the past, "reaching forth unto those things that are before."

The Count does not appear in the place of honor at the Virgin's right, the usual position of the donor, but at the left, an arrangement that is perhaps due to the desire to conceal the injured right side of his face, as in all the large surviving portraits of him. Battista is not represented. This devoted wife, who administered the state during Federigo's frequent absences, and whom he described as the "beloved consort of my fortunes and domestic cares, the delight equally of my public and private hours," would almost

* I have deleted here a statement about the place of burial of the Countess, which I corrected in 1966 (see p. 136).

certainly have appeared in the painting if she had been alive. A few years earlier indeed she was portrayed at her husband's side in Piero's famous diptych.[62] It is highly significant that the foremost figure on the right or "good" side of the Madonna, opposite the Count, is not the patron of the church, but her own, St. John the Baptist. He corresponds moreover to the bearded saint, probably an apostle, who stands immediately behind the Count and looks down toward him as though he were his patron.[63] The altarpiece was intended to honor, then, the Countess.

The Christ Child lies across the Virgin's knees, asleep. The motif of the sleeping Child has recently been interpreted, in an interesting study by Miss Gizella Firestone, as a prefiguration of the death of Christ.[64] Her claim that in some paintings and sculptures the slumbering Child alludes to the dead Man is undoubtedly correct. The image is thus occasionally a kind of Pietà-Madonna. Miss Firestone's inference, however, that this meaning must inhere in all instances seems quite doubtful, and there is good reason to question her limitation of the expressive character of the theme to the simultane-ous representation of death. We are given pause, first of all, by the early history of the image. It was apparently introduced in Italian painting around 1400, at a moment then of a widely diffused taste for lyric expression. This is the period when the Madonna is first placed in a garden, or when she fre-quently gives the Child a flower, or when for the first time the Infant is laid prone in her lap (Gentile da Fabriano, Pisa). Is it not probable that the delicate sentiment, the idyllic mood of much of the art of the time inhere also in the relaxed slumber of the Child, and are an essential reason for its representation?

These lyric qualities, moreover, are most highly developed in the Veneto, and it was in this region that the sleeping Child seems to have been first introduced. There too it quickly became most popular.[65] The motif was rare or completely absent in Tuscan Quattrocento painting, and uncommon in Tuscan sculpture. It would seem to correspond then to a specific taste and to a certain ideal of life and beauty. In a panel by the Venetian painter Jaco-bello del Fiore, not Christ but the Virgin lies asleep, in the lap of St. Anne of course.[66] And it was after all in the same center that painters were fond of representing still another and wholly unrelated figure, Venus, recumbent (Titian) or even asleep (Giorgione). These paintings convey the serenity, the luxuriousness, the mystery of sleep, and there is a related lyricism, like-

wise without any allusion to death, in a poem on the sleeping Christ Child by Jacopone da Todi, written more than a century before the appearance of the image in painting:

> Andiam tutti a vedere
> Jesù quando dormia.
> La terra, l'aria, il cielo
> Fiorir, rider facía:
> Tanta dolcezza e grazia
> Dalla sua faccia uscía.[67]

A second poem attributed to the same writer contains similar sentiments, describing tenderly the relation of mother and infant:

> Quando un poco talora il dì dormiva
> E tu destar volendo il paradiso,
> Pian piano andavi che non ti sentiva,
> E la tua bocca ponevi al suo viso,
> E poi dicevi con materno riso:
> Non dormir più che ti sarebbe rio.[68]

> (When at times by day he slept a little,
> And you wishing to awaken paradise,
> Moved slowly so that he did not hear you,
> And you touched your lips to his face,
> And then you said with a mother's smile:
> Don't sleep longer because that would not be right.)

A somewhat different thought is expressed in a poetic invocation to the Madonna written below Cosimo Tura's *Madonna* in the Museo Civico, Venice (fig. 99), one of two inscriptions that I know on a representation of the sleeping Child, in Quattrocento painting at least. It reads: SVIGLIA EL TUO FIGLIO DOLCE MADRE PIA PER FAR INFIN FELICE LALMA MIA (Wake your son, sweet compassionate mother, to make my soul finally happy). Slumber is human, the invocation implies, and during it the divine consciousness is suspended. Only if the Child is awake will the process of redemption unfold. The ultimate sacrifice desired by the speaker, but not approximated while the Infant sleeps, is signified by the bunches of grapes which hang at either side of the Madonna.

A related inscription may be read in a *Madonna* painted by Neri di Bicci

which shows the Virgin and two angels holding a transparent veil above the sleeping Infant (fig. 103).[69] In the Child's hand there is a scroll on which is written: EGHO DORMIVI ET CHOR (M)EU(M) VIGILAT. Part of the same inscription—COR MEUM VIGILAT—appears on another painting of the sleeping Child, a sixteenth-century Italian picture, whereabouts unknown.[70] The sentence written in these two paintings is drawn from the Song of Songs 5:2. It is usually interpreted in the Middle Ages to mean a withdrawal from the world through sleep so that the mind may contemplate God.[71] In the paintings, where it is explicitly Christ who speaks, the words must have a special connotation. Despite sleep Christ, the Good Shepherd, is vigilant. The reference to salvation which is explicit in Tura's panel seems implied in Neri's as well.

All of this proves then that for the late Middle Ages and the early Renaissance the figure of the sleeping Child had a considerable range of meaning. At times it was primarily lyrical, at others funereal. Occasionally it alluded to redemption and to that problem with which the Quattrocento was so greatly occupied, the relationship, or rather the coexistence, of the human and the divine. Whatever the Christian connotations of the posture in Piero's painting, its use may be bound up with the increasing divergence of the painter's late work from Tuscan taste and its approximation to Flemish and to Venetian. Clear evidence of this tendency in the Brera panel is the introduction of the church, a wonderful monumental form that envelops the figures and to some extent absorbs their own breadth, weight, and gravity. It is significant that this ecclesiastical setting, probably suggested to Piero by a work of Jan van Eyck, became very popular in Venice, whereas the Florentine painters rejected it.[72]

Formal preferences alone, however, scarcely seem to account for the slumber of the Infant, and still less for His informal, sprawling position. In Piero's works above all others in the Quattrocento the Christ Child is grave, poised, portentous, no less than the adults. It seems therefore not improbable that the Child asleep in His mother's lap alludes to the occasion that the painting commemorates—the birth and the infancy of Federigo's son and heir. The Child, too, is very closely connected with the Count. His body, together with Federigo's forearms and hands, form the only prominent diagonal in the design.

Allusions of this sort may at first seem exceedingly bold and even im-

probable to us, but already in the Middle Ages religious representations were
invested with personal meanings, and they would not be exceptional in a
painting of the late fifteenth century. Within the work of Piero himself the
Monterchi *Madonna* would seem to have been affected by the associations for
the painter of the site for which the work was made—the unusual image of
the pregnant Mary in the chapel of the cemetery of his mother's town. As
early as 1427 Michelozzo, developing Trecento precedents, had permitted the
Madonna and the Christ Child to become wholly engrossed with Bartolomeo
Aragazzi, a papal chancellor who was still living when Michelozzo made the
relief as part of his tomb (fig. 90).[73] The Virgin puts her hand on Aragaz-
zi's head, and the Child looks gently and rather shyly at him. The man
standing behind the chancellor and resting one hand on his shoulder is not,
as one would expect, a sponsoring saint, but an older relative; and on the
opposite side of the Madonna there are, instead of saints, other members of
Aragazzi's family. This kind of intimacy between laymen and the cult figures
led in the course of the Quattrocento to a fusion of the two; in short to
impersonation.

More closely related to Piero's altarpiece is the fresco by Ghirlandaio in
Santa Trinita, Florence (fig. 89). Part of a cycle of the legend of St. Francis,
it represents in the middle ground the papal confirmation of the rule of the
Minorite order. In front of the Pope stand Francesco Sacchetti and Lorenzo
de'Medici. They face a number of figures mounting a flight of stairs: Angelo
Poliziano and the sons of Lorenzo, followed by Luigi Pulci and Matteo
Franco.[74] The action in this foreground group is quite parallel to that in the
middle. Just as the Pope, presenting the scroll to Francis, accepts and institu-
tionalizes his teaching, Lorenzo's gesture sanctions the activity of Poliziano as
scholar, humanist, and tutor of his children. The two realms, of religion and
of the newer profane art and learning, are set side by side; the Pope presides
over one, Lorenzo over the other. Thus events in the contemporary world
that in Piero's painting remain masked, conveyed by symbols and unobtrusive
formal devices, are here the subjects of a separate action. Indeed, in Ghirlan-
daio's remarkable painting they are allotted the foreground, and the sur-
rounding environment—the Piazza della Signoria—is that of Lorenzo rather
than the Pope, so that it is difficult to say which event is the primary one in
this fresco—the religious or the secular. Within the oeuvre of Piero himself
there may be a related work, the enigmatic *Flagellation* in Urbino. Neither
the identity nor the significance of the three men standing in the right half of

this painting is clear, but their formal interrelationship suggests a comparison with the whipping of Christ, so that the panel, like Ghirlandaio's fresco, may have been intended as a simile.[75] The Brera Altarpiece, on the other hand, is a kind of metaphor.

Our interpretation of Piero's painting implies that it was actually executed shortly after the birth of Guidobaldo and the death of Battista in 1472. This can be corroborated by evidence of another kind. It is generally agreed that the style of the work places it in the seventies.[76] We can, I believe, fix a precise *terminus ante quem.* Federigo was elected a Knight of the Garter on August 18, 1474, and he was invested in the autumn.[77] In September of that year the King of Naples made him a member of the Order of the Ermine. Federigo wears the badge of the Garter on his left knee in both the large portraits painted after 1474—the panels in Windsor and Urbino (fig. 100). In the latter he wears the collar of the Ermine also. In the Brera Altarpiece, however, the Count wears neither of these insignia, nor indeed any of the others he received in 1474. The panel must therefore have been completed before this year.

We have already found good reason to believe that the work was painted after the death of the Countess in 1472. It is true that in all the major representations of the Count made after the birth of Guidobaldo in January 1472 he is accompanied by his son. The child appears at successive ages: in the arms of a nurse in Joos van Gent's picture of the Communion of the Apostles, kneeling before his father in the *Deposition* in the Carmine, Venice,[78] standing in the Urbino panel (fig. 100), or already constrained to attend a lecture in the picture by Joos in Windsor. The absence of Guidobaldo in Piero's altarpiece would thus provide us with an exceptional case that might even challenge our hypothesis of date, were it not that in this painting, presumably the first to be executed after the child's birth, the sleeping Infant Christ seems to allude to him. We may conclude then that the altarpiece was very probably begun shortly after July 6, 1472, and it must have been finished by the autumn of 1474. We hope that it is not unjustifiable to conclude also that oology may qualify as a branch of iconology.

Postscript

Isa Ragusa discussed instructively a pendant ostrich egg in a fresco in San Francesco, Lodi, which she believes, rightly I think, supports the identifica-

tion of Piero's object as an egg of the same bird ("The Egg Reopened," *Art Bulletin,* LIII, 1971, pp. 435–443).

C. Gilbert, in " 'The Egg Reopened' Again," *Art Bulletin,* LVI, 1974, pp. 252–258, reasserted his conviction that the egg is probably Leda's—an opinion he had already advanced in 1952 and 1954. Since even now he offers no prior Christian tradition for this interpretation I am not more tempted by it than when long ago I wrote note 3. I have commented negatively on two of his basic objections to the ostrich egg in the *Art Bulletin,* March, 1975.

New paragraphs (so designated) in the present text contain additional evidence, important I think, in support of my original hypothesis. These paragraphs also serve—with the entire original text—to disprove, or to render very unlikely, Gilbert's specific interpretations. I wish, however, to acknowledge his correction of my original interpretation of an odd inscription in the *Defensorium;* and I created ambiguity by allowing the original note 13 to ride through attached to an immediately following sentence.

N O T E S

1. Several methods of calculating the actual size of the egg yield approximately the same results. I shall cite one. When the present height of the egg is 3.2, the dentils on the wall of the apse nearest it and parallel to the picture plane measure .7, the dentils in the transept are 1.1 or 1.2, and those in the nave 1.7. Thus in the plane of the last named, the egg would be more than 7.7. This is .8 of the height of Federigo's head, which measures 9.5. Now the ratio of the head to the total height of the figure in the late work of Piero is around 1 to 7⅗; and if we assume for Piero's figures an actual height of 5′ 5″, the height of the head is 8½ inches. Even after allowing for slight spatial discrepancies between the egg and the farthest dentils on the one hand, and the head of Federigo and the nearest dentils on the other, the actual height of the egg can scarcely be less than 6 inches. [The reconstruction of the space undertaken in the subsequent paper—p. 131—proves that the head of the Count is much nearer than the dentils to the beholder.]
2. I am indebted for this information to Dr. Dean Amadon of the American Museum of Natural History. It seems safe to exclude the emu, which produces eggs of similar size, because its habitat is Australia.
3. F. Witting, *Piero dei Franceschi,* Strassburg, 1898, p. 136; A. Schmarsow in *Abhandlungen des phil.-hist. Klasse der Königl. Sächsischen Gesellschaft der Wissenschaften,* XXIX, 1912, p. 119. In response to my questions, Meyer Schapiro independently suggested the egg of an ostrich.
 In an article published while this paper was in the press, Mr. Creighton Gilbert identified the egg as Leda's, laid after her union with Zeus. This event, the author says, prefigures "the Immaculate Conception of Christ," though for this interpretation he presents no Christian tradition ("On Subject and Not-Subject in Italian Renaissance Pictures," *Art Bulletin,* XXXIV, 1952, pp. 208–211).

4. Biblioteca civica, Bergamo (R. van Marle, *Development of the Italian Schools,* The Hague, VII, 1926, fig. 39) and Biblioteca Casanatense, Rome (*op. cit.,* fig. 33).

5. See O. Keller, *Die Antike Tierwelt,* Leipzig, 1913, II, pp. 168–169. For a Mycenaean specimen see V. Staïs, *Collection Mycénienne du Musée National,* Athens, 1915, pp. 70–71 (kindly called to my attention by W. B. Dinsmoor).

6. See J. von Schlosser, *Kunst- und Wunderkammern der Spätrenaissance,* Leipzig, 1908, pp. 13, 61, and figs. 8, 50. [Also J. Braun, *Die Reliquiare des christlichen Kultes und ihre Entwicklung,* Freiburg i.B., 1940, p. 129 f. Braun observed that not all the os- trich eggs listed in the inventories were parts of reliquaries; some served as a "Schmuck- stück," a term which does not exclude symbolical meaning.]

7. J. M. Neale and B. Webb, *The Symbolism of Churches and Church Ornaments,* London, 1906, p. 62 n. 94. The authors surmise that the practice was introduced in the West by the Crusaders. See also W. R. Lethaby, *Architecture, Mysticism and Myth,* New York, 1892, p. 254 ff.; F. W. and M. M. Hasluck, *Christianity and Islam Under the Sultans,* Oxford, 1929, I, p. 232 f.; and R. Pococke, *A Description of the East,* London, 1743, I, p. 31. Curiously enough, in at least one instance the Islamic interpre- tation of the nature of the ostrich is just the opposite of the Christian. The vital nucleus of the egg would die, it was held, if the ostrich averted its eyes from it. Thus the egg is suspended in the mosque as a reminder that the faithful must keep their eyes and minds fixed on the true goal. See X. Marmier in *Revue des deux mondes,* XVII, 1841, p. 756.

8. Durandus, Bk. I, 43, in the translation by Neale and Webb, *op. cit.,* p. 62 f.

9. "Gavest thou the goodly wings unto the peacocks? or wings and feathers unto the ostrich? Which leaveth her eggs in the earth, and warmeth them in the dust, and for- getteth that the foot may crush them, or that the wild beast may break them. She is hardened against her young ones, as though they were not hers. . . ." (39:13–16.) See also the *Etymologies* of Isidore of Seville (Migne, *Pat. Lat.,* LXXXII, col. 461).

10. See F. Lauchert, *Geschichte des Physiologus,* Strasbourg, 1889, p. 131.

11. P. Berchorius, *Reductorium morale,* Antwerp, 1609, p. 219 (Bk. VII, Chap. 69); C. Ripa, *Iconologia,* Siena, 1613, II, p. 99 (s.v. *Oblivione d'Amore verso i figliuoli*).

12. M. Goldstaub, "Physiologus-Fabeleien über das Brüten des Vogels Strauss," in *Fest- schrift Adolf Tobler,* Braunschweig, 1905, p. 153 ff., esp. pp. 156, 160; Lauchert, *op. cit.,* p. 38. See C. Cahier, *Mélange d'archéologie,* Paris, 1853, III, p. 257; M. R. James, *The Bestiary,* Oxford, 1928.

13. *Ein tosco-venezianischer Bestiarius,* ed. M. Goldstaub and R. Wendriner, Halle, 1892, p. 57 f.

14. "*Oblitus fuisse videbatur Deus generis humani.* Notandum: struthio ponit ova sua sub arena, et ibi obliviscitur: calefacta calore solis, fervor iste ova sua exocoquit, et ex eis pullos procreat et educit. Sic spiritualiter: Deus primos parentes et posteritatem eorem, sicut quædam ova, produxit, quorum, propter peccatum eorum, quasi oblitus fuerat. Sed unum ipsorum, quod fuit absconditum sub arena uteri virginalis, fuit. Virgo Maria optime figuratur per arenam, quia sicut arena est sicca, sic ipsa exsiccata ab omni humore peccati; et sicut quanto plus depluitur, tanto plus deprimitur, sic beata Virgo Maria, quanto plus de pluvia gratiæ recepit, tanto fuit magis depressa per hu- militatem. Istud ovum quod fuit absconditum in utero virginis fuit sanctum corpus Christi, quod ex calore Spiritus sancti in hominem perfectum est et formatum, et sic pullus formatus sub arena virtute solis a matre cognoscitur." From two manuscripts in Troyes by the Anonymus Trecensis; see J. B. Pitra, *Spicilegium solesmense,* Paris, 1855, II, p. 504 (reprinted Graz, 1963).

15. The earliest appearance of this myth, according to Goldstaub (*op. cit.,* p. 163), is in the *De naturis rerum* of Alexander Neckham, who died in 1217.
16. *Ibid.*
17. *Die goldene Schmiede des Konrad von Würzburg,* ed. E. Schröder, Göttingen, 1926, lines 528–535.
18. *Ibid.,* p. 83 f.

19.　　Hilf in vz den sünden watten
　　　Vnder diner vetechen schatten
　　　Rvoche siv behuoten
　　　Erbermeclichin brvoten
　　　Als sinv eiger der struz
　　　Div brvetet er wunderlichen vz
　　　Wan der hat solche pfliht
　　　Daz er mit stetir gesiht
　　　An sinv eiger sihet
　　　Als sin nature vergihet
　　　Mit stete ane wenkin
　　　Svz kan er si bedenkin
　　　Unde hilfet in genesin
　　　Von tode bi dem lebin wesin
　　　Die nature hat alle frist
　　　Der vil sveze ihesus crist
　　　Mit der erbermede ovgen
　　　Schowit er vnz tovgen
　　　Steteclich siht er vns an
　　　Beidiv wip vnde man
　　　Vnd bivt vns sinen aplaz
　　　Uaterlich an vnderlaz.

Martina von Hugo von Langenstein, ed. A. von Keller, Stuttgart, 1856, p. 188. See also Lauchert, *op. cit.,* p. 178.
20. *Hermann von Sachsenheim,* ed. E. E. Martin, Tübingen, 1878, p. 237. See also Johannes (or Hermann) von Salzburg, early fifteenth century (P. Wackernagel, *Das deutsche Kirchenlied von der ältesten Zeit,* Leipzig, 1867, II, p. 441), and, between 1415 and 1427, *Lieder Muskatblut's* (ed. E. v. Grote, Cologne, 1852, p. 51).
21. According to an extremely fanciful legend, which was told also in an Italian *Bestiario moralizzato* of the early fourteenth century, Solomon enclosed the chick of the ostrich in glass, from which the adult bird freed it by dropping on it the blood of a worm which it found in the desert. This deed was compared with the Crucifixion and the shattering of the gates of Hell. See J. Lutz and P. Perdrizet, *Speculum humanae salvationis,* Mülhausen, I, 1907, p. 59; G. Mazzatinti and E. Monaci, "Un bestiario moralizzato," in *Atti della R. Accademia dei Lincei, Rendiconti,* Rome, V, 1889, p. 727. The *Bestiario* contains also the simile of the egg and the sand (p. 726).
22. G. Heider, "Beiträge zur christlichen Typologie," *Jahrbuch der K.K. Central Commission,* V, 1861, p. 26 ff.; P. M. Halm, "Zur marianischen Symbolik des späteren Mittelalters," *Zeitschrift für christliche Kunst,* XVII-XVIII, 1904, pp. 119 ff., 179, 207; H. Tietze, "Die typologischen Bilderkreise des Mittelalters in Österreich," *Jahrbuch der K.K. Zentral-Kommission,* N.F. II, 2, 1903, p. 70 ff.; H. Cornell, *Iconography of the Nativity of Christ,* Uppsala, 1924, p. 63; *Reallexikon zur deutschen Kunst-*

geschichte, III, 1954, cols. 833–854; G. Schmidt, *Die Armenbibeln des XIV. Jahrhunderts,* Graz, 1959, p. 93 f.

23. Since this passage from Ulrich's treatise has not, to my knowledge, been published I insert it here, taken from ms. 151, fol. 13, at the monastery of Lilienfeld. I owe the microfilm and clarifying comments to the kindness of Professor Gerhard Schmidt. "Strucio est pater celestis; ovum a se enixum est verbum ex se ante secula generatum, in sabulo vel in beatissime virginis utero posuit, quod non fotum vel non humano sed divino semine incarnatum vi caloris vel etiam solis micante virtute hodie pullum vel dei et hominis unigenitum filium generavit ad nostre liberacionis solacium et produxit."

24. J. von Schlosser, "Zur Kenntnis der künstlerischen Überlieferung im späten Mittelalter," *Jahrbuch der kunsthistorischen Sammlungen des allerhöchsten Kaiserhauses,* XXIII, 1902, pp. 287–313; Cornell, *op. cit.,* p. 74; E. M. Vetter in *Lexikon der christlichen Ikonographie,* Freiburg i.B., I, 1968, cols. 499–503; G. M. Häfele, *Franz von Retz, Ein Beitrag zur Gelehrtengeschichte des Dominikanerordens und der Wiener Universität am Ausgange des Mittelalters,* Innsbruck, 1918, p. 346 ff.

25. W. L. Schreiber, *Manuel de l'amateur de la gravure sur bois et sur métal au XV siècle,* Berlin, 1893, III, pp. 368–380; M. J. Friedländer, *Der Holzschnitt,* 4th ed., Berlin, 1970, p. 30; Franciscus de Retza, *Defensorium immaculatae virginitatis,* ed. K. Pfister, Leipzig, 1925.

26. See the two preceding notes.

27. Cornell, *loc. cit.*

28. Comparison with the manuscripts of the *Defensorium,* which I have been unable to undertake, would undoubtedly clarify the relationship of the fresco and Eysenhut's block book. The inscriptions of both give as a source—presumably of the entire preceding sentence but actually only of its first part—"Albert(us) in de proprie(tatibus) re(rum) libro VII et Ysi(dorus) XII" (fig. 92; the block book then adds a more detailed reference). The reference to Albertus (which is lacking in the block book of 1470) is garbled. He wrote of the ostrich in *De animalibus,* which the *Defensorium* cites nearby. If the author of *De proprietatibus rerum* is intended (Bartolomeus Anglicus) the book cited is not correct. The reference to Isidorus is correct. Isidorus alone is cited, but with the wrong title, in the block book of 1470 (see ed. K. Pfister, *cit.*). In his basic work on the *Defensorium* Von Schlosser (see n. 24) said nothing about the errors or the divided authorship of the inscriptions, and to my knowledge they have not been studied in detail.

29. K. Frey, *Le Vite di Vasari,* Munich, 1911, I, p. 338. Prof. Ruth W. Kennedy called this record to my attention, and I am thus indebted once again to her wide knowledge and her generosity.

30. G. Poggi, *Il Duomo di Firenze,* Berlin, 1909, documents 1189, 1190, 1195.

31. J. Sauer, *Symbolik des Kirchengebäudes,* 2nd ed., Freiburg i.B., 1924, p. 186 f.

32. W. and E. Paatz, *Die Kirchen von Florenz,* Frankfurt a.M., III, 1952, pp. 391, 404, 409.

33. For the inventory of 1482 see S. Borghesi and L. Banchi, *Nuovi documenti per la storia dell'arte,* Siena, 1898, pp. 261–330. For the inventory of 1467 translated into French see J. Labarte, "L'église cathédrale de Sienne et son trésor d'après un inventaire de 1467," *Annales archéologiques,* XXV, 1865, pp. 261–287. The entire passage on the high altar in the inventories of 1423 and 1435 was published by A. Lisini, "Notizie di Duccio pittore," *Bolletino senese di storia patria,* V, 1898, pp. 23 f., 37 f. For this section of the inventory of 1435 see also V. Lusini, *Il Duomo di Siena,* Siena, 1911, p. 149 n. 124. The passage on the chapel of S. Ansano in the inventory of 1458 was published by P. Bacci, *Fonti e commenti per la storia dell'arte senese,* Siena, 1944, p. 166 f.

The other inventories which I have consulted and from which extracts are given above are all in Siena, Archivio di Stato, among the volumes of the Opera Metropolitana. They are as follows: 1420, December 14 (no. 28); 1429, June 21 (no. 29); 1435 (no. 30); 1439 (867, no. 4); 1446, December 30 (no. 31); 1450 (no. 32); 1458 (no. 33); 1467 (867, no. 8); 1463 (no. 34); 1482 (no. 35).

Passages from all these inventories were transcribed by Dr. Gino Corti, to whom I am once again deeply indebted.

34. Lisini, *op. cit.,* p. 24. First cited by M. Levi d'Ancona, letter in *Art Bulletin,* XXXV, 1953, p. 329. This phrase is repeated in the inventory of 1429 (fol. 16). In the inventory of 1420 there is a gap in the text, and perhaps for this reason the eggs and other objects do not appear.

35. Lisini, *op. cit.,* p. 37.

36. Unpaginated. I add the entire description of the high altar, not hitherto published:

Uno altare magiore di marmo con tavola dipenta da ongni lato, con figura di nostra Donna et più altre figure di santi e della passione di Christo, colle voltarelle da ccapo in quatro bordoni di ferro, con tre tabernacoli con tre angnoletti che servano alla messa rilevati et dorati, et più quatro angnoletti con candelieri innanzi et dietro all'altare, et due graticole di ferro da canto, et una tenda vermelglia con frangie, et uno tabernacolo del corpo di Christo dipentovi, da cuprire l'altare, et due cassette da ricevare l'offerte, suvi coll'arme dell'Opera, et due uova di sturzo pendenti et cinque candelieri di ferro in sul detto altare.

37. Siena, Archivio di Stato, Opera Metropolitana no. 34, fol. 3v. In the original publication I quoted the entry in the inventory of 1482 (Borghesi and Banchi, *op. cit.,* p. 271). The egg, like the one in the Cathedral of Florence, was set in metal.

38. Bacci, *op. cit.,* pp. 199, 205 f., 211. I had earlier accepted the view of Lusini, *op. cit.,* p. 290 f., that the relics were in the central chapel.

39. Of the Virgin: her milk, ring and veil (Bacci, *op. cit.,* p. 223 f.).

40. M. Meiss, *French Painting in the Time of Jean de Berry. The Limbourgs and Their Contemporaries,* New York, 1974, pp. 121, 140, figs. 392–394; Lusini, *op. cit.,* pp. 199, 290, 294.

41. Inventory of 1458, fol. 25. The description of this chapel was published by Bacci, *op. cit.,* p. 166.

42. Inventory of 1458, fol. 25. The phrases referring to the eggs vary slightly in the several inventories from 1458, when they are first described, to 1482; often each one is said to be attached "a chapo detto altare" instead of "a chapo detta chapella." See the following inventories: 1467, fols. 14 and 14v; 1473, fol. 15v ;1482, fol. 15v.

43. The payment to Andrea for painting in this chapel does not, however, specify the subject (G. Milanesi, *Documenti per la storia dell'arte senese,* Siena, 1854, I, p. 41 f.).

44. It is worth noting that there were lamps in both these chapels, but the inventories do not connect the eggs with them in any way. There were, too, chapels with lamps but without eggs.

45. For Benaglio's altarpiece see B. Berenson, *Italian Pictures of the Renaissance, Central and North Italian Schools,* London, 1968, III, fig. 1297; for Montagna, Brera, see L. Puppi, *Bartolommeo Montagna,* Venice, 1962, pl. 92; Montagna, Vicenza, see *Il Museo Civico di Vicenza,* ed. F. Barbieri, Venice, 1962, pl. on p. 155; Buonconsiglio in Vicenza, see *Il Museo Civico, cit.,* pl. on p. 101.

46. National Gallery, *Illustrations to the Catalogue,* London, I, 1923, pl. 106.

47. For the painting see M. Salmi, *Ercole de'Roberti,* Milan, 1960, pls. 14 ff., 35. The painting was introduced into the discussion of the Brera Altarpiece by E. Battisti, *Piero della Francesca,* Rome, 1971, II, p. 514 n. 450.

For St. Jerome see "The Perpetual Virginity of Blessed Mary," in *A Select Library of Nicene and Post Nicene Fathers*, 2nd ser., VI, *St. Jerome, Letters and Select Works* (ed. P. Schaff and H. Wace), New York, 1893, pp. 334–346.

48. The size of the egg suggests that the symbol may have been taken unknowingly from Mantegna. An egg hangs over the heads of the Baptist and St. Anthony Abbot in a provincial panel in the Pinacoteca in Cremona, and over the head of a Franciscan saint (Bernardino?) in a second, corresponding panel (A. Puerari, *La Pinacoteca di Cremona*, Cremona, 1951, figs. 100–101). These panels were initially cited by C. Gilbert, *Art Bulletin*, XXXIV, 1952, p. 209 n. 30.

49. The shell of an ostrich egg is sufficiently thick and strong to permit suspension in this manner—that is, by a pin or small plate inserted inside the top. See my remarks on this subject published in the *Art Bulletin*, LVII, 1975, p. 116.

50. L. Charbonneau-Lassay, *Le bestiaire du Christ*, Bruges, 1900, p. 671.

51. Wolfgang Lotz kindly called this painting to my attention.

52. Admiration of the ostrich egg, and something of its earlier religious connotation, survived into the nineteenth century. In 1880, as Miss Helen Franc has kindly pointed out to me, *La Vie Moderne* held an exhibition of painted Easter eggs. The ostrich eggs were suspended on cords of silk and wool after having been painted by several artists, among them Forain, Rops, and Manet. The egg painted by Manet (with a figure of Polichinelle) belonged in 1930 to Bernheim jeune in Paris (Cf. A. Tabarant, *Manet*, Paris, 1931, p. 388, No. 347).

53. See the *Madonnas* by Fogolino (fig. 108) and Buonconsiglio cited above.

54. Sauer, *op. cit.*, p. 185 f., with reference especially to Hugh of St. Victor.

Gilbert, *op. cit.*, p. 209 n. 30, prefers to believe that all the eggs connected with lamps are merely "ovoid weights" intended to hold together the strands that run from the central chain or bar to the sides of the lamps. I do not see that the "ovoid weights" serve this purpose, and I am not at all certain they are "weighty." They are normally white, unlike other parts of the lamp, and precisely to *avoid* adding to the weight they may have been, if not actual ostrich eggs, simulated ones in ceramic or hollow, enameled metal.

55. *Op. cit.*, p. 25.

56. For examples in the Palazzo Ducale at Urbino see R. Papini, *Francesco di Giorgio Architetto*, Florence, 1946, II, pls. 165 and 176. In manuscripts the bird is usually accompanied by the motto: "Ich an vordait ein grosser," which has been translated "I'd like a larger." In fig. 94 the motto reads: "Ic an vordait en crocisem." On the ostrich as an emblem of Federigo, cf. C. Stornaiolo, *Codices Urbinates Latini*, Rome, 1902, I, p. xii; *idem, I Ritratti e le Gesta dei Duchi d'Urbino*, Rome, 1913, p. 16, pls. II, III, VII.

57. See the passage in Berchorius, cited in n. 11. In the course of his travels at the end of the fifteenth century Arnold von Harff saw some captive ostriches in Rhodes. He reports their ability to hatch eggs by their piercing sight, and also their reputed capacity to eat iron. With respect to the latter, however, he adds (as a man of the fifteenth century) "but this I have not seen." (*The pilgrimage of Arnold von Harff*, ed. M. Letts, London, 1946, p. 86.) See also Stornaiolo, *Codices, loc. cit.*; B. Palliser, *Historic Devices*, London, 1870, p. 167; Brunetto Latini, *Li livres dou tresor*, ed. F. J. Carmody, Berkeley, Cal., 1948, p. 153.

This capacity of the ostrich was familiar to Ripa, for whom it symbolized Justice (*Iconologia*, Siena, 1613, p. 295), and to Shakespeare: "I'll make thee eat iron like an ostrich" (*Henry VI*, Part II, Act IV, Scene 10).

58. E. Evans, *Animal Symbolism in Medieval Architecture,* London, 1896. The Emperor Frederick II was said to have possessed "ostrich eyes."

59. See E. MacCurdy, *The Notebooks of Leonardo da Vinci,* New York, 1938, II, p. 475.

60. The belief of L. Pungileoni, *Elogio storico di Giovanni Santi,* Urbino, 1822, p. 53, that the Madonna is a portrait of the Countess, and the Child of Guidobaldo, is of course not tenable.

 For Federigo's delight at the birth of an heir and his sorrow at the loss of his wife, see his letters published by P. Alatri, *Federigo da Montefeltre, Lettere di stato e d'arte,* Rome, 1949, pp. 3, 9, 42. Of Battista the Count wrote: ". . . erat enim consors fortunarum mearum dilectissima et domi laborum meorum private simul et publice gratissimum levamen, adeo ut nihil adversius mihi evenire potuisset . . ." (*idem,* p. 3). See also A. Cinquini, "De vita et morte illustris. D. Baptistae Sfortiae Comitissae Urbini," *Canzone di Ser Gaugello de la Pergola,* Rome, 1905; *idem,* "Il Codice Vaticano Urbinate Latino 1193," *Classici e neolatini,* I, 1905, pp. 12 ff., 117 ff.

 In his volume on Piero della Francesca, which appeared after this article left my hands, Kenneth Clark has suggested that the altarpiece was ordered to commemorate the same occasion (*Piero della Francesca,* Oxford and New York, 1951, p. 48). Clark also comments on the egg, describing it essentially as a symbol of mathematical perfection, but possibly alluding to the four elements or, "like the ostrich eggs formerly suspended in Near Eastern churches," to the creation of the universe (pp. 49, 210).

61. J. Dennistoun, *Memoirs of the Dukes of Urbino,* London, 1851, I, p. 197 ff.

62. Piero della Francesca's Uffizi diptych has recently been dated after the death of the Countess in 1472 by C. Gilbert, in "New Evidence for the Date of Piero della Francesca's Count and Countess of Urbino," *Marsyas,* I, 1941, pp. 41–53. His argument however that the clause *Que modum rebus tenuit secundis* proves that the Countess was dead is not convincing. The perfect tense of the verb *tenuit* may well refer to the behavior of the Countess during the course of her life up to the time when the verse was written, and instead of the translation, "she who had a way with good fortune" (whatever that may mean), the passage should be read, as Prof. Erwin Panofsky has kindly pointed out to me, "she who has preserved moderation in good fortune." The date of the Uffizi diptych furthermore is bound up with that of the Brera Altarpiece. Federigo is represented in both, and he seems to me older in the Brera panel. If one can rely upon such differences—and in the case of late Quattrocento portraits made by the same master there is good reason to do so—the diptych was made several years before the altarpiece. [According to J. Sparrow, "Latin Evidence in Renaissance Painting," *Burlington Magazine,* CXI, 1969, pp. 613–615, such a date, before 1472, is indicated by the inscription, which points strongly to the execution of the portrait of the Countess during her lifetime.]

 With reference to the appearance in Piero's altarpiece of the Count without the Countess, it is true that Francesco Gonzaga alone is represented in the similar votive painting by Mantegna, the *Madonna della Vittoria* in the Louvre. The original plan, however, included the Marchesa (see P. Kristeller, *Andrea Mantegna,* London, 1901, p. 312).

63. The identity of this figure is uncertain. Schmarsow (*loc. cit.*) suggested St. Ubaldo, but in the examples of this rare saint with which I am familiar, he is represented as a bishop. Others have inclined toward St. Andrew (R. Longhi, *Piero della Francesca,* London, 1930, p. 116). For further discussion of this saint see Meiss in Chapter 5, p. 101 f. n. 42.

64. *Marsyas,* II, 1942, p. 43 ff. For the related image of the *Vesperbild* with allusions to the Madonna see E. Panofsky in *Medieval Studies in Memory of A. Kingsley Porter,* Cambridge, 1939, II, p. 490.

65. Piero undoubtedly knew the *Madonna with the Sleeping Child* painted in 1439 by Antonio da Ferrara for the Franciscans of Urbino and now in the Palazzo Ducale (fig. 98). The later Ferrarese masters, Tura, Cossa, Ercole, also represented the Child asleep. [For the sleeping Christ Child see below, p. 227 f.]

66. The panel is in the Schiff-Giorgini Collection, Rome. See *Mostra d'arte italiana al Palazzo Venezia,* Rome, 1945, no. 60.

67. F. De Sanctis, *Storia della letteratura italiana,* Naples, 1870, I, p. 34; D. Giuliotti, *Le più belle pagine di Fra Jacopone da Todi,* Milan, 1922, p. 153; *Le poesie spirituali del B. Jacopone da Todi,* Venice, 1617, p. 267. For a related interpretation of the sleeping Child, see Gilbert, *Art Bulletin,* XXXIV, 1952, pp. 206–207. He quotes a very interesting passage from Giovanni Dominici, in which the writer recommends representations of the sleeping Christ Child as images pleasing to children.

68. De Sanctis, *op. cit.,* I, p. 33. I am grateful to Professors Dino Bigongiari and Creighton Gilbert for suggestions on the translation of this stanza. For the last phrase, which has been translated "or it will hurt you" (English ed. of De Sanctis by J. Redfern, New York, 1931), I follow the reading of Professor Bigongiari.

69. The painting, kindly called to my attention by Dario Covi, was sold at Sotheby, January 31, 1951, as no. 35.

70. The photograph is in the Frick Art Reference Library. In this instance Christ lies on a bed and the inscription is written on the cover. The young St. John nearby puts his fingers to his lips to enjoin silence.

71. See for example Gregory the Great in Migne, *Pat. Lat.,* LXXIX, col. 518 or Isidore of Seville, *op. cit.,* LXXXIII, col. 1125. "Dormit tunc sensualitas, sed vigilat ratio . . . ," Richard of St. Victor says (*op. cit.,* CXCVI, col. 501).

72. Meiss, *op. cit.,* pp. 62, 64, and note 50.

73. See A. Venturi, *Storia dell'arte italiana,* VI, p. 349 ff. and figs. 213–220.

74. For the identification of all these figures see A. Warburg, *Gesammelte Schriften,* Leipzig, 1932, I, p. 101 ff.

75. K. Clark (*op. cit.,* p. 19) rightly rejects the old interpretation of the three men as Oddantonio with evil counselors, but his proposal of a connection with the trials of the Church and the Councils is not convincing. E. Gombrich (*Burlington Magazine,* XCIV, 1952, p. 176) suggests the scene of the repentance of Judas, but appropriate gestures and attributes (pieces of silver) are lacking. C. Gilbert (*op. cit.,* pp. 208–209) proposes, incorrectly I think, that the three men, despite their formal arrangement, are casual bystanders, and that "the Flagellation is shown as one might come on it in the street while passing other people."

76. B. Berenson (*Italian Pictures of the Renaissance,* Oxford, 1932, p. 455) dates it *ca.* 1469–1473; Longhi (*op. cit.,* p. 168) toward 1475; M. Salmi (*Piero della Francesca e il Palazzo Ducale di Urbino,* Florence, 1945, pp. 27, 96) toward 1474.

77. Dennistoun, *op. cit.,* p. 214.

78. See A. S. Weller, *Francesco di Giorgio,* Chicago, n.d., fig. 46.

7

Once Again Piero della Francesca's Montefeltro Altarpiece

WITH THEODORE G. JONES

Piero della Francesca's panel in the Brera has by common consent an important place in the history of the Renaissance altarpiece, similar to that given to Alberti's almost exactly contemporary Sant'Andrea in the history of the Renaissance church. Some aspects of both the early history and the design of Piero's painting have, however, been imperfectly or incorrectly understood by all writers, the present one included. The observations that follow carry us further along the way but not always to the end of the road.

We are all now fully aware of the significance of Piero's composition (fig. 88). The symbolic association of Mary and Ecclesia had earlier, in the North, inspired impressive paintings of the Madonna in the Church by Jan van Eyck and his successors.[1] In Italy, on the other hand, one or two groups of saints were dignified by imposing buildings,[2] and a small panel for private devotion shows the Madonna and saints within a Renaissance church (fig. 18), but Piero was the first painter to adopt this composition on the scale of the altarpiece. His noble building glorifies them, even assuming the function of haloes, which are entirely lacking.

The affinity of the figures for the architecture is so great that they have generally seemed to be not far from the apse. Historians have put them in or just before the choir or in the crossing.[3] The Madonna has sometimes been

This article was published in the *Art Bulletin,* XLVIII, 1966, pp. 203–206.

identified with the high altar in the apse, so that she becomes "l'autel vivant."[4] When engaged a dozen years ago in the measurement of the egg I suspected that the high base visible along the left frame belonged to the capital that appears above it,[5] but only recently could I prove this relationship by examining the part of the painting overlapped by the frame. Virtually the entire painted surface may now be seen in the photograph reproduced here (fig. 88).[6] We can be certain that the figures are not even in the beginning of the nave, as I then thought, but a considerable distance down it. The plan of the church, carefully reconstructed by Mr. Theodore G. Jones, shows that the figures are about ten and a half feet before the crossing and forty-five feet from the rear wall of the apse (fig. 105).

As we would expect, Piero drew his perspective with great care.[7] Where slight discrepancies occur they might well be due to the photograph on which the reconstruction has been based.[8] The horizon is at the level Alberti recommended: approximately the height of a figure standing in the foreground. The distance of the eye from the picture plane, not prescribed in the treatises of Alberti or of Piero himself, is less than twice the width of the picture. It is similarly placed in Piero's *Flagellation*.[9] Leonardo recommended three times the largest dimension of the picture.[10]

In this new reconstruction the actual size of the ostrich egg is larger than the approximate six inches I estimated a decade ago.[11] Two studies of the perspective of the altarpiece published shortly after the present paper, furthermore, have suggested similar dimensions. Shearman proposed between nine and ten inches while Davies and Snyder arrived at eight and a half inches.[12] Exact results are not obtainable because the figures in the painting are the only source of actual dimensions, and they vary in size.

What, in any event, are we to make of the fact that Piero's egg, if reconstructed, proves to be one and a half times or twice the size of an actual ostrich egg? Would the Duke and his entourage for whom Piero painted the composition have been aware of it? Even perspective-minded modern scholars did not discover the fact until the past few years. If Piero had produced an egg half as small, would it not have *looked* like the egg of a chicken or a goose? Was he not striving for visual effect rather than realism and mathematical precision? This last question, which is crucial, we can answer affirmatively, without hesitation. In one striking instance Piero preferred symbolical significance, visually expressed, to realistic consistency. The Virgin is much

larger than the saints and angels.[13] Moreover, no window in a transept of a
church that has a plan like that of Piero's could throw light on the egg and
the apse, as it does in the painting.

At left and right in the Brera Altarpiece sections of the nave walls are
visible; only small sections to be sure, but inasmuch as less appears at the
right than at the left (and Federigo's sword is incomplete) the panel was
probably once trimmed a little along that edge. It seems unlikely that much
was lost at either side,[14] for increasingly large architecture in the fore-
ground would have diminished the figures. Even the small sections of the
nave walls that are represented have, however, a powerful effect. They
emerge in front of the empty space of the transepts and they presumably
move forward without interruption beyond the frame. The observer senses
that he is enclosed by them.

This conception was, so far as I can see, novel in Italian painting. Earlier
painted structures did extend forward to the picture plane, and occasionally,
as in Pietro Lorenzetti's *Birth of the Virgin* or Mantegna's San Zeno Altar-
piece, they were more or less identified with the architectural forms of the
frame. In these instances, however, as in the buildings Piero himself painted
earlier, the structures had terminal forms. In Solomon's palace in the frescoes
at Arezzo, for example, a limiting column and entablature lie in the picture
plane (fig. 74). Piero's church in the Montefeltro Altarpiece does not show
—and never showed—such a "front face." "Incomplete" architecture, over-
lapped more or less at random by the frame, was first championed by Jan van
Eyck. He employed it, normally in conjunction with a close point of sight, in
the Washington *Annunciation,* the Berlin *Madonna in a Church,* the *Ma-
donna* in Frankfurt, and the *Paele Madonna* (figs. 5, 6, 16, 19). In the last-
named a semicircular church extends beyond the frame, as in Piero's panel,
and by implication encloses the beholder.[15] Whereas Jan's figural group is
more open and accessible to the beholder, and the carpet is, as it were, rolled
out for him,[16] the forward movement of Piero's church is less contained.

As we have seen, Piero completed the Montefeltro Altarpiece before the
autumn of 1474, and he probably began it after early July, 1472.[17] It existed,
therefore, before 1475–1476, when Antonello was painting his San Cassiano
Altarpiece, which seems to reflect it (fig. 106). Indeed this master, traveling
north and having seen Piero's paintings in Rome, might well have followed
the route of Arezzo, Sansepolcro, and Urbino. Giovanni Bellini, who began

designing similar compositions for his lost Santi Giovanni e Paolo Altarpiece and during the eighties for his San Giobbe Altarpiece, very probably was nearby when working on his Pesaro *Coronation* between 1471 and 1475 (toward the latter limit).[18] The visual effect of Antonello's picture was close to Piero's, particularly with regard to the relationship of the figures to a choir (fig. 106). The vaulting of the church in the San Cassiano Altarpiece remains conjectural, but it, like Bellini's pictures and most subsequent Venetian representations, may have shown arches or entablatures extending toward the picture plane. Frequently the invisible nearer supports of these forms tended to be supplied in a sense by the pilasters or columns of the frame. The continuity is complete in Bellini's relatively early San Giobbe Altarpiece, as Professor Giles Robertson will make clear in a forthcoming article.* The frame usually only approximated the painted architecture in later Venetian paintings, such as Bellini's altarpiece of 1505 in San Zaccaria, which is still enclosed by its original frame (fig. 107). The actual architecture differs in detail from the painted, and it does not quite conform in perspective.

Though the representation of the Madonna in an apse or under a tabernacle was enthusiastically adopted by painters in Venice not one of them, so far as I can see, followed Piero's example of envisaging a complete church, with visible transepts and a small section of nave walls moving uninterruptedly forward toward the beholder. A very few Venetian masters represented a couple of bays of a church, with the supports of the nearer bay in the picture plane (fig. 108).[19] Piero's long, measured church remained unique.

Like Antonello, Bellini, and other Venetian masters Piero wanted a certain visible proportion in the picture plane between the figures and the architecture—a little over half the height of the pilaster (with its capital) in the Brera panel.[20] The figures are relatively taller in most Venetian compositions. Piero insisted, moreover, on a more naturalistic actual scale also, and the only way to meet both these requirements, the visual and the naturalistic, was to construct a deep church. The perspective then diminishes sufficiently the crossing, the choir and the apse.

Piero designed the wall of the palace behind Christ in the *Flagellation* similarly, but the distance from the figures to the apse in the Montefeltro Altarpiece, which does not *look* great, is in fact no less than forty feet. Piero

* See now the photomontage in G. Robertson, *Giovanni Bellini,* Oxford, 1968, pl. 67.

united them in one pattern of color and of value, the lighter figures set against the shaded part of the apse and vice versa. The resulting spatial ambiguity would have been diminished if more of the nave were visible, but then of course the prominence of the figures would have been more or less reduced. It should be added that though the Venetian columniation was not proportionately as large as Piero's the paintings often have a higher format and give the impression of greater spaciousness (fig. 107).

Both Antonello and Giovanni Bellini probably saw Piero's altarpiece around 1474–1475. But where was it? It stood on the high altar of the church of San Bernardino, just outside of Urbino, in 1703 and in 1810, when it was taken to the Brera (fig. 110).[21] Most historians, including the writer, have accepted the old deduction that the panel was painted for this church,[22] and the same view was repeated four years ago in the new guide to Urbino.[23] It is nevertheless certainly incorrect, for the church was not completed until a decade or two after the painting of the altarpiece, as Professor Rotondi demonstrated in 1947.[24] Still, the connection with San Bernardino was not far wrong, for the original, temporary destination was, I believe, an altar in an older and smaller church one hundred feet away.

A house of the Observants was founded in Urbino by a bull of Pope Martin V of 1425, on the request of Federigo's father, Guidantonio. Soon thereafter, and in any event before the middle of the century, the Observants acquired some rights to the parish church of San Donato, which had stood on a high hill outside the city since the thirteenth century (fig. 111). From around 1450 the building served both the parish and the growing monastery, and it was sometimes designated the Osservanza or even San Francesco. Vespasiano da Bisticci, who had provided Federigo with manuscripts and who knew him well, said that the Duke wished to be buried in this church: ". . . quanto al divino culto, ordinò che a uno munistero, che è fuori d'Urbino circa a uno miglio, dell'ordine di Sancto Francesco dell'Osservanza, che sicchiama di Sancto Donato, fusse fatta la chiesa di nuovo, e il munistero acconcio tutto, che non vi mancasse nulla, come s'è di poi fatto; e volle per la sua divozione essere sepulto in quella chiesa allato al conte Guido."[25] There can be no doubt about the identity of the church and the execution of the Duke's wish. The tomb of his father, who established the Observants in Urbino and who died in 1443, is still in the floor of San Donato (fig. 109). He wears a Franciscan habit.

Baldi, who completed a life of Federigo in 1603, said that his body was still preserved at that time in a simple wooden box: ". . . non fu sepolto in terra, nè posto in arca, o monumento di marmo: ma curato, ed unto di balsamo, dentro ad una cassa di legno appesa al muro in parte elevata alla destra dell' Altar Maggiore. . . ." Baldi did not further describe the church; it was probably San Bernardino, to which the wooden coffin, originally in San Donato, had been transferred.[26]

Vespasiano tells us that the new church of the monastery ordered by the Duke had been built, and since Vespasiano died in 1498 the construction of San Bernardino must have occurred before that date. Possibly it was designed before the Duke's death in 1482, but work had probably not been begun. Francesco di Giorgio, who influenced the design of the church if he was not the architect, entered the service of Federigo in July 1476.[27]

The belief that Piero's altarpiece was painted for San Bernardino was founded on three facts: (1) the painting stood on the high altar of that church, at least from 1703; (2) among the six saints Francis and Bernardino are included; (3) the church was constructed at the request of the Duke, and the painting contains a portrait of him.[28] If the church of San Bernardino is excluded, the most probable original site is San Donato. From that church the painting would naturally have passed to the new building. Donato, bishop of Arezzo, is, to be sure, not represented, but around 1474 the church had a dual patronage, and the monastic is entirely satisfied by the presence of the two Franciscan saints. Where in Urbino other than in the church of the Observants would they—and especially St. Bernardino—have been celebrated? In Federigo's palace the Cappella del Perdono, sheathed in marble and related in style, would have been artistically congenial but it was not designed to contain a large painted altarpiece.[29] The church of San Francesco is quite possible, especially because the obsequies of the Countess (but not the burial) took place there.[30] In Piero's painting St. Bernardino does stand in the second row but he is on the Madonna's right, and he was included in the original design. Indeed he was painted before the saints in front of him.[31] He was far more frequently honored by Observant houses than by any other.[32]

In his Life Vespasiano stresses Federigo's attachment to the Observant friars. "Aveva messo in tutte le sue terre, dov'egli aveva potuto, frati d'Osservanza, prestando loro favore di limosine, e d'acconciare loro i luoghi alle

sue ispese."[33] In this respect Federigo followed his father, and though Fede-
rigo at one time planned a round "tempio" as a mausoleum in the Cortile del
Pasquino of the palace[34] it was not built, and the Duke's choice of San
Donato for his burial, reported by Vespasiano, may have been made years
before his death. The church was itself a family mausoleum, having already
received the bodies of his father Guidantoni and of earlier counts of Urbino,
beginning with Guido il Vecchio da Montefeltro in 1288.[35]

Three saints in the Brera Altarpiece—Jerome, the Baptist, and Francis—
are represented in an altarpiece painted in 1439 by Antonio da Ferrara for
San Donato (in 1439 St. Bernardino was still alive), and the Madonna at the
center of this altarpiece adores a sleeping Child (fig. 98). Antonio's polyp-
tych, too, passed from San Donato to San Bernardino. Federigo's filial piety,
already manifested by his declared wish to be buried alongside his father in
San Donato, might well have led him to ask his painter to adopt part of the
iconography of an altarpiece that stood in that church, especially since his
father had probably commissioned it. Not only that, it was commissioned one
year after the death of his wife!

Vespasiano described a close relationship of Federigo with only one
other church, which he himself had built. He visited it, Vespasiano says, once
a week.[36] It too belonged in the larger sense to the Franciscan Order, but to
the female branch. Santa Chiara, built by Federigo, was a small church of
central plan, now incorporated into the municipal hospital. Its interest for us
is increased by the fact that Battista Sforza was buried there,[37] and not in San
Bernardino as has often been asserted.[38] When relating the commission for
the Montefeltro Altarpiece to the great occasion of the long awaited birth of
Federigo's male heir, Guidobaldo, in 1472 and the death of the Countess a
few months later I accepted the view that Battista was buried in San Bernar-
dino.[39] Since the absence of Santa Chiara (or any Clarissan) from the paint-
ing would seem to prove that it was not made for her church one connection
with these events is lost.

It is still probable, however, that this exceptional wife, whom Federigo
described as the "beloved consort of my fortune and domestic cares, the
delight equally of my public and private hours,"[40] would have appeared in
the painting if she had been alive.[41] A few years earlier Piero portrayed her
at her husband's side in the diptych now in the Uffizi. The place opposite the
Count's patron is occupied by the Baptist, the Precursor but also her patron.[42]

The unique prominence of the ostrich egg may allude to the seemingly miraculous birth of the long-awaited son. A personal connotation seems implied by the exceptional relationship of the Count and the Child, united in the only prominent diagonal in a design of repeated verticals. Federigo's son appears at his side in all subsequent portraits. And finally the painting has always been placed, on stylistic grounds, in the seventies.

The connection of the altarpiece with the two greatest events in Federigo's later life may, therefore, still be maintained. It served as an ex-voto wherever it was originally placed. The single hall of the Gothic church of San Donato degli Osservanti, the most likely destination, would hardly have been judged too simple a setting for this splendid painting by a pious man who chose it for his place of burial.[43] Perhaps both the painter and the patron thought of the gleaming marble church as a prophecy of the new conventual building (figs. 88, 110). To it, in any event, passed both the picture and Federigo's body. [A drawing published for the first time recently, ascribed to Girolamo Genga, seems to show Piero's painting together with its frame on the principal altar of San Bernardino not long after the church was completed (fig. 110).[44]]

Postscript

Recently F. Sangiorgi has presented a different interpretation of the egg and, as a consequence of it, a different original destination of the altarpiece ("Ipotesi sulla collocazione originaria della Pala di Brera," *Commentari*, XXIV, 1973, pp. 211–216). First, he referred to an idea expressed in the late thirteenth-century *Catholicon* that an egg filled with dew and struck by the rays of the sun rises from the ground. In the late sixteenth century Picinelli, in his *Mondo simbolico*, adopted this ascending egg as an impresa of the Assumption of the Virgin. Second, a chronicle of 1539 states that Battista was buried in Urbino in the "cappella dei conti," which may then have been dedicated to the Assumption. This new theory was reported favorably by A. Parronchi in *La Nazione* (Firenze), September 22, 1973.

Piero's egg hangs on a chain and quite clearly does not levitate. It is, furthermore, a very large egg, and no size whatever is ascribed to the ascending egg. When accepting the view of a chronicle of 1539 about the burial of the Countess in San Francesco Sangiorgi disregards the opinion expressed by

a contemporary of the event that she was laid to rest in Santa Chiara (see above, p. 136; Sangiorgi was unfamiliar with my article). Finally, the history and dedication of the Montefeltro Chapel in San Francesco remains very unclear.

Both Parronchi and Sangiorgi, overlooking my discussion of the Virgin Mary and the Incarnation, assert that I believe that Piero's egg symbolizes merely the birth of Federigo's son!

NOTES

1. See Chapters 2 and 5; E. Panofsky, *Early Netherlandish Painting*, Cambridge, Mass., 1953, I, pp. 7 f., 144 ff.
 In correspondence John Shearman and I discovered that we both had papers on the Montefeltro Altarpiece in the press. Through an exchange of copies we learned with great satisfaction that we agreed on the definition of the space of Piero's painting—the main point in both articles. We have reconstructed the church, however, by fundamentally different methods. His penetrating study will appear—probably somewhat later than this one—in an honorary volume, the title of which may not now be divulged. ["The Logic and Realism of Piero della Francesca," in *Festschrift Ulrich Middeldorf*, ed. A. Kosegarten and P. Tigler, Berlin, 1968, pp. 180–186.]
2. See the painting of S. Giovanni Gualberto and other saints in San Pancrazio, Florence by Neri di Bicci, 1454–1455, figure 4 in this article in the *Art Bulletin*, 1966.
3. See, for example, the excellent article by J. Wilde, "La pala di S. Cassiano," *Jahrbuch der Kunsthistorischen Sammlungen*, N.F. III, 1929, p. 71. Also the writer, Chapter 5, p. 93; Panofsky, *op. cit.*, p. 8.
4. C. de Tolnay, "Conceptions religieuses dans la peinture de Piero della Francesca," *Arte antica e moderna*, 1963, pp. 232–235; C. Gilbert, "On Subject and Not-Subject in Italian Renaissance Pictures," *Art Bulletin*, XXXIV, 1952, p. 210. Both authors infer a connection between the altar, the Madonna, and the Child, allegedly alluding to sacrifice and death. Tolnay added that the border of the Madonna's mantle contains an allusive vine, but the presumed grapes at her neckline look like pearls, and this is certainly true of the rather different forms in the hem of her mantle.
5. See above, p. 122, n. 1. [The corresponding base at the right frame is clearly visible also.]
 Although my identification of the object in Piero's panel and in other Quattrocento paintings (beginning with Mantegna's San Zeno Altarpiece) as an ostrich egg has been generally accepted (see now R. Longhi, *Piero della Francesca*, ed. Florence, 1963, p. 167) two scholars have preferred a pearl. C. Marinesco, "Échos byzantins," *Bulletin de la Société nationale des Antiquaires de France*, 1958, p. 200 ff., has cited a Byzantine conception of the Virgin as a shell that bore the divine pearl. B. Widmer, "Eine Geschichte des Physiologus auf einem Madonnenbild der Brera," *Zeitschrift für Religions- und Geistesgeschichte*, XV, 1963, p. 313 ff., referred to the legend that a pearl is formed by the opening of the shell of the mussel to receive the dew of heaven. The Baptist is present in the painting as the finder of the pearl. Widmer dated the painting by Butinone in Isolabella much too early (it cannot have been Piero's model). I owe

knowledge of this article to the omniscience of Lech Kalinowski. Tolnay, who rejects the identification with the pearl and accepts the ostrich egg, rightly observes that Piero's pearls are more translucent (*op. cit.,* p. 234).

Marinesco, *loc. cit.,* makes the improbable suggestion that the unidentified saint at the extreme right is Bessarion (for this saint see Chapter 6, n. 63).

6. For permission to examine the surface below the frame, and for the photograph, I am grateful to the Director of the Brera, Dr. Franco Russoli, and to Dr. Stella Matalon, of the staff of the gallery. The altarpiece measures 2.48 × 1.70 m. Very small strips along the edges of the painting which are not visible in the photograph of the Soprintendenza can be seen in the ektachrome by Scala of Florence.

7. R. Wittkower and B. A. R. Carter, "The Perspective of Piero della Francesca's *Flagellation," Journal of the Warburg and Courtauld Institutes,* XVI, 1953, p. 294, remarked that "it cannot be doubted that Piero mapped out the whole composition [of the *Flagellation*] in plan . . . as if it were real architecture."

8. Curious is the slightly oblique relationship of the front face of the platform to the picture plane. Inasmuch as this plane runs symmetrically at left and right its lack of parallelism is probably deliberate.

9. Wittkower-Carter, *op. cit.,* pl. 44.

10. J. P. Richter, *The Literary Works of Leonardo,* 2nd ed., London, 1939, I, p. 152, no. 86. For this and another estimate by Leonardo, see E. Panofsky, "Perspektive als 'symbolische Form,' " *Vorträge der kunstwissenschaftlichen Bibliothek Warburg 1924–1925,* Leipzig, 1927, p. 327.

11. See above, p. 106. The two paragraphs above, an expansion of my original text, include information from two subsequent articles by other scholars.

12. Shearman, *op. cit.,* p. 181. E. M. Davies and D. Snyder, "Piero della Francesca's Madonna of Urbino," *Gazette des Beaux-Arts,* LXXV, 1970, p. 211 n. 21 (the first dimension given for the egg, 5¼ inches, is in a reconstruction of the space that I cannot accept). In a letter I received just before this copy went to press Mr. Davies says that, recalculating, he now arrives at 11 inches.

13. Shearman, *op. cit.,* n. 7. For visual effects architects and designers of majuscules occasionally departed from geometric constructions. See below, p. 182.

14. In reply to my queries I was kindly informed in May, 1965 that study of the edges of the panel in the laboratory of the Brera had not yielded definite results. C. Ragghianti, quoted in the *Mostra di quattro maestri del Primo Rinascimento,* Florence, 1954, p. 121, suggested that the painting was originally somewhat larger and was framed by pilasters and an arch that composed a "diaframma prospettico."

15. See Chapter 5, p. 95.

16. This extension has been emphasized by Erwin Panofsky, *Early Netherlandish Painting,* I, p. 7 f.

17. See above, p. 121.

18. Because of the relationship with Zoppo's altarpiece dated 1471 I tentatively proposed that Bellini had at least designed his painting by that time (*Giovanni Bellini's St. Francis in the Frick Collection,* Princeton, 1964, p. 41 f.), but I am impressed by the evidence offered by E. P. Fahy, Jr., "New Evidence for Dating Giovanni Bellini's *Coronation of the Virgin," Art Bulletin,* XLVI, 1964, p. 217 f. for a date of 1475 for S. Terenzio. The predella, including this saint, may of course have represented the last stage in this large enterprise.

19. Berenson connected this painting with Antonello's San Cassiano *Madonna (The Study and Criticism of Italian Art,* 3rd ser., London, 1927, p. 113 and pl.). Giles Robertson, who kindly called this painting to my attention, has made the plausible sugges-

tion that the architecture too reflects Antonello's. The position of Fogolino's figures within the building is confused. See also the altarpiece by Giovanni Buonconsiglio, Municipio, Montagnana (Berenson, *Italian Pictures of the Renaissance, The Venetian School,* New York, 1957, I, pl. 518), and Carpaccio, San Francesco, Pirano (*ibid.,* pl. 440). Either the cornices of the frame or of painted nave walls appear in Mocetto's engravings of the Madonna (A. Hind, *Early Italian Engraving,* London, V, 1948, p. 168; VII, 1948, pl. 730).

20. Tolnay, *op. cit.,* p. 234, has observed that the architectural members, especially the pilasters, that are close to the figures are relatively slender, while the arches and vaults are more massive.

21. F. Madiai, "Dei quadri tolti ad Urbino sotto il Regno italico," *Nuova rivista misena,* VIII, 1895, p. 84 f.

22. J. Dennistoun, *Memoirs of the Dukes of Urbino,* ed. E. Hutton, London, 1909, I, p. 287; M. Salmi, *Piero della Francesca e il Palazzo Ducale di Urbino,* Florence, 1945, p. 27; E. Modigliani, *Catalogo della pinacoteca di Brera in Milano* [1950], p. 98 f.; K. Clark, *Piero della Francesca,* London, 1951, pp. 48, 210; Tolnay, *op. cit.,* p. 232. See also Chapter 6, p. 116, and p. 97 in the original publication.

23. F. Mazzini, *Guida di Urbino,* Vicenza, 1962.

24. P. Rotondi, "Quando fu costruita la chiesa di S. Bernardino in Urbino?" *Belle Arti,* I, 1947, p. 191 ff. Most of the history of the two churches given in the text above is drawn from this illuminating article, to which John Shearman kindly called my attention. Rotondi left open, however, the question of the original site of the altarpiece. I am thankful to Professor Giuseppe Marchini, in 1965 Soprintendente in Urbino, for discussing these questions with me.

25. *Vite di uomini illustri del secolo XV,* ed. P. D'Ancona and E. Aeschlimann, Milan, 1951, p. 223.

26. B. Baldi, *Vita e fatti di Federico di Montefeltro duca di Urbino,* ed. Rome, 1824, III, p. 271. The marble tomb of the Duke in the right transept of San Bernardino was erected only in the early 17th century.

27. C. Maltese, "Opere e soggiorni urbinati di Francesco di Giorgio," *Studi artistici urbinati,* I, 1949, p. 60 ff. Maltese proposed *ca.* 1490 for the design.

28. Given the continuation of the diagonal of the Child by the arms of the Duke and the arrangement of the hands of the saints around his head, I can see no merit in the idea proposed recently that the figure of Federigo was not part of the original composition (Tolnay, *op. cit.,* p. 235).

29. See P. Rotondi, *Il Palazzo Ducale di Urbino,* Urbino, 1950, I, p. 357 ff., who believes the architect of the chapel was influenced by the design of Piero's painted church.

30. See A. Cinquini, "De vita et morte illustris. D. Baptistae Sfortiae Comitissae Urbini," *Canzone de Ser Gaugello de la Pergola,* Rome, 1905, Chap. viii, v. 36. I am most grateful to Marilyn Aronberg Lavin for kindly reminding me of this passage as well as for pointing out a couple of slips in my text.

31. The hair and the blue-gray mantle of the Baptist were painted over the hair and the gray habit of Bernardino. Similarly Jerome's left foot was painted over Bernardino's left foot. Where the flesh surface of Bernardino is scored, only the preparatory colors are visible, and no trace of the architecture behind. The saint at the extreme right was likewise painted over St. Peter Martyr. X-ray photographs of the painting show only one notable change: a large jewel on the forehead of the Virgin was painted out.

32. This is demonstrated by a survey of the representations before 1490 in Observant, Conventual, and other churches—an incomplete survey, but too lengthy to print here, especially because the result is not at all surprising.

33. *Vite,* p. 215. See also the story of Federigo's rescue of the snowbound friars of San Donato, told by Muzio, *ca.* 1552 (Dennistoun, *op. cit.,* I, p. 282).

34. In 1587 Baldi said that a wood model existed. See Rotondi, "Quando fu costruita," p. 194.

35. *Ibid.*

36. *Vite,* p. 215.

37. A contemporary wrote clearly that "Federigo . . . la fece sepellire cum magnifica . . . pompa . . . nel monastero de Sancta Clara. . . ." (J. Sabatino de li Arienti, *Gynevera de le clare donne,* ed. C. Ricci and A. Bucchi della Lega, Bologna, 1888, pp. 302–304). The church is not specified in the publication of the funeral oration of Campano (J. A. Campanus, *Oratio in exequiis Baptistae Sfortiae,* Rome, 1488).

38. See Dennistoun, *op. cit.,* I, p. 219; Clark, *op. cit.,* p. 48. The confusion is not surprising when already in 1603 Baldi (*Vita e fatti,* p. 187) said she was buried in "S. Chiara dell'Ordine degli Zoccolanti." On the church and convent of Santa Chiara see P. Rotondi, "Contributi urbinati a Francesco di Giorgio, 2. Il Monastero di Santa Chiara," *Studi artistici urbinati,* I, 1949, p. 106 ff.

39. See above, p. 116 and footnote.

40. *Ibid.*

41. Though I said only this (see also p. 116 f.), and that Battista is not represented, Tolnay, *op. cit.,* p. 235, ascribes to me the belief that the Countess was originally present in the design and suppressed after her death. [This entirely erroneous thought has now been repeated by E. Battisti, *Piero della Francesca,* Rome, 1971, II, p. 54.] He does not accept this view, nor do I.

42. Widmer, *op. cit.,* p. 324, said I appeared unaware of this normal role of the Baptist, and that he must be pointing specifically to the *crucified* Christ. The Child does not wear a cross, as Widmer stated, but the usual coral and a stone on a necklace of beads. Count Federigo was made a duke by the pope in August, 1474.

43. Though Dennistoun must have read Baldi's description of 1603—"dentro ad una cassa di legno appesa al muro"—he felt impelled to state that Federigo's body was originally enclosed in a marble sarcophagus (*op. cit.,* I, p. 283). For Baldi see above, note 26. The use of a wooden coffin might well have been motivated by the prospect of a transfer to the new church. Surprising, however, is the retention of the simple box as late as 1603. Could Federigo have requested this form of burial?

44. A. Bruschi, *Bramante architetto,* Bari, 1969, p. 732 ff., fig. 430, and, with the tentative attribution to Genga, G. Marchini, "Spigolature bramantesche," in *Atti del Congresso Bramantesco* (in press), p. 127.

8

La Sacra Conversazione di Piero della Francesca
Extracts

Color and Light

Each of the figures, exhibiting the peculiarities of Piero's late style, stands erect and composes a rather flat plane, "fluted" like the pilasters (fig. 88). Each figure is allotted an architectural compartment, and the curve they compose resembles the curved wall of the apse. In color, too, and even to a degree in texture the building echoes the figures. The whites, grays, pale greens, and reds of the saints and angels resound in the walls and the vaults. The veins of color in the marble have the random movement of the folds of drapery, and the capitals and coffers show the crisp, sparkling details of the angels and their jewels.

In the painting the partially masked, compressed space between figures and apse is not the only instance of visual ambiguity. The light streams into the church from high on the left; shadows fall toward the right, and the brilliant radiance of a rounded nave window is reflected in the metal shoulder-plate of the Count.[1] Light coming from a normal transept window would, however, not touch the top of the shell, the egg, or the apse; it would

From a booklet, *La Sacra Conversazione di Piero della Francesca, Quaderni della Pinacoteca di Brera* 1, Florence, 1971. Most of this text repeats, in somewhat different form, the content of the two preceding articles. From it I have extracted here only a few new observations and also comments on the views of other scholars which I was asked to include in that summary of the study of the altarpiece.

do so only if the depth of the choir were radically reduced.[2] Here Piero, like other Renaissance artists, did not hesitate to undertake "the unlawful application of laws perfectly understood."[3] Felice Feliciano felt the same freedom to depart occasionally from mathematical principles when designing capital letters.[4]

In other respects, too, Piero was not entirely single-minded. He cared less in the Montefeltro Altarpiece than in his major works of the early sixties, such as the *Meeting of Sheba and Solomon,* about balancing his design in the picture plane with that in space (fig. 74). As in the last works at Arezzo and, still more, in his lastest paintings—*Madonna* now at Urbino (fig. 17) and *Nativity* in London—he was willing to sacrifice part of the rich interplay in both dimensions of shape and color for the analysis of light, color and variegated texture.[5] The steel armor of the Count, the reflection on it of a window, the patterned carpet, the large crystal cross of St. Francis, the rich velvet tunic of the Virgin, the vermilion coral of Christ, the scintillating collars and bejeweled diadems of the angels—all these forms are vibrant with Piero's enthusiasm as a painter, whatever their courtly or religious significance. Even the mantle of the dweller in the wilderness, John the Baptist, is furbished with a golden border. Piero's visual intimacy with these objects was no doubt kindled by his study of Netherlandish, especially Eyckian, painting. Vasari reported, perhaps not correctly, that Federigo possessed a panel by Jan van Eyck; we know the Medici had one, and, as Marilyn Aronberg Lavin has recently reminded us, just when Piero was beginning the Montefeltro Altarpiece Justus of Ghent arrived in Urbino from Ghent to paint the related *Communion of the Apostles* for the Count. Indeed, it was probably Justus, as she argues, who painted the hands of the Count that we now see.[6]

Piero's growing interest in analysis rather than in generalization manifests itself in another aspect of the painting. He dwells on the structure of the bodies of the Baptist and St. Jerome, and indeed the articulation of Jerome's hand so close to the head of the sleeping Child seems relentless. Piero here has taken cognizance of the newer researches of Florentine painters, undertaken in the late work of his former teacher, Domenico Veneziano, and continued by Antonio Pollaiuolo and by Andrea del Verrocchio.

These ties with Florence, however, are less fundamental and certainly less momentous than those innovations in the Montefeltro Altarpiece that

were to have such great repercussions in Venice. Innovations they are, no doubt, but they emerge from Piero's earlier studies and accomplishments. The enveloping church, for example, is a way of embedding the figures in a defined circumambient space, of articulating the upper zone of the composition both in the picture plane and in space. The architectural umbrella serves the formal function of the mantle of Piero's earlier *Madonna of Mercy,* so unusually high and apsidal in its design, of Constantine's tent in his *Vision* at Arezzo, and of the embracing trees in the *Baptism,* in the *Death of Adam,* and the *Queen of Sheba Adoring the Sacred Wood.* While enriching in these respects the composition of the Montefeltro Altarpiece the architecture deepens its meaning by uniting the sacred figures and the donor in a church.

Federigo in Armor

Federigo, the best general of his time, enriched his small and relatively poor state by the exceptionally skillful and highly remunerative leadership of mercenary troops in the service of the great powers of the peninsula, Florence, the Papacy, and the Kingdom of Naples.[7] Although famous for his enthusiasm for the arts he was known primarily as a great *condottiere.* In the diptych Piero painted probably a few years earlier than the Brera Altarpiece. Federigo rides in a chariot, dressed in plate armor like that in the Brera Altarpiece. He appears as a soldier, his shoulders sheathed in armor, in portraits *en buste* on all of the eight medals dedicated to him. The reverse of the medal struck in his honor in 1468 shows not only his emblem of the eagle and an olive branch but his cuirass, sword and shield (fig. 112). "Invictus Federicus" states the inscription.[8] Even though Justus of Ghent represented the Duke absorbed in a weighty tome in the large portrait he painted *ca.* 1476 probably for the *studiolo,* the Duke wears armor beneath his rich red mantle (fig. 100)—the only military figure amidst that famous assemblage of philosophers and writers from the more remote and the recent past. On the floor near the Duke rest his baton, his helmet, and part of his armor, as in the Brera Altarpiece, though more compact and less formally displayed.

A military man could appear before the Madonna in the garb of his profession; several such ex-votos of the fourteenth century, Tuscan as well as North Italian, have survived (fig. 113).[9] We know that Federigo was an

exceptionally pious man, even in military service. If the altarpiece was painted between July 1472 and the summer of 1474, as I proposed above, it would have followed closely on his spectacular conquest of Volterra on June 18, 1472, perhaps the greatest triumph of his military career.[10] This event might well have played a role in the display of armor. We should recall that Duke Francesco Gonzaga in armor kneels below the Madonna in the altarpiece painted by Mantegna to celebrate the victory of Fornovo in 1495.

It is true that all the portraits of Federigo that I have cited above are secular, or at least not in a primary religious context. In the two portraits that represent him in a religious setting—the *Communion of the Apostles* in Urbino and the *Lamentation* of *ca.* 1475 by Francesco di Giorgio in the Carmine, Venice—he appears in mufti. This fact alone should lead us to consider attentively the opinion recently expressed by Marilyn Aronberg Lavin that the donor in armor is the key to the meaning of the Montefeltro Altarpiece.[11] She recalls that Federigo, who had been living quietly in Urbino since the death of his wife in 1472, petitioned Rome in May 1474 for approval of the marriage of his daughter with a nephew of Pope Sixtus IV. Despite the favorable view of the Pope the Cardinals at first disapproved, but by summer they became convinced of the Count's loyalty to the Papacy. At that time Federigo, with papal support, was showered with honors. He was elected to the Garter on August 18, and immediately afterward the King of Naples bestowed the Order of the Ermine. In a ceremony in St. Peter's on August 21, the Pope created him Knight of St. Peter, Duke of Urbino, *gonfaloniere* of the Church, and general of a new Vatican league. Dr. Lavin believes that the altarpiece was "conceived, and probably finished, in respectful anticipation of Federigo's ultimate accreditation in Rome." Since the painting would thus anticipate rather than celebrate the event, it does not include signs of any of Federigo's honors, either secular or religious, so that the interpretation cannot be confirmed by the inclusion of the symbols granted by the Pope, such as the banners of the *gonfaloniere,* the golden chain, or the ducal hat. St. Peter himself is not present in the painting to bear witness to his new knight. A church, however, is there and also the Virgin as the symbol of it. But she does not turn toward him, and in all respects Federigo is much less closely related to her than to the Child. Although, like all the figures in the painting, he remains detached, with distant gaze, he is

emphatically joined to the Infant by the strong diagonal of which we have spoken.

There remain the baton and the pieces of armor displayed so prominently below the enthroned Madonna. They may symbolize gratitude for military victories, or even the fulfillment of a particular vow. Or perhaps, as Dr. Lavin proposes, they serve to fulfill a specific pledge of fidelity to the papacy. Seeking an answer, we may ask how much of the character of these forms, so different from those painted by Joos (fig. 100), is due to the setting and, finally, to the *art* of the great geometer? I have, indeed, asked this kind of question about the ostrich egg, but that was less difficult to answer because the egg was a current symbol. The interpretation of the church raises the same problem, because it had been employed earlier in Quattrocento painting for gatherings of saints and the Madonna (fig. 18), and because Piero himself had chosen similar forms earlier. Whether under Piero's influence or not, within a year or two Antonello da Messina and Giovanni Bellini firmly established the ecclesiastical setting in the tradition of the Venetian and North Italian *Sacra Conversazione*. Indeed the fifteenth century in general developed, more than any earlier period, specific settings. The Virgin Mary, for instance, received Gabriel in a well defined bedroom, and St. Jerome acquired a splendid, well-stocked study. By the mid-fifteenth century the image of the sacred figures assembled within a church was clearly "in the air."

Unlike the armor and the church the supine, sleeping Child does not seem characteristic of Piero. Thus it may be more readily suspected of special symbolical meaning and of a specific personal allusion. The Infant's posture, moreover, does not seem to suggest a ritualized expression of a formal relation of the Count with the papacy. For these reasons I incline to prefer my old interpretation, with its suppositions about the association of the Incarnation with the birth of Federigo's first son, as well as an allusion to the death of the Countess and now—thanks to Dr. Lavin's focus on the armed donor— the great contemporary conquest of Volterra. These allusions conform, it seems to me, to a greater degree with the tradition and function of the Italian altarpiece. Of course both Piero and his patron were quite capable of originality, and I admit that while the ostrich laid very large eggs, it did not inscribe them.

Postscript

E. Battisti, *Piero della Francesca,* Rome, 1971, II, n. 435, called attention to
the observations on Federigo's armor by L. G. Boccia and E. T. Coelho,
L'arte dell' armatura in Italia, Milan, 1967, p. 143, pl. 101. They date the
armor in the late fifties, and they believe, therefore, that he would not be
wearing it in a monumental painting much later than that date. The style of
the armor, these scholars say, is earlier than that of the armor the Duke wears
ca. 1475 in the portrait by Joos van Gent (fig. 100) and in the intarsia of the
studiolo. We thus seem to acquire additional evidence against the late date
(*ca.* 1480) held by two or three historians of art.

NOTES

1. C. Gottlieb, "The Mystical Window in Paintings of the Salvator Mundi," *Gazette des Beaux-Arts,* LVI, 1960, pp. 313–332, and J. Białostocki, "The Eye and the Window," in *Festschrift für Gert von der Osten,* Cologne, 1970, pp. 159–176.
2. See the discussion above of the size of the egg—p. 131.
3. J. Shearman, "The Logic and Realism of Piero della Francesca," in *Festschrift Ulrich Middeldorf,* ed. A. Kosegarten and P. Tigler, Berlin, 1968, p. 183.
4. See below, p. 179.
5. Comparison of the composition with the somewhat later *Sinigaglia Madonna* is especially instructive (fig. 17).
6. M. A. Lavin, "The Altar of Corpus Domini in Urbino: Paolo Uccello, Joos van Gent, Piero della Francesca," *Art Bulletin,* XLIX, 1967, p. 22.
7. J. Dennistoun, *Memoirs of the Dukes of Urbino,* ed. E. Hutton, London, 1909, I, pp. 61–299.
8. G. F. Hill, *Corpus of Italian Medals of the Renaissance,* London, 1930, pls. 12, 47, 48, 50, 71, 185.
9. See also *Madonna with Six Saints and Donor in Armor,* Sienese *ca.* 1365 (circle of Lippo Vanni, private collection, photo Barsotti, Firenze); fresco on left wall, Minutolo Chapel, San Gennaro, Naples, 14th century. M. Lavin, "Piero della Francesca's Montefeltro Altarpiece: A Pledge of Fidelity," *Art Bulletin,* LI, 1969, p. 368, cited Veronese Trecento frescoes of the third quarter of the Trecento.
10. Dennistoun, *op. cit.,* I, pp. 208–213.
11. Lavin, *op. cit.,* 1969, p. 367 ff.

PART III

9

Toward a More Comprehensive Renaissance Palaeography

Of all the accomplishments of the cultural renewal in the fifteenth century the basic change in the symbols of writing has proved one of the most durable, for its results are still clearly with us today. Though the story of the abandonment of "Gothic" and the restoration of "Roman" has, of course, often been told, it has nevertheless been told briefly, with interest concentrated on the early stages of the development and on the design of type in the first printed books.[1] But even for the initial period at the beginning of the fifteenth century many of the important documents have not been published, so that despite a few valuable essays we are still not well informed about the sources or the contributions of the pioneers, such as Niccolò Niccoli and Francesco Poggio. This lack of close investigation is probably due to the weakness of a motive that usually serves as a powerful stimulant of palaeographical studies: the wish, indeed the need, to classify objects or documents on grounds of script. Our comparatively greater knowledge of the production of Renaissance art and history has checked the growth of interest in their script. This is regrettable for aesthetic as well as historical reasons, because few periods in Western history have produced writing of such great beauty.

The existing studies are centered on the early texts of the humanists (always unillustrated) and their correspondence, largely to the exclusion of contemporary or indeed later illuminated manuscripts, and almost all atten-

This article was published in the *Art Bulletin*, XLII, 1960, pp. 97–112.

tion has been turned to the development of minuscules. Very little has been said about capitals, though we shall before long, I hope, learn from Dario Covi about their vicissitudes in the inscriptions on Quattrocento paintings.[2] Nothing, however, has been written or, so far as I know, promised on epigraphy. The inscriptions on buildings or, more important, on sculptures have simply been omitted from palaeographical discussions.

Without a consideration of the epigraphs of the time, studies of Quattrocento majuscules are especially incomplete because it was the Roman epigraph, not Roman script, that could and did communicate to subsequent ages the most refined and the most majestic specimens of the revered *litterae antiquae,* and the forms of these ancient epigraphs were in general studied by architects and sculptors rather than by humanist scribes. Though Renaissance scholarship is thus laggard in palaeography and nonexistent in epigraphy, it is not, curiously enough, far behind the long-established disciplines centered on the ancient world. For it is only in recent years that scholars have sought to draw Roman palaeography and Roman epigraphy together into a more comprehensive historical study.[3] This marriage of disciplines, or at least of fields, has occurred for a specific purpose: a more adequate history of Roman writing viewed aesthetically, as style.

A similar union in Renaissance studies is much to be desired. In the art of this period, letters, for one thing, may become free-standing lapidary monuments, as I pointed out a few years ago.[4] They may assume a monumental scale on buildings, as in the handsome inscriptions *all'antica* inlaid in the friezes of Alberti's façade of the Tempio Malatestiano after 1450, of Santa Maria Novella dated 1470, or of the *Sepolcro Rucellai* dated 1467 (fig. 134). Artists themselves crossed the boundaries between palaeography and epigraphy by introducing into paintings the *simulated* epigraph (figs. 136, 137, 139). It may be that the normal differences between writing (even formal) on the surface and cutting in stone, which reflect a difference of function as well as of technique, are diminished during this time. Apart from "counterfeited" inscriptions, however, writing still tends to differ inherently from incision, so that a comprehensive palaeography is complex and difficult.

The present paper can of course do little more than stress the usefulness of this larger enterprise; the task itself will have to be undertaken by specialists. It does, however, seem possible even now to show that efforts in this broader field will be fruitful. That much is indicated by the exploration of

one problem, limited though the exploration be by the inexperience of a layman. The problem is one with which I had to deal in a still more benighted state three years ago: the emergence around the middle of the century of what I identified as a new type of majuscule. The considerations that follow were stimulated both by the recognition at that time of the inadequacy of our knowledge and by questions about sculptors' inscriptions put to me by H. W. Janson and Richard Krautheimer, who have generously helped me begin to answer them by supplying excellent detail photographs of statues by Donatello and Ghiberti.

There is no need to dwell here upon the early stages of the great palaeographic reform, upon Petrarch's modification of the current *bastarda* to produce a more legible and more beautiful—because more antique—script,[5] nor upon the creation in the early fifteenth century in Florence of the *scriptura humanistica* (figs. 114 and 115). The humanists responsible for this innovation, chiefly Niccoli and Poggio, shaped their script upon models variously identified as Carolingian (fig. 146), Ottonian, or Romanesque, all judged by the early Quattrocento to exemplify *lettere antiche*. The capitals developed by these humanists have a delicacy, attenuation, and simplicity that may be compared with early Quattrocento forms in sculpture or architecture. In the script of Niccoli (fig. 114), as of his contemporaries generally, the letters are set closely, and the vertical accent is enhanced by raising L and occasionally other letters above the line. To produce a sparkle, small spidery horizontal serifs (or even pendant ones on L) are common, and the horizontal bars of E and F cross over the verticals. There is not much shading, that is, variation in the width of the strokes in the several parts of a letter. The foot of R in the specimen reproduced, for instance, is lighter than the vertical and the bowl, but the three strokes of N and the two legs of A are approximately equal in weight. F, curving above the other letters, preserves a little of the ornamental individuality of Italian *bastarda,* which Petrarch had characterized as *vaga ac luxurians* but tiring to read.[6]

Poggio's F was still more florid than Niccoli's, and he adopted a cross-barred I, which gave this letter a greater accent and a closer relationship to E, F, and other capitals.[7] Antonio di Mario elaborated these forms in the second quarter of the century, introducing occasionally for greater variety such a form as uncial E (fig. 115). Amidst a considerable variety of manners in Florence at this time his script may represent for us the ornamental tendency,

while an example of the fifties from the shop of the great stationer Vespa-
siano da Bisticci, still in the same fundamental style, shows a greater clarity
and simplicity (fig. 116).[8]

If now after this thumbnail sketch of the advanced Florentine majuscule
in humanist texts of the first half of the fifteenth century we turn to the first
epigraphs of the great sculptors, we recognize in the words on the scroll of
Ghiberti's *Baptist,* made in 1412–1416, a style basically related to humanist
script (fig. 117). The letters are equally light, closely set, and as tall as the
written specimens we have reproduced. Still, there is a difference. Ghiberti's
letters were not produced, like the script, freehand. They follow a studied,
carefully drawn pattern, and they possess both greater regularity and stability,
and greater refinement. Each of the letters, including its delicate serifs, is
endowed with internal symmetry and balance. They reflect a desire for a style
that is, in the words of Lorenzo Valla, *planius, apertius,* and *distinctius.*[9]
These beautiful capitals seem to presuppose a return to ancient sources them-
selves, to Roman epigraphs (figs. 122 and 123).

In subsequent work Ghiberti somewhat modified his majuscules: on both
the book of *St. Matthew* (1419–1422) and the signature on the North Door
the letters gain in weight but not in character.[10] But when, later in his
career, inscriptions assumed a special prominence on his monuments—the
Shrine of the Three Martyrs (1426–1428)[11] and the *Shrine of St. Zenobius*
(1439–1440, fig. 118)—he rendered them in a style remarkably like that of
the scroll of the *Baptist.* In his own account of his career he refers to the
majuscules on the *Shrine of St. Zenobius* as *lettere antiche,*[12] and he would
surely have characterized the inscription on the early *Baptist* in the same
terms.

A palaeographic style similar to Ghiberti's, and like his possessing some
of the general qualities of humanist script, may be recognized on the major
monuments of Florence up to the late sixties. The light, attenuated, close-set
capitals were employed by Luca della Robbia on the *Cantoria* of the Floren-
tine cathedral (*ca.* 1435; fig. 119), by Bernardo Rossellino on the tomb of
the Beata Villana in Santa Maria Novella (1451–1452; fig. 120), and by
Benedetto da Maiano on the tomb of St. Savinus in the Cathedral at Faenza
(1468–1470).[13] Each of these sculptors, and indeed each of these epigraphs,
has of course a distinctive style. Luca della Robbia, for instance, uses a
curling flourish to indicate the unusually numerous abbreviations on the *Can-*

toria (fig. 119). The capitals on Desiderio's epitaph on the Marsuppini tomb in Santa Croce (1453–1454) are somewhat stumpier, and the horizontal rhythm of the line is stronger.[14] But the similarities in these inscriptions are greater than the differences. They all possess what Ambrogio Traversari described as *puritas* and *suavitas*.[15] There is continuity and what may be called, I think, a strong palaeographic tradition.

This Florentine tradition of the early Quattrocento is best represented perhaps by an inscription that with regard to form as well as content was the subject of special consideration in Florence—the epitaph on the tomb of the great citizen and scholar Lionardo Bruni made by Bernardo Rossellino in the late forties (fig. 121). In this beautiful inscription the grace and austerity of the Florentine epigraphic style are combined. The letters are tall, narrow, and closely set. Individually light in weight, they unite to form a compact word, which in turn fits tightly into the line. Within such controlled geometric simplicity, whimsy and flourish have no place. There are only two ligatures, in MIGRAVIT and, partially, in GRAECAS. Even the animation of serifs is curtailed, and shading is limited essentially to the slight clubbing of the bar at its terminus. The several parts of a letter are quite even in weight: the two legs of H or of A, for instance, or the vertical and the three horizontals of E. The two serifs of T or of C are almost identical. Though the individual capital is not conspicuous for its independence in the line, each possesses an impressive symmetry and balance.

While the origin of the new book-hand of the early Renaissance has been traced to models produced during or in the wake of Carolingian reform, it is generally assumed that the new epigraphy was derived directly from the ancient monuments themselves. It is assumed also that the ancient monuments presented to the Renaissance a single more or less invariable, paradigmatic style. Epigraphs were, however, produced throughout the course of Roman history, and the examples visible in the fifteenth century must have extended over a period of at least six or seven centuries. These extensive Roman remains differed considerably in character, and it is legitimate to ask whether the Quattrocento artists recognized these differences—whether, in other words, Florentine style resembles one era of Roman epigraphy more than another. The possibility of answering this question depends at the outset upon a developed history of the palaeography of Roman epigraphs. Though epigraphy is an old discipline, a stylistic history of this kind has only been

proposed and begun in recent years, especially by A. E. and J. S. Gordon in publications of 1957 and 1958. The Gordons have published only their work on Imperial epigraphs in and around Rome from Augustus to Nerva; the volume on the Republican period is to follow.[16] Still, they have identified and partially characterized two periods: Republican, and Imperial to the end of the second century.

Early Renaissance epigraphs in their larger aspects seem to resemble Republican examples: Republican letters are equally light in weight, their module or proportion is similar, and they are set comparatively close in the line (fig. 122).[17] Foreign to both these groups is the wide and even spacing of capitals in Imperial epigraphs (fig. 123).[18] Shading in lapidary lettering—the varying width and depth of the members—is undeveloped in both early Renaissance and in Republican epigraphs, but it began to be employed in antiquity early in the first century A.D.[19] The use, indeed, of members of different breadth and depth in one letter is one of the major innovations of Roman epigraphy at the beginning of the Imperial age.

In all these qualities early Florentine epigraphs remind us of pre-Imperial ones, and there are some subtler relationships also, such as a symmetrical A. In detail, however, the similarities with Imperial epigraphs seem to be more numerous, although the range of variations in both periods remains to be established, and generalizations cannot now be based on very solid foundations. The second cross-bar in the Florentine E and F, usually as long as the first, approximates the slightly diminished Imperial bar more than the greatly reduced Republican one.[20] O is oval, closer to the Imperial oval than the Republican circle. In the Republican R the foot usually takes off from the vertical, whereas in the early Renaissance, as in the Empire, it drops from the bowl.

It would be gratifying to assert that the early Florentine humanists, who were greatly attracted by Republican Rome and who revised the date of the decline of that nation in accordance with their preference for the Republic over the Empire, manifested a corresponding preference for Republican epigraphy also. I know, however, of no contemporary statement that would suggest that the humanists had learned consciously to distinguish the style of the two eras. The early epigraphers, like their modern successors, were preoccupied with content and relatively indifferent to style. Neither the sylloge of Ciriaco nor—still less—those of Marcanova and Feliciano disclose, so far

as I can see, an intention to attain a high visual fidelity to Roman models. More important, the facts of the relationship of Roman and Renaissance epigraphy would not seem to support the supposition of such a preference. The problem is greatly complicated, in addition, by the variations in Roman epigraphical style in regions distant from the metropolis.

The truth may be that the Florentines, with their strong convictions about style in all the arts, were translating Imperial epigraphy into an idiom that happened to resemble Republican. There is also the possibility that the style of another era played a significant role. I refer to pre-Gothic or Romanesque, especially Florentine (fig. 124), which, despite occasional uncials, irregular lines, and intertwined letters, often has capitals of very similar weight, module, and symmetry.[21] Inscriptions of this character were to be found on the buildings of the eleventh and twelfth centuries which sculptors and architects such as Brunelleschi, Donatello, and Ghiberti were then studying intently, and the whole phenomenon of a connection between Renaissance and "proto-Renaissance" epigraphy would be an intriguing subject of study.

In the preceding account of the inscriptions of Quattrocento sculptors those by Donatello were omitted, for reasons that will shortly become apparent. One of the earliest, and the longest, is on his tomb of Giovanni Pecci, who died in 1426 (fig. 125). The artist's signature, strangely placed and a little cruder than the epitaph, seems to have been an afterthought.[22] The rather spindly letters of the epitaph look as though they had been drawn freehand, and they have indeed the shapes as well as the fluency of contemporary script (figs. 114 and 115). I is barred in the manner favored by Poggio and Antonio di Mario (fig. 115). The foot of R takes off from the vertical, as in early humanist script, and not from the bowl, as (usually) in epigraphs.[23] Inscriptions on the earliest Renaissance paintings—on the *St. Anne* of about 1422 by Masolino and Masaccio,[24] and above the skeleton by Masaccio in Santa Maria Novella (fig. 126)—resemble the Pecci epitaph and seem to derive likewise from contemporary script, but the letters are somewhat heavier and more regular.

The two very similar signatures on the bases of the *Zuccone* (probably 1423–1425) and the *Jeremiah* (probably 1427–1435)[25] are more refined and more authentically epigraphic than the Pecci epitaph, and they resemble more the inscriptions of Ghiberti (figs. 127 and 128). There are subtle differences between the two signatures, and the one on *Jeremiah* shows a

more open P, epigraphic evidence, it may be, that supports the later dating of this statue on grounds of style.[26] The character of the epitaph on the sarcophagus of Coscia (probably 1426–1429) is, however, quite different, showing more regular, exceptionally bold-faced, though still closely set letters. Since we know that on this tomb Donatello had associates, Michelozzo, Pagno di Lapo, and others, it seems probable that one of them was responsible for the design of this rather cold and pretentious inscription.[27]

After the signature on *Jeremiah* the next extant inscription on a work by Donatello is the signature on the pedestal of *Gattamelata* (fig. 129). Documents prove that the pedestal was under construction in 1448, and the signature must be of that date, or at most a year or two later.[28] The inscription has been photographed from below, so that the letters appear shortened, but it is nevertheless evident that Donatello's epigraphic style—there seems to be no good reason for questioning his authorship—has changed. While the signature is still reminiscent of the earlier Florentine tradition, the letters are broader and the serifs are larger. The shapes of the capitals, more carefully studied, are regular and geometric.

The new tendencies are more developed in the signature on the *Judith* of 1456–1457, the last inscription by Donatello that has come down to us (fig. 130). In it we recognize a new style. The module has been radically altered to produce broader letters. The strokes or bars are wider and deeper, and shading has been greatly increased. In O, for example, the thinnest sections (as usual in Roman and Renaissance epigraphs, on an axis just to the left of the perpendicular) are not more than a quarter the width of the thickest sections. There is a crescendo of weight in the three bars of A—from the horizontal to the left leg to the right leg. N has a diagonal that is about twice the width of each of the verticals. The bowl of P, which is open, diminishes as it approaches the vertical. The vertex of A is not simply a ridge but notched on the left. Serifs are larger and they move out into the proportionately wider spaces between the letters. Altogether each of the letters possesses a novel weight and independence and also a novel linear and plastic energy.

Two or three years before Donatello signed the *Judith*, Mantegna wrote his name on a *cartellino* in his painting of *St. Euphemia* in Naples (fig. 131). This is one of the earliest *cartellini* known to me. Perhaps the first surviving example is in Fra Filippo's *Madonna* now in the Palazzo Barberini, Rome

(fig. 15). The panel was painted in 1437 shortly after the master had visited Padua and thus, though prepared by Trecento ventures into still life, the *cartellino* may have been inspired by an illusionistic inscription on a Netherlandish painting that Fra Filippo had seen in that city.[29] Mantegna, working in the same center, sought to give a similar but more effective facsimile of soiled and crumpled paper, though he preferred to keep the letters themselves free of such accidents of nature. One wonders whether Mantegna's *cartellino* was inspired by the same models that presumably affected Fra Filippo; indeed there are other aspects of the *St. Euphemia,* as we shall see below, that raise the suspicion of Netherlandish inspiration. Still, the illusionism of both Lippi and Mantegna assumes a different specific form: a *cartellino* rather than the simulated epigraph favored by Jan van Eyck. Jan's inscriptions frequently give the illusion of incision; they are identified, in other words, either with the frame or the architecture of the painting. Mantegna, on the other hand, gives the impression of adding to a finished "monument" of great durability a casual, temporary ticket of authenticity written on a scrap of paper he happened to have around the shop. A little later Pollaiuolo employed a related means of authentication, but with a more antique connotation, in his *Battle of the Nudes,* hanging a *tabula ansata* inscribed with his name on the branch of a tree. In this way the Italian Renaissance painter separates himself more from his handiwork.[30]

The palaeographic form of Mantegna's signature is remarkably similar to Donatello's on the *Judith* (fig. 130). It possesses every one of the sculptor's qualities that we have enumerated, even the heavy diagonal of N, the notched vertex of A, the broad, tapering bowl of P, and the long, fine serifs. The only conspicuous divergence is Donatello's use of large interpuncts— stylistically consistent with the letters as sharply pointed rhomboids with concave sides. Otherwise, there are a few differences of detail: Mantegna's E has a shorter middle bar, and the two serifs on Donatello's T are oblique and parallel whereas the one at the right in Mantegna is vertical.

There would certainly seem to have been some palaeographic exchange between these two artists, both working in the same town until late 1453, when Donatello left Padua for good after about ten years of residence.[31] The known dependence of the young Mantegna's art upon Donatello's would lead us to suppose *a priori* that in matters of palaeography the relationship between the two was of the same order. Certainly an early stage of

the new majuscules appears on the pedestal of *Gattamelata,* and Mantegna must have learned in this sphere too from the great Florentine sculptor. The refinement of the new letters was, however, in part at least the work of the painter. He strengthened, for instance, the soft P that still appears in Donatello's signature on the *Judith,* and he differentiated more decisively between the horizontals of E. It is in his letters that the new qualities are more consistently developed.

The signature on the South Pulpit in San Lorenzo is in the style of that on the *Judith,* but later, weaker, and disturbed by a curious graduate diminution from the top to the lowest row of letters. It is probably imitative and posthumous, as has been suggested,[32] but in any event it shows that the new style was established in Donatello's workshop. This style seems to have affected also the "signature" DONATELLO on the statue of "St. John" on the campanile.[33] The letters, though preserving much of the earlier Florentine character, are squarer and spaced more widely, so that the inscription would seem to have been applied, not around 1430 but after the late fifties, perhaps in imitation of the epigraphy of the twenties. Its style would thus seem to confirm the opinion, already advanced for other reasons, that it is not a genuine signature but was inscribed at the time of the rearrangement of campanile statues by the *operai* in 1464.[34]

In general Donatello's new epigraphic style seems not to have had much effect in Florence, either on scribes (fig. 116)[35] or on sculptors. In the late Quattrocento in that city as elsewhere in Italy there was, it is true, a tendency toward squarer letters, wider intervals, and greater shading, as on Antonio Rossellino's tomb of the Cardinal of Portugal in San Miniato. Two superb inscriptions of the late sixties and early seventies—Alberti's on the *Sepolcro Rucellai* (fig. 134) and Verrocchio's, probably influenced by Alberti, on the Medici tomb (fig. 135)—show nevertheless the persistence of the restrained measure and spare elegance—the *puritas* and *suavitas*—of the Florentine tradition. The letters, with very small serifs and almost imperceptibly graduated variations of weight, very nearly fill the space in which they are placed. They have a new strength and majesty, and they seem to rise in the frieze like caryatids that support the cornice above. The majuscules of the greatest artist active at the court of Urbino are consistent with the palaeographic conservatism of central Italy. In the important inscriptions on his portraits of the Duke and Duchess, painted probably in the late sixties, Piero della Francesca

still avoided serifs and employed uncial E as well as the non-classical M with the apex of the central angle high above the base line rather than in it.

We possess no inscription that can definitely be ascribed to Mantegna before the signature of 1454. The letters around the monogram in the fresco on the Santo have been repainted, but the epigraph below this fresco bearing the date 1452 is generally assumed to have been cut into the stone after a drawing by the painter (fig. 132). Its content is pretentious, but the signature on the lost altarpiece of 1448—ANDREA MANTINEA PAT. AN. SEPTEM ET DECEM NATUS SUA MANU PINXIT . . .[36]—is not without exceptional self-consciousness and pride either. The letters of the epigraph on the Santo are related to those of 1454, but taller, more symmetrical, and more closely set, in short more traditional. The straight serifs and the general rigidity may be due to the more refractory material, but the serifs are surprisingly large, the letters heavy, and R and G have forms which do not recur in Mantegna's majuscules. The design of this inscription cannot, I believe, be ascribed to Mantegna, nor even to the period of the painting, without further evidence. . . .

The inscription below the portrait of Marcello in the Arsenal *Passion of St. Maurice,* completed before June 1453, is interesting as one of the early Italian simulated epigraphs, but it is not very instructive palaeographically because, as a cryptogram, it is composed of deliberately outlandish letters.[37] The inscription below *St. Maurice* and the words on the scroll in the *Dialogue* of the same manuscript are written in gold and hence, like all gold letters, are less refined than those written in ink. As Dario Covi has rightly pointed out,[38] they resemble closely the titling capitals on adjoining folios, and it seems probable that the scribe rather than the painter is responsible for these inscriptions. One would not expect Mantegna to permit this sort of invasion of his province, and its occurrence might be considered evidence against his authorship of the miniatures. It should, however, be said that the humanist patron Marcello, who composed the text, was unusually close to all aspects of the execution of this manuscript. The majuscules in question, furthermore, are far more Roman than those in the slightly earlier, main section of the manuscript, and they reflect a new experience of some sort.

The signature on the *St. Euphemia* thus remains the earliest certain example of Mantegna's majuscules, but it does not hold this honor alone. For the saint's name is written on the arch in this painting (fig. 133), the letters

somewhat displaced to be sure by the pendant festoons, but large and ma-
jestic. Now, references to Mantegna's inscriptions have hitherto assumed the
existence of only one style. But in *St. Euphemia* Mantegna has used different
letters on the arch than on the *cartellino*. For whereas the capitals on the arch
resemble in some respects those in the signature—see, for example, the low-
est horizontal of E—their weight and shading are greatly reduced, their serifs
are curtailed, and their height is increased.

Why, we wonder, should Mantegna have employed these two styles in the
St. Euphemia? The very light capitals on the arch are certainly not intrinsi-
cally more monumental than those on the *cartellino*. Were they, then, in-
tended as more appropriately Roman for the arch of this late Roman (early
fourth century) martyr? Without implying an immediate answer we should
say that capitals of similar style appear in the famous epigraph in Mantegna's
fresco of the Judgment of St. James, painted a little earlier, and this epigraph
not only appears on a Roman triumphal arch but is a copy of a Roman
inscription (fig. 136). This inscription, we know, was on a votive stone that
stood at Monte Buso, Este, and the whole was exactly the kind of monument
that Mantegna and his friends, including the epigraphers Feliciano and
Marcanova, hoped to find as they set out on the celebrated archaeological
expedition of 1464.[39]

It is, in fact, Marcanova who, in his collection of Roman epigraphs begun
in 1457 in Padua and finished in 1460 in Bologna (fig. 145), informs us
where the stone was.[40] The epigraph was used also by Jacopo Bellini, as is
well known, for one of his more or less fanciful monuments in the Louvre
codex.[41] Jacopo's version differs slightly from Mantegna's. One would of
course expect Mantegna, the great antiquarian, to be more accurate, but—
caveant historici—the opposite in this instance is true. In the last line of the
fresco S is reversed (shades of Ghiberti!), perhaps testimony to the presence
of an assistant not yet initiated into the splendors of the *litterae antiquae*. In
the fresco too Pullius Linus is qualified, perhaps accidentally, as ɪɪɪɪɪɪ *vir,*
that is, one of the *septemviri,* members of a Senatorial priesthood, whereas in
Bellini's inscription he holds the lower and much more common office of the
seviri.[42] Bellini concurs in this respect as well as in all others (except linea-
tion) with Marcanova and later epigraphers.[43] Other epigraphs by Bellini,
however, prove that he was not normally less inaccurate than Mantegna.[44]

Mantegna is again not quite correct in the epigraph on the arch in the

fresco of St. James on the Way to Execution (fig. 137). He has there in-
scribed in a medallion the signature of the architect of the so-called Arco dei
Gavi in Verona, L. VITRUVIUS L. L. CERDO, whom he may have confused with
a far better-known architect, Vitruvius Pollio. The actual signature of the
architect is said to have appeared twice on the intrados of the arch, and one
of the inscriptions, palaeographically related to Mantegna's, has even been
tentatively described as a Quattrocento copy of the first-century original (fig.
138).[45] Mantegna abbreviated the architect's name to L. VITRUVIUS CERDO,
but while recorded in full it is corrupted to CAERDO by Marcanova (after
Ciriaco?) in the Bern manuscript, to VITURVIUS in the Princeton copy of
Marcanova's Modena manuscript, and to VITRURIUS in Feliciano.[46] Perhaps
Mantegna's inscription was drawn directly from the original, which is in two
lines. To adapt this to a medallion the painter used three lines. He made the
letters in the lower lines much squarer than those above, he dropped L. L.,
and he separated, *horribile dictu,* ARC from HITETUS. Worse still, he shortened
and, as it seems, italianized the last word by dropping a C.[47] This inscription
is a year or two later than the one in the *Judgment* (fig. 136). Its style is
different, and the last two lines, with their squarer letters, resemble the
signature on *St. Euphemia* (fig. 131).

Because of Mantegna's error in the epigraph in the *Judgment* as well as
the more obvious fact that many of the letters are concealed by the figures
(fig. 136), we can be certain that his inscription in the fresco was not the
source of Bellini's. The reverse, however, is possible, especially because Bel-
lini's inscription appears properly on a votive stone. The tall, light, close-set
letters, on the other hand, though used elsewhere by Mantegna, are unusual
among Bellini's simulated epigraphs. Bellini's other inscriptions show
squarer, more widely set letters, visible also in the signature on the Lovere
Madonna, and if they can be dated before 1450 they are harbingers of the
new style of the mid-century.

The sources of Mantegna's inscriptions, whether the Roman original or a
sylloge, remain to be ascertained, but the fidelity of their *style* to the Roman
model varies, in any event, according to another principle. Though the votive
stone in Monte Buso no longer exists, the inscription on it can be dated in the
late first or second centuries.[48] The epigraph as it appears in the fresco of
the Judgment, however, is not characteristically Imperial (fig. 136), at least
not Imperial in the sense of metropolitan Rome (fig. 123). Letters very

similar to those in the *Judgment* may, however, be seen on the arch of *St. Euphemia,* so that we may conclude that they represent Mantegna's majuscular style of 1453 (when the *Judgment* is often dated) and 1454. The signature of the architect Vitruvius in the *Way to Martyrdom* (fig. 137), usually dated 1454–1455, exhibits two styles, that of the upper line similar to the inscriptions of the *Judgment* and the arch of *St. Euphemia,* that of the two lower lines closer both to the signature on *St. Euphemia* and, so it seems, to the Imperial epigraph itself (fig. 138).

It was apparently in 1454–1455, then, that Mantegna made a palaeographic change, first in a small signature where he could be more venturesome, and then some months later on a larger scale in a fresco. The new style, more boldly announced in the signature, approximates Roman Imperial epigraphy not only with regard to details of shape but also in its module and shading (fig. 123). In other words those qualities, identified above, that are novel in Mantegna's signature of 1454 and that relate it so closely to Donatello's signature on the *Judith* (fig. 130), are characteristic of epigraphic style in Rome from approximately the beginning of the Imperial era, as we have described it above. May it suffice to point here to the particular fact that the Imperial ratio of the horizontals to the verticals in E, F, and L, ranging from 2:3 to 4:5,[49] is visible in the signatures on the *St. Euphemia* and the *Judith* but not on the arch of *St. Euphemia* or the *Judgment.*

Mantegna's third epigraph in the Chapel, in the fresco of St. Christopher, is in the style of the CERDO ARCHITETUS or the *cartellino,* though it is more refined (fig. 139). Thus it contradicts the recently revived hypothesis that this fresco is relatively early,[50] and it supports the usual view that this is the latest work by Mantegna in the Chapel.[51]

While the similarity of the signature on the *St. Euphemia* with the later simulated epigraphs in the Ovetari Chapel is clear, the capitals of the signature retain a certain distinctiveness because they are intended to appear written rather than incised. They are not geometrically constructed but the work of a free hand. Their peculiarities as written letters are made especially evident by comparison with the incised letters that most closely resemble them, the signature on the *Judith,* even though here when choosing a cushion for the inscription Donatello wanted a rather informal effect (fig. 130). The strong accents of Mantegna's capitals suggest the influence, alongside ancient epigraphs, of pre-Gothic written letters, perhaps Carolingian (fig. 146). The

originators of the Carolingian reform had already derived from late Roman models letters of considerable weight, strongly shaded. Their capitals possess details, such as T with asymmetrical serifs, that may be seen in our mid-fifteenth-century examples. N has a very heavy diagonal and light verticals. In early medieval script too (fig. 146) there appear many telescoped letters of the kind that Donatello introduced in the signature on the *Judith*. The scribe of the *Strabo,* presumably under Mantegna's influence, used them in the titles (fig. 142), and Mantegna favored them throughout his career. Late instances may be seen in the *Madonna della Vittoria* in the Louvre.

It is the style of the signature on the *St. Euphemia* or the epigraph in the fresco of St. Christopher that prevails in Mantegna's later work. We may recognize the same module in the Greek signature on the pier of the Vienna *St. Sebastian* of about 1460,[52] and though there are some differences of detail (the bowl of P is closed), the shapes of the letters are very similar: T (with its asymmetrical serifs), O, A, and E (with the accented serif on the lowest horizontal). The same style is used for the trial letters written on the gesso of the San Zeno Altarpiece of 1456–1459 (fig. 149). In the early seven-ties it reappears, heavier and more bold-faced, in the titles of the Roman emperors in the ceiling of the Camera degli Sposi (fig. 140). The letters look as though they had been strengthened by a restorer, but they seem to preserve much of their original character. The axis of O, to be sure, is vertical rather than diagonal, T has more nearly symmetrical serifs, and there is a horizon-tal bar across the vertex of A, but the similarities with earlier majuscules by Mantegna are far more numerous than the differences. Well-preserved capitals in the same style may be seen in the print of the Entombment (fig. 141)[53] and, later, on the scroll or banner of the Baptist in the *Madonna della Vittoria* and the Trivulzio *Madonna* from the late nineties. In the early years of the next century there are the inscriptions in the Louvre allegory, on the tree in *Samson and Delilah* in London,[54] and the scroll in the *St. Sebastian* in the Cà d'Oro,[55] all in a recognizably similar mold.

The most beautiful capitals of this kind are the initials in the *Strabo* of 1459 in Albi (figs. 142, 147, 148), commissioned by the Governor of Padua for King René d'Anjou. Though conceived as little monuments and more carefully contrived, these majuscules are clearly in the same style as the freer letters of the signature in *St. Euphemia* (fig. 131), and they recall still more the beautiful letters of the same date on the San Zeno Altarpiece (fig. 149).

Beyond resemblances of weight, shading, and module, there reappear such peculiarities of detail as the long, curling lowest horizontal of E, the broad open bowl of P, and the slanted, concave vertex of A. The color, too, of the *Strabo* letters is Mantegna's. They have some of the lapidary dustiness of the Eremitani surfaces, but they are closest to the *St. Euphemia* of 1454. They have its combination of cold gray and blue-black with warm, glowing salmon, orange, and ivory white. Similarly, the handsome arabesques that weave around the majuscules in the manuscript recall the great master, as I endeavored to show in 1957.[56]

The beauty and advanced character of the initials of the *Strabo* now prove to be matched by its covering, for, as Anthony Hobson has pointed out recently, the original binding of the manuscript, still preserved in the Bibliothèque Rochegude, is the earliest known European binding tooled in gold.[57]

Among published manuscripts there is nothing datable in the fifties or sixties that matches these letters in character and strength. In a manuscript of Eusebius in the Marciana, dated 1450 and written in Padua,[58] we may surely recognize a style that anticipates Mantegna's of 1454 in module, spacing, shading, and other respects, though uncial E is used for an initial, E in the line shows horizontal bars of approximately equal length, A has a heavy midhorizontal, the serifs are smaller, and the axis of the letters shifts constantly (fig. 143). This text was written, it should be remembered, after the beginning of Mantegna's career. The indentations of the ground of the initial, probably suggested by Romanesque forms, anticipate those of the initials in the *Strabo* (fig. 142).

Whatever the sources of the palaeographic change, it is clear that Padua was the center of it. Among the painters, the Vivarini were still employing conservative lettering in their polyptych of 1450 in the Pinacoteca at Bologna,[59] and Bartolommeo had "modernized" this very little in his altarpiece of 1465 in Capodimonte, Naples.[60] Squarcione, on the other hand, who was no scribal giant, to judge from the inscription on the Baptist's scroll in the altarpiece of 1449–1452,[61] shows a familiarity with the new style in his signature on the later *Madonna* in Berlin.[62] This style is reflected, too, in the inscriptions of Zoppo,[63] who entered Squarcione's shop in 1453, and Schiavone, who arrived there in 1456.[64] In the early fifties, within the Ovetari Chapel itself, the signatures of two of Mantegna's collaborators, OPUS BONI and OPUS ANSUINI, clearly reflect his early manner. The remarkable similarity

of these two inscriptions induces, indeed, some speculation about the actual author of them. Giovanni Bellini, too, had looked intently at Mantegna's inscriptions, and his interest in the signature on *St. Euphemia* is proved by his own signature on a somewhat crumpled and torn *cartellino* in the Frick *St. Francis.*

What is known of manuscripts of the time—and by now we may assume that nearly all the best illuminated manuscripts have been published—presents the same pattern of diffusion as panel paintings and frescoes. In manuscripts the new style was employed in humanist texts. While the titles of a Pontifical for the cathedral chapter in Padua would, in 1455, still have a traditional character,[65] the *Cosmography* of Ptolemy written there in 1457[66] shows a style about midway between the *Eusebius* of 1450 and the signature of 1454 or the *Strabo* of 1459. Many of the new forms may be seen also in a Solinus, *Polystoria,* written in 1457, probably in Padua.[67] The script in this codex shows tilted letters and a rollicking movement that becomes characteristic of the Paduan scribe Bartolommeo San Vito, who in the sixties carried Paduan style to Rome.[68] A more formal manner is employed for the epigraph on a simulated monument in a manuscript of Synesius Cyrenensis, *De Laudibus Calvitii,* written in nearby Vicenza in 1461–1465.[69]

It seems possible that the most competent and the most passionate of the early epigraphers, Cyriac of Ancona, may have contributed to the formation of the new style. The capitals in his later manuscripts, such as Berlin, Hamilton 254, of the early forties (written with Bishop Pietro Donati of Padua), draw away from a calligraphic manner toward the formality of Roman epigraphs (fig. 144).[70] While these majuscules in some respect anticipate the new Paduan style of the fifties, those in the next important dated sylloge, by one of Cyriac's followers, seem to reflect it. The beautiful capitals in the manuscript begun by, or at least for, Giovanni Marcanova in Padua in 1457 show the new module and spacing, and many of the new shapes—for instance, of C and D (fig. 145).[71] The second sylloge made for Marcanova and completed in 1465 is in a related but inferior style, and the same may be said of the mediocre script of Felice Feliciano.[72]

Our review of monumental paintings and manuscripts made in the Veneto around the middle of the century points to Donatello and Mantegna as the perfecters of the new majuscular style.[73] A major contribution by the painter is suggested also by the known fact of his study of ancient remains,

and by his association with the epigraphers Marcanova and Feliciano. Felici-
ano, moreover, dedicated a collection of epigraphs to Mantegna *ca.* 1464
and praised the painter's knowledge of antiquity.[74] It is important also to
remember that Feliciano said that he had made drawings of Roman majus-
cules, and he compiled, *ca.* 1460, the first treatise on the proper method of
shaping them (figs. 150–155). His use of the square for the construc-
tion of the letters is bound up with their new broad proportion and with that
of the Imperial letters which they reflect. The paradigmatic capitals that
illustrate Feliciano's text are, however, only mediocre specimens of the style
that appeared in Mantegna's signature of 1454 and then, in the prismatic
version that Feliciano followed, the *Strabo* initials of 1459 (figs. 142, 147,
148).[75] It is noteworthy that Mantegna also wrote a good humanist minis-
cule.[76] He was active near a great university and in a center famous since Pe-
trarch for antiquarian interests. In this environment the painter was seized
with a more passionate desire than any other artist of the century to bring
antiquity back to life.

Until evidence to the contrary is produced, the best hypothesis remains
now, as it seemed a few years ago, that Mantegna played an important part
in the revival of the Roman Imperial majuscule.[77] Furthermore, it seems to
have been he who gave these letters a prismatic shape and set them like
monuments before a patch of vines or other vegetation. This *littera man-
tiniana,* as I called it, was widely adopted in illuminated manuscripts and it
became the standard initial in the Renaissance book. The majuscules them-
selves represent a late stage in the rapid evolution of modern letters. Though
of course change is inherent in the history of majuscules after Mantegna as
well as before—it is apparent already in the High Renaissance and in the
treatise of Pacioli[78]—our Paduan capitals survive at the center of the
Western tradition. Their descendants are still with us everywhere today—and
not less so on the pages of this book.

The new majuscules are of course essentially Roman, but we have already
observed the similarity, especially of the "written" versions, with Carolingian
or Romanesque letters conceived *all'antica* (fig. 146). We may ask also
whether the strong accents and the large serifs, though not without precedent
in this period and in antiquity, echo the Gothic letter and the Gothic wish for
rhythmical continuity and vibrancy.[79] It would be consistent for Gothic ani-
mation to quicken Mantegna's roman letters just as it does his swaying fig-

ures or his curving compositions. If this is true, our alphabet, like other aspects of modern culture, though basically antique, bears memories of medieval experience.[80]

Postscript

Since this essay and its predecessor of 1957 were published study of fifteenth-century illumination has increased strikingly. Many manuscripts and initials have been published for the first time, and kind colleagues, especially J. J. G. Alexander and Alfred Fairbank, have called my attention to others. No prismatic letters have appeared that can be definitely dated before those of the *Strabo.* The one exception so far that proves the rule is the initial, weaker in form but wholly Mantegnesque, in a *Ptolemy* of 1457, also made for the Governor of Padua (see *Andrea Mantegna,* 1957, p. 57 f.). None of the initials published (or found and photographed) in recent years equals those of the *Strabo* in beauty of color and shape.

The attribution of the actual *execution* of the best initials to Mantegna himself seems to me today more questionable than it did years ago; there are no arabesques narrowly comparable among the painter's known works, and the nuances of his epigraphic style vary somewhat from work to work. But if he had a close pupil and associate who painted the initials on Mantegna's designs, what else did this outstanding artist do?

Valuable comprehensive essays on the development of the capital letter have been written in the last few years by the eminent palaeographer Emanuele Casamassima. In them he incorporates the most recent accounts, including the preceding and following essays in this book. See his "Lettere antiche: note per la storia della riforma grafica umanistica," *Gutenberg Jahrbuch,* 1964, pp. 13–26, and, still more important, *Trattati di scrittura del Cinquecento italiano,* Milan [1968], pp. 17–31. See also J. Wardrop, *The Script of Humanism,* Oxford, 1963, esp. p. 7 f.; D. Covi, "Lettering in Fifteenth-Century Florentine Painting," *Art Bulletin,* XLV, 1963, pp. 1–17; A. Fairbank and B. Volpe, *Renaissance Handwriting,* London, 1960; J. Sparrow, *Visible Words, A Study of Inscriptions in and as Books and Works of Art,* Cambridge, 1969, esp. p. 38 ff.; S. Morison, *Politics and Script,* Oxford, 1972, esp. p. 264 ff.

A. C. de la Mare has suggested that the scribe of the text of the *Strabo*

may have written other manuscripts, but none of those I know contains initials comparable to those of the *Strabo* (see J. J. G. Alexander and A. C. de la Mare, *The Italian Manuscripts in the Library of Major J. R. Abbey*, New York, 1969, pp. xxix, xxxvii, 97). These authors do not consistently maintain a distinction between what they call "epigraphic" capitals and "faceted" (or prismatic) capitals; in this respect they seem to me to blur an interesting aspect of the development.

Major contributions by Donatello and Mantegna to the development of the majuscule constituted an unusual but not unique achievement of Renaissance artists. We know that Giulio Campagnola designed type for the great Venetian printer Aldo Manuzio.

NOTES

1. See especially S. Morison, "Early Humanistic Script and the First Roman Type," *The Library*, XXIV, 1943, pp. 1–29; P. Lehmann, "Aufgaben und Anregungen der lateinischen Philologie," *Sitzungsberichte der philosophisch-philologischen und der historischen Klasse der Bayerischen Akademie der Wissenschaften*, 1918, p. 16 ff. (hereinafter referred to as Morison and Lehmann, respectively); B. L. Ullman, *Ancient Writing*, New York, 1932, p. 140 ff.; G. Battelli, *Lezioni di Paleografia*, Città del Vaticano, 1949, pp. 245–249; A. Hessel, "Die Entstehung der Renaissanceschriften," *Archiv für Urkundenforschung*, XXVIII, 1935, pp. 1–14; D. Thomas, "What Is the Origin of the *Scrittura umanistica?*" *Bibliofilia*, LIII, 1951, pp. 1–10; F. Steffens, *Lateinische Paläographie*, 2nd ed., Trèves, 1909, p. XXIII ff.
 I feel grateful to Dr. James J. John and Rev. Edward W. Bodnar, S.J., for valuable suggestions and to Professor E. A. Lowe for the loan of books from his rich library.
2. Meanwhile see his brief "Lettering in the Inscriptions of 15th-Century Florentine Paintings," *Renaissance News*, VII, 1954, pp. 46–50 (hereinafter referred to as Covi).
3. J. Mallon, *Paléographie romaine*, Madrid, 1952; J. S. and A. E. Gordon, *Contributions to the Palaeography of Latin Inscriptions*, Berkeley, 1957; J. Mallon, R. Marichal, and C. Perrat, *L'écriture latine de la capitale romaine à la minuscule*, Paris, 1939.
4. *Andrea Mantegna as Illuminator: An Episode in Renaissance Art, Humanism, and Diplomacy*, New York, 1957, pp. 52–78 (hereinafter referred to as Meiss).
5. See especially Morison. For comments on Petrarch see O. Pächt, "Notes and Observations on the Origin of Humanistic Book-Decoration," in *Fritz Saxl: A Volume of Memorial Essays*, London, 1957, p. 186.
6. Lehmann, p. 17.
7. Morison, p. 15, derives the cross-barred I from Byzantine models.
8. For another specimen probably from Vespasiano's scriptorium, see Meiss, fig. 68. Here the capitals, laid in gold, are heavier. A manuscript of the fifties from this scriptorium could, according to Morison (p. 17), still be influenced by Donatello's epitaph on the Pecci tomb (fig. 125).
9. Lehmann, p. 23. Majuscules similar to Ghiberti's on the *Baptist* may be seen on the slightly later tomb of Maso degli Albizzi († 1417) in San Paolino, Florence (M. Lis-

ner, "Zu frühen Bildhauerarchitektur Donatellos," *Münchner Jahrbuch der bildenden Kunst,* IX-X, 1958–59, fig. 12).

10. R. Krautheimer and T. Krautheimer-Hess, *Lorenzo Ghiberti,* Princeton, 1956, pls. 7, 27.

11. *Ibid.,* pl. 76.

12. J. von Schlosser, *Lorenzo Ghibertis Denkwürdigkeiten,* Berlin, 1912, p. 48. See Krautheimer, *op. cit.,* p. 147.

13. L. Dussler, *Benedetto da Maiano,* Munich, 1924, pl. 1.

14. L. Planiscig, *Desiderio da Settignano,* Vienna, 1942, pl. 23.

15. Lehmann, p. 23.

16. J. S. and A. E. Gordon, *Contributions to the Palaeography of Latin Inscriptions,* Berkeley, 1957; A. E. Gordon in collaboration with J. S. Gordon, *Album of Dated Latin Inscriptions,* Berkeley, 1958, 2v.

17. For additional reproductions of Republican epigraphs see *Album,* nos. 3 and 60; J. E. Sandys, *Latin Epigraphy,* Cambridge, 1919, figs. 31, 33.

18. *Contributions,* p. 214. *Album,* no. 154, is cited as an example of the new spacing.

19. *Contributions,* pp. 80–81.

20. *Op. cit.,* p. 210.

21. See also the inscription over the main door of the Badia at Fiesole (M. Salmi, *L'architettura romanica in Toscana,* Milan, n.d., pl. CCXXI).

22. H. W. Janson, *The Sculpture of Donatello,* Princeton, 1957, II, p. 77 (hereinafter referred to as Janson).

23. An earlier form of E is preserved.

24. U. Procacci, *Masaccio,* Milan, 1951, pl. 1. The inscription in the halo of St. Anne is much more traditional in character and related to the *bastarda.* S is reversed, reminding us of the reversed N in Ghiberti's signature on the *Gates of Paradise.*

25. The reference to the reproductions of these two signatures in Janson, II, p. 77, reverses their identity. For the dates of Donatello's sculpture I follow Janson's catalogue.

26. See Janson, II, pp. 38–39.

27. Janson, II, p. 65, concludes that the design of the sarcophagus may have been Donatello's but the execution must be attributed to a mediocre collaborator. For a reproduction see *ibid.,* I, pl. 86a.

28. *Ibid.,* II, p. 151 ff. The majuscules in the panel at the left in the *Heart of the Miser* of 1447 are crude and difficult to judge (*ibid.,* I, pl. 310). The A and N, rather broad and widely spaced, perhaps anticipate the inscription on the *Judith* as well as Mantegna's *St. Euphemia.*

29. See p. 25.

30. The illusionistic *cartellino* is adopted with enthusiasm by Squarcione and by members of his workshop (Zoppo from 1453, Schiavone from 1456), and from Padua it was diffused, like other elements of Mantegna's style, to Venice and all over North Italy. I owe the photograph of Mantegna's signature on *St. Euphemia* to the kindness of Dr. Ferdinando Bologna.

31. Janson, II, p. 188.

32. *Ibid.,* II, p. 215.

33. *Ibid.,* II, p. 230, and I, pl. 434b.

34. The inscription on the figure's scroll, EGE AGNUS DEI, is likewise problematic. Mixed in with the roman capitals are archaisms such as uncial D, and four of the letters bear curling marks of abbreviation like those on Luca della Robbia's *Cantoria* (fig. 119), but the words are not abbreviated. Capital N is reversed (a corruption found rather frequently, however, in the inscriptions of Ghiberti and some other Quattrocento

artists). The words on the scroll were written by an ignoramus; probably, as has recently been suggested, in the late fifteenth century (in 1464 perhaps, at the same time as the supposed signature). A later "forger" would very likely not have thought of corrupting ECCE.

35. For two other examples of Florentine written majuscules at this time, see Meiss, figs. 67, 68. The inscription on Castagno's *Nicholas of Tolentino* of 1456 does show certain newer forms, including Imperial M (but not N), and there are telescoped letters, as in Donatello's and Paduan script. The majuscules are however spaced closely and they show clubbing rather than serifs.

36. E. Tietze-Conrat, *Mantegna,* New York, 1955, p. 3.

37. Meiss, p. 27, fig. 6.

38. In a review of Meiss in *Renaissance News,* XI, 1958, p. 128.

39. Meiss, pp. 55–56.

40. Bern, Bürgerbibliothek, ms. B. 42, fol. 405. See *Corpus Inscriptionum Latinarum,* V, part I, no. 2528 (no reference is made here to Bellini nor to Mantegna; Meiss, p. 59, incorrectly states there is). A second sylloge by Marcanova, finished in 1465 for the Duke of Cesena, is in Modena, Biblioteca Estense, ms. X.L.5.15.

41. V. Golubew, *Die Skizzenbücher Jacopo Bellinis,* Brussels, 1908, II, pl. XLIII.

42. J. E. Egbert, *Introduction to the Study of Latin Inscriptions,* New York, 1896, pp. 169, 187. This difference between Mantegna's and Bellini's epigraphs has been noticed by A. Moschetti, "Le iscrizioni lapidarie romane negli affreschi del Mantegna agli Eremitani," *Atti del Istituto Veneto di Scienze, Lettere, ed Arti,* LXXXIX, 1929–1930, part 2, p. 227 ff., but with the erroneous statement that the *septemviri* did not exist. Moschetti believes that Mantegna drew directly from the votive altar because he alone records the inscription on its base. There is, however, good reason to believe that this inscription was not on this votive altar but on some other monument. Moschetti's view that Mantegna drew his other epigraphs directly from the Roman original also is not substantiated. Moschetti is not concerned with palaeographical questions.

43. See *CIL, loc. cit.*

44. Golubew, *op. cit.,* pls. XLIII, XLIV. Thus in pl. XLIIId ACUTS should read ACUTIO (*CIL,* v, I, no. 2553). In pl. XLIVa he dropped the D from D · MANIBUS (*CIL,* v. I, no. 2623), and committed other errors.

45. This is the opinion of C. Anti, "L'Arco dei Gavi di Verona," *Architettura e Arti Decorative,* I, 1921, pp. 121–138, and fig. 11. See, however, P. Marconi, *Verona Romana,* Bergamo [1937], p. 100. Prof. Raffaelle Brenzoni, who has kindly looked briefly into the confused question for me, reports that it is not certain that a second inscription ever existed. This arch was dismantled and the stones stored in the Arena until some thirty years ago, when it was reconstructed.

46. For Marcanova's Bern ms. (1457–1460) and Feliciano see *CIL,* v. I, no. 3464. See also the copy of Marcanova's sylloge of 1465 in the Princeton University Library, Garrett ms. 158, fol. 105v. The Vatican copy of Feliciano's sylloge records the inscription correctly (Vat. lat. 5257, fol. 32).

47. In the inscription from the Arco the two letters T in ARCHITECTUS rise above the line, whereas in Mantegna's version the T in VITRUVIUS is elevated.

48. I am indebted for this date to Professor Johannes Straub.

49. Gordon and Gordon, *Contributions* (see above n. 16), p. 83.

50. Tietze-Conrat, *Mantegna,* p. 7. For the epigraph on the arch see *CIL,* v. I, no. 2989.

51. [This date has since been proved by a rereading of the documents by G. Paccagnini, "Cronologia della Cappella Ovetari," in *Atti del VI Convegno Internazionale di Studi*

sul Rinascimento, 1961, Florence, 1965, pp. 77–85, which indicates that the fresco had not yet been painted in 1457.]

52. Meiss, fig. 58.
53. The T again has symmetrical serifs. [I reproduce the earliest of about four states of the print which have been distinguished by J. A. Levenson, K. Oberhuber, and J. L. Sheehan, *Early Italian Engravings from the National Gallery of Art,* Washington, D.C., 1973, p. 175. This state is dated *ca.* 1465–1470.]
54. Tietze-Conrat, *Mantegna,* pl. 136.
55. *Ibid.,* pl. 121.
56. *Mantegna as Illuminator,* p. 52 ff.
57. "Two Renaissance Bindings," *The Book Collector,* VII, 1958, pp. 265–266. The next example, interestingly enough, is Marcanova's Modena manuscript of 1465.
58. Ms. 3 [L.IX.I] MK. See Meiss, p. 92 n. 15, and Pächt, "Notes and Observations," p. 190 n. 1.
59. L. Testi, *Storia della pittura veneziana,* Bergamo, 1915, II, fig. on p. 384.
60. *Ibid.,* pl. XI.
61. G. Fiocco, *L'arte di Andrea Mantegna,* Bologna, 1927, fig. on p. 117.
62. *Ibid.,* fig. on p. 129.
63. See the signature on the *Madonna* in the Collection of Lord Wimborne (A. Venturi, *Storia dell'arte italiana,* Milan, VII, part 3, 1914, fig. 5).
64. See the signatures on the polyptych in the National Gallery, London; the *Madonna* in Berlin; or the portrait in the Musée Jacquemart-André, Paris (*ibid.,* figs. 22, 26).
65. A. Barzon, *Codici miniati della Biblioteca Capitolare della Cattedrale di Padova,* Padua, 1950, no. 40, pl. 44.
66. Meiss, fig. 28.
67. Oxford, Bodleian Library, ms. Can. Class. Lat. 161; *Italian Illuminated Manuscripts from 1400 to 1550,* Bodleian Library, Oxford (ed. O. Pächt), 1948, no. 20, pl. 5. See also Bodley 646, *ibid.,* no. 98, pl. IV, dated *ca.* 1460 and ascribed, with a question, to Padua.
68. For a specimen of his script see Meiss, fig. 76.
69. See F. Saxl and R. Wittkower, *British Art and the Mediterranean,* London, 1948, no. 36, fig. 1.
70. See D. Fava, "La scrittura libraria di Ciriaco d'Ancona," in *Scritti di paleografia e diplomatica in onore di Vincenzo Federici,* Florence, 1944, pp. 296–305. See also R. Sabbadini, "Ciriaco d'Ancona e la sua descrizione autografa del Peloponneso trasmessa da Leonardo Botta," in *Miscellanea Ceriani,* Milan, 1910, figs. 1–11.
71. Bern, Bürgerbibliothek, ms. B 42. I owe the photostat of this manuscript, of which I was unable to find a published reproduction, to the kindness of the Rev. Edward W. Bodnar and Professor Benjamin Meritt.
72. See C. Huelsen, *La Roma antica di Ciriaco d'Ancona,* Rome, 1907, for reproductions of the drawings in Marcanova's Modena ms. of 1465; also the articles on the Modena and Princeton mss. by E. B. Lawrence and H. V. M. Dennis in *Memoirs of the American Academy in Rome,* VI, 1927.

For a specimen of Feliciano's script, see fig. 156. The usual view, advanced for example by J. Poppelreuter, "Zu Feliciano Felicianis römischen Schriftformen," *Repertorium für Kunstwissenschaft,* XXVII, 1904, p. 59, and even recently by Covi, p. 48, that Mantegna's majuscules were derived from those of Feliciano and other epigraphers has, I think, been challenged by the demonstration in my *Mantegna* and in the present text.

73. That Donatello may have been impressed by other aspects of Mantegna's work has been suggested by Janson, II, p. 216 n. 7.

74. Ms. 269, Biblioteca Capitolare, Verona. See Meiss, p. 71.

75. A Gothic ancestor of the Mantegnesque prismatic initial may be seen in the borders of the *Grandes Heures* of Jean de Berry, finished in 1409 (Paris, Bibl. nat., lat. 919).

76. A specimen is reproduced in Tietze-Conrat, *Mantegna,* p. 250.

77. Meiss, chapters III-IV. M. Bonicatti, "Aspetti dell'illustrazione del libro nell'ambiente padano . . . ," *Rivista d' Arte,* XXXII, 1959, pp. 120, 146, says that the present writer's view of the role of Mantegna and of the history of the prismatic capital is incorrect, but against this view he offers only vague and irrelevant generalities.

78. See below, pp. 182, 183; figs, 161, 162.

79. If this is true, the common understanding of the capitals of Mantegna and his period, as simply "perfected" imitations of Roman models (a view held recently by, for instance, Covi, *Renaissance News,* XI, 1958, p. 128) is not quite adequate.

 For specimens of late Roman written, as opposed to incised, capitals see the Virgil in the Vatican (Vat. Lat. 3256—S. Bassi, *La scrittura calligrafica greco-romana,* Cremona, 1957, pls. LI-LII).

80. It is a pleasure to recórd the appearance of a paper on fifteenth-century majuscules, G. Mardersteig, "Leone Battista Alberti e la rinascita del carattere lapidario romano nel Quattrocento," in *Italia Medioevale e Umanistica,* II, 1959, pp. 285–307, which became accessible to me just before receipt of the proof of this article. The author proposes that the first stage of the revival of the Roman *scriptura monumentalis* may be seen in architectural inscriptions in Rimini, beginning with a tablet by Matteo de' Pasti of 1446, and continuing with the monumental inscriptions by, or inspired by, Alberti: first at Rimini (1455–1456), then on the *Sepolcro Rucellai* (our fig. 134) and on the façade of Santa Maria Novella. This movement was influenced, he believes, by Felice Feliciano, to whom he rightly I think attributes a lapidary inscription of 1468 in Verona—a very interesting addition to our knowledge of this *"antiquarius."* The last important contribution, Mardersteig claims, was made by Luca Pacioli in the early sixteenth century.

 The reader will recognize that this view differs from that presented in the pages above, as well as in the last two chapters of my book of early 1957, of which Mardersteig has remained unaware. I am troubled that I differ from so eminent a connoisseur of type, but I believe that the constriction of the frame of reference for the revival of the Roman letter to a few architectural inscriptions, even if by Alberti, and to two alphabetical treatises does not permit sound conclusions. Thus Matteo de' Pasti's majuscules of 1446 at Rimini certainly have a place in the history of the revival because of their broad module and geometric shapes. But the M with central point in the base line, cited as novel by Mardersteig, was employed earlier by Cyriac (our fig. 144), and Matteo's capitals are set very close and wholly lack shading and serifs, both prominent in Cyriac's script and in Paduan examples from 1450 on. Similarly, serifs are still lacking in the inscription on the façade of the Tempio Malatestiano (1455–1456), and the Roman Imperial types of M (with alternate light and heavy bars) and N (with a relatively heavy diagonal), which Mardersteig describes as innovations, had already appeared in inscriptions by Donatello and Mantegna. Small serifs do appear on Alberti's *Sepolcro Rucellai* of *ca.* 1467 (our fig. 134), but the letters are still tall, close-set, and relatively unshaded. Furthermore a letter such as E is not advanced but still shows three bars of equal length. The letters seem to me in general very different from the Imperial majuscules on the Mausoleum of Cecilia Metella with which Mardersteig compares them.

The significant question about Alberti in my opinion seems to be rather: why should the great student of Roman architecture, who reintroduced the monumental inscription on the façades of buildings, not have approximated more closely the shapes and spacing of Imperial majuscules? The clue may perhaps be found in that aspect of Alberti's letters to which I have referred above. In each inscription by him they are exceptionally tall in proportion to their field, and Alberti assigns a structural function to them, as if they were—as I said—caryatids. This is a function sometimes given letters in Florence but not in ancient Rome. Alberti's letters are not nearly so close to these Roman majuscules as are earlier capitals by Mantegna and Donatello.

Mardersteig attributes great importance to Felice Feliciano, whom he considers one of the triad mainly responsible for the revival of the Roman letter. Feliciano's text had no doubt some influence, but the geometric construction of majuscules was undertaken before he wrote it. Furthermore, the letters he produced, with or without geometric aids, were I think something less than exemplary. But I have emphasized Feliciano's mediocrity in this respect fully enough in 1957, and the uneven spindly letters of the new epigraph are a further proof of the point. I should say finally that Mardersteig's paper contains many interesting observations, and should help to stimulate studies in this neglected field.

10

Alphabetical Treatises in the Renaissance

A new form of didactic and theoretical writing appeared in the early Renaissance: treatises on the design of the alphabet, which is to say, of course, the Roman alphabet. The first of these texts known to us was written by none other than Felice Feliciano, a friend of the painter Andrea Mantegna who recorded the chief events in a famous archaeological trip they made together to the Lago di Garda. Feliciano's treatise on the alphabet was followed by similar "trattati delle lettere antiche," one by Damiano Moille, printed at Parma *ca.* 1480, and another by Luca Pacioli, printed in Venice in 1509. Still another, by Sigismondo de' Fanti, was published in Venice in 1514.[1] This species of literature was then adopted north of the Alps, appearing first as a section of Dürer's *Underweysung der Messung,* printed in 1525.

Treatises of this sort seem to be entirely novel; they were, at least, written without awareness of precedents in antiquity. They bear witness to the seriousness of the concern of Quattrocento artists and humanists with the creation of a new script, based on Roman example. They also testify to the desire of these innovators to describe, record, and communicate their intellectual and artistic conquests, contributing thereby to the advancement of contemporary culture, of whose progress they held such an unshakable conviction. The treatises reflect also the desire of these men to get at fundamental laws,

This article is an adaptation of Chapter IV in *Andrea Mantegna as Illuminator. An Episode in Renaissance Art, Humanism and Diplomacy.* New York and Hamburg, 1957.

even those underlying the shapes of letters. In fact the primary motive of Feliciano, Moille, and Pacioli was to demonstrate the principles of proportionality in the *lettera antica formata*, as the formal script in the new style was called. Sigismondo de' Fanti says at the beginning of his discussion of the majuscules (Book IV) that he wishes to impart the principles of the letter "cum doctrina erecta," and this *doctrina* is based on the premise (ultimately Greco-Roman itself) that "nature has ordered the things of this earthly microcosm according to their true and proper proportions." Feliciano introduces his discussion of the first letter of the alphabet as follows (fig. 150):

"According to ancient practice the letter is shaped from the circle and the square, the sum of whose forms rises to 52, from which is drawn the perfect number, which is 10. And thus the width (of the main stroke) of your letter should be one-tenth of its height. In this way the letter has as much of the circle as of the square, and the letter inscribed above should be taken from where the diagonals cross the circumference. And this is what by measurement I, Felice Feliciano, have found in the ancient letters in many marbles, in noble Rome as well as in other places."

> Suole lusanza antiqua cauare la litt(era) di tondo e quadro, la summa de le qual forme ascende al numero LII, del qual si caua il n(umer)o perfecto che e .X. e cossi uol esser la tua litt(era) grossa la X^a. parte delalteza et per qu(e)sto modo hauera tanto del tondo quanto del quadro et uolsi causare la s(opra)s(crip)ta littera doue si tagliano le linie .+. cola circonferentia. Et questo e qua(n)to p(er) misura io Felice Feliciano habia nelle antique caractere ritrouato p(er) molte pietre marmoree, cossi ne lalma Roma quanto negl(i) (a)ltri (luoghi).[2]

Thus in the very first account of the "exquisite litere latine antiquarie," as Francesco Colonna describes them in the *Hypnerotomachia,* the premises conform to the mathematical mystique of the early Renaissance. It was not only the world and man and architecture and music that possessed beauty as the consequence of an inherent numerical proportionality, but the letters of the alphabet as well! In the passage quoted above, Feliciano probably had Vitruvius in mind. It was probably from Vitruvius that he derived the idea of the perfection of the number 10, which the Roman writer in turn admits having taken from the "ancients," particularly Plato and the Pythagoreans.[3] These older writers, Vitruvius says, considered 10 perfect because of its

relation to members of the body—fingers and toes—and also because it is equal to the sum of the *monades* $(10 = 1 + 2 + 3 + 4)$. The human body, Vitruvius adds, manifests a canon of proportion that is based on the ratio $1 = 10$. The figure may be divided longitudinally into 10 units, each of which is equal to the face from the chin to the top of the forehead.

It was, moreover, not only the idea of the perfection of 10 that Feliciano took from Vitruvius. In his treatise he proceeded to apply to capital letters the perfect forms of the square and the circle that, when applied by Vitruvius to man, had stirred the imagination of Ghiberti, Leonardo, and the entire Renaissance (fig. 166). In short, to the Vitruvian *homo ad quadratum et ad circulum* Feliciano and his successors add the *littera ad quadratum et ad circulum*. The letters of the alphabet, like the human body, manifest a geometric as well as a numerical canon.

Feliciano's ideas and procedures were adopted and given a more philosophical explanation by Luca Pacioli, who wrote a half century later. In the *Divina proportione,* to which his little treatise on letters is appended, he says that "the ancients, after having considered the right arrangement of the human body, proportioned all their work, particularly the temples, in accordance with it. For in the human body they found the two main figures without which it is impossible to achieve anything, namely the perfect circle . . . and the square." Pacioli adds a metaphysical interpretation of these figures and of the shape of the body: ". . . from the human body derive all measures and their denominations and in it is to be found all and every ratio and proportion by which God reveals the innermost secrets of nature."[4] These secrets are evidently inherent also in the perfect capital letter (fig. 161).

The man who, as far as we now know, inaugurated the Renaissance tradition of alphabetical treatises, Felice Feliciano, was an almost exact contemporary of Andrea Mantegna.[5] Famous as one of the first collectors of ancient inscriptions and nicknamed "l'antiquario," he was also something of a poet, a printer, and toward the end of his life, an alchemist. He transcribed a biography of his Quattrocento predecessor in epigraphy, Ciriaco d'Ancona. Among painters he knew Marco Zoppo and Giovanni Bellini as well as Mantegna, and on one occasion he addressed to the latter a sonnet pleading for assistance in his poverty. We know that in 1464 he joined the excursion to the Lago di Garda; in 1476 he printed a Petrarch, *De viris illustribus,*

at Pojano near Verona; and he died around 1480 not far from Rome. About 1464 he dedicated a collection of inscriptions to Mantegna, "amicus incomparabilis," speaking warmly of their common passion for ancient culture, and praising the painter's learning and archaeological experience.[6]

Feliciano's treatise on the alphabet is preserved in a single copy in the Vatican Library (figs. 150–155).[7] Like the capital A discussed above, all of Feliciano's letters exhibit his conception of the perfect Vitruvian ratio, $1 = 10$. After giving an account of D, Feliciano adds: "Nota non te domenticar far tutte le littere grosse la parte Xa." Although Feliciano's concern with proportion and geometry is essentially theoretical, it is with practical and didactic purposes. Of the R he says: "La piu difficil parte di questa littera (e) la coda perche non vi si trova alchun tracto di compasso perfecto . . . e fassi la coda . . . per praticha piu che per rasone . . . regiti secondo che l'occhio ti consiglia." R, not reducible to proper geometry, is a sort of second-class letter (fig. 153).

Close study of Feliciano's manuscript proves that he not only advocated geometric construction of the majuscule but applied his principles, in the case of many letters at least. Faint traces of circles, squares, and diagonals, as well as the central prick of the foot of the compass, may be seen on many folios. Geometry had, however, only a proximate meaning. Feliciano, for instance, preferred a narrow H and he produced it, even though it does not come near to filling the square with which he began.

The capitals in Feliciano's alphabet are prismatic or faceted, the reverse, as it were, of incised letters. In this respect they resemble the much more beautiful capitals in the initials of a manuscript of Strabo, *De Situ Orbis,* which can be dated 1459 (figs. 142, 147, 148). These splendid letters approximate so closely the capitals in contemporary inscriptions by Andrea Mantegna (figs. 139, 149) that they seem to me to have been designed by him and painted in his workshop.[8] If this is true, how are we to understand the relationship between Feliciano and Mantegna? Was the prismatic letter introduced earlier, in examples unknown to us, and then greatly refined by Mantegna? The known facts of its history seem to disprove this. Could Feliciano, professional antiquary, have been its creator? The problem is somewhat complicated by the fact that Pratilli has recently shown that the Vatican manuscript, contrary to general belief, is not dated, though some facts do point to *ca.* 1463, the year when it is commonly believed to have

been finished.[9] We are therefore thrown back on internal evidence, and fortunately this seems clear and decisive.

Feliciano, first of all, was not an artist nor even a first-rate calligrapher. A Latin miscellany preserved in the Museo Correr at Venice provides abundant proof of that (fig. 156). Dated 1460, it contains the statement "scripto e miniato per mano di me felice feliciano da Verona. . . ."[10] We can be certain then—or, intellectuals being what they are, reasonably certain—that the initials in this manuscript were painted by Feliciano himself. They are altogether conventional.[11] The letters themselves are not only without special distinction but are strikingly similar to those in the Vatican manuscript, so that we can assume that the latter also are specimens of Feliciano's limited craft. They are scarcely comparable to those in the Strabo. The transversal in Feliciano's H, for instance, is painfully thin, especially for a statuesque letter (fig. 151). The letters generally lack the entasis and other refinements of the Strabo letters, and while they are constructed in light and dark, these value changes are unpredictable and unsystematic. In the Strabo the light strikes the initials consistently from the upper left. Feliciano's R is lighted from the right (fig. 153), while the H (fig. 151) is lighted from within and the A (fig. 150) from both sides. Feliciano was perhaps applying, with limited comprehension, a principle initiated by the friend and colleague to whom he dedicated his treatise.

Given the friendship of Feliciano and Mantegna, as well as their known collaboration in the study of antiquity, we might suppose that the proportions of their letters would be the same. Such, however, is not the case. The Strabo capitals were perhaps laid out on a square and a circle (fig. 160), but their ratios do not conform to the prescriptions of Feliciano. When the latter tells us, in the passage quoted above, that the "width" of the letter A is $\frac{1}{10}$ of its height, he undoubtedly refers to the ratio of width to height in the right shank (fig. 150). The corresponding ratio in the Strabo is about 1 to 12 (fig. 159). If we turn to other letters, H for example, we discover similar differences. Feliciano again stipulates a ratio of 1 to 10 for both the uprights (fig. 151), whereas Mantegna or his assistant, with equal consistency, again employed 1 to 12 for the more important right shank, while reducing the left— for the sake of a more active pattern—to about 1 to 16 (fig. 160). Feliciano prescribes for E an upper transversal that passes the axis of the square by a half of a tenth, while the lower transversal passes it by one-tenth. In the

Strabo the variation in the lengths (as well as the thicknesses) of the three transversals is greater. The lower transversal is actually shorter than the upper, but it has a larger serif. The ratio of width to height in the upright is again about 1 to 12.

In his choice of a ratio of 1 to 12 Mantegna, like Feliciano, may have intended to conform to ancient authority, particularly Vitruvius. Actually this writer, in the same passage on proportion to which we have referred above, says that while many of the "ancients" held 10 to be the perfect number, others preferred 6. Twelve was an essential part of the numerical pattern that is inherent in 6, and it was called *diplasios.*

Measurement of initials like those in the *Strabo,* whose parts are merely a fraction of a centimeter wide, is of course only approximate, and our belief that the designer had in mind the ratio $1 = 12$ therefore receives welcome support from the theory of Damiano Moille. This stationer, miniaturist, and calligrapher of Parma produced in that city around 1480 the first printed treatise on the design of the *littera antiqua* (figs. 157, 158).[12] The little book, printed on only one side of the sheet and unbound—probably because it was intended only for craftsmen—combines a short description of each letter with a diagram that shows it inscribed within a circle and a square. The author prescribes for the ratio of the width of an upright to its height the same ratio that we supposed to be inherent in the *Strabo.* "The I," Moille says, "should be of a width that is the twelfth part of the height of the square, like all the other letters." In describing the A, Moille says that the right shank is $\frac{1}{12}$ of its height, and then stipulates for the other shanks some of the ratios that, according to the ancients, contribute to the perfection of 6 ($\frac{1}{2} = 3$, and $\frac{1}{3} = 2$). The width of the left shank is $\frac{1}{2}$, and the transversal is $\frac{1}{3}$ of the right shank. Such variations, lacking in Feliciano's A (fig. 150), may be found in the *Strabo* (fig. 159). Here, however, the relation of the transversal to the left shank is reversed, the transversal in the *Strabo* being larger than the left shank in the ratio of *ca.* 3 to 2.[13]

[Comparison of the A of Moille with that of Feliciano discloses the range of choice left to the painter's judgment by even so simple a geometric scheme as the circle inscribed within a square. Moille fixed the outer edges of the lower shanks at the intersection of the diagonals of the square with the circumference (fig. 157). Feliciano's text seems to refer—unclearly—to the same arrangement, but he held the left shank inside the point of intersection

and the serif of the foot does not reach the corner of the square. As a result the letter, in conformity with Feliciano's *taste,* is narrower and more acute than Moille's. For H Moille as usual employs a geometrical procedure like Feliciano's, which he must have known, and again he utilized the diagram for a very different effect (figs. 151, 158). The width of Feliciano's letter, like Moille's, is determined by the intersection of the diagonals with the circle, as Feliciano explicitly states. For him these points fix the *outer* edges of the shanks whereas for Moille's left shank they fix the *inner* edge. Once again Moille wished a broader letter that much more closely filled the square.

In these respects the letters in the *Strabo* resemble Moille's; indeed, although much earlier, they represent a more decisive stage of the same taste. They are still broader than Moille's. Although the square provides a general guide for the A the circle and diagonals do not seem to add precise points (fig. 159), but the H would seem to have been constructed geometrically (fig. 160). The intersections of diagonals and circle provide points not for one (Moille) or both (Feliciano) outer shanks but for both *inner* edges. Similarly the comparative massiveness of the transversal of the A, together with its low position and the wide spread of the shanks, increases the weight and the monumental effect of the letter. These qualities characterize all the letters in the *Strabo.* The H approaches a square even more closely than Moille's H, which leaves an unfilled space at the right (fig. 158).] In Moille's constructions, as well as in those of Pacioli and other later writers, the letters frequently fail to fill the square or project a little beyond it. The ideal shape is only approximated. Geometry provides guidance without exerting strict control.

The relations of Feliciano and Moille with the *Strabo,* and with one another, are evidently quite complex. Only Feliciano adopts the letter in relief, but Moille's proportions are closer to Mantegna's. Luca Pacioli's connections with his predecessors are no less complex (figs. 161, 162).[14] It has been argued that he knew both Feliciano and Moille, even though he didn't follow either very closely. And when one considers such aspects of the letters as the serifs, it is apparent that though Moille, like the Romans themselves, omits top serifs on M, Pacioli as well as Feliciano employs them.[15] At the same time Pacioli's letters, shaped in 1509 in the period of the High Renaissance, are bulkier than those of his predecessors. This change is reflected in his basic proportion of the width of the stroke to its height, which is no

longer 1 = 12, but 1 = 9. The ratio of the smaller stroke to the larger—the transversal of H, for instance, to the uprights (fig. 162), or the transversal of A to the right shank (fig. 161)—is moreover often 1 = 3. In all of this (1–3–9) we recognize not only a predilection for a certain shape but for a certain abstract proportion, namely the Platonic, as set forth in the *Timaeus*.

Pacioli is the last of the major early Italian theorists of the design of the alphabet. Sigismondo de' Fanti's book, published in Venice five years after Pacioli's, is notable chiefly as a full-fledged manual, giving precise and detailed instructions for the construction of the letters, which are illustrated by complex diagrams (fig. 163).[16] It is a sign of the times that Fanti should discuss first not Roman capitals but Gothic minuscules. As we have observed elsewhere,[17] after the first wave of enthusiasm for the *littera antiqua* Gothic letters returned to favor, especially for religious texts.

But an account, however brief, of the first half-century of the theory of the design of the alphabet cannot end with Pacioli, and much less with Fanti. For a highly significant contribution was made at this time, first apparently by the originator—whoever he was—of the ideas contained in a manuscript that belonged in the early sixteenth century to the Nürnberg physician and scholar, Hartmann Schedel (fig. 164). This manuscript, of which only the briefest notices have been published,[18] proposes three possible ratios for the letters: 1 = 12, 1 = 10, 1 = 9, though 1 = 10 is favored. [In our reproduction (fig. 164) the upper A, which is *gracilior*, corresponds exactly with Moille's, except for the flat tip. A *crassior* A is provided by the lower one. In this letter, which is similar to the one in the *Strabo* (fig. 159), the inner edge (not the outer) of one shank coincides with the juncture of a diagonal with the circumference.]

A similar concept of alternatives emerges in the thought of Albrecht Dürer, perhaps inspired by this anonymous text. Dürer in any event had been twice to Venice, and he was no doubt familiar with at least those alphabetical treatises that had been published, two of which had appeared in that city itself. Just as in his speculation about the human figure Dürer had come to recognize more than one beautiful form and one canon of proportion,[19] so in his account of Roman capitals in the *Underweysung der Messung* he presented more than one perfect example of each letter (fig. 165). He offered for each letter the ratio 1 = 9 as well as 1 = 10, and two or more shapes, recommending to the reader the use of the one "weliche dir am

basten gefelt." Thus Dürer and his anonymous forerunner undermined the central concept of the earlier theorists—that of a single perfect form. Without abandoning geometry and numerical law they opened the door to multiformity and to individual taste.

But the idea of a perfect letter, possessing a fixed proportion, continued to haunt the sixteenth and seventeenth centuries. Indeed in France, where Italian criticism and theory were rigorously systematized, the mathematical determination of letters was raised to an astonishing level of precision. In 1692 the Académie des Sciences, composing a set of models of capitals for the engraver of the Imprimerie Royale, laid them out on a field subdivided into 2,304 squares (fig. 167). The story is not complete, however, without adding that the engraver, confronted with these laboriously contrived geometric patterns, absolutely refused to adhere to them, insisting that the eye was the sovereign creator and judge of form.[20] Feliciano, Mantegna, and his contemporaries would probably not deny this, but they would not, at the same time, sense an inherent conflict. Even while invoking geometry as a guide to form they assumed its limits, and they knew intuitively how to make something living and personal of it.

Postscript

One year after the appearance of this essay Henry Millon published a remarkably similar estimate of the use of geometry and mathematical proportionality by architects of the period—specifically the one architect who has left us adequate evidence ("The Architectural Theory of Francesco di Giorgio," *Art Bulletin,* XL, 1958, pp. 257–261). The basic forms of Francesco di Giorgio, too, were the circle and the square. "He used a mathematically coherent system in a highly flexible way. . . . Proportionality becomes something which is dependent at its inception on geometry and arithmetic, but final adjustments are made by the eye of the architect and do not depend on the abstract rules of the compass."

My own essay, printed in 1957, has been revised by insertion of a paragraph describing the traces of Feliciano's preparatory geometric drawings in his alphabetical treatise. I found these dots and faint lines when re-studying the manuscript in April, 1958, and discussed them in my article of June, 1960 (here reprinted without the passage, to avoid duplication). In a valuable

facsimile of the manuscript, *Felice Feliciano Veronese, Alphabetum Romanum,* ed. G. Mardersteig, Verona, 1960 (available to me only later), a diagram of a geometric construction is printed on the page facing each page of Feliciano's treatise. These diagrams are not, however, based for the most part on the few dots and lines that are now visible in the manuscript but upon Feliciano's text, or upon the application to a given letter of the method that Feliciano prescribes for other letters. There are, in fact, some small discrepancies between Dr. Mardersteig's useful reconstructions and Feliciano's surviving drawings. Thus the lower-right serif of A extends significantly beyond Feliciano's dot that marks the corner of the square, and the diagonals for I do not cross on the line that divides the two facets of the letter but in the yellow facet at the right.

A good recent account of the alphabetical treatises may be found in E. Casamassima, *Trattati di scrittura del Cinquecento italiano,* Milan [1968], pp. 17–31.

NOTES

1. There is also a manuscript on letter design now in the Newberry Library, Chicago, formerly in the Ricketts Collection. Measurements and brief instructions are written on or around the letters (cf. F. W. Goudy, "The Roman Alphabet," in *Ars typographica,* II, 1926, pp. 202–205, with an unfounded ascription to Leonardo—see below, note 14.

2. Bibl. Vaticana, ms. lat. 6852, fol. 1.

3. Vitruvius, Bk. III, Chapter 1.

4. *Divina proportione,* ed. C. Winterberg, Vienna, 1889, pp. 129, 131. The two passages are quoted above in the English translation given by R. Wittkower, *Architectural Principles in the Age of Humanism,* London, 1949, p. 14.

5. He was born in 1433. The published accounts of the life and works of Feliciano evidently abound in error. A recent study by L. Pratilli, "Felice Feliciano alla luce dei suoi codici," in *Atti del Reale Istituto Veneto di Scienze, Lettere, ed Arti,* XCIX, 1939–40, pp. 33–105, makes real progress, but much remains to be done. See also G. Tiraboschi, *Storia della letteratura italiana,* ed. Milan, 1824, VI, 1, p. 304, and S. Maffei, *Verona illustrata,* Milan, 1825, III, p. 191 ff.

6. Ms. 269, Biblioteca Capitolare, Verona. The dedicatory preface is printed in Pratilli, *op. cit.,* p. 49.

7. Ms. lat. 6852. The text on the alphabet was printed by R. Schöne, "Felicis Feliciani Veronensis opusculum ineditum," in *Ephemeris epigraphica,* Rome, 1872, p. 255 ff. See also J. Poppelreuter, "Zu Felice Felicianos römischen Schriftformen," in *Repertorium für Kunstwissenschaft,* XXVII, 1904, pp. 57–60 (with the incorrect statement that the Vatican manuscript was finished in 1481), and R. Bertieri, "Gli studi italiani sull'alfabeto nel Rinascimento," in *Gutenberg Jahrbuch,* 1929, p. 269 ff. The letters E, M, S have not hitherto been reproduced.

W. R. Koehler has kindly informed me of a sort of Carolingian prelude to this Quattrocento concern with the measurement of roman script, described in a letter dated 836 of Lupus of Ferrières to Eginhard. "Praeterea scriptor regius Bertcandus dicitur antiquarum litterarum, dumtaxat (i.e. videlicet) earum quae maximae sunt, et unciales a quibusdam vocari existimantur, habere mensuram descriptam." (Cf. *Lettres de Servat Loup, Abbé de Ferrières,* ed. Desdevises, Paris, 1888, pp. 60–61.)

8. The relationship of the *Strabo* capitals to Mantegna, and Mantegna's role in the revival of the Roman imperial majuscule, are discussed on pp. 165 f. and 169.

9. The date 1481 on fol. 17, taken by some students to be determining, is actually, according to Pratilli (*op. cit.,* p. 58), an addition.

10. Museo Correr, ms. 314. VI, 351, fol. 5. Cf. Pratilli, *op. cit.,* p. 96.

11. A similar kind of interlace appears in the friezes of the Petrarch printed by Feliciano (cf. Pratilli, *op. cit.,* fig. 7).

12. Cf. the facsimile published by S. Morison, *A Newly Discovered Treatise on Classic Letter Design,* Paris, 1927. Damiano was born shortly after 1439 and died probably in 1500. Cf. also *Tesori delle Biblioteche d'Italia, Emilia e Romagna,* Milan, 1932, p. 542 and figs. 305–306.

13. The relationship is peculiar to the *Strabo,* and differentiates it from all the treatises, including Pacioli's.

14. The opinion, shared by Morison (*op. cit.,* p. 20), that Pacioli wrote his account of the alphabet in 1483, has been refuted by R. Bertieri, *op. cit.* Bertieri shows that this treatise was written expressly for the volume of the *Divina proportione* published in 1509. Bertieri argues also that there is no substance in the old view that Pacioli's letters were drawn by Leonardo, and he suggests instead (with little evidence) Piero della Francesca. Bertieri also points out that there is no evidence for the attribution to Leonardo (even ultimately) of the alphabet now in the Newberry Library, Chicago. On this see above, note 1.

15. On this point see Morison, *loc. cit.*

16. *Theorica et practica de modo scribendi,* Venice, 1514.

17. See p. 168 f.

18. See G. Dehio, "Zur Geschichte der Buchstabenreform in der Renaissance," in *Repertorium für Kunstwissenschaft,* IV, 1881, pp. 269–279, and E. Crous, *Dürer und die Schrift,* Berlin, 1933, p. 11. The text for one letter has been published (by Dehio), but none of the letters themselves. Dehio proposed that the text was copied from a lost late fifteenth-century treatise, probably by Leonardo, and also was the source of the ideas of Pacioli, Dürer, and Feliciano, whose *ars litteraria* he dated after 1481. It is to be hoped that this manuscript, apparently important, will soon be studied adequately. Crous, whose book became available to me only after my own was in galleys, gives a short account of the alphabetical treatises. His statements of fact are sometimes incorrect, as, for instance, about Moille's preferred ratio. He is the only writer who comments on the prismatic letter, wondering whether the innumerable examples in printed books of the nineties derive from Feliciano.

19. See E. Panofsky, *Albrecht Dürer,* Princeton, 1943, I, p. 266 ff. See also p. 258 for a discussion of Dürer's alphabet.

20. See S. Morison, *op. cit.,* p. 22. See also A. Christian, *Débuts de l'imprimerie en France,* Paris, 1905, p. 83 and plate opposite p. 275. Already in 1529 Geofroy Tory utilized a more elaborate system of coordinates than his Italian predecessors, aiming at a more precise mathematical determination of the letters (fig. 166). Cf. *Champ Fleury,* Paris, 1529 (ed. G. Cohen, Paris, 1931).

PART IV

11

Scholarship and Penitence in the Early Renaissance: The Image of St. Jerome

Among the large company of Christian saints, memorable for thoughts and deeds of various kinds, every period finds some more congenial than others. Persons not long dead are, of course, usually remembered more vividly, but not infrequently saints from the remote past suddenly attract special attention. Thus Jerome, a Father of the Church and always important throughout the Middle Ages, began in the late fourteenth century to become much more prominent in religious thought and in the visual arts. He appeared, furthermore, in novel ways. Before the middle of the century Johannes Andreae, professor of canon law at the University of Bologna, wrote a widely read book, *Liber de laudibus S. Hieronymi,* in which he stressed not only the saint's learning and piety, but, with far less reason, his prominence in the Church as a cardinal.[1] In North Italian paintings of the second half of the century the translator of the Bible from Greek into Latin began to be represented as both a cardinal and a scholar in his study (fig. 168).[2]

This image became one of the favorite themes of the Quattrocento, and it soon passed from Italy to northern Europe. There the Limbourgs painted representations of St. Jerome in his study for Jean de Berry, and the workshop of Jan van Eyck (Petrus Christus?) executed the well-known panel now in Detroit, perhaps for Philip the Good of Burgundy; in their choice the

This article was published in *Pantheon,* XXXII, 1974, pp. 134–140.

princes were no doubt influenced by the learned men around them. In the *Belles Heures* of the Duke of Berry the Limbourgs painted before 1409 an exceptional series of twelve scenes of Jerome's life (figs. 169, 177), including the saint in his study, and they presumably painted another representation of this subject *ca.* 1412, which was copied in the well-known frontispiece to the *Bible moralisée,* Bibl. nat., fr. 166.[3]

The rise of this subject corresponded with the rise and the diffusion of humanist scholarship. The earliest representations of the studious Church Father, furthermore, are almost indistinguishable from the representations of the father of humanism, Petrarch.[4] Jerome was to a degree an ancient forerunner, devoting himself to philological study, to translation from Greek into Latin and to the establishment of texts. Later, Erasmus prepared an edition of his works.[5]

In this period Jerome appeared just as often in a very different guise. Deprived of his study, his books, his ecclesiastical vestments and sometimes even of normal clothing, he dwells in the wilderness, his breast bloody from self-inflicted blows with a stone. Scholars have assumed that this image, in contrast to the saint in his *studiolo,* presented the medieval conception of the holy man.[6] Indeed, the penitent St. Jerome is so familiar to us from paintings by Leonardo da Vinci, Castagno, and countless other masters of the fifteenth and later centuries that its long life has been taken for granted. The truth is, on the contrary, that if it occurs at all before 1400, it is extremely rare,[7] whereas from approximately that date examples multiply rapidly. Most, if not all, of them appeared in the very center of the Renaissance movement, in Florence and its *dintorni.*[8]

The representation of Jerome in penitence was based upon his own description of his life in the wilderness after he fled from Rome.

> How often, when I was living in the desert, in the vast solitude which gives to hermits a savage dwelling-place, parched by a burning sun, how often did I fancy myself among the pleasures of Rome! I used to sit alone because I was filled with bitterness . . . I had no companions but scorpions and wild beasts . . . the fires of lust kept bubbling up before me when my flesh was as good as dead. Helpless, I cast myself at the feet of Jesus . . . I remember how I often cried aloud all night till the break of day and ceased not from beating my breast till tranquility returned at the chiding of the Lord.[9]

The passage occurs in a letter written by Jerome to Eustochium, a disciple who, with her mother Paola, left Rome for Palestine and joined Jerome near the Church of the Nativity in Bethlehem.[10] First Paola and then Eustochium became the abbess of a nunnery he had founded near his own monastery. His famous letters to the two women were written to help them become good Christians, and a now damaged mosaic of *ca.* 1290 on the triumphal arch of Santa Maria Maggiore, to which relics of St. Jerome were transferred, shows him addressing his two disciples.

Though the letters were widely read throughout the Middle Ages, neither his penitence in the wilderness nor another equally climactic episode described in the same letter, to which we shall turn shortly, were illustrated until our period. Then Florentine painters showed the saint kneeling in or near a cave, and sometimes an altar, a stone in his hand (figs. 170, 171).[11] His companions are, as the letter to Eustochium states, a scorpion or serpents, and often his faithful lion. In the early predella panels he kneels, but soon he becomes a more imposing erect figure (fig. 172).[12] The saint often repents before a crucifix (figs. 170, 176). He may also appear, always in penitence, below Christ on the cross, as in a badly worn Florentine panel of the Bicci circle (fig. 173). Here his companion on the opposite side of the cross is St. Benedict with a scourge.

It seems improbable that so numerous a series of examples of a novel subject was unrelated to a change in contemporary religious life. Three congregations under the patronage of St. Jerome were, in fact, founded in the late fourteenth century. One society was established in 1377 by Pietro Gambacorta of Pisa at Cessano near Urbino. Not much is known about the early history of the group. The first papal bull is as late as 1437, and it does not describe the habit.[13] A second group, founded before 1374 in Spain, spread to North Italy, where the members were known as the "monaci eremiti di San Gerolamo di Lombardia," and Giangaleazzo Visconti gave them a monastery at Castellaccio, near Milan.[14] Martin V confirmed the Order in 1424, conferring on them the rule of St. Augustine, which was changed to that of St. Jerome only five years later.

The third order of Hieronymites was founded at the center of the region in which all the early representations of the penitent saint were painted. In 1360 Carlo, of the noble Florentine Guidi family of Montegranelli and a Franciscan Tertiary, retired to a simple building in Fiesole for a life of medi-

tation, prayer, and mortification of the flesh.[15] Disciples gathered around him, many of them, like Carlo, Tertiaries and members of great Florentine families. Indeed, toward the middle of the fifteenth century, as the Order prospered, Cosimo de'Medici himself undertook to build a new monastery and church near the original one.[16] The church, across the Vecchia Strada Fiesolana from the Villa Medici, still stands, though completely transformed in later centuries. A bull confirming the Order, under the rule of the "constitutiones S. Hieronymi," was written by Pope Innocent VII in 1406, but it was left unsigned at his death and Gregory XII issued it in 1415.[17]

In 1441 Pope Eugenius IV replaced the rule of St. Jerome with that of St. Augustine, but the bull explicitly states that the brothers are to retain their traditional denomination and their accustomed habit.[18] To the modern historian of art this last statement is tantalizing because there seem to be no reliable earlier records stating just what this habit was; this bull says nothing more about it, and the bull of 1415 does not mention it at all.[19] Curiously, this evasiveness persists in the next bull directed to the Order, although it does introduce a new fact. Responding in 1460 to an appeal of the General of the Hieronymites, Pius II agreed that they might, as they requested, adopt a habit that would distinguish them from the Tertiaries.[20] The new habit is not described, but the traditional one must have resembled the ashen gray tunic and leather belt of the Third Order.[21] When the Third Order was given its first general rule by Nicholas IV in 1289 a gray tunic, "neither white nor black," was stipulated, together with a leather belt.[22] The Tertiaries continued to wear this habit at least until 1448, when Pope Nicholas gave them permission to abandon it.[23] This, then, is very probably what Carlo and his company wore. The permission the Hieronymites received from Pius II in 1460 to differentiate their dress from that of the Tertiaries probably referred to their mantle and not to the traditional gray tunic and belt, which they were still wearing at a much later period.[24]

Since most of the early representations of the penitent St. Jerome up to the middle of the fifteenth century were painted in the immediate environment of the Hieronymites, we might expect to discern some relationship between his dress and their habit. The saint does indeed wear a tunic that varies from light to dark gray. Though in a very few paintings his girdle is the Franciscan cord (fig. 172),[25] he normally wears a leather belt (figs. 173,

175, 182, 183).[26] It is significant that the belt was used by Fra Angelico (fig. 183),[27] because the Dominicans were close to the Hieronymites—S. Antonino was a friend of Beato Carlo—and their monasteries stood nearby in Fiesole.

By good fortune two Quattrocento altarpieces from the church of the Hieronymites in Fiesole have come down to us. One, in the Louvre, was painted by a follower of Fra Angelico (fig. 175).[28] It bears the Medici arms, and the saints on the right hand of the Madonna are Jerome, who beats his breast, followed by Cosmas and Damian. Probably Cosimo himself commissioned the altarpiece for the new church he built for the Order in the early fifties.[29] The style of the painting conforms with this date, but it has been placed after 1460 because of the belief, for which I can find no evidence, that the gray tunic and leather belt worn by St. Jerome were first adopted by the Hieronymites in that year.[30]

In the second altarpiece from San Gerolamo, painted some two decades later by Francesco Botticini and now in London, St. Jerome wears a tunic of lighter gray and what Martin Davies describes, with his usual care, as "rather vague indications of a belt" (fig. 176).[31] This painting, like the one in the Louvre, bears the arms of an eminent Florentine family, the Rucellai. The most probable donor was Gerolamo di Piero di Cardinale Rucellai, who died in 1497 and was buried in the Hieronymite church in Fiesole.[32] He and his son kneel at opposite sides of the penitent Jerome.

St. Jerome is accompanied by St. Eusebius, who became abbot of his teacher's monastery, and by Pope Damasus, who called Jerome to Rome and entrusted him with the translation of the Bible. On the opposite side stand St. Paola and her daughter Eustochium, who, as often, carries a lily. The varying shades of gray in their mantles and tunics refer, no doubt, to the habit of the Hieronymites. The four saints appear in a sort of courtyard defined by a high wall. In the blue sky above, angels, equal in number to the lateral figures, celebrate on musical instruments. The central figure is completely framed, becoming an image within an image.[33] The saints and donors do not venerate Jerome himself but a picture of him. By this device Botticini stresses that he is revered by the saints as well as by the donors. The painter probably knew those altarpieces of Fra Angelico that contain an image of a distinctive iconic character. His painting for the high altar of San Marco, for example,

shows in the foreground, in front of the deep space, a small panel of the Crucifixion with a gold frame and background. Unlike Botticini's icon, however, it is an object of veneration for the beholders of the altarpiece only.

The presence of Paola and Eustochium, definitely identified, enables us to conclude, as I did a few years ago,[34] that they are the two women who accompany St. Jerome in Castagno's fresco in the SS. Annunziata in Florence (fig. 180).[35] They do not carry attributes, nor are they dressed as Hieronymites, but their very apparent difference of age conforms with the identification as mother and daughter. The fresco, painted in 1454–1455, antedates the altarpiece of Botticini, who owed, in fact, much to Castagno's style. The two ladies, however, were not newcomers to Florentine hagiography; we know from Vasari that they appeared in Starnina's frescoes in the Chapel of St. Jerome in the Carmine.[36] The possibility of a connection between the iconography of Castagno's fresco and the new Order is strengthened by the fact that the Hieronymites had a lay house, known as the Buca di San Gerolamo, near the Annunziata.[37] Many well-known Florentines belonged to it, and the patron of Castagno's fresco, Girolamo de' Corboli, may have been a member.[38]

Reflections of the penitential self-mortification practiced by the Hieronymites may be seen in a strange altarpiece in San Domenico, Fiesole, near their own church (fig. 181). The grieving Madonna (or perhaps Eustochium) and St. Jerome with breast bloodied by a stone appear below a crucified Christ, whose blood-stained body is highly unusual in Florentine art. The painter, however, was indubitably Florentine, a follower of Botticelli and, for his Christ, Castagno; he had also seen Botticini's Jerome in the neighboring church (fig. 176).

When in the later fourteenth century the congregation at Fiesole began to attract followers Carlo, the founder, was invited to establish houses in other cities, such as Verona, Padua, and Venice. In the city in the lagoon a building was made available to them in 1412 on the island of Santa Maria delle Grazie; there Carlo died in 1417.[39] The church was destroyed in the mid-nineteenth century, and it is difficult to discover now what effect the Venetian and other north Italian houses had upon religious imagery. St. Jerome in the wilderness, meditating or reading, began to be represented in the second quarter of the century, in the panel by a follower of Pisanello, signed by Bono da

Ferrara, in the National Gallery in London and in a similar panel by a painter close to Francesco dei Franceschi (fig. 174). Jacopo Bellini made drawings of this type,[40] and he also represented Jerome beating his breast with a stone.[41] His son Giovanni chose this action for one painting, an early predella made for Pesaro,[42] but the many pictures of Jerome he painted later all show the saint quietly reading in a primitive but benign country retreat.[43] The Venetians quite clearly did not, in this instance as in others, take to the mortification of the flesh.

In another passage in the same letter to Eustochium, which we have quoted above and which provided the Hieronymites with their central image, Jerome describes a different occasion on which he was scourged, though this time not by himself.

> Many years ago, when for the kingdom of heaven's sake I had cut myself off from home, parents, sister, relations, and—harder still—from the dainty food to which I had been accustomed; and when I was on my way to Jerusalem to wage my warfare, I still could not bring myself to forego the library which I had formed for myself at Rome with great care and toil. And so, miserable man that I was, I would fast only that I might afterwards read Cicero. After many nights spent in vigil, after floods of tears called from my inmost heart, after the recollection of my past sins, I would once more take up Plautus. And when at times I returned to my right mind, and began to read the prophets, their style seemed rude and repellent. I failed to see the light with my blinded eyes; but I attributed the fault not to them, but to the sun. While the old serpent was thus making me his plaything, about the middle of Lent a deep-seated fever fell upon my weakened body, and while it destroyed my rest completely—the story seems hardly credible—it so wasted my unhappy frame that scarcely anything was left of me but skin and bone
>
> Suddenly I was caught up in the spirit and dragged before the judgment seat of the Judge; and here the light was so bright, and those who stood around were so radiant, that I cast myself upon the ground and did not dare to look up. Asked who and what I was I replied: "I am a Christian." But He who presided said: "Thou liest, thou art a follower of Cicero and not of Christ. . . ."
>
> Instantly I became dumb, and amid the strokes of the lash—for He had ordered me to be scourged—I was tortured more severely still by the fire of conscience. . . .[44]

This dramatic episode in Jerome's life was, like his penitence in the desert, not given visual form until the fifteenth century.[45] It appeared, however, in the predella of both extant altarpieces painted for the church of the Hieronymites in Fiesole (fig. 179). Clearly they favored the representation, and they may well have originated it. Florentine also is what appears to be the earliest surviving Italian representation of the Dream and of the Saint scourged (fig. 178). The scenes are in the predella of an altarpiece painted about 1425 by Francesco d'Antonio for a "cittadino fiorentino, Rinieri di Luca di Piero Rinieri," as an inscription informs us. The main panel represents the Madonna enthroned with St. John the Baptist and St. Jerome.[46] The earliest example known to the writer, however, is a miniature probably by Jean de Limbourg in the *Belles Heures* of Jean de Berry, painted *ca.* 1407–1408 (fig. 177). This miniature, part of an unusual cycle of twelve miniatures devoted to Jerome, is preceded by one that depicts the occupation for which the saint is punished—he is shown listening to a lecture on ancient Greek writers (fig. 169). The cycle contains no particular indication of a relationship with the Hieronymites of Florence, but we should observe that the *style* of the painter is very Italianate, and that the humanists in the circle of Jean de Berry, such as Gontier Col and Jean de Montreuil, were in close touch with their Florentine colleagues.

Jerome's trials anticipated by a millennium a fundamental problem of the early humanists: the relationship between Greco-Roman and Christian civilization. These two diverse worlds, never readily reconciled, could in times of trouble seem incommensurable and even contradictory. Thus towards 1355 Boccaccio, tormented by guilt in a period of economic collapse, pestilence and social change, disavowed his earlier work. He decided to devote himself exclusively to Christian writers, to abandon the pagans, and to dispose of his library of pre-Christian authors.[47] Boccaccio was reassured by Petrarch's insistence on the value, even if only secondary, of the great ancient writers. On another occasion Petrarch said: "I think I can retain my love for both the Christian writers and the ancients so long as I keep in mind which is preferable for style and which for content."[48] This sense of uncertainty persisted, often provoked by conservative theologians such as the forceful Dominican Giovanni Dominici in Florence around the turn of the century.

Just at the time of Boccaccio's crisis Beato Carlo retired to Fiesole. When in 1360 he chose a severe life of penance he was no doubt influenced by the

same events as affected Boccaccio. There were, furthermore, other eminent Tuscans who a few years earlier abandoned society and challenged its values. Soon after 1351 Giovanni dalle Celle took up a hermit's life in a cell above the monastery of Vallombrosa and became one of the most influential religious figures of the time. In 1355 the wealthy Sienese merchant Giovanni Colombini gave his possessions to the poor, had himself publicly whipped, and with his disciples established what was to become the Order of the Gesuati.[49]

The scholar who established the text of the Vulgate, and who wrote so eloquently about both the ascetic life and the magnetism of the pre-Christian world, symbolized perfectly the diverse values of the Renaissance humanists. Writing in Paris in 1500, Erasmus said he had long wished to undertake a commentary on the Epistles. "I am moved by the piety of that holy man," he said, "of all Christians beyond controversy the most learned and most eloquent . . . what a mass there is in his works of antiquities, of Greek literature, of history—and then what a style, what a mastery of language, in which he has not only left all Christian authors far behind him but seems to vie with Cicero himself."[50] Given such views, it is not surprising that the two widely diffused images of St. Jerome were sometimes juxtaposed.[51] A learned cardinal, furthermore, might be portrayed as the sanctified ancient scholar in his study, while outdoors, visible through the window, his alter ego beats his breast in the wilderness (fig. 184).[52]

NOTES

1. *Acta Sanctorum,* VIII, Sept. 30.
2. A. Strümpell, "Hieronymus im Gehäuse," *Marburger Jahrbuch,* II, 1925–26, p. 173 ff.; O. Pächt, "Zur Enstehung des 'Hieronymus im Gehäus,'" *Pantheon,* XXI, 1963, pp. 131–142; Meiss, "French and Italian Variations on an Early Fifteenth-Century Theme: St. Jerome and His Study," *Gazette des Beaux-Arts,* LXII, 1963, p. 157 ff. To the examples I cited in this article should be added one in the polyptych of the Presentation in the Temple by "Jacopino" in the Pinacoteca, Bologna.
3. For the frontispiece to the *Bible moralisée* see Meiss, *loc. cit.* Pächt (*loc. cit*) argued that this drawing is based on a *joyau* of the period of Charles V. The most recent article on the Eyckian *St. Jerome* in Detroit is a fascinating study by E. Hall, "More about the Detroit Van Eyck: The Astrolabe, the Congress of Arras and Cardinal Albergati," *Art Quarterly,* XXXIV, 1971, pp. 181–201. For the cycle of St. Jerome in the *Belles Heures* see Meiss (with the assistance of S. O. Dunlap Smith and E. H. Beatson), *French Painting in the Time of Jean de Berry. The Limbourgs and their Contemporaries,* New York, 1974, pp. 115 f., 127 f.

4. Meiss, *loc. cit.;* Pächt, *loc. cit.*

5. A. Chastel, *The Age of Humanism,* London, 1963, p. 83. On Guarino and St. Jerome see M. Baxandall, *Giotti and the Orators,* Oxford, 1971, p. 92.

6. For this assumption see the writers on St. Jerome cited in preceding and following notes.

7. No example is listed by the Index of Christian Art, which classifies subjects to 1400.

8. The basic observations of this essay were presented very briefly in my entries in the successive catalogues of the exhibition of detached frescoes, beginning at the Metropolitan Museum in 1968. See especially Munich, Haus der Kunst. *Fresken aus Florenz,* Munich, 1969, p. 160 f., and Meiss, *The Great Age of Fresco: Discoveries, Recoveries and Survivals,* New York and London, 1970, p. 153 ff., and the French and German editions. For participation in the exploration of these problems I wish to thank Elizabeth H. Beatson, my assistant at the Institute for Advanced Study. P. A. Pöllmann, "Von der Entwicklung des Hieronymus-Typus in der älteren Kunst," *Benediktinische Monatschrift,* II, 1920, p. 438 ff., already observed that the theme of Jerome in penitence was created in Florence.

9. Letter XXII. The translation is from *Nicene and Post-Nicene Fathers,* ed. P. Schaff and H. Wace, New York, VI, 1893, p. 24 f.

10. "Before this church stands the monastery in which St. Jerome, St. Paula, and Eustochium, and very many other saints once dwelt, and by the grace of God wrought many miracles. A Saracen now dwells on this spot, and receives one Venetian penny from anyone who wants to go into the church." (Ludolph von Suchem, *ca.* 1350, *Description of the Holy Land, and of the Way Thither,* tr. A. Stewart [Palestine Pilgrims Text Society], London, 1895, p. 95.) Also Niccolò da Poggibonsi, 1346–1350, "e poi truovi una piccola capella, con uno altare, dove santo Ieronimo diceva la messa; verso mezzo dì si è una porta nel sasso della grotta. Come entri dentro, a parte destra, entro nel sasso, si è una bella sepoltura, dove seppellita fu santa Paula, e Eustochia sua figliuola. A levante si è una piccola entrata; et entrando dentro, truovi una grande porta che risponde nella citerna. A levante si è una tribuna, con uno altare, e ivi si è dipinta la Vergine Maria, col suo Figliuolo in braccio, ma li Saracini l'ànno quasi tutta guasta, e colpita. Di sopra alla grotta santo Ieronimo fece penitenzia, e traslatò la Bibia di greco in latino." *Libro d'oltremare,* ed. A. Bacchi della Lega (Scelta di curiosità letterarie inediteo rare dal secolo XIII al XVII, CLXXII), Bologna, 1881, I, p. 229 f.

11. For fig. 171 see F. Zeri, "Investigations into the Early Period of Lorenzo Monaco," *Burlington Magazine,* CVII, 1965, p. 7. Other examples of this popular subject in Florentine painting are: early fifteenth-century predella, S. Domenico, S. Miniato al Tedesco; immediate circle of Masaccio, Lindenau Museum (R. Oertel, *Frühe italienische Malerei in Altenburg,* Berlin, 1961, p. 140 ff.); "Sherman predella," Museum of Fine Arts, Boston (see *Bulletin of the Museum,* XX, 1922, no. 121); Workshop of Fra Filippo Lippi, Fogg Art Museum, Cambridge, Mass.; Domenico di Michelino, predella, Museo, Prato. See also the predella by the Osservanza Master (R. Salvini and L. Traverso, *The Predella from the Thirteenth to the Sixteenth Century,* London, 1960, pl. 90). In his life of Fra Filippo, Vasari refers to a "Sant'Ieronimo in penitenza . . . in guardaroba del duca Cosimo" (*Vite,* ed. Milanesi, II, 1906, p. 626). The penitent Jerome appears below the Madonna in a panel by Neri di Bicci in the Yale Gallery, New Haven. For the spread of this type into later Northern painting see S. Herzog, "Gossart, Italy, and the National Gallery's St. Jerome Penitent," *National Gallery of Art, Report and Studies in the History of Art,* 1970, p. 67. For a valuable study of some aspects of the type in the second half of the Quattrocento see now

R. Wittkower, "Desiderio da Settignano's St. Jerome in the Desert," *ibid.,* 1971–1972 (but without "Report" in the title), pp. 7–37. The dramatic figure in the relief discussed as an acolyte or monk seems to me puzzling because of the lack of tonsure, which is conspicuous in all related representations.

12. This *St. Jerome* in Princeton has been an art-historical puzzle. When in the Mather Collection it was published by Richard Offner as a work of Masolino ("A Saint Jerome by Masolino," *Art in America,* VIII, 1919, pp. 68–76). Offner remarked that the arms in the lower corners are those of the Ridolfi and Gaddi families, but these identifications, especially that of the Ridolfi, need further study. Offner observed, furthermore, that Maddalena di Niccolò di Antonio Ridolfi married Agnolo di Zanobio Gaddi in 1424, and he asserted (far too confidently in my opinion) that the painting was made to celebrate the birth of their first son, and thus was executed *ca.* 1425. Perhaps archival investigation would throw light on the question, but this quite unsubstantiated date of 1424–1425 has since been generally accepted (but see the skepticism of L. Berti, *Angelico,* Florence, 1967, p. 32). On the other hand, Offner's attribution (one of his first efforts and very few errors) has been unanimously rejected, often in favor of a very early work by Fra Angelico (see R. Longhi, "Fatti di Masolino e di Masaccio," *Critica d'arte,* XXV–XXVI, 1941, p. 174).

 The surface of the painting is abraded, especially the face of the saint, and it is also covered by old yellow varnish. It nevertheless remains an impressive work. The outlines of the figure are simple, bold, and expressive. The landscape extends the powerful spatial implications of the figure and of the scroll, which winds forward in so dramatic a manner. The large, voluminous limbs, feet, and hands derive beyond any doubt from Masaccio, and they are lighted in accordance with his principles. If, as has been assumed, the painting was executed in the period 1425–1428, there are few candidates for its authorship. The figure is both less Giottesque and less linear than Angelico's earliest works (altarpieces of S. Pietro Martire and of S. Domenico, Fiesole). It resembles in certain respects Arcangelo di Cola, but it seems too strong for him. Perhaps cleaning of the surface will help to solve the problem.

 Some additional examples of St. Jerome standing and striking his breast are: follower of Fra Angelico, no. 58.1181, Museum of Fine Arts, Montreal; Domenico di Michelino, Dallas Museum of Fine Arts (F. R. Shapley, *Paintings from the S. H. Kress Collection,* London, 1966, Fig. 271); Pesellino, *Madonna and Saints,* Metropolitan Museum, New York; Benozzo Gozzoli, Thyssen Collection, Lugano; Neri di Bicci, triptych of the Annunciation, Accademia, Florence.

13. *Bullarum Diplomatum et Privilegiorum Sanctorum Romanorum Pontificum,* V, 1860, p. 29 ff. For the congregation see M. Heimbücher, *Die Orden und Kongregationen der katholischen Kirche,* Paderborn, I, 1933, p. 592 f.

14. Hélyot, *Histoire des ordres monastiques, religieux et militaires,* Paris, III, 1721, p. 447 ff.; Heimbücher, *op. cit.,* p. 592 ff.

15. Hélyot, *op. cit.,* IV, p. 20.

16. *Ibid.*

17. *Bullarum, cit.,* IV, 1859, p. 653 f.; Hélyot, *op. cit.,* p. 23. The *Eremiti di S. Girolamo* had no connection with the *Monaci di S. Girolamo* of S. Maria di S. Sepulcro in the Via delle Campora, founded earlier in the fourteenth century.

18. ". . . habitum quem hucusque gestare consuevistis, gestare . . .," *Bullarum,* V, 1860, p. 53.

19. G. M. Brocchi, *Vite di santi e beati fiorentini,* Florence, II, 1761, p. 198, says that in 1415 the habit was gray with a cowl, scapular, and short cloak. His information on the Order was based on a manuscript then in the library of Sta. Maria Novella.

20. Hélyot, *op. cit.*, IV, p. 23, published an extract of the bull; the entire document is given by Wadding, *Annales Minorum,* XIII, 1735, p. 171 f. ". . . tunc ab eorum primaeva institutione talem habitum, qualem Fratres Tertii Ordinis sancti Francisci de poenitentia nuncupati et nonnulli Eremitae gerunt deferentibus, et ab ipsis Eremitis et Fratribus Tertii Ordinis hujusmodi in habitu differentiam habere cupientibus differentem habitum ad cautelam dumtaxat ab eisdem Eremitis et Fratribus Tertii Ordinis ejusdem coloris recipiendi et receptum perpetuo gestandi per alias nostras concessimus. . . ." The bull permitted those Hieronymites who wished to retain the traditional habit to do so, but then they had to enter houses in Padua and Vicenza, with a different denomination, the Hieronymites of the Congregation of Carlo.

21. As maintained by Wadding, quoting Marianus (*Annales,* IX, 1734, p. 274). "Post paucos annos Institutum approbavit Gregorius XII. deinde, assumpta regula sancti Augustini, confirmavit Eugenius IV et multis munivit privilegiis. Professores nativo leucophaei coloris vellere, in memoriam prioris habitus, inquit Marianus, amiciuntur, pallio rugato a summo ad imum scisso, scortea zona tunicam cingunt, et calepodiis pedes Franciscano more ad nostram usque aetatem muniebant."

22. "Fratres insuper ipsius fraternitatis, de humili panno in pretio et colore, non prorsus albo vel nigro, communiter vestiantur Bindis et ligaturis sericis non utantur, pelles dumtaxat agninas. . . ." *Bullarum,* IV, 1859, p. 91.

23. Hélyot, *op. cit.,* VII, 1721, p. 235, without, however, citing his published source. Hélyot does not describe an alternative habit, and I have not had access to the bull of 1448.

24. Hélyot, *op. cit.,* IV, p. 24 and plate.

25. In a few panels it is difficult to be certain whether the painter intended a cord or a belt. See, for example, figs. 170, 171, 173. In the altarpiece of 1463 by Benozzo Gozzoli, no. 283 in the National Gallery, London, Jerome's tunic is encircled by a cord. According to J. Moorman, *A History of the Franciscan Order,* Oxford, 1968, p. 224 n. 5, in 1396 Tertiaries were permitted to take the cord of the Franciscan Order. The bull of Nicholas V cited above (note 23) indicates that few of them did, and there is no reason, in any event, to believe that the Hieronymites changed also.

26. See also above, notes 11, 12. The Augustinians, too, wore a leather belt, but the Hieronymites, who in 1441 took the Augustinian rule, did not adopt the Augustinian habit—which was, furthermore, black.

 The rustic branch that serves as St. Jerome's girdle in the panel by Piero della Francesca in Venice is unusual. Exceptional also is the confrontation of saint and donor, both represented on the same scale. The composition thus resembles, as we have said above, Jan van Eyck's *Chancellor Rolin before the Madonna* (see p. 52, figs. 50, 51).

27. See also the figure of St. Jerome beating his breast in the right pilaster of Angelico's *Deposition,* S. Marco (*Angelico, Klassiker der Kunst, Stuttgart, 1911,* ed. F. Schottmüller, pl. 65).

28. The iconography was discussed by L. Pillon, "La légende de Saint Jerome," *Gazette des Beaux-Arts,* XXXIX, 1909, pp. 303–318. The altarpiece was ascribed to a follower of Angelico (the Buckingham Master) by M. Laclotte, *De Giotto à Bellini,* Paris, 1956, p. 68 f.; M. Salmi, *Il Beato Angelico,* Florence, 1958, gave it to Zanobi Strozzi.

29. For the date of the church see M. Davies, *The Earlier Italian Schools* (National Gallery Catalogues), London, 1961, p. 121 n. 8, and the sources there cited.

30. Davies, *op. cit.,* p. 120; Laclotte, *loc. cit.* Although the accompanying reproductions of the belted saint show a tunic of lighter gray (figs. 169, 171) the saint wears a

dark gray tunic and belt in, for example, Andrea di Giusto's *Assumption of the Virgin* (*National Gallery of Ireland, Illustrations to the Paintings*, Dublin, 1963, no. 861).

31. *Loc. cit.* The altarpiece in London seems to me to resemble much more Botticini's dated works of the eighties than his altarpiece of 1471 in the Musée Jacquemart-André, Paris.

32. Davies, *op. cit.*, p. 119.

33. For later examples see M. Warnke, "Italienische Bildtabernakel bis zum Früh-Barock," *Münchner Jahrbuch der bildenden Kunst*, XIX, 1968, p. 64 ff.

34. See the publications cited in note 8, and especially *The Great Age of Fresco: Discoveries, Recoveries, and Survivals*, New York and London, 1970, p. 153 ff.

35. When, in preceding descriptions, these two women were identified at all they were usually called "two Maries."

36. Vasari, *Vite*, ed. Milanesi, II, p. 7.

37. Brocchi, *loc. cit.;* V. Follini, *Firenze antica e moderna*, Florence, 1791, III, p. 269 f.; G. Richa, *Notizie istoriche delle chiese fiorentine*, Florence, 1758, III, p. 92 f. The Buca was situated behind the structure now incorporated in the Accademia, which was previously the hospital of S. Matteo. Later the *compagnia* used the church in the south-west corner of Piazza SS. Annunziata. A plaque with names of notable members and the inscription from the urn that enclosed Beato Carlo's head are still to be seen. Even with the generous help of Professor Guido Pampaloni, director of the Archivio di Stato, it has not proved possible to discover the present whereabouts of the archive of the Buca, if indeed it still exists.

38. The Trinity, however, is not known to have been especially venerated by the Hieronymites, and St. Jerome, furthermore, according to the sources, had no vision of it. Perhaps its presence reflects the theological controversy about it at the recent Council of Florence. In the painting of the *Death of St. Jerome* that Geminiano Inghirami, a papal theologian at the Council, commissioned of Fra Filippo Lippi for the Cathedral of Prato the Trinity hovers over the body of the saint. For citation at the Council of the authority of St. Jerome on the Trinity see *Acta Concilii Oecumenici Florentini*, Rome, 1638, p. 263 f.

39. Brocchi, *loc. cit.*

40. V. Golubew, *Die Skizzenbücher Jacopo Bellinis*, Brussels, 1908, II, pl. 14.

41. *Ibid.*, pl. 21. He holds a stone also in the damaged painting in Jacopo's style in the Museo di Castelvecchio in Verona.

42. Meiss, *Giovanni Bellini's St. Francis*, Princeton, 1964, p. 19 ff., fig. 36. In the early *St. Jerome* in Birmingham he addresses the lion (*ibid.*, fig. 37). Of course Crivelli (no. 724, National Gallery, London) and Marco Zoppo (Walters Art Gallery, Baltimore) represent the penitent saint.

43. G. Robertson, *Giovanni Bellini*, Oxford, 1968, pls. LVIII a and b, CXIII. It is interesting to observe that although Jerome frequently writes, as Hall, *op. cit.*, p. 200 n. 43, pointed out, he more often reads in Bellini and in Venetian paintings.

44. Letter XXII, as translated in *Nicene and Post-Nicene Fathers, cit.*, p. 35.

45. The subject is not recorded in the Index of Christian Art, which extends to the year 1400.

46. There is another representation in a predella by Sano di Pietro in the Louvre.

47. Meiss, *Painting in Florence and Siena After the Black Death*, Princeton, 1951, p. 161 ff.

48. *Epistolae de rebus familiaribus* (ed. G. Fracassetti), Florence, 1859, XXII, 10.

49. Meiss, *op. cit.*, p. 84 ff. In this account of religious movements in Tuscany I over-

looked entirely Beato Carlo and the Hieronymites, who would have contributed significantly to my thesis.

50. *The Epistles of Erasmus,* trans. by F. M. Nichols, New York, 1901, p. 289 (Epistle 134).
51. See the fifteenth-century panel in the Museo Nazionale, Pisa (Anderson 28733).
52. E. Fahy, "A Portrait of a Renaissance Cardinal as St. Jerome," *Bulletin of the Minneapolis Institute of Arts,* LIX, 1970, p. 5 ff. Cranach painted Cardinal Albrecht of Brandenburg as St. Jerome (A. Chastel, *The Myth of the Renaissance 1420–1450* [1969], pp. 169, 172).

12

Raphael's Mechanized Seashell: Notes on a Myth, Technology and Iconographic Tradition

From the time of its completion in 1513 Raphael's *Galatea* in the Villa Farnesina in Rome has been judged a supreme visualization of an ancient myth (fig. 185). To a Roman of the Imperial Age, however, many aspects of the painting would surely seem surprising. On sarcophagi, engraved gems or the walls of Pompeian houses he had seen Galatea fleeing from Polyphemus on the back of a dolphin (fig. 186), not, as in Raphael's fresco, in a seashell, the familiar vehicle of Venus immediately after her birth.[1] The dolphins pulling the shell would seem normal enough, but entirely unexpected, and indeed extremely puzzling would be the radial blades of wood—clearly man-made—attached to the side of the shell.

The story of Galatea and Polyphemus offered a range of episodes to the painters of the Sala di Galatea and their patron, the wealthy merchant and banker, Agostino Chigi. We do not know how many ancient representations —if any—the painters knew. In some of them the Nereid fled on the back of a dolphin from the one-eyed monster (fig. 186), in others she responded to his song, and she might even sit in his lap or permit an embrace.[2]

In 1511 Sebastiano del Piombo initiated the work on the walls of the room by painting Polyphemus seated on a cliff, facing the sea and the nymph whom Raphael was to add shortly afterward (fig. 189). Galatea, listening to

This article was published in *Gatherings in Honor of Dorothy E. Miner*, Baltimore, 1974, pp. 317–332.

the giant's ecstatic song, is surrounded by manifestations of çarnal love (fig. 185). Raphael's fresco, indeed, seems to celebrate its power more than her indifference to, or triumph over, her brutish wooer, which is signalized by her flight and by the small and for centuries unnoticed detail of the dolphin biting an octopus.[3] Cupids aim arrows at her, while another holds an additional supply, as if to suggest the strength of Galatea's resistance. A Triton embraces a Nereid, and sea-gods sound conches and trumpets. While two dolphins draw her away from her suitor she turns around to fix her eyes on him. The reins are taut and she skims the sea with such speed that her mantle and hair blow straight out behind her.

The ancient representation that most resembles Raphael's fresco is a painting described by Philostratus in the second century A.D.

> The nymph sports on the peaceful sea, driving a team of four dolphins yoked together and working in harmony; and maiden-daughters of Triton, Galatea's servants, guide them, curbing them in if they try to do anything mischievous or contrary to the rein. She holds over her head against the wind a light scarf of sea-purple to provide a shade for herself and a sail for her chariot. . . .
>
> Her foot, with the graceful part that ends in it, is painted as on the sea, my boy, and it lightly touches the water as if it were the rudder guiding her chariot. Her eyes are wonderful, for they have a kind of distant look that travels as far as the sea extends.[4]

Advisers of Raphael might have known a manuscript of Philostratus, but they were in any event certainly familiar with a description of Galatea based on his in the *Stanze* of Angelo Poliziano. Poliziano reduced the number of dolphins from four to two and in this respect his image is closer to Raphael's:

> Due formosi delfini un carro tirano;
> Sovr'esso è Galatea, che il fren corregge:
> E quei notando parimente spirano;
> Ruotasi attorno più lasciva gregge,
> Qual le salse onde sputa, e quai s'aggirano. . . .[5]

The *carro* derives from the "chariot" of Philostratus. Neither he nor Poliziano describes the vehicle, but already in antiquity Neptune and Amphitrite ride the waves in a triumphal wagon drawn by Tritons (fig. 188). The wheel, so effective an instrument for movement on land, is again made to

serve Neptune on the sea in a famous passage at the beginning of the *Aeneid*. When Aeneas and the Trojan ships, wandering near Italy, were threatened by a great storm Neptune "allays the flood, and on light wheels (*rotis levibus*) glides over the topmost waters."[6]

In illustrations of the *Aeneid* in the early Renaissance, as on a cassone painted *ca*. 1460 by Apollonio di Giovanni, Neptune glides along on a four-wheeled vehicle drawn by a sea horse (fig. 187).[7] When writing of a *carro* Poliziano might have had Neptune's vehicle in mind, and he probably knew that in his time a chariot transplanted to water could bear also the goddess Venus (fig. 190). On the other hand the sixteenth century revived the ancient conception of Galatea riding directly on a dolphin, although now she does not recline but stands (fig. 199).

Although the lively scenes described by Poliziano and Philostratus—the tugging dolphins, the gliding *carro,* and the streaming garments—impressed Raphael deeply, he found them not quite what he wanted. Abandoning the chariot he gave the nymph a sort of super-shell. To it he added a paddle wheel, obviously to suggest propulsion. The painter was not, however, interested in how the wheel (and a corresponding one presumably on the opposite side) functioned. Indeed it is striking that an artist so deeply concerned with the structure and movement of the human body and of horses should not have cared more about how other things worked. The dolphins are not yoked to the shell; they pull only on Galatea's reins.

This attitude of the painter makes the introduction of the paddle wheel all the more puzzling. In the countless discussions of the fresco by art historians, however, there are only a few and rather vague references to it.[8] Goethe in *Faust* implied that it is really an ordinary wheel when he called the vehicle a "Muschelwagen."[9] One or another part of the pre-history of the paddle wheel has been noticed by students of drawings and of Quattrocento engineering, but no one has put the main pieces together.

What are the meanings of Raphael's strange contraption? First of all, as a rotating form, the paddle wheel fits well into a composition which, as Poliziano suggested, is full of rotations and gyrations. If, moreover, we consider the entire wall we discover a correspondence between the fresco and the lunette above, painted in 1511 by Sebastiano (fig. 191). There Juno rides in a wagon, preceded by peacocks. Of course the wagon, a real *carro,* rolls on ordinary wheels, whereas Raphael's paddle wheel, with an entirely different

function, is, so far as I know, unprecedented in the arts and in iconographic tradition. The idea of the paddle wheel, however, had appeared in another sphere, engineering, and even in ancient engineering. By a series of amazing links with the remote past—fifteenth-century copies of a now lost Carolingian copy of a lost Roman treatise—we know that paddle wheels to propel a ship had been invented in the mid-fourth century. The inventor, taking his idea from the watermill, which had been only recently employed, described his ship and drew a picture of it (fig. 192).[10]

> A Liburnian ship suitable for naval warfare, so large that human weakness more or less precluded its being operated by men's hands, is propelled in any required direction by animal power harnessed by the aid of human ingenuity to provide easy locomotion. In its hull or hold oxen are yoked to machines, two to each, and turn wheels attached to the ship's sides; the spokes project beyond the circumference or rim of the wheels, and, striking the water forcibly like oars as the wheels rotate, work with a wondrous and ingenious effect, their impetus producing locomotion.

By extraordinary good luck we even know that one of the copies which descend, with regard to both text and illustrations, from the Roman original was in the possession of A. Maffei in Rome in the late fifteenth century.[11] The thesis we have begun to develop does not depend, however, upon Raphael's familiarity with this manuscript. The *Liburna* of our fourth-century author, disseminated in several copies, evoked the enthusiasm of many engineers and artists of the fifteenth century, who were exploring intensively the possibilities offered by machines and the use of power, especially water-power, for what we would call labor-saving devices. Thus a ship with paddle wheels was described between 1402–1405 by Conrad Kyeser in his treatise *Bellifortis* (fig. 194).[12] Kyeser preserved the capstan of the *Liburna* and the platform around it for the oxen, but omitted the animals. In Italy the Sienese Mariano Taccola, a specialist in machines, devised boats with paddle wheels moved upstream by either cranks or the winding of rope on the axle (fig. 195).[13] Soon the idea of a boat propelled by cranked paddle wheels became familiar to a wide audience when it was described and illustrated in the treatise by Roberto Valturio, *De re militari,* which was printed at Verona in 1472 (fig. 196).[14]

In the years preceding the painting of the *Galatea* major artists with an interest in mechanics gave attention to the propulsion of boats by paddle

wheels. We possess drawings of them by Leonardo and Giuliano da Sangallo (figs. 193, 197).[15] The more interesting of these for us is the drawing by Giuliano of *ca.* 1490, because it shows ancient Roman ships floating, it seems, on the Tiber near the Castel Sant'Angelo and the Villa Farnesina itself. Among these ships is one that, as Hülsen observed, copies our *Liburna,* including the head of a goat at the prow and the lion uncertainly reposing on a platform above (fig. 192).[16] Even if Raphael and his advisers did not know the manuscript in the Maffei collection, this drawing by Guiliano da Sangallo suggests the possibility that the inclusion of the paddle wheel in the *Galatea* signified one more reference to classical antiquity.

Whatever the truth about this additional allusion in the fresco might be, the question soon lost its importance because Raphael's own authority rapidly began to equal that of antiquity. The *Galatea* enjoyed an exceptional fame, and those who did not see the original knew it, paddle wheel and all, through Marcantonio's engraving (fig. 198).[17] Artists of all kinds copied the composition; appropriately, it decorates the surface of a bowl or cistern of the late sixteenth century (fig. 201).[18] About 1620 the fresco so deeply impressed Pietro da Cortona that he made an accurate copy.[19] A drawing in Windsor from the circle of Annibale Carracci (fig. 203) and a similar one in the Louvre represent Galatea with a prominent paddle wheel; they apparently reflect a stage in the design of the ceiling fresco prior to the composition finally adopted, in which the wheel is lacking.[20]

The paddle wheel replaced the normal wheel in representations of Neptune's triumphs[21] and even in illustrations of those passages in the *Aeneid* where the normal wheel had appeared earlier (figs. 187, 206). In the eighteenth century Venezia herself glides along in the lagoon, no longer standing but relaxed in a throne-shaped shell fitted out with a large paddle wheel (fig. 204).[22] This conveyance would not, however, seriously threaten the business of a vigorous gondolier.

In representations of Galatea the shell and the paddle wheel received literary and, as it were, official sanction in the seventeenth century by becoming prominent in illustrations of Vincenzo Cartari's iconographic manual, *Imagini delli dei de gl'antichi* (fig. 200).[23] Translated into the principal European languages, this book assured our strange side-wheeler a long life.[24] Even though in the text Cartari referred to the description by Philostratus of a "carro tirato da delfini," the illustration demonstrates that the paddle

wheel is a more telling attribute than the dolphins because it omits the latter and includes two of the former, the most conspicuous entirely misunderstood and lying uselessly in the shell.

As we have seen, however, painters tended more often than not to conceive of the paddle wheel as a device that rotates, though its mechanical function was not well understood. In Tiepolo's splendid *Triumph of Amphitrite* the water spills from the churning blades (fig. 205). They are poorly shaped for propulsion yet clearly worn by long use. When in depictions of Galatea or other marine figures we see paddle wheels of this kind we wonder whether they continued to be represented only because of the authority of Raphael and of the tradition he established. Did they, as well as the archetype by Raphael itself, reflect an excitement about technology? From the fourteenth century on engineering underwent a very rapid development. We know that the most widely diffused of the new inventions, the mechanical clock, quickly became a common symbol of a major virtue, Temperance (fig. 202).[25] In the early fifteenth century, technology, as Lynn White has observed, began to be judged "virtuous."[26] The clock, to be sure, worked, whereas the paddle wheel persisted as a valuable fiction, awaiting the really practical source of power it ultimately found in the steam engine. That culmination was largely achieved, however, not on the Tiber but on the Hudson, when in 1807 Robert Fulton's steam-powered side-wheeler traveled from New York to Albany and back (fig. 207).[27] Curiously, the designer of this ship was a painter, first of miniatures and then a student of Benjamin West. The picturesque representation of his invention is his own.

In considering the genesis of the fresco in the Farnesina we must not forget the patron. The ceiling of the Sala di Galatea, after all, presents a horoscope of Agostino Chigi.[28] All ancient sources agree that Galatea personifies the white foam of the sea. Chigi il Magnifico owed part of his immense fortune to a monopoly on salt, obtained from old or new deposits of sea water. He possessed, furthermore, a fleet of a hundred ships, and naturally he would have been curious about the possibilities of mechanical propulsion.[29] In the fresco the wheel obviously has no visible source of power, unless we ascribe it to the nymph herself, and we wonder what a shipping magnate, however captivated by antiquity, would make of that. Never, however, underestimate the power of myth! Listen to that intrepid explorer,

Cyriac of Ancona, as in 1455 he departed from Delos for other Greek islands.

> Oh Mercury, nurturing father of the arts . . . best lord of ways and journeys . . . vouchsafe on this happy, favorable, fortunate Sunday, as I depart from once-sacred Delos . . . in the governor's ship which is equipped with 14 rowers, and with a favoring sea and chorus of Nymphs and Nereids, vouchsafe to direct, favor and accompany this our journey through the whole world. . . .[30]

Postscript

Since the publication of this article kind colleagues have shown me many more late examples of the paddle wheel in representations of Galatea and various marine deities—so many, in fact, that I infer the number is legion. I shall, therefore, list only a couple: a drawing of Galatea by Girolamo da Treviso, recently acquired by the National Gallery of Art, Washington (called to my attention by Konrad Oberhuber) ; eighteenth century, *Fountain of Neptune,* Madrid (fig. 208—identified and photographed by H. W. Janson).

John Shearman has pointed to a particular reason for the identification of the Villa Farnesina with Amor: a bundle of four darts served as an emblem of Agostino Chigi (see J. Shearman, "Die Loggia der Psyche in der Villa Farnesina und die Probleme der letzten Phase von Raffaels graphischen Stil," *Jahrbuch der kunsthistorischen Sammlungen in Wien,* LX, 1964, pp. 59–100). This emblem would seem to have played a part also in the choice of a subject such as Galatea.

NOTES

1. Galatea and Venus were closely related in late Latin poetry, but, as A. von Salis (*Renaissance und Antike,* Erlenbach-Zurich, 1947, p. 210 ff.) pointed out, Galatea never rides a shell in ancient art. For a mural painting of Galatea riding on a dolphin see K. Schefold, *Vergessenes Pompeji,* Bern, 1962, pl. 155.
2. For a recent summary of the ancient types of Galatea and Polyphemus see C. Caprino in *Enciclopedia dell'arte antica,* Rome, 1960, s.v. Galatea.
3. D. T. Kinkead, "An Iconographic Note on Raphael's *Galatea*," *Journal of the Warburg and Courtauld Institutes,* XXXIII, 1970, pp. 313–315. Since the color of the object in the dolphin's mouth is exactly that of the sea, I at first doubted Kinkead's

identification, but close scrutiny of a large ektachrome disclosed the presence of two glossy pink eyes.

4. *Philostratus Imagines,* trans. A. Fairbanks (Loeb ed.), Cambridge, Mass., 1960, p. 215. It is Ovid, in the *Metamorphoses,* Book XIII, who gives to Polyphemus a long and remarkably beautiful song.

5. *Stanze di messer Angelo Poliziano cominciate per la giostra del magnifico Giuliano di Piero de' Medici,* Florence, 1822, p. 40. The texts of both Poliziano and Philostratus have been related to Raphael's fresco; see, for example, F. Hermanin, *La Farnesina,* Bergamo, 1927 and J. Seznec, *The Survival of the Pagan Gods,* New York, 1953, p. 114 n. 123.

6. *Aeneid,* I, 146–147. Julius Held kindly called this passage to my attention.

7. See also a niello signed by Peregrino da Cesena (A. Hind, *Nielli, Chiefly Italian of the XV Century . . . in the British Museum,* London, 1936, p. 48, no. 194, pl. XXXIV). This representation was kindly called to my attention by Miss Jennifer Montagu. For a related niello with the composition in reverse see Hind, *op. cit.,* p. 60, no. 271, pl. XLVIII.

8. F. Hartt, *A History of Italian Renaissance Art,* Englewood Cliffs [1970], p. 479, suggested the paddle wheels might be stabilizers.

9. *Faust,* II, 2.

10. E. A. Thompson, *A Roman Reformer and Inventor, Being a New Text of the Treatise De rebus bellicis,* Oxford, 1952, p. 119. See also especially pp. 1 ff., 47, 48. The manuscript of the ninth–tenth century, famous in the Renaissance as the *Codex Spirensis,* perhaps copied only a copy of the Roman original.

 Professor Lionel Casson, a specialist in ancient ships, kindly informs me there is no other antique representation of paddle wheels.

11. Oxford, Bodleian Library, Canon. misc. 378 (ship on fol. 75v). This copy was made for Bishop Pietro Donato in 1436, who had learned of the Carolingian manuscript at the Council of Basle (Thompson, *op. cit.,* p. 7). Donato belonged to a circle of scholars and humanists in Padua.

12. *Conrad Kyeser aus Eichstätt, Bellifortis,* ed. G. Quarg, Düsseldorf, 1967, pp. XVI, XXIII, 36, and fol. 54v of the facsimile. Also M. Berthelot, "Le livre d'un ingénieur militaire à la fin du XIVᵉ siècle," *Journal des savants,* 1900, pp. 1–15, 85–94 (esp. p. 86).

13. J. Beck, *Mariano di Jacopo detto il Taccola, Liber Tertius de Ingeneis,* Milan, 1969, esp. p. 37.

14. B. Gille, *Les ingénieurs de la Renaissance,* Paris, 1964, p. 78. Valturio knew both Taccola and Kyeser.

15. For Leonardo's paddle boats, one of which was operated by pedals, see also *Il codice atlantico di Leonardo da Vinci nella Bibliotheca Ambrosiana di Milano,* Milan, 1894, pl. vol. IV, fols. 319v, 344, 374v, 384. See also F. Feldhaus, *Leonardo der Techniker und Erfinder,* Jena, 1913, pp. 123–126.

16. C. Hülsen, *Il libro di Giuliano da Sangallo, Codice Vaticano Barberiniano Latino 4424,* Leipzig, 1910, p. 50. Earlier H. Egger with C. Hülsen and A. Michaelis (*Codex Escurialensis,* Vienna, 1906, p. 157 ff.) saw no prototype for Sangallo's *Liburna,* and thought that the blades illustrated the measuring device described by Vitruvius in Book X, chapter 9. The teeth discussed there by Vitruvius are, however, different from the blades on the ship's wheels, and Hülsen's proposal of 1910 is undoubtedly correct. See also B. Degenhart and A. Schmitt, *Corpus der italienischen Zeichnungen, 1300–1450,* Berlin, part I, II, 1968, p. 279.

17. A. M. Hind, *Marcantonio and Italian Engravers and Etchers of the Sixteenth Century,* New York, n.d., fig. xxx.

18. London, Wallace Collection, c.iii.100. *Ca.* 20 inches long, 8½ inches high. See also *A History of Technology,* ed. C. Singer et al., Oxford, ii, 1956, pl. 37.

19. The painting is in the gallery of the Accademia di S. Luca. G. Briganti, *Pietro da Cortona,* Florence, n.d., p. 155 ff.

20. In a nearly identical drawing by the workshop of Annibale, Louvre 7198, the paddle wheel appears also. Louvre 7197, by Annibale himself, lacks the wheel, but in it the position of the supporting nymph is less close to the fresco than in the two workshop drawings. See R. Wittkower, *The Drawings of the Carracci at Windsor Castle,* London, 1952, p. 162 no. 507; J. Martin, *The Farnese Gallery,* Princeton, 1965, p. 261 no. 86, figs. 196, 269.

21. See the Gobelin tapestry of Neptune and Thetis, symbolizing Water, designed by Le Brun *ca.* 1664 (M. Fenaille, *Etat général des tapisseries de la manufacture des gobelins depuis son origine jusqu'à nos jours 1600–1900,* Paris, ii, pt. 1, 1903, pl. opp. p. 52).

22. See J. Schulz, "The Printed Plans and Panoramic Views of Venice," in *Saggi e memorie di storia dell'arte,* vii, 1970 (1972), cat. no. 187; also, for other similar representations, cat. nos. 116, 121.

23. The first engravings for this book, in the edition of 1571, do not illustrate Galatea. Our illustration, in the edition of 1647, was used already in 1615. For the engravings in general see Seznec, *op. cit.,* p. 252 ff.

24. After several editions in Italy and Lyon it was translated into Latin in 1581, English in 1599, French in 1606, German in 1692.

25. See the excellent article by L. White Jr., "The Iconography of *Temperantia* and the Virtuousness of Technology," in *Action and Conviction in Early Modern Europe,* ed. T. K. Rabb and J. E. Seigel, Princeton, 1969, pp. 197–219.

26. L. White Jr., *Medieval Technology and Social Change,* Oxford, 1962, p. 124 ff.

27. J. T. Flexner, *Steamboats Come True,* New York, 1944, p. 387 and caption to pl. opp. p. 86, with a reference to Raphael's fresco.

28. F. Saxl, "The Villa Farnesina," in *Lectures,* London, 1957, i, p. 189 ff.

29. See *Il Magnifico Agostino Chigi,* Rome, 1970 (Associazione bancaria italiana), pp. 249 f., 319. Edith W. Kirsch kindly consulted in Italy a copy of this rare book. See also R. Förster, *Farnesina-Studien,* Rostock, 1880, p. 1 ff.

30. Trans. in the interesting article by E. W. Bodnar, "A Visit to Delos in April, 1445," *Archaeology,* xxv, 1972, p. 215.

13

Sleep in Venice: Ancient Myths
and Renaissance Proclivities

Kenneth Clark has remarked that the Dresden *Venus* by Giorgione must be accorded the same place in European painting as is held in antique sculpture by the *Cnidian Venus* of Praxiteles (fig. 209).[1] Giorgione's picture was momentous, however, not only because of the beauty of the goddess, which Clark described admirably, but because of her slumber, which he mentioned only in passing. Poussin, Renoir, and innumerable other masters composed variations on the figure, or on one of the more widely known versions of it by Giorgione himself, Titian or other Venetian painters (fig. 210).[2] The sleeping female nude became so common in later Western painting that we are inclined to overlook how novel it was around 1500 when first it began to appear. Within a generation—the early years of the High Renaissance—Venetian painters and patrons, may I say, embraced the subject with great enthusiasm. Giorgione's *Venus,* however enchanting, is only one, and not the earliest, of numerous similar representations. They constitute a very considerable proportion of all Venetian non-religious paintings in this first great era of secular art. By reconstituting this series, or at least the major surviving examples, we may learn something about their meaning and about art and taste in the radiant city in the lagoon.

Let us begin with the Dresden picture. Marcantonio Michiel, author of

This article was published in the *Proceedings of the American Philosophical Society,* CX, 1966, pp. 348–382.

the earliest guidebook to collections of the Veneto, described it in 1525 as a nude Venus in a landscape with a Cupid. The landscape and the Cupid were finished, he said, by Titian.[3] Probably they were begun, or at least envisaged, by Giorgione. X rays have revealed traces of the Cupid, holding, it seems, an arrow and a small bird (fig. 211).[4] The damaged little figure was painted out around 1837 and the entire picture has been retouched.

Though the painting was no doubt presented as a mythological subject *all'antica,* Venus is never represented lying asleep in Greco-Roman art, and no such conception in ancient literature has ever been cited. Even recumbent nudes are uncommon as independent figures in antiquity; the exceptional instances are creatures that embody free natural forces, such as nymphs and fauns, or cupids, who are very youthful, or hermaphrodites, who are abnormal. With regard to the reclining (but not sleeping) goddess, the Dresden picture had one notable Renaissance predecessor, Botticelli's exquisite painting of Venus subduing Mars (fig. 212). The subject was perhaps inspired by Ficino or directly by the apostrophe of Lucretius to Venus.[5] It is not surprising to recognize that Botticelli, who was close to Florentine Neoplatonic circles and who had his own very un-Venetian ideas of the human body, made more of the idea expressed by Lucretius at the outset—"Cause the savage works of war to sleep and be still over every sea and land"—than of the sensuous relationship between god and goddess upon which the poet dwells. Venus, though a dazzling mistress in the poem, is clothed in the painting, while Mars is nude, less as a lover than a soldier off duty, whose armor serves as toys for frolicking *satirini.* Sleep is not mentioned by Lucretius, nor indeed by Ficino or other writers sometimes regarded as the inspiration of this composition. It is Botticelli's way of showing peace attained through love.

Botticelli's painting probably served as a panel in a piece of furniture, and indeed such a humble fact as the proportions of panels in chests (*cassoni*) or other furniture that provided surfaces suitable for paintings probably affected the compositions selected for them, and also the subjects. Some of the earliest extant single sleeping figures, in fact, appeared during the later Quattrocento in the very low fields provided by the lids of marriage chests. Into these spaces, most unpromising for normal representations, a nude figure, normally alluding to the bride or groom, was introduced (fig. 213).[6] Later, when recumbent and sleeping figures became popular as the

subjects of easel paintings, they normally assumed a new long, low format, as we have begun to see.

Piero di Cosimo's *Mars and Venus,* made shortly after 1500, basically transforms Botticelli's (fig. 214). The gaiety with which Botticelli had endowed the satyrs pervades Piero's entire picture. At the same time the natural world, partly excluded and partly distilled in Botticelli's painting, is affectionately rendered, almost in Venetian fashion. But Piero, unlike Giorgione, turns it toward parody of his mythological characters: witness the whiteness of the flesh of Mars but the red roughness of his normally exposed hands. Though Venus is nude and has been cited as the source of Giorgione's[7] the gulf is very wide indeed.

On the whole Piero's vein of facetious naturalism, though prominent, as we shall see, in North Italy and the Veneto, is exceptional in Tuscan painting. In Tuscany, furthermore, recumbent nude female figures evoked little interest, Venuses included. When one is represented, as in copies of a lost composition of Michelangelo,[8] the landscape is only a sort of footnote and the goddess, far from sleeping, is disturbed in every joint by a dark force that is partly explained by the symbols at the left (fig. 219). Two representations of sleeping women painted around 1495 by Botticelli, interesting as they are, do not really constitute exceptions to prevailing Florentine taste (figs. 215, 216). As simulated reliefs surrounding the *Calumny of Apelles,* they are both minute in scale and historical in nature.[9]

In Giorgione's picture the cushions and the drapery separate Venus from the ground, but the mound at the left—a typical Venetian device—serves as a sort of natural crown for her head. Her tranquillity is enhanced by the utter silence of the lush, peaceful landscape, which echoes the rhythms of her outlines. This closeness of body and nature, of flesh and flowers, is foreign to Tuscany and, indeed, to the classical world.

As Fritz Saxl rightly observed years ago in a lecture that was published only recently,[10] Giorgione's *Venus* was influenced by the *Hypnerotomachia Poliphili,* printed in Venice in 1499, eight or nine years before the painting of the picture, and illustrated with woodcuts in a style related to Giovanni Bellini and the Lombardi.[11] At one point the author of this archaeological romance describes a wonderful fountain containing at its center a sleeping nymph (fig. 217).[12] The writer certainly had in mind an ancient naiad of the type represented by the beautiful marble formerly in Wilton House (fig.

220). One example was in the collection of Gabriel Vendramin in Venice, as we know from Marcantonio Michiel.[13] We cannot be certain that this statue was actually ancient, because naiads in the antique manner began to be made in the sixteenth century. One, then in the Collocci garden in Rome and now known only in an engraving, bore an inscription that was said to have been carved below an ancient nymph on the banks of the Danube (fig. 218).[14] Though the epigram is actually an invention of the fifteenth century it was long believed to be ancient, even by Alexander Pope, who, as Otto Kurz has pointed out, translated it charmingly:

> Nymph of the grot, these sacred springs I keep,
> And to the murmur of these waters sleep;
> Ah, spare my slumbers, gently tread the cave!
> And drink in silence, or in silence lave![15]

The author of the *Hypnerotomachia,* however, had in mind no simple fountain *all'antica.* He added two *satirini* and a satyr who draws away or simply holds a curtain fastened, as in Hellenistic and Roman reliefs (fig. 230), to an over-arching tree.[16] The author thus assimilated the naiad to one of the ancient themes of a satyr's approach to a slumbering nude, either a nymph such as Lotis or Vesta, or Ariadne, though Bacchus does not stand by. The story of Ariadne, quite familiar of course to the humanists, had not been forgotten in the Middle Ages. When illustrating Dante's *Paradiso* around 1445 even an artist so lacking in classical interests as Giovanni di Paolo introduced it, showing the fully clothed, sleeping figure approached by a sort of medieval, angelic Bacchus (fig. 223). The poem refers only to the later event of the creation of the constellation, but the painter or his adviser could have found a brief reference to the myth in the commentary around 1370 of Benvenuto da Imola and in the *Ovide moralisé.*[17] The author of the *Hypnerotomachia* may have known ancient representations of the discovery on coins (fig. 222).[18] An impressive statue of Ariadne was visible in Rome around this time; Pope Julius II acquired it and in 1512 he put it on exhibition in the Belvedere (fig. 221).[19] One aspect of the woodcut enjoyed important historical sanction, for Pliny referred to a picture by the outstanding painter Nicomachus that showed "Bacchants with Satyrs prowling towards them."[20]

None of the associations of the fountain in the *Hypnerotomachia* with

ancient myths would, however, prepare us for the inscription written below it—ΠΑΝΤΩΝ ΤΟΚΑΔΙ "to the parent of all," or, as the text phrases it ΠΑΝΤΑ ΤΟΚΑΔΙ "all things to the parent."[21] Both inscription and text honor the parent. This is indeed a "mysterioso dicto," as the author characterizes it. It proves that we are not, as Saxl believed, confronted with an Ariadne.[22] It identifies the naiad, already involved in a scene of discovery, with a universal parent, not further specified but probably Venus. The two doves in the pediment above may refer to her.[23] But in antiquity the goddesses and the gods were majestic and awesome, and no ancient Venus was ever imagined stretched out on the ground asleep, and certainly not disclosed by satyrs. This conflation in the *Hypnerotomachia* of Venus, a fountain nymph and an episode of discovery by satyrs, is, from the classical point of view, nonsense. The image struck nonetheless a responsive chord in Venice; it quickly became one of the most popular and respected of "ancient mythologies." Few confusions, or perhaps deliberate combinations, have had as great an effect upon the Western iconographic tradition.

The extraordinary image in the *Hypnerotomachia* was quickly followed in the Veneto by two related but different groups of representations. The first group consisted of the single nude sleeping woman, Venus or another mythological figure.[24] In the second group the sleeping woman is approached by satyrs. Giorgione's Dresden picture was the most influential example of the first type. It shares with the woodcut a nude recumbent figure, the subject Venus, and the large natural form above the head—a mound replacing the tree. In two respects, however, it implies a fresh study of ancient monuments. The right arm of Venus is bent over her head, in the typical Greco-Roman gesture of sleep.[25] Her left hand is an adaptation of the gesture of the *Venus pudica* (fig. 231)—a very bold adaptation in which concealment yields to demonstration, accentuated by the large tree stump placed just behind the hand.[26]

This erotic gesture, quite different from its models in ancient art, was no doubt created by Giorgione. It appears again in a beautiful red chalk drawing in Darmstadt which is probably his (fig. 228).[27] Here a wisp of drapery has been added. The bear and dogs in the landscape may indicate that the drawing is a telescoped representation of the story of Jupiter and Callisto. Ovid tells that Callisto, when first approached by Jupiter in the guise of Diana,

was lying, tired, on the ground, her head pillowed on her quiver.[28] Gior-gione, however, chose to show the nymph in deep slumber.

Marcantonio Michiel recorded three representations of a nude woman by Giorgione in addition to the Venus. One he mentioned without further de-scription; another was in a landscape, and he knew the third from a copy in a miniature by Giulio Campagnola, which belonged to the humanist Pietro Bembo in Padua.[29] Since Michiel described this third figure as "stesa e volta" (stretched out and averted) an engraving by Giulio Campagnola of a sleep-ing nude probably preserves the composition of the miniature (fig. 225).[30] A strangely infelicitous composition it is, hardly worthy of Giorgione, but of course we cannot be certain that it preserves all of the model rather than merely one figure. The odd posture in fact strikingly resembles that of the nearer of two sleeping women in an engraving of an unidentified subject by Marcantonio Raimondi that may also be related to the lost Giorgione (fig. 226).[31] The figure is almost identical also with a Roman Ariadne of the type represented by the mural from the Casa della Caccia, Pompeii, now in Na-ples (fig. 227). There, of course, the posture makes sense. While Ariadne in this averted position does not seem to appear in sarcophagi, other figures do.

Apart from the *Urbino Venus,* in which the goddess is awake, Titian composed two variations of Giorgione's sleeping figure, but in different con-texts; they will be discussed shortly. Not much more need be said about a lost *Venus* known through several painted copies and engravings that ascribe it to Titian. It would seem to be a pastiche of Giorgione's figure and elements drawn from Titian's work of the middle of the sixteenth century.[32]

A superb figure by the young Titian is related to this group though it appears in a scene of great animation, the *Bacchanal of the Andrians* (fig. 229). The story is taken from Philostratus, but the painter did not follow the text closely, and certainly not with regard to the startling nude maenad in the foreground, who is not mentioned in it.[33] The head of Titian's figure rests on a jug, her left hand holds a shallow dish, and we may be sure that the miraculous wine had induced an ecstatic sleep. Perhaps she is Ariadne, who in late antiquity was sometimes considered the leader of the maenads.[34] She resembles a figure on a Bacchic sarcophagus that stood in Rome, at Palazzo San Marco, in the early sixteenth century (fig. 230).[35]

Venus asleep was painted several times by lesser masters of the Veneto. In a picture by Paris Bordone she is accompanied by a curiously withdrawing Cupid who seems too conspicuously lifted from an ancient relief (fig. 234). In a drawing by a follower of Titian somnolence proves highly contagious, and sleep becomes a group occupation (fig. 224).[36]

There are other sleeping nude women whose identity is not clear. Michiel spoke three times simply of a *nuda* by Giorgione, and he mentioned another by Savoldo in the bedroom of Andrea Oddoni, perhaps the painting now in the Borghese Gallery in Rome (fig. 233).[37] Bearing in mind the concern for the dress of the goddess in the background of Titian's *Urbino Venus*,[38] one cannot help wondering about the woman at the edge of the river in Savoldo's picture. She is small but not inconspicuous, and she vigorously washes clothes. Neither Michiel nor the owners knew the subjects of these *nude,* and twenty-five years later Vasari complained that Giorgione did not paint people known in ancient or modern history, and that nobody in Venice could tell him what his works represented.[39]

Only in Venetian art, at least during the Renaissance, do figures slumber even while seated upright. The nude woman in the drawing and the corresponding print by Jacopo de' Barbari has usually been identified as Cleopatra, but she does not put the snake to her bosom (fig. 232). It crawls on the rock behind her. Erwin Panofsky has suggested that she is Olympias, the mother of Alexander;[40] once during sleep a serpent stretched out beside her, but in Plutarch's description and on coins she was lying down at the time.[41]

As Dionysus approached Ariadne in her sleep, Selene visited Endymion. Cima seems to have been the first Renaissance master to represent this myth of love and eternal sleep (fig. 238). The poetry of his painting is Venetian, achieved without benefit of, or perhaps in this instance we should say disturbance by, ancient models. In antiquity the goddess flies or drives down in her chariot, and Endymion is normally nude (fig. 236).[42] In Cima's enchanting roundel the crescent moon alone hangs over the slumbering shepherd. The animals of the forest, a characteristically Venetian addition to the scene, gather sympathetically around him and enhance the silence by sleeping too. It is notable, however, that this male counterpart of the themes we have been discussing did not prove equally popular in Venice. Its future lay further south, in Bologna, Florence, and Rome.[43]

There is, to be sure, a beautiful panel, sometimes ascribed to Titian but

more likely by a follower, that has been said to represent Endymion (fig. 235).[44] Though his eyes may seem to be closed, they actually are not. From beneath narrow drowsy lids he peers out at the beholder. It is true that in some ancient paintings and reliefs Endymion sleeps with eyes partly open,[45] but in the panel in the Barnes Collection Selene is nowhere visible. Whether or not an allusion to Endymion is intended, the painter certainly wished to celebrate the luxurious, somnolent tranquillity of the simple rural life. The shepherd, gazing quietly at us from his vantage point, seems aware of its superiority.

A print of 1510 by Pomedelli of Verona demonstrates that the reclining nude in a landscape, even when awake, is the form chosen to express peace (fig. 239).[46] In the Veneto this conception acquires the character of a sort of solitary *fête champêtre*. The print bears the inscription QUIES, and the bow and quiver hanging from the tree signify that the hunt has ended. A similar figure, but with lowered lids, occupies the front face of a very interesting, unpublished sarcophagus in the courtyard of the Palazzo Odescalchi in Rome (fig. 240). Though made *all'antica* it seems clearly late Quattrocento. The bow and arrow and animals probably signify that here and in Pomedelli's print the huntress is Diana, reclining however in a pose that would be unprecedented in antiquity.[47]

The foregoing paintings of the isolated sleeping figure represent one of the two main streams that followed upon the inventions of the *Hypnerotomachia* and of Giorgione. Many of them represent Venus with Amor, and although all of them are erotic they are at the same time images of internal as well as external tranquillity. They tend to exalt love in accordance with moral and philosophical ideas of the time, to which we shall shortly refer. The second category of representations shows the sleeping nude unveiled, usually by a satyr. These works introduce the actuality or the promise of disturbance. Often, however, they relate carnal love to a superior principle, or show it subjugated by a superior power. This may be true of the most splendid example of the group, Titan's so-called *Pardo Venus* in the Louvre (fig. 237).

For the precise meaning of the episodes around the two main figures we must await the outcome of Professor Panofsky's researches.* Titian's own

* *Problems in Titian, Mostly Iconographic,* New York, 1969, p. 190 ff.

references to the subject are neither clear nor decisive. At the center we probably see Venus admired by a satyr rather than Jupiter and Antiope; the latter identification has prevailed only since the eighteenth century.[48] The fact is that our own Renaissance painters again created the possibility for a confusion because for the first time in their works, and not in antiquity, Antiope was shown asleep when approached by Jupiter in the guise of a satyr.[49] To the left of Venus a clothed woman and a satyr sit quietly. Titian's nude resembles the Dresden *Venus* or, still more, the Darmstadt drawing, which has been considered Titian's model for this painting.[50] The style of Titian's figure is remarkably Giorgionesque, and the hypothesis advanced in recent years that the painting, though completed as late as 1567, was begun several decades earlier may well be correct.[51]

Scenes of the discovery of a sleeping nude were in any event represented early in the sixteenth century. A drawing and a corresponding engraving by the Venetian Gerolamo Mocetto is an early and one of the very rare representations of the myth of Amymone (fig. 241).[52] Hyginus describes her vain search in the countryside for water, her fatigue and collapse in sleep, and the attempted seduction by a satyr,[53] which Mocetto rendered by the now conventional act of uncovering. In the background the engraver added the figures of Apollo and Pan, who do not appear in the story.[54] At the moment Neptune stands guard in an oddly detached manner. According to Hyginus he drove the satyr away, then fell in love with Amymone himself, and transformed her into a spring. Its waters merge with a stream issuing from a dish containing a head, probably of her husband, whom she as a Danaïd had murdered.[55] The disturbing myth is appropriately told with simplicity, as a possible and indeed recurring sequence in life, and this meaning is conveyed also by the presence of the beneficiaries of all this trouble—the dolphin, frogs, and ducks that cavort in the newly created water. In ancient art the love of Neptune for Amymone is represented, particularly on vases,[56] but the earlier part of the story, with Amymone asleep, is rare or indeed unknown.

The impetus for the revival of this myth may have come from Mantegna and Mantuan humanists, all of whom were in close touch with Venice. A painting that is in part nearly identical with Mocetto's engraving was published several times between 1904 and 1930 as a work of Mantegna's Mantuan follower, Lorenzo Leombruno (fig. 242), and it was recently repro-

duced in a new form, cut into three pieces and otherwise somewhat altered.[57] In it an old woman, who has no place in the story of Amymone, threatens the satyrs. She is a replica of the figure of Envy in Mantegna's engraving of the Sea Gods.[58] Behind her a head emerges from a basin, rising higher than the similar head of Amymone's husband, so that the staring eyes are fully visible. An inscription identifies the laurel-crowned apparition as Mantua's greatest son, Virgil. The similar head on the other side is labeled Battista Spagnoli, a Mantuan admirer and prolific imitator of Virgil. He received the great honor of a portrait bust set alongside that of Virgil shortly before his death in 1516.[59] At the left Neptune sits astride a dolphin that is mostly above the water, and at the right appears Mars, one foot resting on his armor.

Perhaps the hexameters that were written on the two basins clarified the subject of this painting, but earlier historians were unable to read them and they are not legible in the present state of the work. Surely an allegory of Mantua was intended, the enrichment of its culture symbolized by the clear streams flowing from its two great poets into its famous lake.[60] Neptune and Mars perhaps represent its power on sea and land. The satyrs, its enemies, are admonished by an old woman. It is tempting to see in her the prophetess Manto, the founder of the city according to the *Divina Commedia,* but Dante's description of her explicitly says that her hair covers her breasts,[61] and Virgil and the humanists attributed the founding to her son Ocnus.[62]

The connections of this allegory with the myth of Amymone are multiplied by the fact that the head of her husband, like those of the other Danaïds, was identified with a stream,[63] and that one of the *imprese* of the Gonzaga was ΑΜΥΜΟΣ. Which, then, was created first, Mocetto's engraving with its rare representation of the myth, or the allegorical painting? In most respects the composition of the painting is superior to that of the engraving,[64] and it may even reflect a design by Mantegna himself. The figure of Mars follows a drawing by him of *ca.* 1495 that is preserved in the British Museum (fig. 243).[65] In any event the specific and rather outlandish application of a myth is not uncharacteristic of the Renaissance.

Around 1510 Benedetto Montagna engraved a related composition, and this in turn was utilized in a series of plaquettes (figs. 244, 246).[66] The priority of the engraving is suggested by the putto's loss of an adequate support in the plaquettes. A sleeping woman is again unveiled by one of two

approaching satyrs. Her identity is unclear; as the mother of twin infants she resembles the ancient figure of Tellus or Earth, but neither Tellus nor any of the other candidates, such as Latona, was represented asleep.[67] In the plaquettes the altar on which she reclines is inscribed VIRTUS, so that the sleeping figure once again has a positive moral significance, challenged perhaps by the bestial satyrs.[68] A relief that was twice represented on the reverse of this one shows a satyr, perhaps Pan, blowing a horn to arouse a reclining figure holding a cornucopia and therefore possibly representing Abundance (fig. 245).[69]

The chief episode in Giovanni Bellini's *Feast of the Gods,* painted only some six years after the Dresden *Venus,* is the frustrated attempt of Priapus to disclose a sleeping nymph, either Lotis or Vesta (fig. 247). The old master of the preceding generation showed her leaning nearly upright against a mound. In the *Fasti,* the source of the story, Ovid tells that an ass brayed just as Priapus began to draw off the nymph's garment. In his story the gods laughed, but not in the pious master's painting.[70] Bellini did not find the jocular theme congenial to the solemn poetry of his art.

There were other, younger painters who would have enjoyed the opportunity to paint this subject. Indeed the popularity of works of art celebrating the luxuriousness of sleep provoked, in the genial and sophisticated culture of the Veneto, facetiousness and satire. Ovid's story of Priapus and Vesta pokes fun not only at the amorous adventures of woodland creatures but also indirectly at those gods who, like Zeus or Apollo, impersonate them. Mockery was a vein familiar to humanist literature from the time of Poggio on. In a print in the manner of Domenico Campagnola the recumbent winged figure parodies a common subject in ancient art, the sleeping Cupid (figs. 248, 249).[71] In the engraving Cupid's bed, so to speak, is entirely unantique, consisting of a huge mound of assorted fruits and vegetables. The objects at his side are perhaps grapes. His lower hand rests on a fruit, half clutching it, and his right lies on an uncomfortably swollen stomach. His eyes are not entirely closed, and he seems to be lying prostrate from overindulgence. This idea is maintained by the lions' heads, which allude to Bacchic sarcophagi.[72]

In an extraordinary Mantegnesque drawing in the British Museum a couple is sprawled on a huge, soft bed, uncomfortably asleep (fig. 250).[73] Cupid, too, slumbers, his task impossible or his work done. On the tree hang

objects that look like oversize specimens of the seedpods of poppies, which in Greco-Roman art are attributes of Hypnos or sleeping figures (fig. 249). The woman's left arm is disposed according to the classical convention, the man's bloated shape devastatingly exploited by every possibility of position and foreshortening. The amused satyrs minister to the couple. One wears, of all things, pants. He performs a mock unveiling of the woman while he eases her slumber with a fan. The other tries hesitantly to reduce the man's discomfort by supplying a pillow—probably an illusion to the *pluma Sardanapoli,* the symbol of the Assyrian king famous for his idleness and lust.[74] The scene is satirical and points a moral. The rather large drawing is pricked for transfer, probably to a painting.

An enchanting painting by Lorenzo Lotto is related to these works; it too is an allegory but its mood is merry and idyllic (fig. 251). A late work of the Venetian painter, it carries us a few years beyond our period to the middle of the century, and in a sense beyond Venice to Rome, where the picture was painted. Apollo has fallen asleep in a secluded laurel grove on Parnassus, still holding his viol in his hand. The Muses, seeing their god so to speak on holiday, quickly abandon not only their attributes but their clothes. The ground before Apollo is strewn with dresses, musical instruments, books, and an armillary sphere. Overhead Fame soars away. Of the Muses who have fled four are still visible over the hill, nude, excitedly gesticulating. Lotto listed the painting three times in his account books, calling it in 1552: "Apollo dormiente in Parnaso e le muse andar disperse e la phama levarsi a volo" [Apollo sleeping on Parnassus and the Muses going astray and Fame rising to fly away]. He put it more pithily in 1551: "Apollo . . . con le muse, quello dorme et quelle coniuse" [Apollo with the Muses, he asleep and they confused].[75] The *concetto* seems not to have antique precedents, though Horace spoke of the Muses dancing nude. The humanists, on the other hand, were pleased to suppose that the Muses had been sound asleep for centuries until they woke them up.[76] The painting could be an allegory of the deterioration of the arts in the Middle Ages, or simply of their decline under a rival contemporary patron.

The Greeks and Romans imagined a god of sleep, Hypnos, or Somnus,[77] and many persons influenced by him were represented in their art, although persons of certain kinds only. Commonest were woodland creatures, close to nature, such as nymphs and fauns, and youthful beings, such as Cupids. In

medieval art images of sleeping figures signified diverse, indeed opposite values. On the one hand women who only recline, such as Eve[78] or Vainglory (fig. 255), but not of course mothers in childbirth, were associated with moral failure. Sleep itself brought the downfall of Samson, and a sleeping figure became the symbol of the vice of *accidia* or sloth (fig. 256). Sleep possessed also, however, a very different significance.[79] It provided an especially favorable condition for direct experience of the supernatural. In art visions of heaven come to people who appear to be dreaming. In a thirteenth-century sculpture over the central door of San Marco in Venice the sleeping patron saint himself has one. In the relief, called the *Sogno di San Marco*, he has a vision of the site of his church and the final resting place of his bones.[79a] In the later fifteenth century Ficino and the Neo-Platonists developed a closely related conception of sleep. They understood it as a form of *vacatio,* which predisposed the soul to contemplation and to communication with the divine.[80] These ideas, familiar to Bernardo and Pietro Bembo and other humanists of the Veneto, may not be directly reflected in the subjects we are considering but, like ancient conceptions of sleep, they are based on a positive evaluation of it.

Correggio's *Venus Disclosed by a Satyr*, in the Louvre, is obviously related to our Venetian paintings, but it abandoned their serene sensuousness by bringing the figures close to the beholder and tossing them into strongly foreshortened zigzags (fig. 257). This painting, with its sleeping Eros, and a painting in London of Mercury teaching Anteros to read represent the two platonic Venuses (fig. 258).[81] Cupid's literary education signifies an aspiration to the primary and universal splendor of divinity, symbolized by the celestial Venus who sponsors his efforts—or perhaps we should say, keeping our eyes on the painting, does not much interfere. The sleeping figure is thus the terrestrial Venus, sharply distinguished by Ficino from lust, and the contemplation of her even by a satyr would convey love satisfied in a world of vision. Whatever one may think about the capacity and the firm purpose of painters to translate the exalted but somewhat vaporous Neo-Platonic ideas into adequate pictures, they did serve as a point of departure for Correggio.

Medieval conceptions of love were themselves influenced by Neoplatonic thought. In the *Vita Nuova* Dante described a scene that combines in a remarkable way a recollection of an ancient nymph with a medieval image of the soul.[82] He had a vision of Beatrice, wrapped only in a red cloth, lying

asleep in the arms of the Lord. After gazing upon her, like Bacchus upon Ariadne, he awakened her. The episode is an allegory of the awakening of spiritual love, and Boccaccio employed the same imagery for a similar purpose in a story in the *Decameron*. A panel in the National Gallery in London seems to represent the central episode of this story. The loss of the left half makes an absolute control difficult (fig. 252), but the combination of recumbent and seated figures appeared in an earlier illustration of the *novella* in a manuscript of the *Decameron*.[83] Once again a Venetian painter of the early sixteenth century appears to have been responsible for the earliest easel painting of the subject.

Boccaccio tells that Cimone, a handsome young man of a wealthy family in Cyprus, refused to be educated or even properly socialized. Preferring to remain uncouth he became a farmer. One day while passing through an exceptionally fine meadow surrounded by trees he saw a fountain, and near it an essentially unclad young woman lying asleep near her servants. He stood transfixed by her beauty, thinking she must be a goddess. Finally she awoke and Cimone, determined to win her love, applied himself vigorously to letters, music and the arts, until he became eminent in all of them. The beauty of Efigenia awakened, Boccaccio says in a striking reversal of the image, all his dormant powers.[84]

The significance of sleep may thus sometimes be bound up with awakening but it has its own independent meaning. It gives Cimone, as Boccaccio says, an unhurried opportunity to contemplate the excellences of Efigenia's body. Ariosto, imagining a similar circumstance, remarked on a similar advantage.[85] The sleeper is always unaware of spectators, and the *vacatio* serves along with important aspects of Renaissance style to maintain a distance between the pictorial and the real world. Sleep is a means of idealization, especially valuable in the new and emotionally charged sphere of the erotic.

In the Middle Ages to look upon a nude female body was regarded as sinful spying. The story of Susanna and the Elders was first represented by symbols (fig. 253), and she was normally shown without clothes (in accordance with the Biblical account) only after the establishment of a new attitude toward sexuality and the body in the Renaissance (fig. 254).[86] In this change ancient mythology played a fundamental role, not only taming the passions but sanctioning them.

The Venetian painters, we have observed, found the image of the sleeping

woman so expressive of their conceptions of love, of life, and of the power of natural generation that in a couple of decades, with remarkable enterprise and consistency, they and their colleagues in Mantua revived all relevant ancient myths. They drew from ancient texts as well as from surviving ancient monuments, even illustrating aspects of stories, such as that of Amymone, that were rarely if ever illustrated in antiquity. Nor did they hesitate, though ancient precedent was completely lacking, to put the gods and goddesses to sleep: Apollo, Venus, and perhaps Tellus. Where the myths were inadequate they invented. Hypnos was not represented himself, but he clearly became the *éminence grise*. His Venetian admirers, moreover, required him to carry regularly the roses of Venus as well as his accustomed poppies.

The power of the image of sleep in Venetian mythological and secular painting would seem to imply ramifications in Venetian religious art, and we can, I believe, detect some of them. When the landscapes that were spread behind the sacred figures in the fifteenth century began to be inhabited the population in paintings made in the Lagoon quickly acquired a distinctive character. In the landscapes of Giovanni Bellini's late religious paintings shepherds commonly lie in the grass. Though not far from the Madonna and Child or the Assumption they are utterly relaxed, drowsy, and sometimes asleep (fig. 261).[87]

Shortly before his death in 1514 Bellini painted the first independent representation, outside a Biblical cycle, of the *Drunkenness of Noah* (fig. 259). In medieval thought the patriarch was associated with Christ, and the mockery of his son with the Derision. Bellini redesigned the figure, abandoning the head-in-hand posture of the relief on the Campanile, Florence, or the more self-sustaining postures of Ghiberti and Quercia.[88] The upper arm of Noah is disposed in the antique manner, and some relationship with Bacchic figures there must be.[89] The nudity of the old man is for the first time prominently displayed, but of course it is being covered rather than revealed. The scene was chosen occasionally for canvases or reliefs in the later sixteenth century (fig. 260) but Bellini's composition remained unique. Only in it is the old man stretched across the foreground, his deep sleep and pathetic exposure the main theme of the work.[90]

A proposal that another subject is collateral may seem at first improper, and the similarity merely fortuitous. We must remember, however, that from

the time of antiquity on poets have called Sleep the brother of Death.[91] I
observed some time ago that the Christ Child sleeping in the arms or the lap
of the Virgin was *par excellence* a Venetian subject.[92] The image is first
known in the painting of this center; it appeared late in the fourteenth
century (fig. 265), and it was in Venice during the following century that it
enjoyed by far its greatest popularity.[93] Possibly the original idea was in-
spired by a mystical Byzantine subject known through a few paintings from
the late thirteenth century on. Christ, usually as a child, is identified with
Judah, whom Jacob addresses in Genesis 49:9–10 as a couched lion's whelp.
The young lion will be roused from rest by the coming of him "that is to be
sent." This messianic conception of the ANAΠEΣON is represented by a re-
cumbent Christ. Like the lion in the Physiologus he sleeps with open eyes.[94]
Sometimes, as in the early fourteenth-century mural in the Protaton at Mount
Athos, Christ appears alone (fig. 262). Occasionally the Virgin is seated
alongside,[95] and more frequently he lies in the arms of his mother (fig.
263). When, however, a Roman master from Cavallini's circle adopted the
motif, he modified the attitude of the Child in such a way that he betrayed his
ignorance of its meaning in the East (fig. 264). Though a few of the later
Venetian representations of the sleeping Child may possibly reflect the pos-
ture of the ANAΠEΣON (fig. 268) the early ones are entirely different.

It seems clear that neither the exceptional connections of Venice with the
Byzantine world nor indeed a religious cult of any kind would alone explain
the great Venetian enthusiasm for the sleeping Child. Unlike other new
subjects, such as the Man of Sorrows or the Madonna of Humility, it evoked
very different responses in the different regions of the peninsula, the Floren-
tine as negative as the Venetian was affirmative. Examples are extremely rare
in Florentine painting, though there are two in sculpture,[96] and the theme
thus polarized the two great centers in precisely the same way as the mytho-
logical subjects did some decades later.

The new image of the Christ Child shares with the later secular figures
not only sleep but, very frequently, nudity. Indeed by a paradoxical develop-
ment the first commonly represented nude figures in late medieval or early
Renaissance art (except for the traditional Savior on the cross) were the
Christ Child and the putto *all'antica*. The representations of the sleeping
Child were interpreted in two quite different ways: they were lyrical in char-

acter or proleptic, with an allusion to the death to come. The delight of the world in the rather natural sleep of the newborn Infant was expressed already in the thirteenth century in the poetry of Jacopone da Todi. A similar understanding of the subject led Giovanni Dominici, leader of the Dominican reform in the early fifteenth century, to recommend representations of it because they would be pleasing to children. Paintings in which the Child lies in the lap of his mother often seem to contain clearer allusions to his impending death (fig. 265). His posture, however, not infrequently precludes any implication of *rigor mortis* (fig. 268). "Dolcezza e grazia," to use Jacopone's phrase, are more definitely expressed by Madonnas in which the Infant sleeps upright (fig. 266).[97] Proof that the image could have an idyllic connotation alone, without reference to death, and that this connotation was important to the Venetians, is provided by a painting by Jacobello del Fiore (fig. 267). In it not Christ but the youthful Mary sleeps. There can be no question about the identities: the hooded St. Anne is older than the Virgin as she was portrayed at this time, the halo of the child lacks Christ's cross, and St. Anne's open book carries a hymn to the Virgin.[98]

Of the three fourteenth- or fifteenth-century representations of the sleeping Child that bear inscriptions two are not Venetian.[99] In that center the content was apparently taken for granted; elsewhere the image might need a label. In a rare Florentine example the Infant holds a scroll on which is inscribed "I sleep and my heart watches" (EGHO DORMIVI ET CHOR (M)EU(M) VIGILAT—fig. 103). This line from the Song of Songs was interpreted in the Middle Ages as a withdrawal from the world through sleep for contemplation of God, but when applied to Christ it would seem to refer particularly to his role as the shepherd of souls. Like the lion in the ΑΝΑΠΕΣΟΝ he is vigilant despite sleep. A related inscription below a painting of the same subject by Tura contains an invocation to wake the Child from slumber so that the process of redemption can unfold (fig. 99).[100] This delicate fusion of the human and the divine, characteristic of the Renaissance, defines a precise analysis, but it is quite possible to say that the *vacatio* of the Christ Child temporarily thwarts the faithful much as the *vacatio* of Apollo confounds the Muses and the arts.

A withdrawal less extreme than sleep characterizes many Venetian religious figures of the period. In Giorgione's wonderful altarpiece at Castelfranco both the Virgin and the Child lower their eyes and, oblivious of their com-

panions or their audience, they are entirely rapt in their own thoughts (fig. 269). Giorgione's *Judith* in Leningrad is an exceptionally meditative version of a woman who usually appeared as a triumphant heroine (fig. 270). She is so gentle and so detached that the very weapon she employed with such success seems foreign to her. In view of these peculiarly Venetian values it is no accident that a master of this city, Vittore Carpaccio, should have painted the most memorable of all representations of a saint asleep envisaging a supernatural visitor (fig. 271).[101]

The trend in Venetian art we have been describing had deep roots, and its ramifications are subtler and more extensive than our brief account has shown. It is linked no doubt with peculiarities of Venetian history and Venetian culture. It was sustained by the Arcadian ideal in Venetian literature.[102] The epithet initially applied to the city's peaceful political policy and then to the republic itself—*La Serenissima*—clearly does not possess political connotations alone. No more compelling image of peace and serenity has ever been conceived than Giorgione's *Venus*.

We do not propose now to extend our comparative somnology further into Venetian literature and history, interesting though such a venture might be. Only one observation of another kind should probably be made. Venice was certainly the *locus classicus* of the sleeping figure (usually female) as Florence was of the figure (usually male) that struggles and aspires. Though the question is delicate, these choices do seem to correspond to choices made by both centers in the realm of form. It is not only Florentine painting that shows us that line and *disegno* have an affinity for action. The still figure, on the other hand, is more congenial to an art in which color and light move. The relationship is of course neither binding nor exclusive. The two have, however, existed together often enough to be significant: outside of Venice during the fifteenth century in the work of Jan van Eyck or of Piero della Francesca, in Vermeer in the seventeenth century, and in the nineteenth, in the paintings of the Impressionists.

Correlations of style, iconography, and content are difficult to prove because normally neither artists nor their contemporaries were aware of them, so that written evidence is lacking. Still, for this endeavor, as well as for other methods of illuminating content, there surely is a place in the iconodrome.

NOTES

1. *The Nude,* London, 1956, p. 110. I proposed the hypothesis with which I began this study in "Ovum Struthionis," 1954; see above, p. 117. I am very grateful to Giovanni Becatti, Phyllis Pray Bober, Harold Cherniss, Erwin Panofsky, and Gösta Säflund for valuable suggestions.

2. The Dresden *Venus* was still in the house of the Marcello family in Venice in 1660 (cf. M. Boschini, *Carta del navegar pittoresco,* Venice, 1650, no. 665). The tradition of the sleeping nymph or Venus was still vigorous in the time of Renoir (see his painting in the Barnes Collection, Merion, Pennsylvania), and comparable figures are not uncommon in the work of Picasso.

3. "Casa de M. Hieronimo Marcello . . . la tela della Venere nuda, che dorme in uno paese cun Cupidine, fu de mano de Zorzo da Castelfranco, ma lo paese et Cupidine forono finiti da Titiano," in *Notizia d'opere di disegno,* ed. Th. v. Frimmel, Vienna, 1888, p. 88. I am very skeptical of recent attempts to enlarge Titian's role to the conception and execution of the entire painting.

4. Cupid's bird was noted by Ridolfi in 1648; see H. Posse, "Die Rekonstruktion der Venus mit dem Cupido von Giorgione," *Jahrbuch der preussischen Kunstsammlungen,* LII, 1931, p. 29 ff. L. Venturi (*Giorgione,* Milan, 1913, p. 100) and other historians read Michiel's statement to mean that Titian *added* the Cupid and the landscape. Of course this would open the question of the identity of the sleeping figure, but the position of her right hand is far more appropriate for Venus. Recently T. Reff referred to her as a nymph ("The Meaning of Titian's Urbino Venus," *Pantheon,* XXI, 1963, p. 361). Michiel said, however, "finiti," not "aggiunti." The reconstruction of the Cupid by Posse has been questioned by G. M. Richter (*Giorgio da Castelfranco,* Chicago, 1937, p. 214 ff.).

5. For the connection of Lucretius, *De rerum natura,* I, 29–40, see E. Panofsky, *Studies in Iconology,* New York, 1939, p. 63. The two figures that have often been cited—I am not sure correctly—as prototypes are not asleep (see the Bacchic sarcophagus in the Vatican discussed by E. Tietze-Conrat, "Botticelli and the Antique," *Burlington Magazine,* XLVII, 1925, p. 125). For Ficino's idea of Mars dominated by Venus see a passage in his *Convito,* quoted by N. Robb, *Neoplatonism of the Italian Renaissance,* London, 1935, p. 218; also E. H. Gombrich, "Botticelli's Mythologies," *Journal of the Warburg and Courtauld Institutes,* VIII, 1945, p. 46 ff. The resemblance discussed by Gombrich between Botticelli's *amorini* and those described by Lucian as in a painting of Alexander and Roxana is impressive, but the ekphrasis does not mention sleep, and in fact explicitly states that "Alexander does not forget his armor." For a discussion of this question see E. Wind, *Pagan Mysteries in the Renaissance,* New Haven, 1958, p. 84 n. 3. Botticelli's painting may be dated *ca.* 1485.

6. For the other parts of this *cassone* see P. Schubring, *Cassoni,* Leipzig, 1923, p. 284. The identity of the woman is not clear, but the corresponding nude sleeping man in the chest that forms a pair with this one holds a red flower, probably as a symbol of the marital bond. For another nude woman asleep see *ibid.,* p. 262, pl. 38. Other kinds of figures appeared in these lids. A recumbent man in a Quattrocento lid in the Horne Museum, Florence, is labeled Paris. For the view that sleeping figures such as the one shown in fig. 213 are private but ideal see E. H. Gombrich, "Apollonio di Giovanni," *Journal of the Warburg and Courtauld Institutes,* XVIII, 1955, p. 27.

7. See W. Paatz, *Giorgione im Wetteifer mit Mantegna, Lionardo, und Michelangelo,*

Heidelberg, 1959, p. 15. Piero's painting may have been made four or five years before Giorgione's.

8. C. de Tolnay, *Michelangelo,* Princeton, III, 1948, p. 195. It should be added that in his youth Michelangelo carved a sleeping Cupid (*ibid.,* I, 1943, p. 201).

9. H. Horne, *Sandro Botticelli,* London, 1908, p. 261, unconvincingly suggested that one of the reliefs below the Judge represents Jupiter and Antiope (fig. 216). The sleeping woman and the ship nearby suggest the possibility of Ariadne on Naxos, but the man is characterized as a shepherd rather than as Theseus or Bacchus. Another relief might seem to be Jupiter in the guise of Diana approaching Callisto; but there is no identifying bow and arrow and "Callisto" is rather old. Horne, *op. cit.,* p. 260, erroneously identifies this "Diana" as a man.

A composition very similar to one of Botticelli's reliefs (fig. 215) definitely represents Apollo watching the sleeping Daphne in a *cassone* panel by Bartolomeo di Giovanni (see *The Samuel H. Kress Collection at the Museum of Fine Arts of Houston,* 1953, pl. 5). In this unusual representation Apollo is better dressed than Botticelli's shepherd and leans on a slender staff. The pendant *cassone* panel shows the usual scene of the metamorphosis of Daphne.

10. F. Saxl, *Lectures,* London, 1957, I, p. 162 f.

11. See *Francesco Colonna, Hypnerotomachia Poliphili,* ed. G. Pozzi and L. Ciapponi, Padua, 1964, I, p. 62 ff.; *idem,* "La cultura figurativa di Francesco Colonna e l'arte veneta," *Lettere italiane,* XIV, 1962, pp. 151–169. For an earlier Renaissance example of the not yet common anthropomorphic fountain the authors refer to a drawing of Jacopo Bellini.

12. The woodcut follows the text closely except in omitting the jets of water, one hot and one cold, that issue from the breasts of the nymph. The fountain was on the wall of an octagonal building.

13. *Notizia, cit.,* p. 106: "la Nympha vestita che dorme distesa." Ancient nymphs often recline on urns, from which water flows (S. Reinach, *Répertoire de la statuaire,* Paris, 1930, I, p. 436 f.).

14. B. de Montfaucon, *L'Antiquité expliquée,* Paris, 1719, I, pt. 2, pl. 220.

15. O. Kurz, "Huius Nympha Loci," *Journal of the Warburg and Courtauld Institutes,* XVI, 1953, p. 171 ff. In this important study Kurz pointed out that the inscription was first recorded before 1493 by a certain Michael Fabricius Ferrarinus. The combination of inscription and recumbent nude was exploited by Lucas Cranach from around 1518 through 1534. The nude figure, sometimes with eyes partly open, is accompanied on occasion by a spring or a bow and arrow (see M. J. Friedländer and J. Rosenberg, *Die Gemälde von Lucas Cranach,* Berlin, 1932, pls. 100, 101, 211, 323, 324). For many of the subjects that follow in the text above see the useful compilation of A. Pigler, *Barockthemen,* Budapest, 1956, II.

16. The text says that the satyr casts shade on the nymph by bending the branches with his left hand, and with his right "traheva lo extremo di una cortinetta che era negli rami al tronco proximi innodata." The meaning of this is not entirely clear, but it suggests, as in some antique reliefs, privacy (fig. 230), if not privacy invaded, as in representations of the disclosure of Ariadne (fig. 227) and other figures, part of whose garment a satyr or other figure *traheva.* Scenes of sleeping nymphs or maenads unveiled by satyrs were not uncommon in antiquity (see W. Amelung, *Die Skulpturen des Vaticanischen Museums,* Berlin, 1908, II, p. 388, pl. 43). Peruzzi reproduced a group of this kind in the Sala del Fregio, Villa Farnesina, Rome (S. Freedberg, *Painting of the High Renaissance in Rome and Florence,* Cambridge, Mass., 1961, II, fig. 193).

17. *Paradiso,* XIII, 14–15. For Benvenuto see G. Biagi, *La Divina Commedia,* Turin, 1939, III, p. 295. In the *Ovide moralisé* (ed. C. de Boer, Amsterdam, 1954, p. 227) Bacchus marries Ariadne and "elle fut royne et grant dame du pays."

18. It was visible also on sarcophagi, for instance one in the Camposanto, Pisa (C. Lasinio, *Raccolta di sarcofagi, urne e altri monumenti di scultura del Camposanto di Pisa,* Pisa, 1814, pl. CXVIII).

19. The statue, drawn by Amico Aspertini, was then believed to be a Cleopatra, but Pope Julius III installed it as a fountain figure in a grotto (Vasari, *Vita di Daniello Ricciarelli*), and *ca.* 1555 Joachim du Bellay described it as a nymph—"Et seule et nue et chaste je sommeille" (*Œuvres poétiques,* ed. H. Chamard, Paris, 1910, II, p. 265). See also P. Bober, *Drawings after the Antique by Amico Aspertini,* London, 1957, p. 61; W. Amelung, *op. cit.,* II, p. 636 ff.; Kurz, *op. cit.,* p. 174 (but not Pope Paul III).

20. Pliny, XXXV, 109.

21. The inscriptions on the woodcuts may, as here, vary slightly in meaning from the corresponding ones in the text (see *Hypnerotomachia,* ed. 1964, p. 161) or they may contain errors (*ibid.,* pp. 46, 324 f.).

22. *Op. cit.,* p. 162, pl. 103.

23. For doves as birds of Venus see V. Cartari, *Imagini delli dei de gl'antichi,* Venice, 1571, p. 533. The Greek inscription on the fountain recalls the *genetrix omnium* applied to Venus by Lucretius and the entire context suggests this goddess, but the vagueness and intricacy of the text will probably always make a certain identification impossible. The text speaks only of a nymph, comparing her beauty, however, to the Venus of Praxiteles.

24. "Venere dormiente" became a common name for sleeping nude women, even when not specifically characterized as Venus. Thus the enigmatic Dosso Dossi in the Borghese was identified in 1650 as a sleeping Venus with two nymphs (P. della Pergola, *Galleria Borghese, I Dipinti,* Rome, 1955, I, p. 31). She might be conceived as resting from a hunt, as in a description of a Giorgione by Franz von Imstenraedt, *Iconophylacium sive artis apelleae thesaurarium,* 1667:

> Venus vitam exprimens, in regione iacens a venatione
> lassa cum figuris aliquot animalibusque de longe . . .
> Hinc requiem quaerit sylvestrique incuba strato
> Morphea somnicapis quaerit adesse oculis.
> Dextra caput fulcit, sed virginis inde pudenda
> Laeva tegit, nudum caetera corpus habent.

(This text was published by O. Kurz, "Holbein and Others in a Seventeenth-Century Collection," *Burlington Magazine,* LXXXIII, 1943, p. 281.) The posture of this figure might be described as intermediate between the woodcut of 1499 and the Dresden *Venus.*

25. It was employed for nymphs, fauns, cupids, Endymion, and other figures. In addition to the works reproduced above see, for example, Reinach, *Statuaire,* I, pp. 63, 164, 354, 405 f., 436, and also E. Simon, *Die Portlandvase,* Mainz, 1957, p. 10 f. In the Middle Ages sleeping figures normally supported their head on a bent arm, as in the woodcut (fig. 217). See also fig. 256.

26. In antiquity, furthermore, the gesture was allotted to standing, not recumbent figures (I do not refer to the rather different representations, like the woodcut, in which the hand lies on the thigh). Raffaele Zavenzonio mentioned a Praxitilean Venus that

belonged to Gentile Bellini (*Notizia d'opere di disegno,* ed. G. Frizzoni, Bologna, 1884, p. 155).

27. For opinions on this question and on the subject see H. Tietze and E. Tietze-Conrat, *The Drawings of the Venetian Painters,* New York, 1944, p. 173, no. 706. The man in the foreground does not seem to be characterized as Jupiter.

28. *Metamorphoses,* II, 420–422.

29. Two in the house of Michele Contarini (ed. Frizzoni, p. 230). For Bembo's see *ibid.,* p. 51.

30. See H. Tietze, *Tizian,* Vienna, 1936, I, p. 83. A. M. Hind, *Early Italian Engraving,* London, 1948, V, p. 202, is much more tentative.

 It is interesting that Sannazzaro, describing frescoes in his *Arcadia,* composed initially *ca.* 1482, wrote of an averted Venus, and gave an explanation for it that no historian would have thought of: ". . . discreto pintore, il quale avendo fatta Giunone e Minerva di tanto estrema bellezza che ad avanzarle sarebbe stato impossibile, e diffidandosi di fare Venere sì bella come bisognava, la dipinse volta di spalle, scusando il difetto con la astuzia." (*Arcadia,* III, 23, in *Opere Volgari,* ed. A. Mauro, Bari, 1961, p. 19 f.

31. Richter, *op. cit.,* p. 259.

32. I have much more confidence in this conclusion because of the concurrence of Erwin Panofsky. For the engraving in the British Museum see G. M. Richter, "Titian's *Venus and the Lute Player,*" *Burlington Magazine,* LIX, 1931, p. 53, and for the one in Paris, Reff, *op. cit.,* fig. 5, and F. Hermanin, *Il mito di Giorgione,* Spoleto, 1932, p. 116.

33. *Imagines,* I, 25. For the identity of Titian's figure see E. Wind, *Bellini's Feast of the Gods,* Cambridge, Mass., 1948, p. 60, who suggests that as an Andria she might be Ariadne (an anagram of Andriae). E. Battisti (*Rinascimento e Barocco,* Milan, 1960, p. 138 ff.) unconvincingly argues that Titian drew his figure from another painting described by Philostratus (Battisti must mean I, 15), but there Ariadne is bare only to the waist, and "her left hand rests on her mantle that a gust of wind may not expose her."

34. Propertius, Bk. II, 3rd Elegy, 18. See *Elegies,* trans. H. Butler, Cambridge, Mass., 1952, p. 71 (". . . Ariadne led the Maenad dance. . . .").

35. See Bober, *op. cit.,* p. 51. See also the Pompeian painting of Ariadne (under a sort of tent!) reproduced by A. von Salis, *Theseus und Ariadne,* Berlin, 1930, fig. 12.

36. H. Tietze and E. Tietze-Conrat, *op. cit.,* no. 1980, as Titianesque *ca.* 1530, probably reflecting a lost work of Titian.

 Bugiardini's painting in the Cà d'Oro, Venice, is an unusual Florentine example of a sleeping nude. Though the accompanying putto has no wings he is no "satirello" (as C. Gamba, "La Cà d'Oro," *Bolletino d'arte,* X, 1916, p. 324, identified him) and this figure seems to exclude the identification with Ariadne (tentatively proposed by Freedberg, *op. cit.,* I, p. 588; II, fig. 275). Venus seems much more probable. The gesture of "Cupid" suggest the painting had a pendant.

37. The painting, sometimes attributed to Gerolamo da Treviso, is damaged but good in color. A puzzling blue cloud rises behind the fantastic buildings (never in front of them). It extends below the horizon at the left, but only about 1½ cm., so that one cannot know whether the overlap was intended. There is no trace of fire. For the history of the painting see P. Della Pergola, *op. cit.,* p. 126. See also A. Boschetto, *Savoldo,* Milan, 1963, pl. 3.

38. E. Wind, *Pagan Mysteries in the Renaissance,* New Haven, 1958, p. 121, aptly spoke of the reduction of the celestial mantle to domestic apparel.

39. See the vivid passage in *Le vite,* ed. G. Milanesi, Florence, 1906, IV, p. 96.

40. *Albrecht Dürer,* Princeton, 1943, II, p. 25 no. 70. For the identification with Cleopatra see, for instance, Hind, *op. cit.,* V, p. 157. Tietze and Tietze-Conrat, *op. cit.,* p. 40, maintained that the supposed snake is only a root.

41. *Plutarch's Lives,* trans. B. Perrin, Cambridge, Mass., 1949, VII, pp. 27–29. For the contorniates see A. Alföldi, *Die Kontorniaten,* Budapest, 1943, pls. III, 1, 2; IV, 1, 2; X, 5; XIII, 12; XIV, 1, 2, etc. Olympias always reclines on a *lit de parade.* In the Pseudo-Callisthenes, sometimes illustrated in the Middle Ages, Olympias is approached by Nektanebos in the form of a serpent, but she is always, according to the story, seated at table (see D. J. A. Ross, "Olympias and the Serpent. The Interpretation of a Baalbek Mosaic and the Date of the Illustrated Pseudo-Callisthenes," *Journal of the Warburg and Courtauld Institutes,* XXVI, 1963, p. 4 ff.).

42. See also, for instance, the relief discovered no later than the second quarter of the sixteenth century and now in the Capitoline Museum, Rome (K. Robert, *Die Antiken Sarkophagreliefs,* Berlin, 1897, III, pt. 1, p. 61, pl. XII). Sometimes Endymion is unveiled by putti (*ibid.,* pls. XVI f., LXI).

43. See, for example, *Mostra di Lelio Orsi,* Reggio Emilia, 1950, pl. 3; late sixteenth-century fresco, ceiling, Uffizi (Selene sails down on the moon); Girolamo da Carpi, Dresden (A. Venturi, *Storia dell'arte italiana,* Milan, 1933, IX, pt. 6, fig. 396).

44. E. Tietze-Conrat, "Titian as a Landscape Painter," *Gazette des Beaux-Arts,* XLV, 1955, p. 20; B. Berenson, *Italian Pictures of the Renaissance, Venetian School,* New York, 1957, p. 188 (as Titian).

45. Pauly-Wissowa, *Realencyclopaedie,* V, 2, 1905, col. 2560.

46. Hind, *op. cit.,* V, p. 225. For the later Renaissance conception of *Quiete* as a woman standing on the cube of earth see C. Ripa, *Iconologia,* Siena, 1613, p. 197. Erwin Panofsky has suggested to me that the *quies* might be the specific one that in Venice followed the Battle of Cadore of 1508. The wounded boar might allude to the *furor Teutonicus* of the Germans, and the porcupine to the French. The latter was the device of Louis XII (see M. Praz, *Studies in Seventeenth-Century Imagery,* London, 1939, I, pp. 48, 56 f.).

47. I am grateful to Dr. Giulia Brunetti for suggesting that I look at the sarcophagus. It is about 7½ feet long. On the sides there are badly abraded coats of arms. Dr. Helmut Sichtermann has kindly communicated to me his comments on the iconography of the relief in his forthcoming study of ancient Endymion sarcophagi. [H. Sichtermann, *Späte Endymion-Sarkophage,* Baden-Baden, 1966, pp. 105–109.]

 The board appears in both the sarcophagus and the engraving. In the latter it bears an arrow, as on coins of Aetolia (cf. *Sylloge Nummorum Graecorum, Danish National Museum,* ed. W. Schwabacher, Copenhagen, 1944, pl. 1). If I were a zoologist I would no doubt be still more uncertain of the species of the two other animals represented.

48. See the full recent discussion of the problem by P. Hofer, "Die Pardo-Venus Tizians," in *Festschrift H. R. Hahnloser,* Basel, 1961, pp. 341–360, especially the relevance of Titian's reference of 1567 to a "Venere ignuda" and of 1574 to a "nuda col il paese con el satiro." The title *Jupiter and Antiope* was applied later, before 1729.

49. See the etching after Primaticcio and the Venetian *cassone* in Schwerin reproduced by L. Soth, "Two Paintings after Correggio," *Art Bulletin,* XLVI, 1964, figs. 4, 6. The representation of Jupiter and Antiope is rare in antiquity, and the latter is not shown asleep (see Roscher, *Lexikon,* s.v. Antiope, and Soth, *op. cit.,* p. 539).

 Perhaps the power of the representative tradition we are tracing accounts for the hitherto unexplained presence of a satyr near the sleeping Psyche in the Palazzo del Te, Mantua (F. Hartt, *Giulio Romano,* New Haven, 1958, p. 130, fig. 234).

50. See, for example, C. Nordenfalk, "Tizians Darstellung des Schauens," *Nationalmusei Årsbok,* 1947–1948, p. 59 f.
51. Tietze and Tietze-Conrat, *op. cit.,* p. 173.
52. The drawing by Mocetto in the Morgan Library is more Bellinesque than the engraving, which was executed by another hand. It is not reversed, but it does nevertheless seem to me to be a preparatory study rather than a copy from the engraving. See Hind, *op. cit.,* V, p. 166. Hind's suggestion that the nymph and satyrs derive from the drawing in the British Museum (fig. 250) seems to me not helpful. See also B. Baron, "Girolamo Mocetto," in *Madonna Verona,* III, 1909, p. 40 ff.
53. *Fab.* 169. See *The Myths of Hyginus,* trans. M. Grant, Lawrence, Kans., 1960, p. 132.
54. Servius, however, does say that after the miraculous appearance of the spring Danaus went to the oracle of Apollo (*Comm. in Verg. Aen.* IV, 377).
55. Some authors, such as Pindar (*Pyth.* IX, 117), denied marriage and hence also murder to Amymone, but Hyginus (*Fab.* 170), Apollodorus (*The Library,* trans. J. G. Frazer, London, 1921, I, p. 139) and others include her with the other daughters of Danaus, even giving the name of her husband.
56. See J. D. Beazley, *Attic Red-Figure Vase Painters,* Oxford, 1963, I, p. 656; II, pp. 991, 1020, 1041, 1087. Philostratus, *Imagines* I, 8, describes this scene. See also *Enciclopedia dell'arte antica,* Rome, 1958, I, p. 335. Occasionally Amymone is attacked by satyrs, but not during sleep (Beazley, *op. cit.,* II, pp. 1042, 1155).
57. C. Gamba, "Lorenzo Leombruno," *Rassegna d'arte,* VI, 1906, p. 91; G. Gerola, "Un'impresa ed un motto di casa Gonzaga," *Rivista d'arte,* XII, 1930, p. 400. I am grateful to Dr. Eberhard Ruhmer for knowledge of the reproduction of the painting in the sale at F. Heberle (Lempertz), Cologne, 1904 (the catalogue itself has not been available to me) and for communicating his view—which I had tentatively formed— that it is identical with the "triptych" published by H. Zimmermann, "Drei Chiaroscuro-Bilder von Andrea Mantegna," *Pantheon,* XXIII, 1965, pp. 17–21. Whereas the painting simulates bronze and the documents on Isabella's famous *grotta* in the Palazzo Ducale in Mantua refer to two paintings by Mantegna "finiti di bronzo," the subjects do not correspond (C. d'Arco, *Delle arti e degli artefici di Mantova . . . ,* Mantua, 1857, II, p. 134). The original painting is, furthermore, rather small (36 × 56 cm.).

 Just as this paper goes to press Dr. Ruhmer has kindly sent me his publication of the observation mentioned above ("Zu einer Mantegnesken Allegorie," *Pantheon,* XXIV, 1966, pp. 111–115). He describes instructively the areas repainted since 1904. (He is unaware of the studies of the painting since 1904, and of the relation with Mocetto's *Amymone.*)
58. Mantegna's Envy was used also as a Fury by Dürer in B 127, *Hercules and Cacus* (Panofsky, *Hercules am Scheidewege und andere antike Bildstoffe in der neueren Kunst,* Leipzig, 1930, p. 184, fig. 112).
59. The terra cotta bust, set up in an arch near the Porta Nuova in 1514, is still preserved in the Palazzo Ducale (see *Andrea Mantegna, Catalogo della mostra,* Mantua, 1961, p. 153, pl. 128). The bust of Virgil is preserved in a copy only. The poets are crowned with laurel, as in the painting. A medal of Spagnoli was struck around 1513, when he became general of the Carmelite Order (G. F. Hill, *A Corpus of Italian Medals,* London, 1930, I, no. 253). See also *The Eclogues of Baptista Mantuanus,* ed. W. P. Mustard, Baltimore, 1911, p. 31.
60. A very similar head of Virgil in a flowing basin appeared on coins of Guglielmo Gonzaga in 1554 (A. Magnaguti, "Numismatica virgiliana," *Atti e memorie della R. Accademia Virgiliana,* XIV, 1923, p. 286 f.). Magnaguti unconvincingly ascribed

the strange representation to the fact that Virgil was said to have been the son of a potter.

61. *Inferno,* XX, 52 ff. Some illustrators of the *Commedia,* however, represented Manto's breasts uncovered (see Holkham Hall, ms. 514, p. 30, reproduced in *Early Illustrations of the Divine Comedy,* by P. Brieger, M. Meiss, and C. S. Singleton, New York, 1967, pl. 225). Giles Robertson kindly suggested to me the possibility of Manto.

62. *Aeneid,* X, 198–203. M. Equicola, a Mantuan humanist of the period, said in his *Dell'istoria di Mantova,* Mantua, 1608, pp. 5–8, that Virgil was right and Dante wrong. Boccaccio, who dedicated a chapter to Manto in *De mulieribus claris,* says that Manto's son (about whose name he is uncertain) founded Mantua and named it after her.

63. See Pauly-Wissowa, s.v. Danaides.

64. Mocetto's extant dated prints range from 1484–1513; he died in 1531. He lived in Venice and in 1507 served as an assistant of Giovanni Bellini. The painting cannot be fixed in time either. Though since 1906 it has always been ascribed to Leombruno (born 1489), it is much more Mantegnesque than other works by this painter, and the attribution seems to me questionable (on Leombruno see *Mantova, Le arti,* Mantua, 1961, II, p. 392 ff.). The armillary sphere behind the sleeping figure in the painting is not represented in the drawing and the engraving, but in that zone one leg of the woman crosses under the other whereas the legs are parallel in the painting. It is Mocetto's posture rather than that of the painting that Leombruno employed in his sleeping nymph in the Uffizi (*ibid.,* pl. 338).

65. The figure appears between a Diana and an unidentified goddess. See A. E. Popham and P. Pouncey, *Italian Drawings in the Department of Prints and Drawings in the British Museum, The Fourteenth and Fifteenth Centuries,* London, 1950, p. 94.

66. Hind, *op. cit.,* V, p. 179. In a second state, lacking the tree and the pedestal, the eyelids of the woman are raised somewhat. For the plaquettes see E. Molinier, *Les plaquettes,* Paris, 1886, I, p. 83, no. 122; E. F. Bange, *Die italienischen Bronzen der Renaissance und des Barock,* pt. 2, *Reliefs und Plaketten,* Berlin, 1922, p. 89, no. 645 (Bange wrongly claims the relief influenced the woodcut—actually earlier—in the *Hypnerotomachia*); J. Pope-Hennessy, *Renaissance Bronzes from the Samuel H. Kress Collection,* London, 1965, p. 57, no. 189.

67. The figure of Tellus with twins in the relief in the Uffizi from the *Ara Pacis* is especially similar (Roscher, *Lexikon,* V, fig. 2). See also the *Gemma Augustea* in the Kunsthistorisches Museum, Vienna, and the figure in the ninth-century *Sacramentary of St. Denis* (H. Swarzenski, *The Monuments of Romanesque Art,* Chicago, 1954, fig. 9). Erwin Panofsky kindly suggested the possibility of the rare Acca Larentia, mother of Romulus, and of Latona, the mother of Apollo and Diana, but these children are not twins (Roscher, *Lexikon,* s.v. Leto). Ovid, *Metamorphoses,* VI, 313, connects Latona with an altar. None of these figures were, however, associated with sleep.

In the *Arcadia,* published in Naples in 1504, Sannazaro described a nymph suckling an infant represented on a vase painted by Mantegna (ed. E. Carrara, Turin, 1926, p. 116). The nymph, however, is quite awake, and there are no satyrs and no second child, as in the print.

68. For the equation of satyrs with vice see the long passage in Filarete's *Sforzinda* quoted by Panofsky, *Hercules am Scheidewege, cit.,* p. 190. For a similar sixteenth-century Venetian view of satyrs see L. Dolce, *Dialogo della pittura,* Venice, 1565, p. 51.

69. Bange, *loc. cit.,* observed the relationship of the figure of "Abundance" with an en-

graving by Marcantonio (B. 319) and *Der Hercules* of Dürer (Panofsky, *Albrecht Dürer*, Princeton, 1943, fig. 108).

70. *Fasti*, I, 391–400; VI, 319–348. See E. Wind, *Bellini's Feast of the Gods, cit.,* p. 28 ff.

71. Hind, *op. cit.,* V, p. 214. For ancient representations see M. Bieber, *The Sculpture of the Hellenistic Age*, New York, 1955, p. 145, and Reinach, *Statuaire*, I, p. 353 f.

72. See the Bacchic sarcophagus reproduced by Saxl, *Lectures*, London, 1957, pl. 103.

73. B. Shaw, "A Group of Mantegnesque Drawings," *Old Master Drawings*, XI, 1937, no. 44, p. 57 (as probably Zoan Andrea). Whereas the sleeping Cupid does, as has been suggested, resemble ancient predecessors, the posture has been modified by the change of position.

74. See the passage from Juvenal, *Sat.,* X, 360, quoted by Panofsky, *op. cit.,* p. 97; *idem,* "Zwei Dürerprobleme," *Münchner Jahrbuch der bildenden Kunst,* VIII, 1931, p. 8.

75. Lotto referred to the painting briefly also in 1550. For extracts from the account book he brought back from Rome see A. Pigler, "A New Picture by Lorenzo Lotto: The Sleeping Apollo," in *Acta Historiae Artium,* I, 1953, pp. 165–168.

76. For the history of this metaphor, introduced by Boccaccio, see B. L. Ullmann, *Studies in the Italian Renaissance*, Rome, 1955, p. 16 ff.

77. Ovid, *Metamorphoses,* XI, 529 ff. In Roman art Somnus was normally an old man bedecked with butterfly wings and carrying poppies.

78. See especially the several representations of the recumbent Eve below the Virgin, beginning in the circle of Ambrogio Lorenzetti (G. Rowley, *Ambrogio Lorenzetti,* Princeton, 1958, fig. 72).

79. I refer, of course, primarily to art. The Bible contains various conceptions of sleep, for example Psalm 126 (127):2: ". . . he giveth his beloved sleep."

79a. The sculpture was put over the central door shortly after 1500, before then it was probably in the Cappella Zeno. It may originally have represented the Dream of St. Joseph. See O. Demus, *The Church of San Marco in Venice,* Washington, 1960, p. 14 f., figs. 66, 101. Perhaps the threat of pigeons kept me from looking up at this prominent relief; it was kindly called to my attention by Professor Hans H. Buchwald.

80. The essential ideas, expressed by Ficino in the *Theologia,* Bk. XIII, are discussed by P. O. Kristeller, *The Philosophy of Marsilio Ficino,* New York, 1943, pp. 216 f., 313.

81. The similar interpretations proposed by L. Soth, *op. cit.,* and F. Verheyen, "Eros et Anteros, 'L'éducation de Cupidon' et la prétendu 'Antiope' du Corrège," *Gazette des Beaux-Arts,* LXV, 1965, pp. 321–340 (Soth more concerned with the two Venuses, Verheyen with the two Cupids) were supported by the titles given the two paintings in an inventory probably of 1640 and cited by M. Laskin (*Art Bulletin,* XLVII, 1965, p. 543 f.). Verheyen, who showed that the Cupid in the painting in the Louvre was based on a sculpture belonging to Isabella d'Este and ascribed to Praxiteles, quoted an interpretation of the statue by Castiglione. Cupid, exhausted by his victory over Hercules, falls asleep on his booty (lion skin and club).

82. *Vita nuova,* Chap. III.

83. See illustration, Florentine, *ca.* 1400, in Paris, Bibliothèque nationale, ital. 482, fol. 102. The painting in London, often attributed to Palma Vecchio, was ascribed by J. Wilde to Domenico Mancini. He also identified the subject. See National Gallery Catalogues, *The Sixteenth-Century Venetian School* (C. Gould), London, 1959, p. 135. Usually the fountain and the sleeping servants mentioned by Boccaccio are included in representations of this story, but a drawing by Bloemaert and an engraving by J. Matham show only Cimone and Efigenia. See Vienna, Albertina, *Die Zeich-*

nungen der niederländischen Schulen des XV. una XVI. Jahrhunderts (O. Ben-
esch), Vienna, 1928, p. 42, pl. 115. On the subject in general see Pigler, *op. cit.,*
II, p. 433 f., and G. von Terey, "Boccaccio und die niederländische Malerei,"
Zeitschrift für bildende Kunst, XXX, 1919, pp. 241–248.

84. *Giornata V, nov.* 1. Though no precise source for this story is known, the idea
that Venus first made men civilized was old (see for example V. Cartari, *op. cit.,*
p. 543, who ascribed it to Ovid).

85. "Istos, quaeso, oculos operi, dum caetera lustrem
 Spectator formae, Lydia bella, tuae;
 Namque meos hebetant sensus prohibentque tueri
 Quam sit digna oculis pars tua quaeque tuis."
(Ariosto, *Opere minori,* ed. C. Segre, Milan, 1954, p. 60.) These lines were
called to my attention by Dora Panofsky.

86. Though rare the nude figure is not entirely lacking before the Renaissance: see
Paris, Bibliothèque nationale, lat. 11560, fol. 212 (A. de Laborde, *La Bible
moralisée, conservée à Oxford, Paris et Londres . . . ,* Paris, 1913, III, pl. 436)
and gr. 923, fol. 373v. Inasmuch as the glance of the eyes was not precisely con-
trolled in the Middle Ages the elders gesticulate toward Susanna.

87. See also, for example, the *Assumption,* San Pietro Martire, Murano (P. Hendy,
Giovanni Bellini, London, 1945, pl. 99); *Madonna,* Brera, Milan (*ibid.,* pl. 108).

88. For the latter two see C. de Tolnay, *Michelangelo,* II, 1945, figs. 279, 282, and
p. 24 f. See also the fresco by Bartolo di Fredi, Collegiata, S. Gimignano.

89. The similarity with the bearded old Polyphemus in an urn at Volterra is sugges-
tive but probably fortuitous (H. von Brunn, *I rilievi delle urne etrusche,* Rome,
1870, I, pl. 87, no. 3).

90. For other examples of different conceptions of Noah in the sixteenth century see
B. Luini, Brera (L. Beltrami, *Luini,* Milan, 1911, p. 520); ascribed to Savoldo,
private collection (A. Venturi, *Studi dal vero,* Milan, 1927, fig. 182); Moretto,
Collection Conte Mazzotti, Brescia (G. Gombosi, *Moretto,* Basel, 1943, pl. 17);
A. Schiavone, Giovanelli Collection, Venice, and Museo Civico, Verona (Venturi,
Storia dell'arte italiana, Milan, 1929, IX, pt. 4, fig. 495 f.).

91. Cartari, *op. cit.,* p. 29 ff., refers to Hesiod, Homer, and Seneca.

92. "Ovum Struthionis," p. 117.

93. It may be appropriate to list a few: Jacobello del Fiore: Museo Correr, Venice, and
Fogg Museum, Cambridge. Bartolommeo Vivarini: Accademia Carrara, Bergamo; De
Young Museum, San Francisco; Capodimonte, Naples; Accademia, Venice. Antonio
Vivarini: Museo Davia Bargellini, Bologna. Alvise Vivarini: Palazzo Ducale, Urbino.
Giovanni Bellini: Accademia, Venice. Cima: Sant'Anna, Capodistria. There are, of
course, non-Venetian examples, such as Pietro da Montepulciano, Metropolitan Mu-
seum, New York; Florentine (Master of the Annunciation at Brozzi), Galleria
Nazionale, Parma; Antonio da Fabriano, Galleria Nazionale, Urbino (under the in-
fluence of the Venetian Niccolò di Pietro). See also G. Firestone, "The Sleeping
Christ-Child in Italian Renaissance Representations of the Madonna," *Marsyas,* II,
1942, figs. 2, 4, 5, 15, 17, 22, 39.

94. See M. Chatzidakis (who kindly called this uncommon iconography to my attention),
Icones de Saint-Georges des Grecs, Venice, 1963, p. 9. An example is included in this
Venetian collection, which, however, was begun only in the mid-fifteenth century. See
also A. Grabar, *La peinture religieuse en Bulgarie,* Paris, 1928, p. 257 ff.; G. Millet,
Monuments de l'Athos, Paris, 1927, I, pl. 30. In the ΑΝΑΠΕΣΟΝ the Child wears dis-
tinctive bands across his breast and shoulders (fig. 262) or epaulets (fig. 263). In

some accompanying inscriptions the prediction of Jacob is replaced by the related prophecy of Balaam in Numbers 24:9. Grabar observed that the image refers at times to the birth of Christ, or to his death and resurrection (the lion, born dead, is animated three days later by the breath of its father), or to the Heavenly Jerusalem.

95. Mt. Athos, Stavronikita, ms. 45, fol. 12v, *ca.* 1300. Christ is not here a child.

96. Only two sculptures, both terra cotta, seem definitely to represent the sleeping Child, one reflecting the style of Ghiberti, the other Donatello, both difficult to date. For the examples, which are in the Louvre, see W. Bode, *Florentine Sculptors of the Renaissance,* London, 1928, pls. 32, 41 (Mrs. Harriet Caplow kindly reminded me of these examples). Duveen Bros. in New York formerly owned a relief in late Quattrocento style representing a Madonna with a sleeping Child bearing a scroll inscribed with the same phrase as the *Madonna* by Neri di Bicci (fig. 103). As for the glazed terra cotta *Madonna* ascribed to Michelozzo in the National Gallery in Washington I can say only that I am perplexed by its style and date. For a Verrocchiesque sleeping Child in terra cotta see *Berlin, Staatliche Museen. Die italienischen und spanischen Bildwerke der Renaissance und des Barock,* Berlin, I (F. Schottmüller), 2nd ed., 1933, p. 63, no. 2009.

97. On all the above see p 118, and Firestone, *op. cit.,* p. 43 ff. The frequent idyllic and non-funereal connotation of the image is suggested also by the almost simultaneous appearance of the Child lying *awake* in the lap of his mother. This type too may have originated in Venice, or at least North Italy. See Gentile da Fabriano, Museo Civico, Pisa; followers of Gentile, formerly Collection Paolini, Florence; Mrs. William Hill, Manchester, New Hampshire; and F. J. Mather, Princeton (I give the classification on the photographs in the *fototeca* at I Tatti); Jacopino da Tradate (?), Collection Salavin, Paris (R. Longhi, *Paragone,* no. 13, 1962, pl. 61); Giambono, Walters Art Gallery, Baltimore. [An additional Venetian example of the Christ child sleeping upright is the *Madonna* by Pietro Lombardo in the Metropolitan Museum, New York.]

98. Published as a Madonna and Child by R. van Marle, *Italian Schools,* The Hague, 1926, VII, fig. 226.

99. A *Madonna* in the Museo Correr signed by Jacobello del Fiore, kindly called to my attention by Howard Davis, is inscribed: IN GREMIO MATRIS SEDE SAPIENCIAE PATRIS. Notable is the absence of any reference to Christ's death. The *sedes sapientiae* of Solomon is more often identified with the Virgin (see F. Wormald, "The Throne of Solomon," in *De Artibus Opuscula XL: Essays in Honor of Erwin Panofsky,* New York, 1961, I, p. 533 ff.).

100. See p. 118.

101. It is worth noting that when this uncommon scene is represented outside Venice St. Ursula may be awakened by the heavenly visitor: for example, painting by the St. Ursula Master in the Wallraf-Richartz Museum (A. Stange, *Deutsche Malerei der Gotik,* Berlin, 1952, V, fig. 200).

102. Especially the *Asolani* of Pietro Bembo. Sannazaro's *Arcadia* (published in Naples in 1504, but circulated earlier in manuscript) envisaged forests peopled by satyrs and nymphs, but not asleep. See also R. Wittkower, "L'Arcadia e il Giorgionismo," in *Umanesimo europeo e umanesimo veneziano,* ed. V. Branca, Venice, 1963, pp. 473–484, and E. Tietze-Conrat, "Titian as a Landscape Painter," *Gazette des Beaux-Arts,* XLV, 1955, p. 15 f.

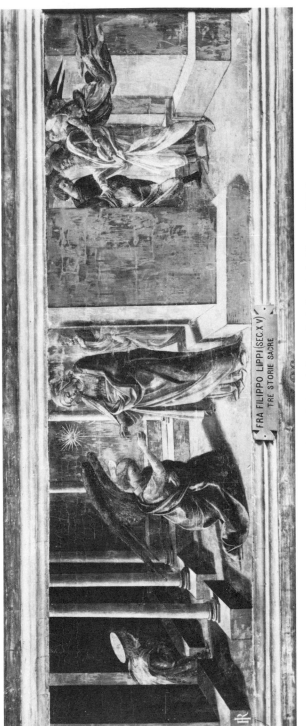

1. Fra Filippo Lippi: *Annunciation of the Death of the Virgin*, Florence, Uffizi.

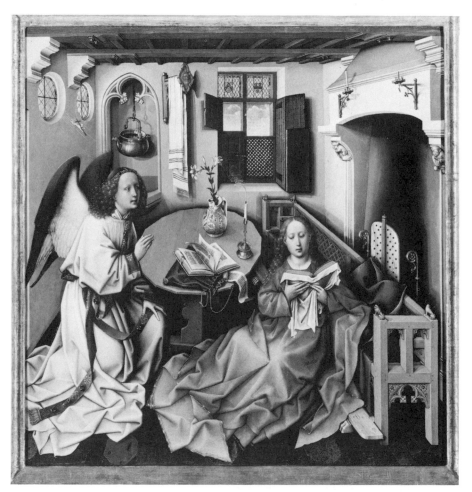

2. Master of Flémalle: *Annunciation* (central panel of *Mérode Altarpiece*). New York,
The Cloisters.

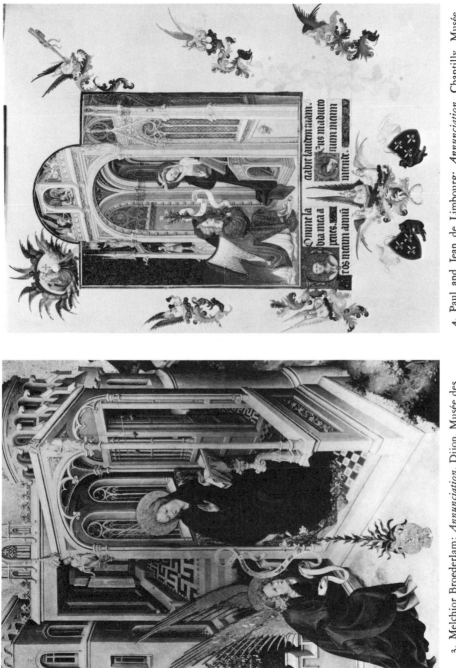

4. Paul and Jean de Limbourg: *Annunciation.* Chantilly, Musée Condé, *Très Riches Heures*, fol. 26.

3. Melchior Broederlam: *Annunciation.* Dijon, Musée des Beaux-Arts.

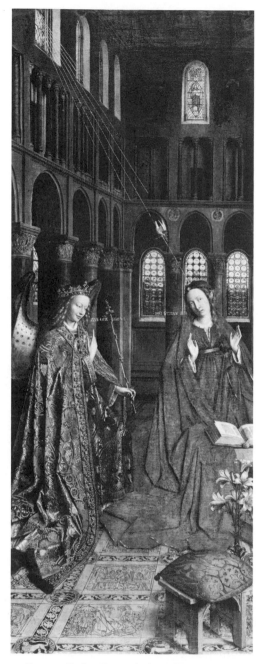

5. Jan van Eyck: *Annunciation*. Washington, National Gallery.

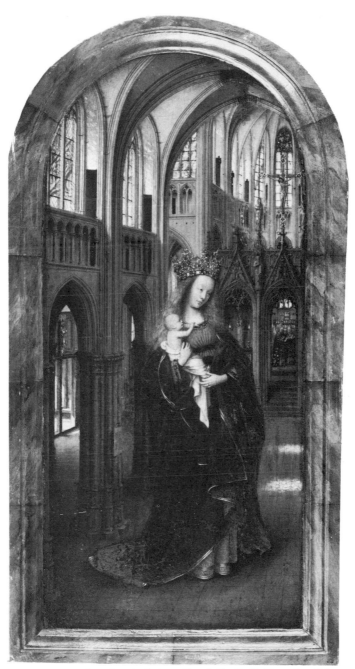

6. Jan van Eyck: *The Virgin in a Church*. Berlin-Dahlem, Staatliche
Museen.

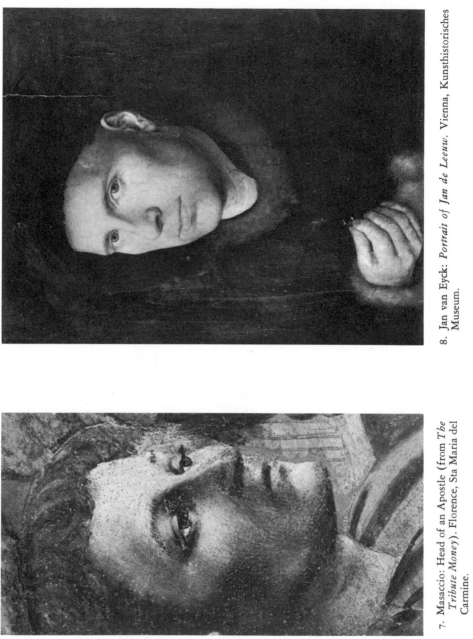

7. Masaccio: Head of an Apostle (from *The Tribute Money*). Florence, Sta Maria del Carmine.

8. Jan van Eyck: *Portrait of Jan de Leeuw*. Vienna, Kunsthistorisches Museum.

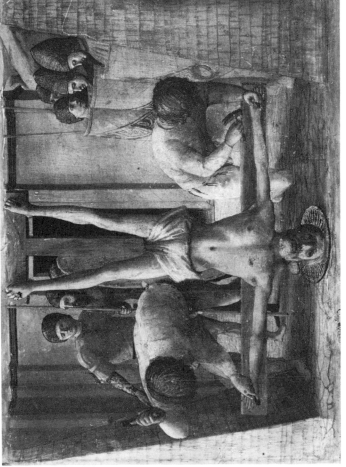

10 Masaccio: *Martyrdom of St. Peter*. Berlin-Dahlem, Staatliche Museen.

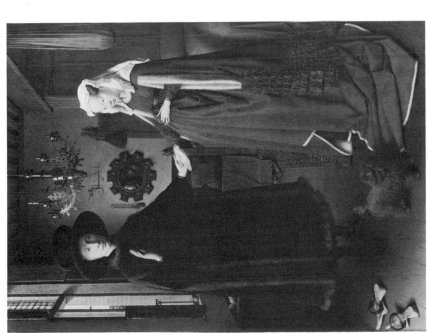

9. Jan van Eyck: *Giovanni Arnolfni and his Wife*. London, National Gallery.

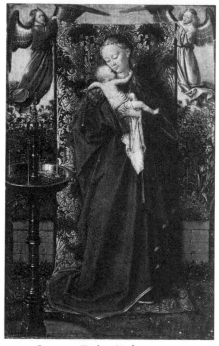

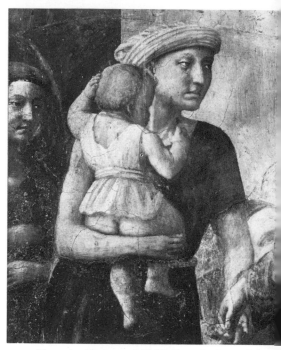

11. Jan van Eyck: *Madonna*. Antwerp, Musée Royal.

12. Masaccio: Mother and Child (from *St. Peter giving Alms*). Florence, Sta Maria del Carmine.

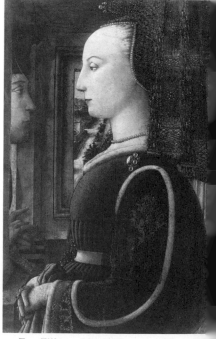

13. Fra Filippo Lippi: Glass Vase (detail of *Annunciation*). Florence, San Lorenzo.

14. Fra Filippo Lippi: *Portrait*. New York, Metropolitan Museum.

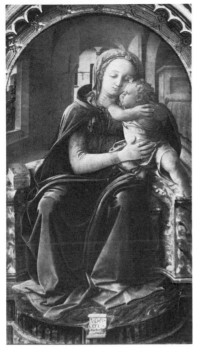

15. Fra Filippo Lippi: *Madonna*. Rome, Palazzo Barberini (formerly Corneto Tarquinia, Museum).

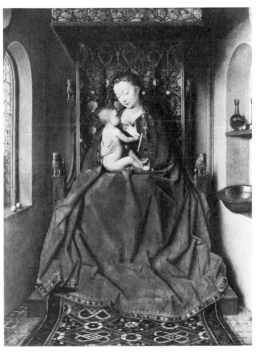

16. Jan van Eyck: *Madonna*. Frankfurt, Städel Institut.

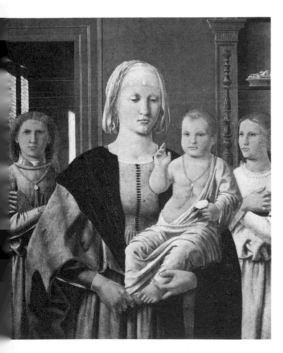

17. Piero della Francesca: *Madonna*. Urbino, Galleria nazionale.

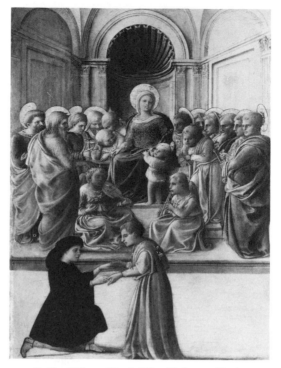

18. Fra Filippo Lippi (?): *Madonna*, Venice,
Count Vittorio Cini Collection.

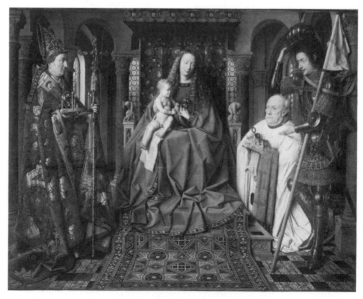

19. Jan van Eyck: Paele Altarpiece. Bruges, Museum Groeninge.

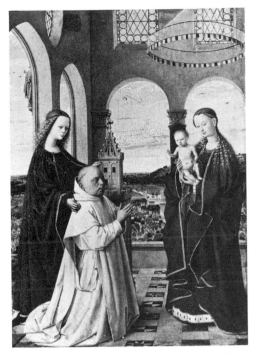

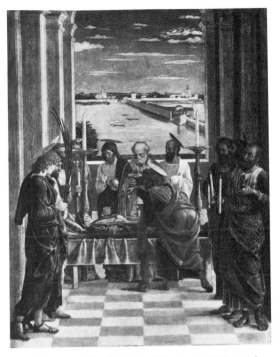

20. Petrus Christus: *Madonna*. Berlin-Dahlem, Staatliche Museen.

21. Mantegna: *Death of the Virgin*. Madrid, Prado.

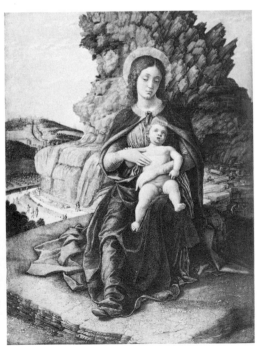

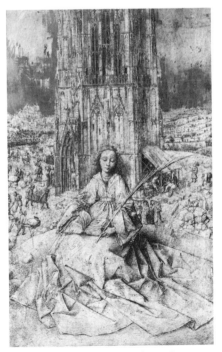

22. Mantegna: *Madonna*. Florence, Uffizi.

23. Jan van Eyck: *St. Barbara*. Antwerp, Musée Royal.

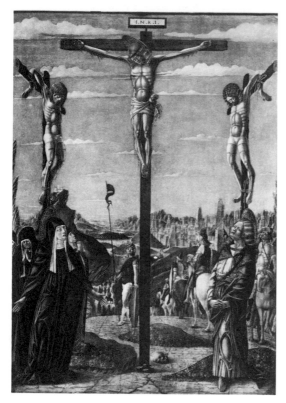

24. Paduan Painter: *Crucifixion*. Venice, Accademia.

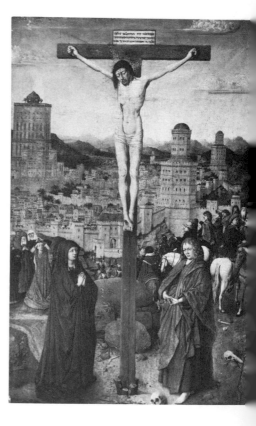

25. After Jan van Eyck: *Crucifixion*. Venice, Cà d'Oro.

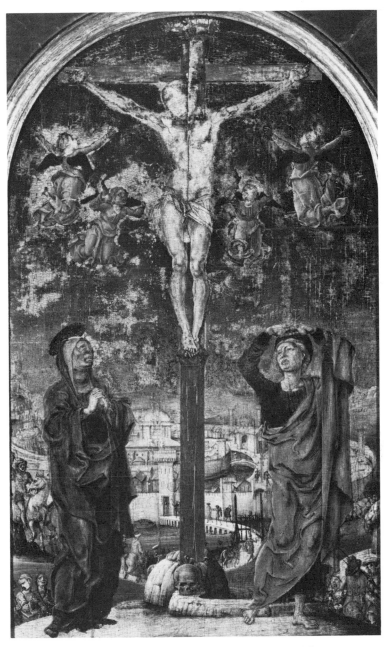

26. Cosimo Tura: *Crucifixion*. Cambridge, Fitzwilliam Museum.

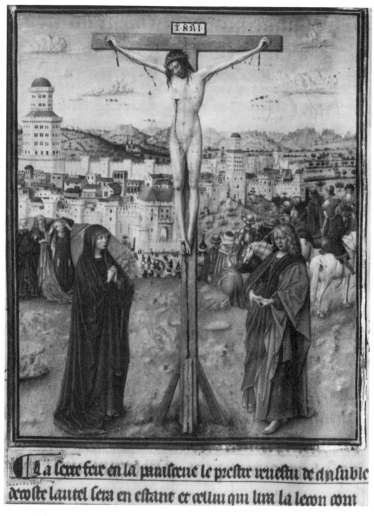

27. After Jan van Eyck: *Crucifixion*. Turin, Museo Civico, *Heures de Milan,* fol. 48v.

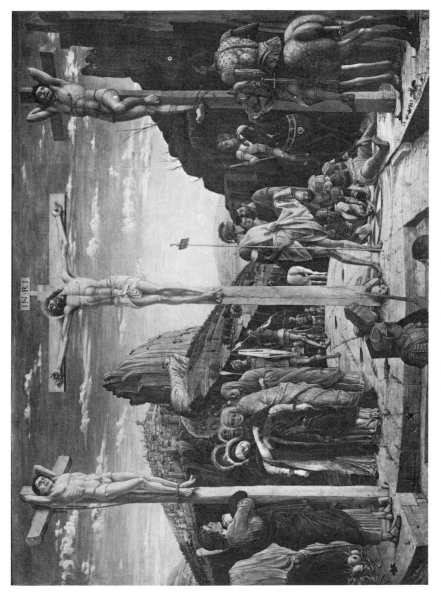

28. Mantegna: *Crucifixion*. Paris, Louvre.

29. After Jan van Eyck: *Way to Calvary*. New York,
Metropolitan Museum.

30. Pieter Bruegel: *Way to Calvary*. Vienna, Kunsthistorisches Museum.

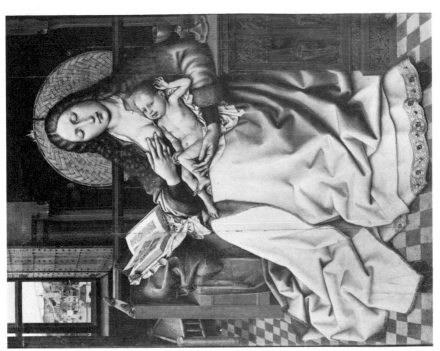

32. Master of Flémalle: *Madonna*. London, National Gallery.

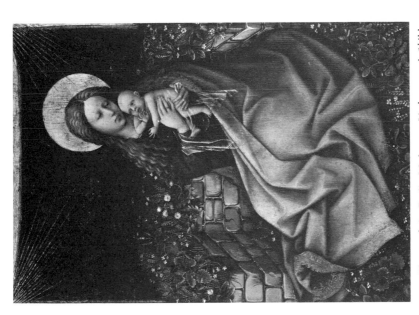

31. Master of the Berlin Madonna: *Madonna and Child*. Berlin-Dahlem, Staatliche Museen.

33. Dutch, *ca.* 1400: *Trinity*. Amsterdam, Royal
Academy of Sciences, ms. XVIII, fol. 10.

34. Follower of Ambrogio Lorenzetti: *Holy
Family*. New York, Abegg Collection.

35. 8th century: *Crucifixion*. Rome, Sta Maria
Antiqua.

36. Follower of Pucelle: *Crucifixion*. Oxford, Bodleian Library, Douce 313, fol. 234.

37. Ambrogio Lorenzetti: A Gate in Siena (from *The Good City*). Siena, Palazzo Pubblico.

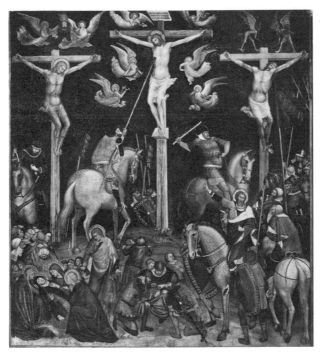

38. Barna: *Crucifixion*. San Gimignano, Collegiata.

39. Meo da Siena (after Ambrogio Lorenzetti): *Crucifixion*. Subiaco, Sacro Speco.

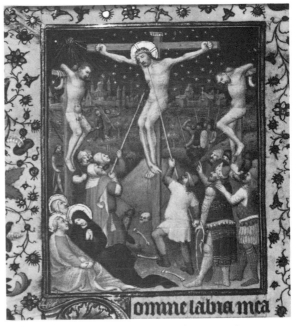

40. Follower of Jacquemart, 1405–1410:
Crucifixion. London, British Library,
Thompson 37, fol. 118v.

41. Boucicaut Master: *Crucifixion*. London,
British Library, Add. 16997, fol. 153v.

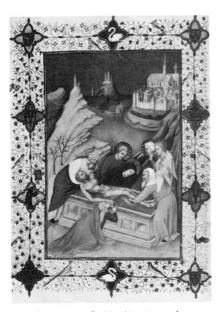

42. Jacquemart de Hesdin: *Entombment*.
Brussels, Bibliothèque Royale, ms.
11060-1, p. 198.

43. Masolino: Sinopia of *Crucifixion*. Rome,
San Clemente.

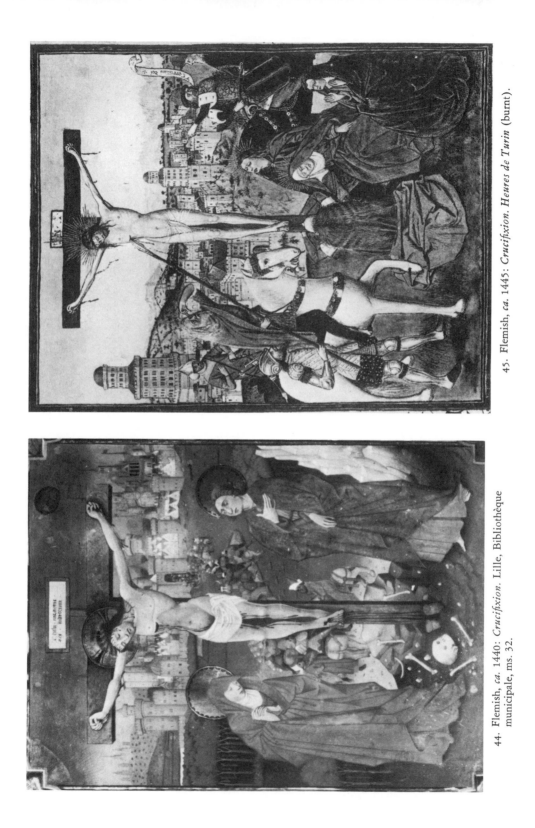

45. Flemish, *ca.* 1445: *Crucifixion. Heures de Turin* (burnt).

44. Flemish, *ca.* 1440: *Crucifixion.* Lille, Bibliothèque municipale, ms. 32.

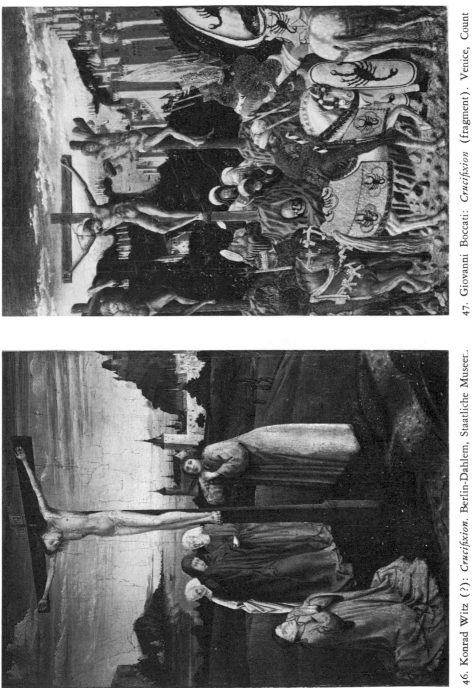

47. Giovanni Boccati: *Crucifixion* (fragment). Venice, Count Vittorio Cini Collection.

46. Konrad Witz (?): *Crucifixion*. Berlin-Dahlem, Staatliche Museen.

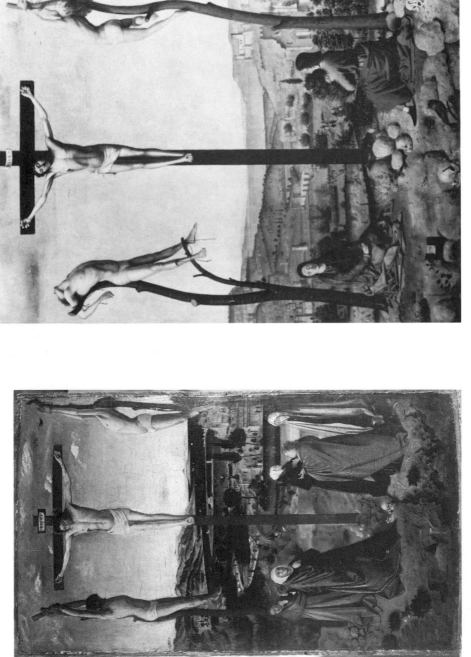

49. Antonello da Messina: *Crucifixion*. Antwerp, Musée des Beaux-Arts.

48. Antonello da Messina: *Crucifixion*. Sibiu, Museo.

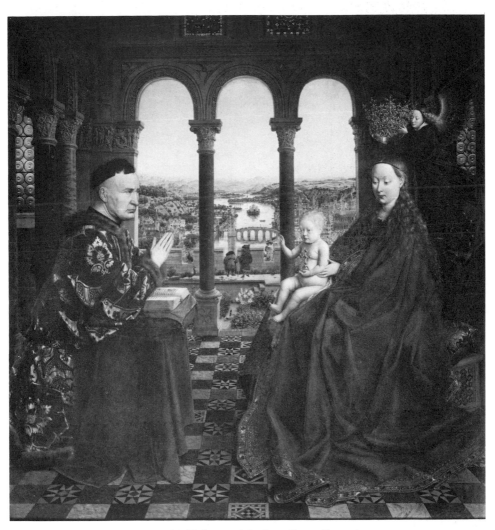

50. Jan van Eyck: *Madonna with Chancellor Rolin*. Paris, Louvre.

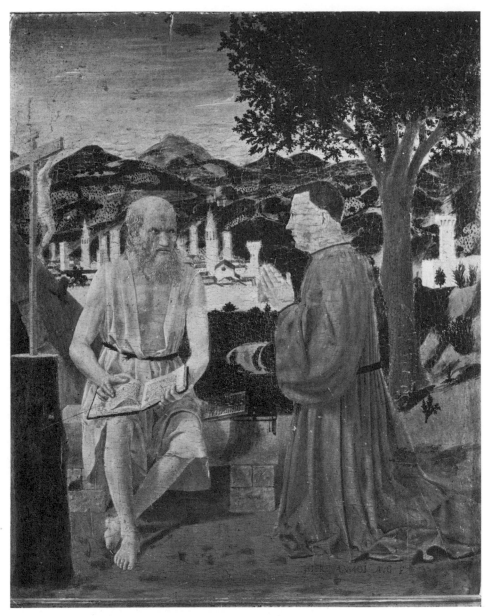

51. Piero della Francesca: *St. Jerome and a Donor*. Venice, Accademia.

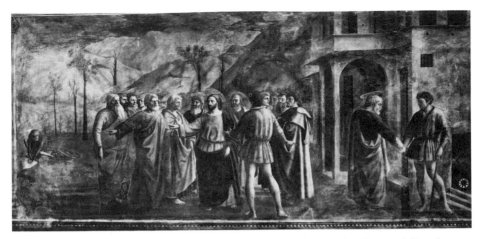

52. Masaccio: *The Tribute Money*. Florence, Sta Maria del Carmine, Brancacci Chapel.

53. Byzantine, 11th century: *The Tribute Money*. Florence, Bibl. Laurenziana, Plut. VI, 23, fol. 36.

54. Gospel Book, *ca.* 1260: *St. Peter Catching the Fish.* Aschaffenburg, Hofbibliothek, ms. 13, fol. 31.

55. Early Christian: *Christ and Six Apostles.* Rome, SS. Pietro e Marcellino (after Wilpert).

56. Masaccio: *Adoration of the Magi*. Berlin-Dahlem, Staatliche Museen.

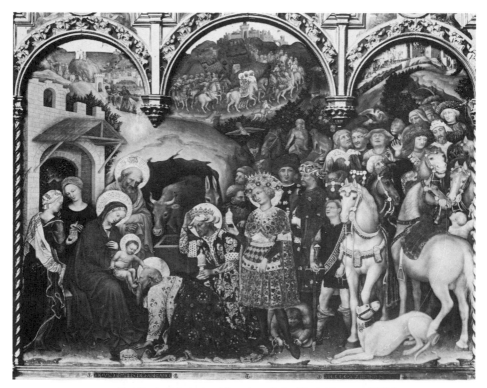

57. Gentile da Fabriano: *Adoration of the Magi*. Florence, Uffizi.

58. 5th–6th century: *Christ and the Twelve Apostles*. Dijon, Museum.

59. 4th century: *Socrates and Six Disciples*. Apamea, Basilica.

60. 1st century: *The Seven Sages*. Rome, Villa Albani.

61. Byzantine, 9th century: *Second Ecumenical Council of Constantinople*. Paris, Bibliothèque Nationale, gr. 510, fol. 355.

62. Byzantine, 11th century: *Christ among the Doctors*. Mount Athos, Dionysiu 740, fol. 135.

63. Byzantine, 12th century: *Pentecost*. Monreale, Cathedral.

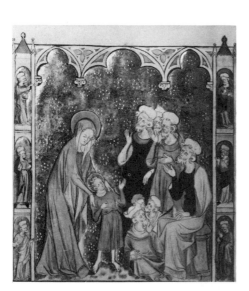

64. English, 14th century: *Christ among the Doctors*. London, British Library, *Queen Mary's Psalter*, Royal 2 B VII, fol. 150v.

65. Giotto (?): *Christ among the Doctors*. Assisi, San Francesco, Upper Church.

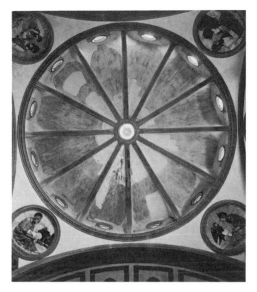

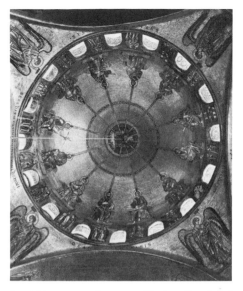

66. Brunelleschi: Cupola of Pazzi Chapel. Florence, Sta Croce.

67. 12th century: *Pentecost*. Venice, Cupola of San Marco.

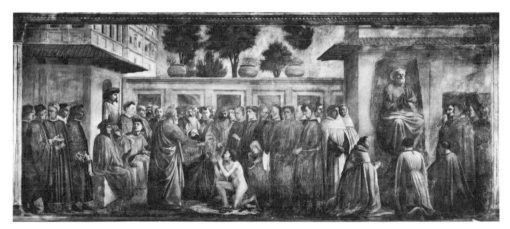

68. Masaccio and Filippino Lippi: *St. Peter Raising the Prefect's Son*. Florence, Sta Maria del Carmine, Brancacci Chapel.

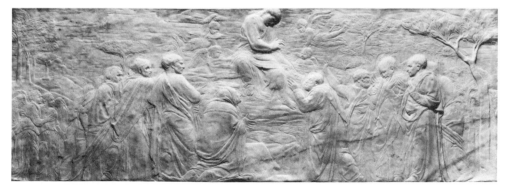

69. Donatello: *Ascension of Christ*. London, Victoria and Albert Museum.

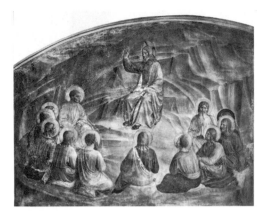

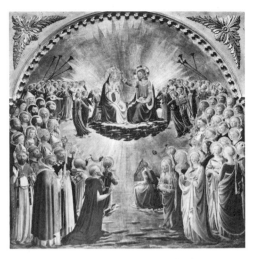

70. Fra Angelico: *Sermon on the Mount.* Florence, San Marco.

71. Fra Angelico: *Coronation of the Virgin.* Florence, Uffizi.

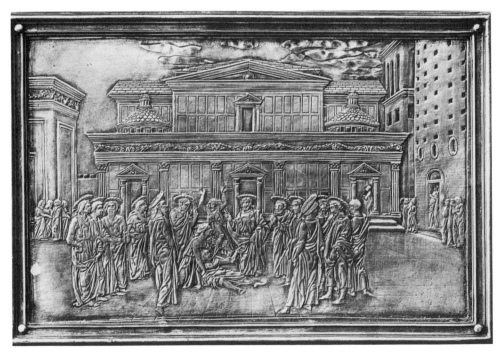

72. Florentine, 15th century: *Christ Healing the Woman Possessed.* Paris, Louvre.

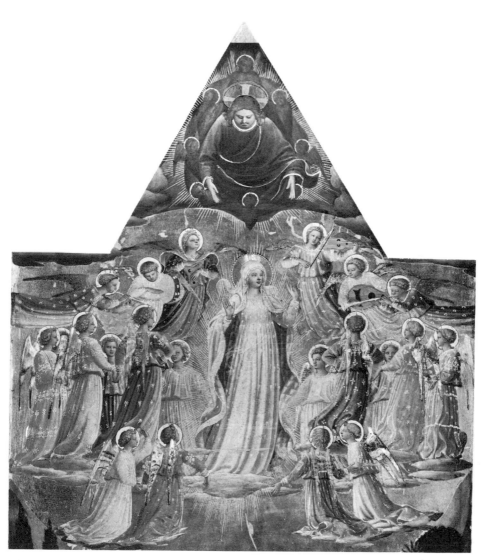

73. Fra Angelico: *Assumption of the Virgin*. Boston, Isabella Stewart Gardner Museum.

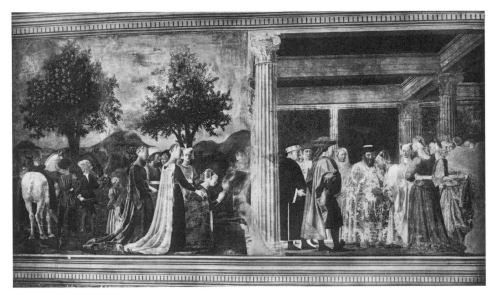

74. Piero della Francesca: *The Queen of Sheba Visiting Solomon.* Arezzo, San Francesco.

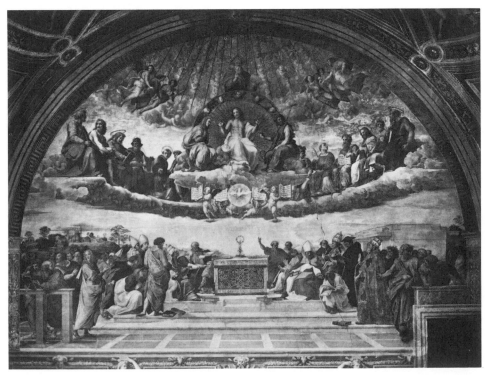

75. Raphael: *Disputa.* Vatican, Stanze.

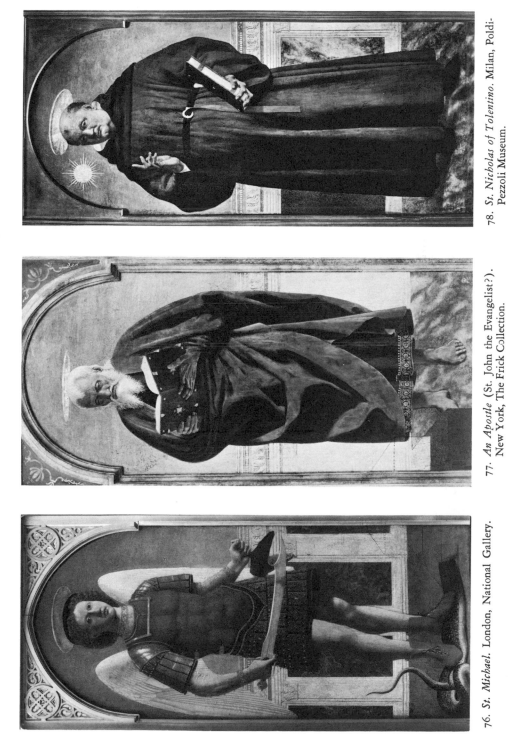

76-78. Panels of a Polyptych Painted by Piero della Francesca for Sant'Agostino, San Sepolcro, between 1454 and 1469.

78. *St. Nicholas of Tolentino*. Milan, Poldi-Pezzoli Museum.

77. *An Apostle* (St. John the Evangelist?). New York, The Frick Collection.

76. *St. Michael*. London, National Gallery.

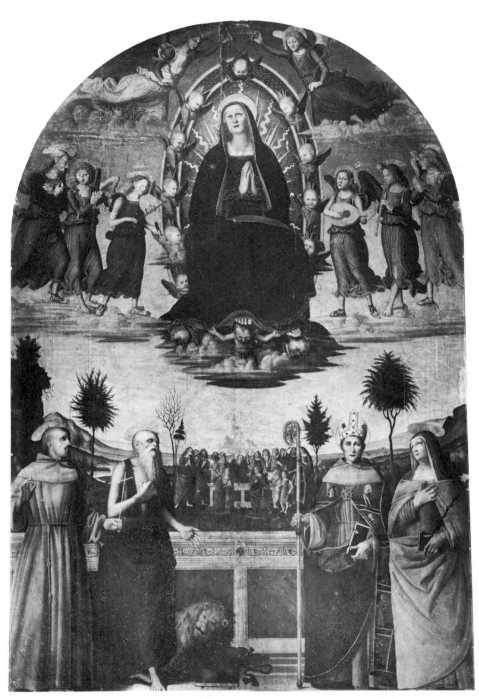

79. Umbrian Painter, *ca.* 1500: *Assumption of the Virgin*. San Sepolcro, Pinacoteca.

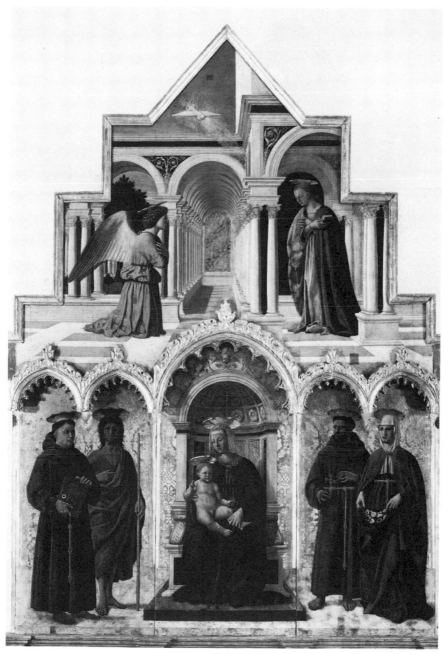

80. Piero della Francesca: Altarpiece. Perugia, Galleria nazionale.

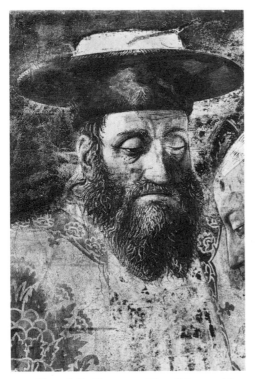

81. Piero della Francesca: King Solomon (detail of *The Meeting of Solomon and Sheba*).
Arezzo, San Francesco.

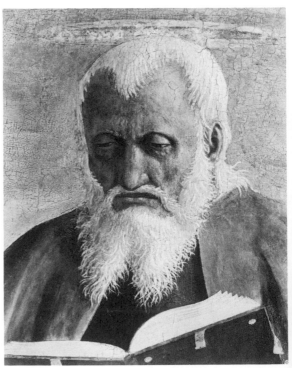

82. Piero della Francesca: Detail of fig. 77. New York,
The Frick Collection.

83. Workshop of Orcagna: St. Michael
(detail of a panel). New York,
Metropolitan Museum, Lehman Col-
lection.

84. Benozzo Gozzoli: *St. Nicholas*
of Tolentino. San Gimignano,
Sant' Agostino.

85. Taddeo Gaddi: *David*. Flo-
rence, Sta Croce.

86. Piero della Francesca: *St. Michael*
(after cleaning, 1966). London,
National Gallery.

87. Piero della Francesca: *St. Augustine*.
Lisbon, Museu nacional de arte
antiga.

88. Piero della Francesca: *Madonna and Saints* (photographed outside its frame).
Milan, Brera.

89. Ghirlandaio: *The Approval of the Franciscan Rule*. Florence, Sta Trinita.

90. Michelozzo: *The Aragazzi Family before the Madonna*. Montepulciano, Duomo.

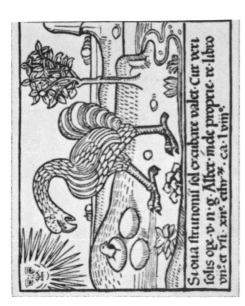

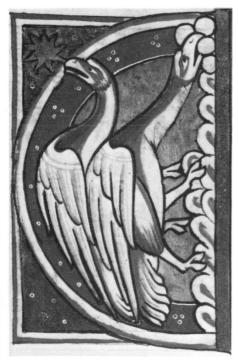

91. English, late 12th century: Ostrich in a Bestiary. New York, Pierpont Morgan Library, ms. 81, fol. 34.

92. Late 15th century: *The Sun Hatching Ostrich Eggs*. Eisenhut's Blockbook.

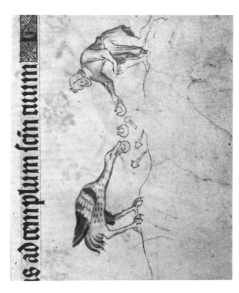

93. *The Ferrous Diet of the Ostrich*. London, British Library, Royal 2 B VII, fol. 114.

94. Ostrich as Emblem of Duke Federigo. Rome, Vatican Library, Urb. lat. 508, fol. 1.

95. Third quarter of 15th century: The Sun Hatching Ostrich Eggs (detail of fresco). Bressanone, Cathedral Cloister.

96. Mantegna: *Madonna*, Verona, San Zeno.

97. Bernardino Butinone: *Madonna*. Isolabella, Castello.

98. Antonio da Ferrara: *Madonna with Sleeping Child.* Urbino, Galleria Nazionale.

99. Cosimo Tura: *Madonna with Sleeping Child.* Venice, Museo Civico.

100. Justus of Ghent: Federigo and Guidobaldo da Montefeltro. Urbino, Galleria Nazionale.

101. Vittore Carpaccio: *Vision of the Prior of Sant'Antonio di Castello, Venice.* Venice, Accademia.

102. Luca Signorelli: Pendant Ostrich Egg. Orvieto, Duomo, Cappella di San Brizio.

103. Neri di Bicci: *Madonna with Sleeping Child*. Whereabouts unknown.

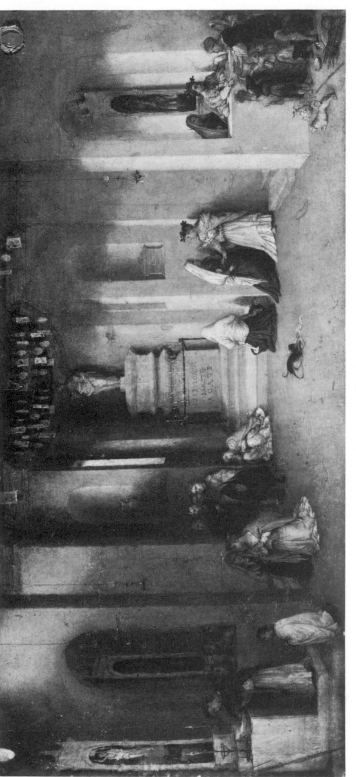

104. Lorenzo Lotto: *Legend of St. Lucy.* Jesi, Pinacoteca.

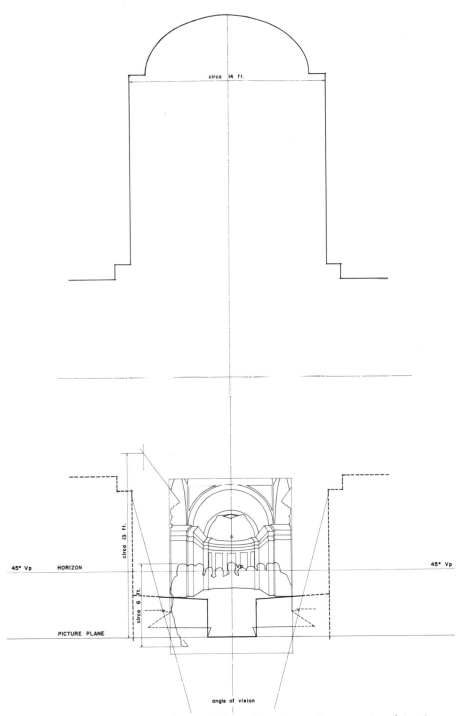

circa 14 ft.

circa 13 ft.

45° Vp HORIZON Vp 45° Vp

circa 6 ft.

PICTURE PLANE

angle of vision

105. Piero della Francesca: *Madonna and Saints*. Milan, Brera. Reconstruction of the plan.

107. Giovanni Bellini: *Madonna and Saints* (with original frame).
Venice, San Zaccaria.

106. Antonello da Messina: Reconstruction by J. Wilde of the San Cassiano
Altarpiece.

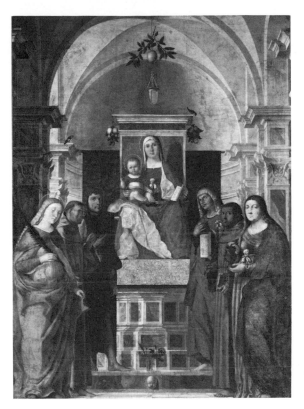

108. M. Fogolino: *Madonna and Child with Saints.*
Amsterdam, Rijksmuseum.

109. Tomb of Guidantonio da Montefeltro
(†1443). Urbino, San Donato degli
Osservanti.

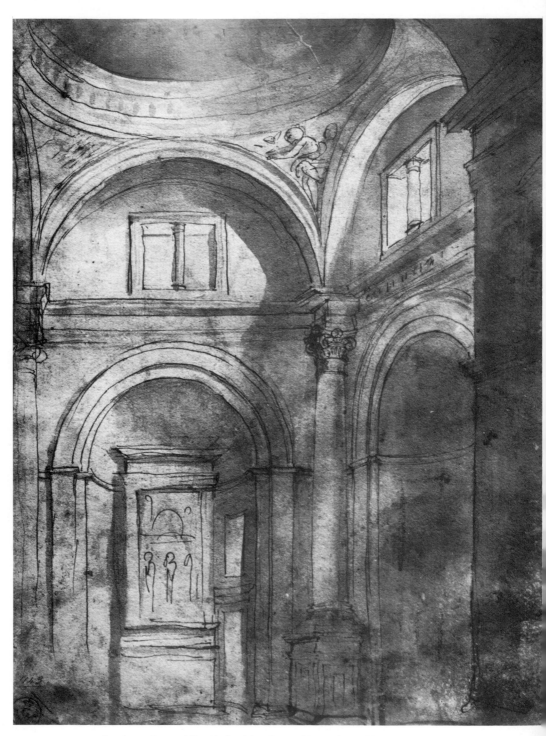

110. Gerolamo Genga (?): Choir of San Bernardino, Urbino (detail). Florence, Uffizi.

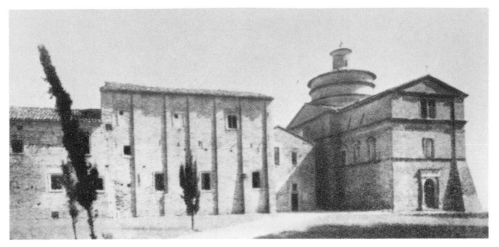

111. View of San Donato and San Bernardino, Urbino.

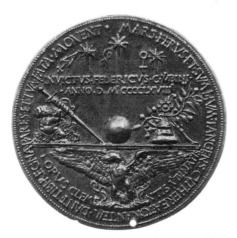

112. Clemente da Urbino, 1468: Medal of Federigo da Montefeltro (reverse).

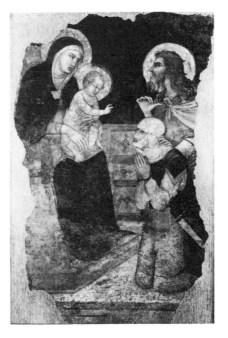

113. Pietro Lorenzetti: *Madonna with John the Baptist and Donor*. Siena, San Domenico.

AMMIANI · MARCELLINI · RERUM · GESTARUM ·

LIBER · XXXI · EXPLICIT · FELICITER ·

114. Niccolò Niccoli, 1423: Ammianus Marcellinus, *Rerum gestarum*. Florence, Biblioteca nazionale, C.S. I. V. 43, fol. 1.

CICERONIS · RHETORICO
HERENNIVM · LIBER · INCI

116. Scriptorium of Vespasiano da Bisticci, *ca.* 1455: Cicero, *Opera rhetorica*. Rome, Biblioteca Vaticana, Vat. lat. 1712, fol. 125.

117. Ghiberti, 1412–1416: John the Baptist (detail). Florence, Or San Michele.

Q. CVRTI · RVFI · HISTORIAE · ALEX · LIBER · X ·
EXPLICIT · FELICITER ·
VNC. LIBRVM. SCRIPSI. T. ANTONIVS. MARIVS.

CAPVT
BEATI ZENOBII
FLORENTINI EPISCOPI
IN CVIVS HONOREM
HEC ARCA INSIGNI OR
NATV FABRICATA
FVIT

115. Antonio di Mario, 1419: Q. Curtius Rufus, *Historiam Alexandri Magni*. Rome, Biblioteca Vaticana, Vat. lat. 1865, fol. 142.

118. Ghiberti, 1439–1440: Shrine of St. Zenobius (detail). Florence, Cathedral.

LAVDATE DNM IN SCIS EIVS · EA EV IN FRMAMENTO ATVTIS EA EV IN ATVTIB EA EV SODM MVLTITVDINEM MAG

119. Luca della Robbia, *ca.* 1435: *Cantoria* (detail). Florence, Opera del Duomo.

120. Bernardo Rossellino, 1452: Tomb of Beata Villana (detail). Florence, Sta Croce.

121. Bernardo Rossellini, *ca.* 1447: Tomb of Leonardo Bruni (detail). Florence, Sta Croce.

122. Roman, 167 B.C.: Inscription. Delphi, Sanctuary.

123. Roman, *ca.* A.D. 10: Inscription. Rome, Museo nazionale.

124. Inscription from Sant'Andrea di Candeli (Florence), 1176. Florence, Museo nazionale.

125. Donatello: Tomb of Giovanni Pecci (detail), †1426. Siena, Cathedral.

126. Masaccio: Inscription above Skeleton (detail of *Holy Trinity* fresco). Florence, Sta Maria Novella.

127. Signature on *Zuccone, ca.* 1425. Florence, Campanile.

128. Signature on *Jeremiah, ca.* 1430. Florence, Campanile.

129. Signature on *Gattamelata*, ca. 1448. Padua, Santo.

130. Signature on *Judith*, 1456–1457. Florence, Palazzo Vecchio. Figs. 127–130. Donatello Signatures.

131. Mantegna, 1454: Signature on *St. Euphemia*. Naples, Capodimonte.

132. Inscription below fresco by Mantegna, 1452. Padua, Santo.

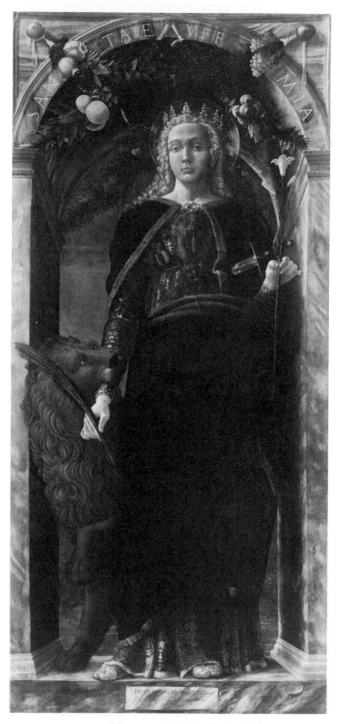

133. Mantegna, 1454: *St. Euphemia.*
Naples, Capodimonte.

134. Alberti, 1467: Santo Sepolcro (detail). Florence, San Pancrazio, Cappella Rucellai.

135. Verrochio, 1472: Tomb of Giovanni and Piero de'Medici (detail). Florence, San Lorenzo.

136. Mantegna, *ca.* 1454: Epigraph on Arch in *The Judgment of St. James.* Formerly Padua, Eremitani.

137. Mantegna, *ca.* 1455: Epigraph in *St. James on the Way to Execution.* Formerly Padua, Eremitani.

138. Roman: Signature of the Architect. Verona, Arco dei Gavi.

139. Mantegna, after 1457: *Martyrdom of St. Christopher* (detail). Padua, Eremitani.

140. Mantegna, before 1474: *Emperor Otto.* Mantua, Ducal Palace.

141. Mantegna: Inscription on print of *Entombment.*

142. Mantegna and workshop, 1459: Initial *E* in Strab? *De situ orbis.* Albi, Bibliothèque Rochegude, ms. fol. 230v.

> VSEBIVS HIERONY
> MVS VINCENTIO
> ET GALIENO SVIS
> SALVTEM
> *Vetus iste disertorum mos fuit ut exercendi causa ingenii grecos libros lati*

143. Paduan (?), 1450: Initial *E*. Venice, Biblioteca Marciana, ms. 3 [L. IX. I] MK, fol. 2.

> PROVIDENTISSIMO·PRINCIPI·
> SENATVS·P·Q·R·QVOD·
> ACCESSVM·ITALIAE·HOC·
> ETIAM·ADDITO·EX PECVNIA·
> SVA·PORTV·TVTIOREM·
> NAVIGANTIBVS·REDDIDERIT·

144. Cyriac of Ancona, ca. 1443: Transcription from the Triumphal
Arch at Ancona. Berlin, Staatsbibliothek, Hamilton 254, fol. 81.

> ISCONII
>
> FLAVIA CONSI ET SINVI
> AE FILIA SCAPVLAE ET SI
> NVIAE NEPTIS. BARBI ET
> DIRVTIAE PRONEPTIS
> CONSOBRINA EADEMQ
> VXOR P. PAQVII SCAEVE.
> FILII SCAEVE CONSI NEPO
> TIS BARBI. PRONEPOTIS
> SIMVL CVM EO CONDITI.

145. Sylloge of Marcanova, 1457–1460. Bern,
Bürgerbibliothek, B 42, fol. 22.

> COMPLETAE
> SVNT RERV
> SICVT RAD
> DERVNT
> NOBIS QV

146. 9th century: Majuscules in a Gospel
Book. Rome, Biblioteca Vaticana, Pal.
lat. 50, fol. 8.

147. Mantegna (?): Initial *A*. Albi,
Bibliothèque Rochegude, ms. 4,
fol. 183v.

148. Mantegna (?): Initial *H*.
Albi, Bibliothèque Roche-
gude, ms. 4, fol. 273.

149. Mantegna, 1456–1457: Lettering on gesso. Altarpiece. Verona,
San Zeno.

150. F. Feliciano, *ca.* 1460–1463: *A.* Rome, Biblioteca Vaticana, Vat. lat. 6852, fol. 1.

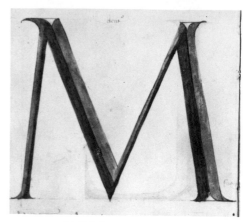

151. F. Feliciano, *ca.* 1460–1463:
H. Rome, Biblioteca Vati-
cana, Vat. lat. 6852, fol. 4v.

152. F. Feliciano, *ca.* 1460–1463:
M. Rome, Biblioteca Vati-
cana, Vat. lat. 6852, fol. 6v.

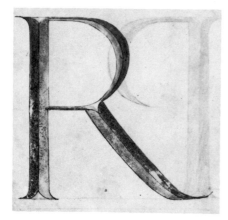

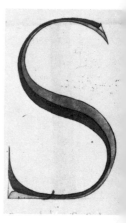

153. F. Feliciano, *ca.* 1460–1463:
R. Rome, Biblioteca Vati-
cana, Vat. lat. 6852, fol. 8v.

154. F. Feliciano, *ca.* 1460–1463:
S. Rome, Biblioteca Vati-
cana, Vat. lat. 6852, fol. 10.

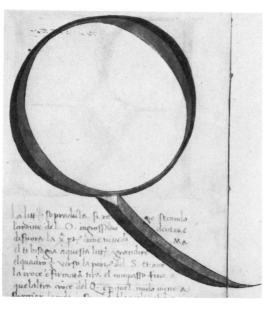

155. F. Feliciano, *ca.* 1460–1463:
Q. Rome, Biblioteca Vati-
cana, Vat. lat. 6852, fol. 9v.

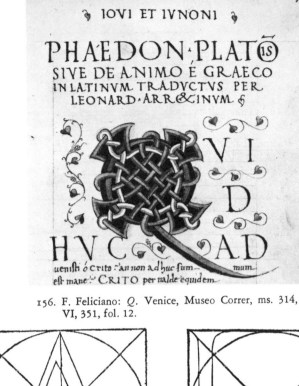

PHAEDON·PLATŌ
SIVE DE ANIMO E GRAECO
IN LATINVM TRADVCTVS PER
LEONARD·ARR&INVM &

VI
D
AD
HVC

uenisti ó Crito ·'an non ad huc fum— mum
est mane·' CRITO per ualde equidem

156. F. Feliciano: *Q.* Venice, Museo Correr, ms. 314,
VI, 351, fol. 12.

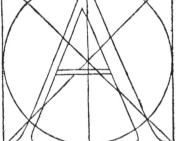

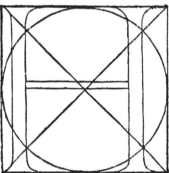

157. D. Moille: *A*, from *Alpha-
betum*, Parma, *ca.* 1480.

158. D. Moille: *H*, from *Alpha-
betum*, Parma, *ca.* 1480.

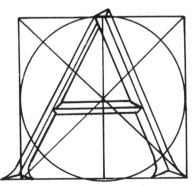

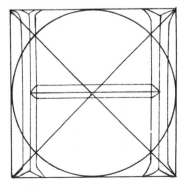

159. Diagram of Mantegna (?):
A. Albi, Bibliothèque Roche-
gude, ms. 4, fol. 183v.

160. Diagram of Mantegna (?):
H. Albi, Bibliothèque Roche-
gude, ms. 4, fol. 273.

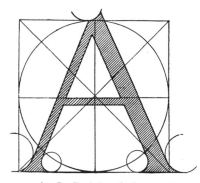

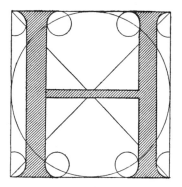

161. L. Pacioli: *A*, from *Divina Proportione*, Venice, 1509.

162. L. Pacioli: *H*, from *Divina Proportione*, Venice, 1509.

QVARTVS.

A littera.E.antiqua certamente cauarfe dà le medefime circuftantiæ & modi de la præcedéte nõ negamo. Quãdo adũque lafta naturale de q̃ta littera fera cũ le medefime normæ ptracta. Faciaffe fopra il cétro.E. cõmuno la portiõe del circulo.x.y.fecúdo la q̃tita de.e.x.tágendo lo diametro a.d.in.y.dal q̃le pũcto fia la linea.y.z.ppendiculariter extéduta fopra il diametro.a.d.per la.xi.de Euclide:& de ditta l̃a la gamba ife riore hauerai fabricatoːe fe la fupiore gãba uorai generare. Alhora dal pũcto.z.per la.xi.del Megaréfe fia la linea.z.&. ppendiculaʒiter

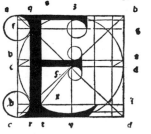

fopra lo lato.c.d. ptract 1: fecádo.f.g.in.ɔ. Et qñ il circulo partuo fopra il centro.g̃. fera defcripto fecúdo la q̃tita de.g̃.ɔ.la quale e pofta effere æquale a li tri quarti de la largheza de la péna cioe de. f.a. Et q̃fto fatto fe la media afta. A.C.B.D. cõtingéte al cétro.e. cõmuno fera lineata il cui termío fia la linea.E.F. diftáte da la linea.u.z.p tri q̃rti de tefta. Hauerai alhora la mediale gãba de dita l̃a cũ doctri na erecta. Et maxíe qñ p g̃a de q̃lla li ferano li dui paruiffimi circu li fecúdo la q̃tita de media tefta defcripti. Se da poi li dui parui circu li fecúdo la q̃tita de.h.c. et de.f.a. cioe de la latitudine de la tefta ferano fopra li centri.f.et.h. defcripti: ut fupra iam oftenfum eft: la lit tera.E. Antiqua fera cum perfectione inftituita.

163. S. de'Fanti: *E*, from *Theorica et Practica de modo scribendi*, Venice, 1514.

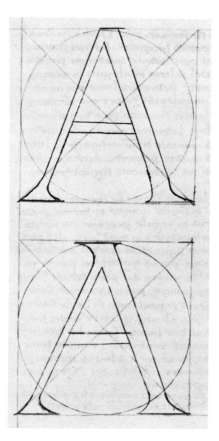

164. Early 16th century: *A*. Munich, Staatsbibliothek, lat. 451, fol. 15.

zerteyl dise fierung mit zweyen kreüß linien die aufrecht.e.f. die zwerch.g.h. Damach setz vnden in
der fierung bey.c.d. zwen puncten.i.k. eyn zehen teyl hinein/vnd zeüch den dünnen strich des buſtaben
von dem.i. vberſich an die fierung von daſ zeüch den breyten strich wider herab alſo das jre beder breytē
ten auſſen die zwen puncten.i.k. an rüren ſo belęybt mitten ein dryangel/aber der punct e kumpt oben
in ttēn den buſtaben. Damach zeüch das.a. vnder dem zwerch strich.g.i zůſamē/den ſtrich mach
eynes drytteyls breyt von der gröſſerē breytē. Damach laß an dem breytē strich oben ein rund eir-
keldrum hinderſich vber die fierung auß ſtreychen/vnd nim den buſtaben oben mit einer ſchlangen-
lini ab alſo das die hölen gegen dem dünnen strich ſte/vnd ſchwenf des buſtaben strich vnden auf bre
den ſeytē auſ alſo das ſie fierung eck.e.d. rüren/das thů mit einem eirkeldrum des halben Dia
meter eyn ſiben teyl von der fierung ſeytē hab/aber innen hinein laß den auſ dit von der gröſſeren
breytē des ſtrichs zwey drytteyl weyt fürdretten/das nim zů bedem teyl mit einem eirkeldrum auſ des
D.ameter des breytē ſtrichs breyt ſey.

Item diſes.a.magſt du auch oben mit der fierung blat ab nemen vnd den buſtaben auf beden ſeytē
auſſchwenffen wie vnden/doch das der lenger teyl fornen werde/aber oben müſen die ſtrich ein wenig
nęher zůſamen gerücket werden. Diſer dreyer meynung mußt du dich gebrauchen/welche dir am ba-
ſten geſelt vnd merck zů gleycher weyſ wie diſer buſtab.a. oben vnd vnden außgeſchwenſt wirdt/alſo
ſolſt du auch auſſchwenffen die buſtaben der ſtrich ortſchelchs gezogen werden/als da iſt.v.r. y. aber
do.ſ.ein wenig geendert wie du hernach hören wirſt. Item das.a. magſt du noch anderſt machen/
nemlich oben ſcharpf ſo leüten ſich die ſtrich oben nęher zůſamen Damach rück den zwerch zug ein
wenig mer herab vñ machjn noch ſo breit als fo: du magſt auch den ſtrich oben ſtumpf abſchneyden
oder fornen auß ſchwenffen. Vnd diſer buſtab iſt hernach aufgeriſſen.

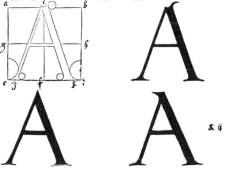

166. Geofroy Tory: *I*, from *Champ Fleury*, Paris, 1529.

165. A. Dürer: *A*, from *Underweysung der Messung*, Nuremberg, 1525.

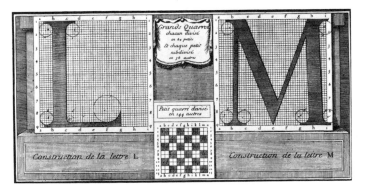

167. N. Jaugeon: *L* and *M*, Drawing. Paris, Bibliothèque Nationale.

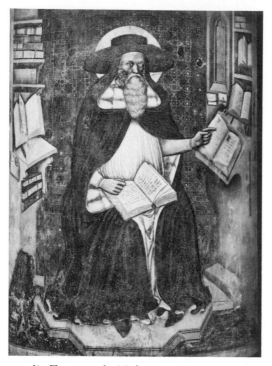

168. Tommaso da Modena: *St. Jerome in his Study*. Treviso, San Niccolò.

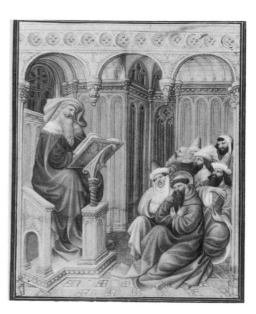

169. Jean de Limbourg: *St. Jerome Hearing a Lecture on Plato*. New York, The Cloisters, *Belles Heures*, fol. 183.

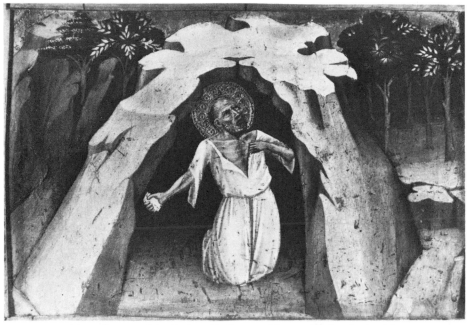

170. Florentine, *ca.* 1400: *Penitent St. Jerome.* Princeton, University Art Museum.

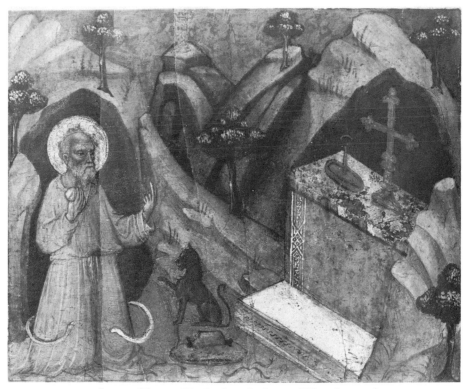

171. Lorenzo Monaco (?): *Penitent St. Jerome.* Whereabouts unknown.

172. Circle of early Masaccio: *Penitent St. Jerome.*
Princeton, University Art Museum.

173. Bicci di Lorenzo (?): *Penitent St. Jerome
and St. Benedict below the Cross.* Where-
abouts unknown.

174. Francesco dei Franceschi (?): *St. Jerome in
the Wilderness.* Private Collection.

175. Follower of Fra Angelico: Altarpiece. Paris, Louvre.

176. Botticini: Altarpiece. London, National Gallery.

177. Jean de Limbourg: *St. Jerome Scourged.*
New York, The Cloisters, *Belles Heures,*
fol. 183v.

178. Francesco d'Antonio: *St. Jerome Scourged.*
Paris, Louvre (Campana Collection).

179. Follower of Fra Angelico: St. Jerome Scourged (detail of fig. 175).
Paris, Louvre.

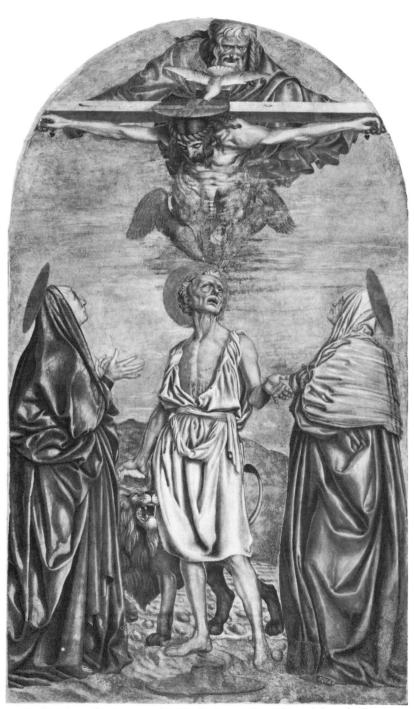

180. Castagno: *St. Jerome with SS. Paola and Eustochium below the Trinity.*
Florence, Sma. Annunziata.

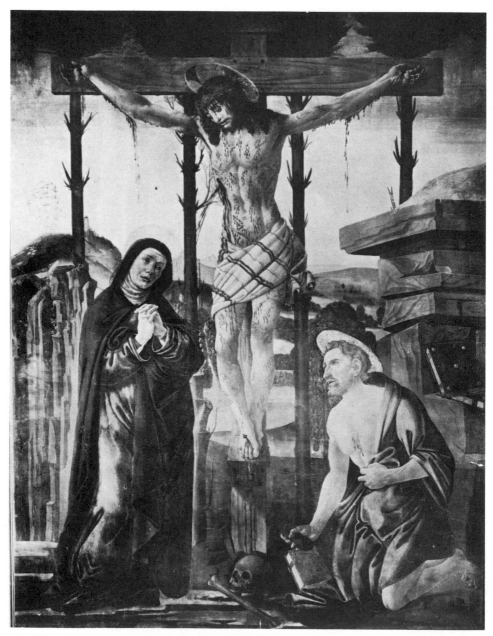

181. Florentine, late 15th century: *St. Eustochium (?) and St. Jerome below the Cross*. Fiesole, San Domenico.

182. Prato Master: *Penitent St. Jerome*. Prato, Duomo.

183. Fra Angelico, 1441–1442: St. Jerome (detail of *Crucifixion*). Florence, San Marco.

184. Attributed to Correggio: *A Cardinal as St. Jerome and the Saint Penitent*. Minneapolis, Institute of Arts.

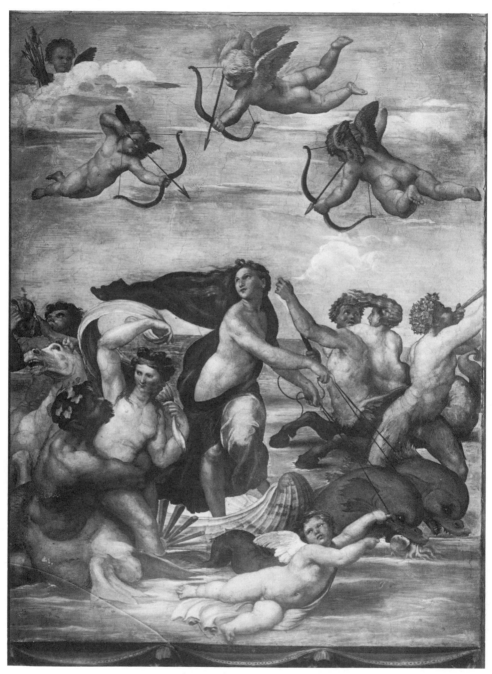

185. Raphael: *Galatea*. Rome, Villa Farnesina.

186. Roman, 1st century: Galatea (detail of a drawing of a sarcophagus).

187. Apollonio di Giovanni: Neptune (detail of a cassone panel). New Haven, Yale University Art Gallery.

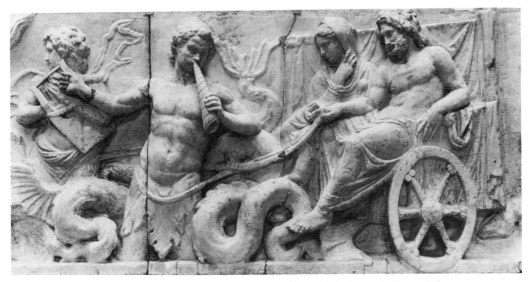

188. Roman, 1st century B.C.: *Neptune and Amphitrite*. Munich, Glyptothek.

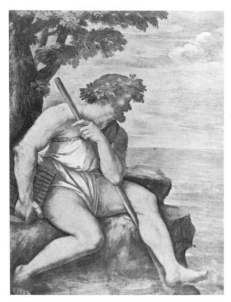

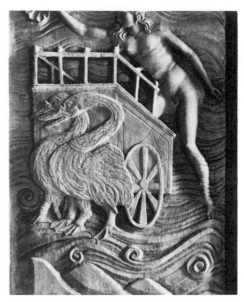

189. Sebastiano del Piombo: *Polyphemus.*
Rome, Villa Farnesina.

190. Matteo de' Pasti (?): *Venus.* Rimini,
Tempio Malatestiano.

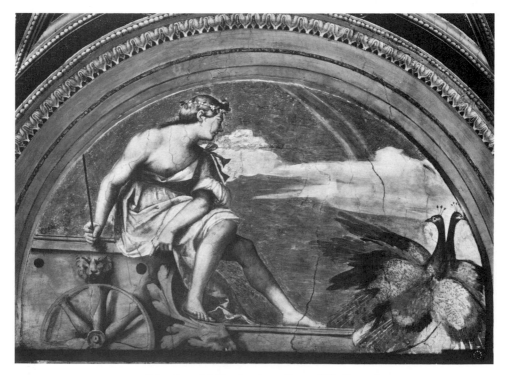

191. Sebastiano del Piombo: *Juno.* Rome, Villa Farnesina.

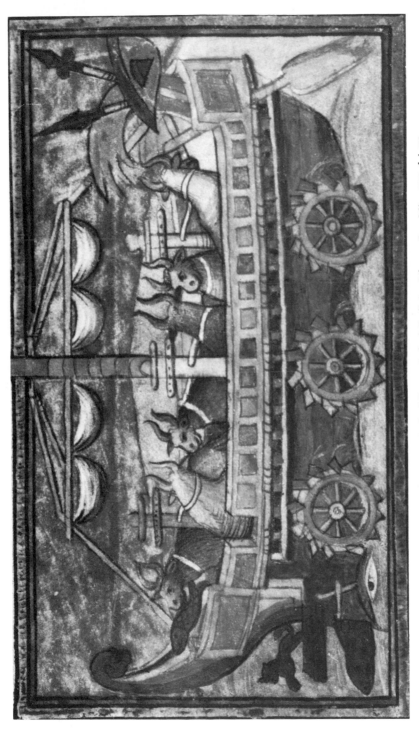

192. Roman, 4th century (copy *ca.* 1436): *Liburna.* Oxford, Bodleian Library, Can. Misc. 378, fol. 75v.

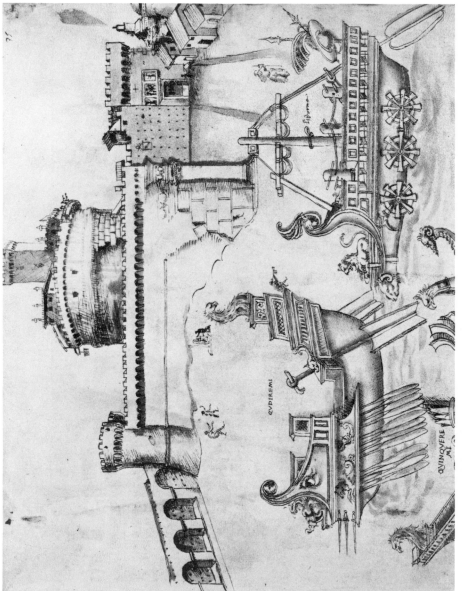

193. Giuliano da Sangallo: *Roman Ships*. Biblioteca Vaticana, Barb. lat. 4424, fol. 37.

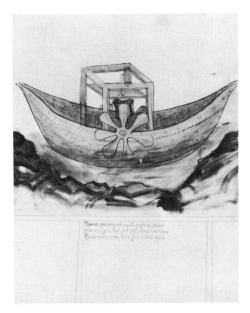

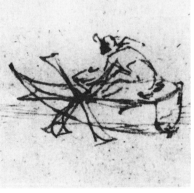

194. Conrad Kyeser, *ca.* 1405: *Paddle Boat.* Göttingen, Niedersächsischen Staats und Universitätsbibliothek, philos. 63, fol. 54b.

195. Mariano Taccola: *Paddle Boat* (copy). Paris, Bibliothèque Nationale, lat. 7239, fol. 87.

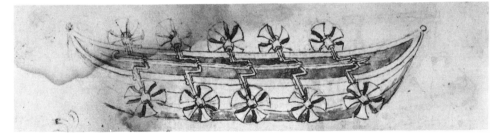

196. Roberto Valturio: *Paddle Boat.* Paris, Bibliothèque Nationale, lat. 7236, fol. 170.

197. Leonardo da Vinci: *Paddle Boat.* Paris, Institut de France, Codex B, fol. 83.

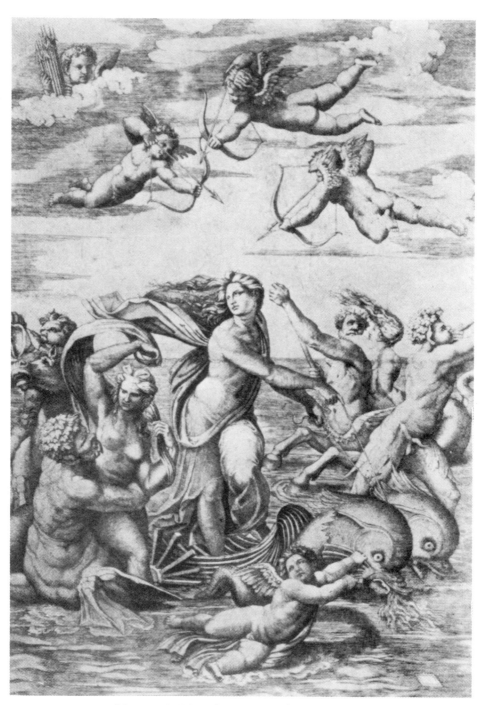

198. Marcantonio Raimondi: Engraving of Raphael's *Galatea*.

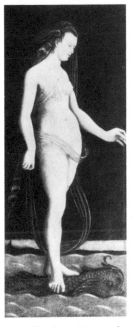

199. North Italian, early
16th century: *Gal-
atea*. Dresden, Ge-
mäldegalerie.

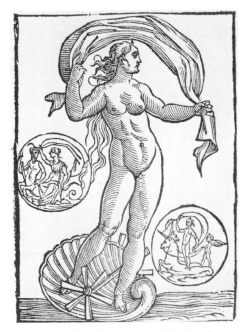

200. *Galatea* (engraving). V. Cartari,
Imagini delli dei de gl'antichi,
Venice, 1647.

201. Italian, late 16th century: Cistern. London, Wallace Collection.

202. Master of the Epître d'Othéa, 1405–1408:
Temperance and Clock. Paris, Bibliothèque
Nationale, fr. 606, fol. 2v.

203. Studio of Annibale Carracci: *Galatea.* Wind-
sor Castle.

204. G. Fossati: Venice (engraving, detail).

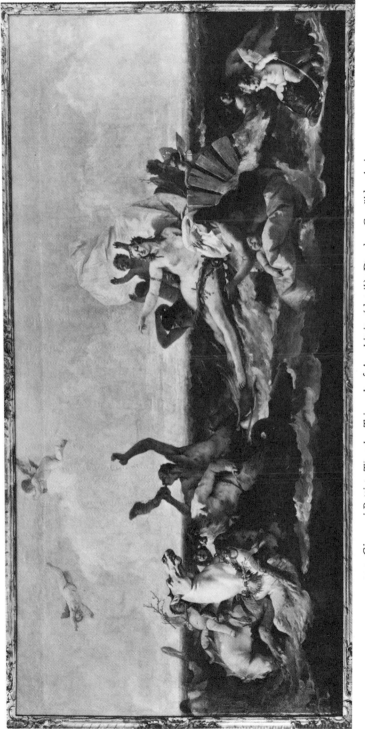

205. Giovanni Battista Tiepolo: Triumph of Amphitrite (detail). Dresden, Gemäldegalerie.

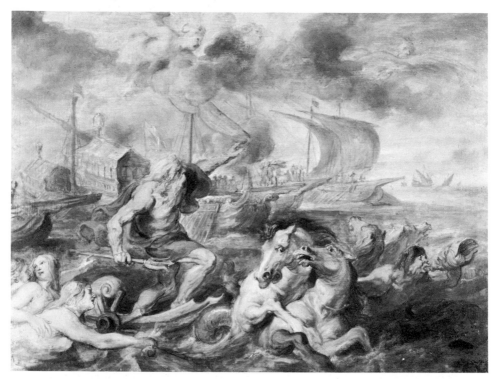

206. Peter Paul Rubens: Neptune Calming the Storm (detail). Cambridge, Mass., Fogg Art Museum.

207. Robert Fulton: His own Steamboat on the Hudson (detail). New York, Marine Museum.

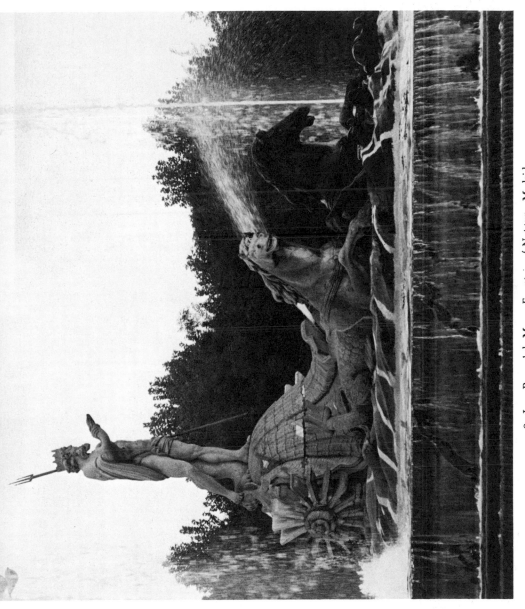

208. Juan Pascual de Mena: *Fountain of Neptune*. Madrid.

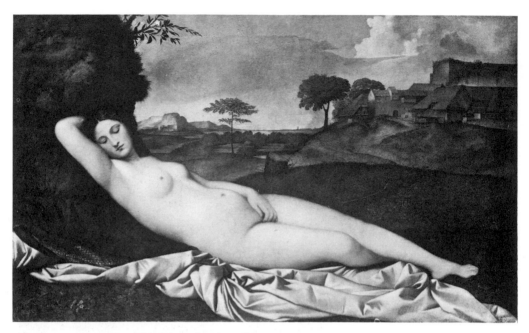

209. Giorgione and Titian: *Sleeping Venus*. Dresden, Gemäldegalerie.

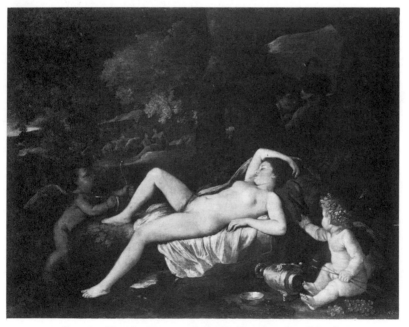

210. Poussin: *Sleeping Venus and Cupids*. Dresden, Gemäldegalerie.

211. Proposed reconstr
tion of the Cupid
fig. 209.

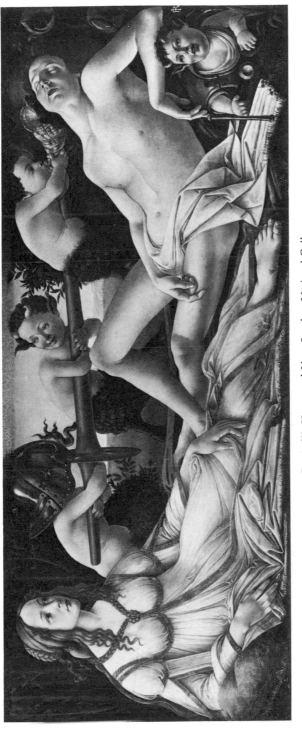

212. Botticelli: *Venus and Mars*. London, National Gallery.

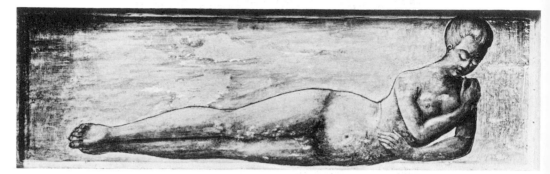

213. Late 15th century: *Sleeping Nude*. Copenhagen, Statens Museum for Kunst.

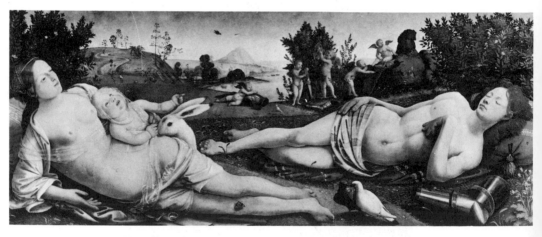

214. Piero di Cosimo: *Venus and Mars*. Berlin-Dahlem, Staatliche Museen.

215. Botticelli: Sleeping Woman and Shepherd (detail of *Calumny*). Florence, Uffizi.

216. Botticelli: Sleeping Woman, Spectator and Putti (detail of *Calumny*). Florence, Uffizi.

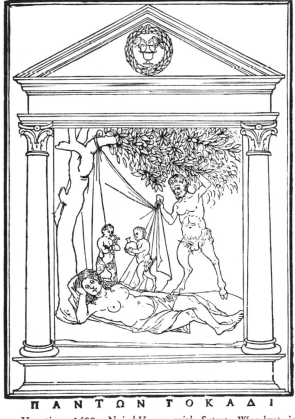

ΠΑΝΤΩΝ ΤΟΚΑΔΙ

217. Venetian, 1499: *Naiad-Venus with Satyrs*. Woodcut in *Hypnerotomachia Poliphili,* Venice, Aldus.

218. After Montfaucon: Fountain Nymph at Palazzo Collocci.

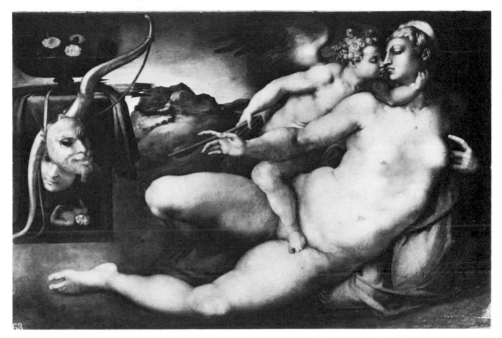

219. Florentine, after Michelangelo: *Venus and Cupid*. Hampton Court Palace.

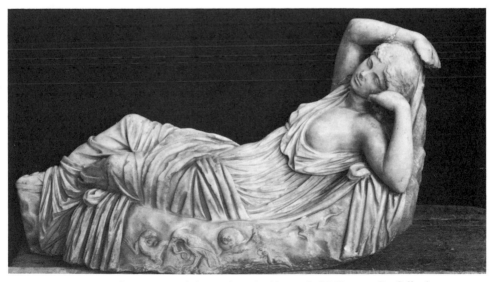

220. Roman, 2nd century: *Naiad*. San Antonio, Texas, G. M. Denman Jr. Collection.

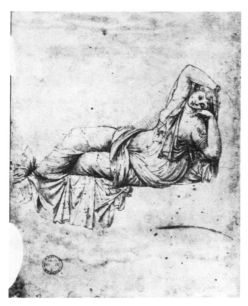

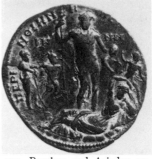

222. Bacchus and Ariadne on the medallion of Perinthos.

221. Amico Aspertini: Drawing of a statue of Ariadne. London, British Museum.

223. Giovanni di Paolo: *Bacchus and Ariadne*. London, British Library, Yates Thompson 36, fol. 152.

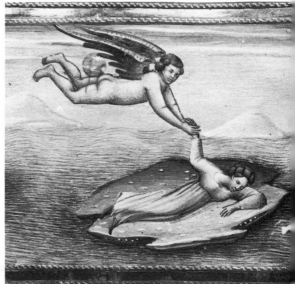

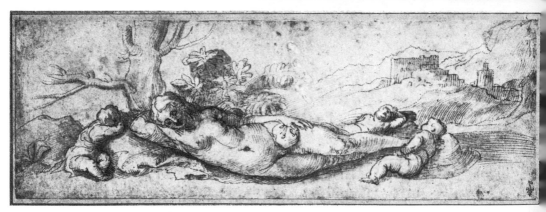

224. Follower of Titian: *Venus and Cupid Asleep*. Chantilly, Musée Condé.

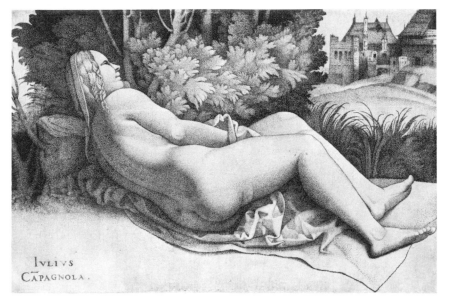

225. Giulio Campagnola: *Sleeping Nude.* Cleveland, Museum of Art.

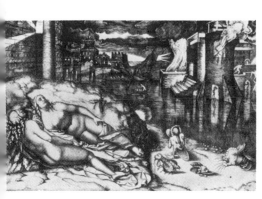

226. Marcantonio Raimondi: Unidentified subject (after Giorgione?). Engraving.

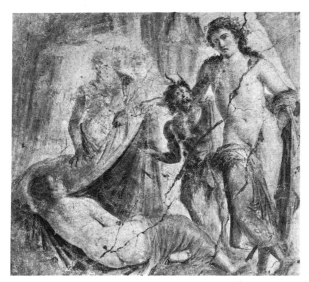

227. Pompeian: *Bacchus and Ariadne.* Naples, Museo nazionale.

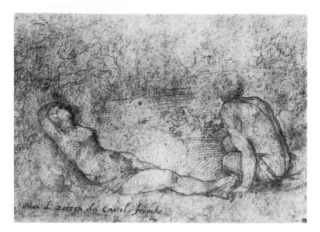

228. Giorgione: Subject *all'antica*. Darmstadt, Hessisches Landesmuseum.

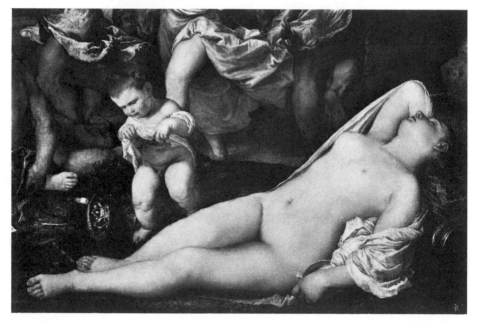

229. Titian: Maenad, perhaps Ariadne (detail of *Bacchanal of the Andrians*). Madrid, Prado.

230. Roman: Bacchic Sarcophagus. Naples, Museo nazionale.

231. Copy of *Cnidian Aphrodite* of Praxiteles. Munich, Antikensammlungen.

232. Jacopo de' Barbari: *Sleeping Nude*. London, British Museum.

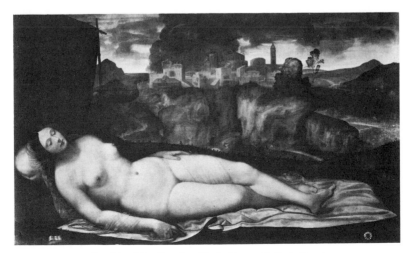

233. Savoldo (?): *Sleeping Nude*. Rome, Galleria Borghese.

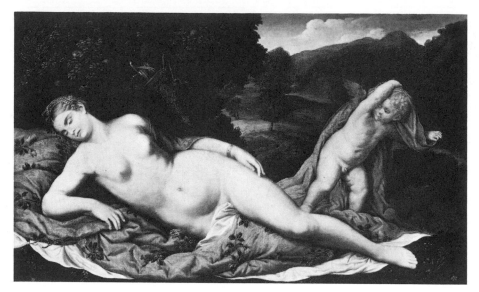

234. Paris Bordone: *Venus and Cupid.* Venice, Cà d'Oro.

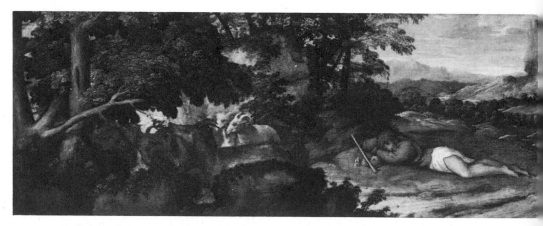

235. Follower of Titian: *Shepherd in a Landscape.* Merion, Pennsylvania, Barnes Collection. Copyright October, 1966, by Barnes Foundation.

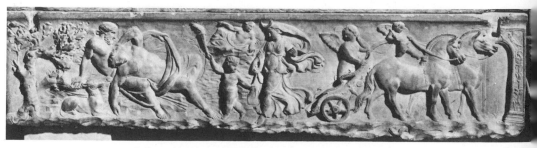

236. Roman: *Diana and Endymion.* Rome, Museo Capitolino.

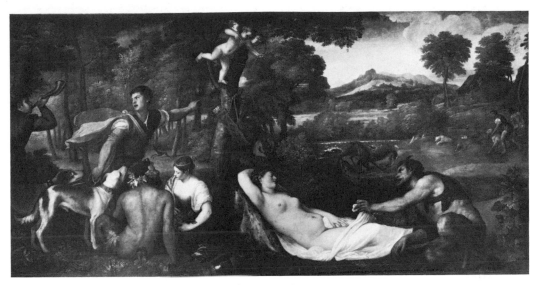

237. Titian: *The Pardo Venus*. Paris, Louvre.

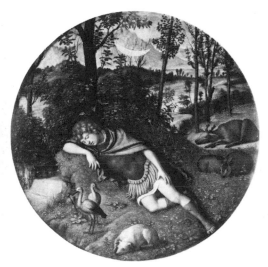

238. Cima da Conegliano: *Endymion*. Parma, Pinacoteca nazionale.

239. Pomedelli, 1510: *Quies*. London, British Museum.

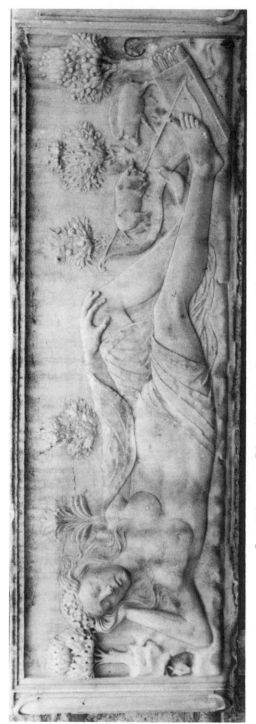

240. Late 15th century: *Diana* (?) *Dozing*. Rome, Palazzo Odescalchi.

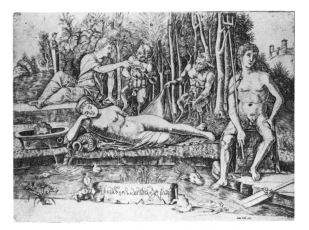

241. Mocetto: *Amymone*. London, British Museum.

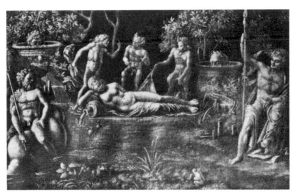

242. Mantegnesque, *ca.* 1500: *Allegory of Mantua* (as it was in 1930).

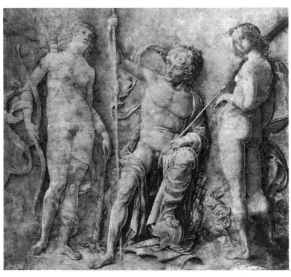

243. Mantegna: *Mars and Two Goddesses*. London, British Museum.

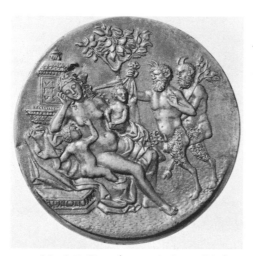

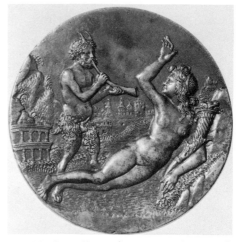

245. North Italian, after 1506: *Satyr and
Abundance* (?). Washington, National
Gallery.

244. North Italian, after 1506: *Satyrs Disclose
a Sleeping Mother*. Washington, National
Gallery.

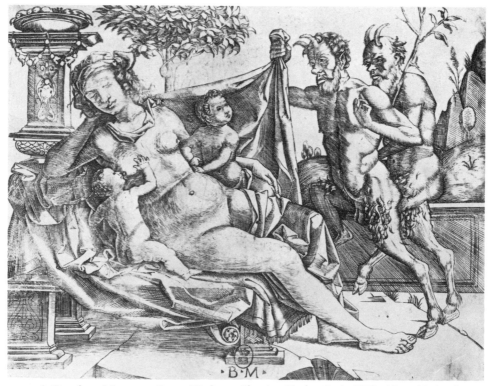

246. Benedetto Montagna: *Satyrs Disclose a Sleeping Mother*. Paris, Bibliothèque Nationale,
Cabinet des Estampes.

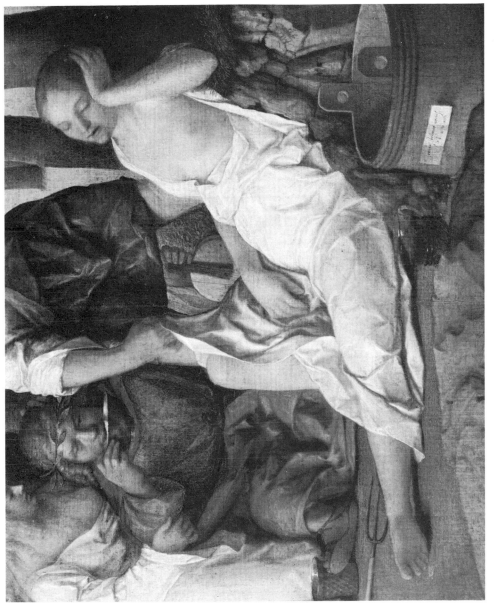

247. Giovanni Bellini: Priapus Disclosing Lotus (detail of *The Feast of the Gods*). Washington, National Gallery.

248. Circle of Domenico Campagnola: *Surfeited Cupid* (from Hind).

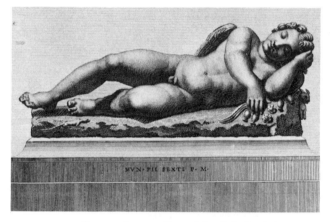

249. Roman: *Somnus*. Rome, Musei Vaticani.

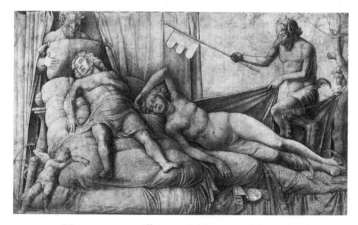

250. Mantegnesque: *Allegory of Idleness and Lust*. London, British Museum.

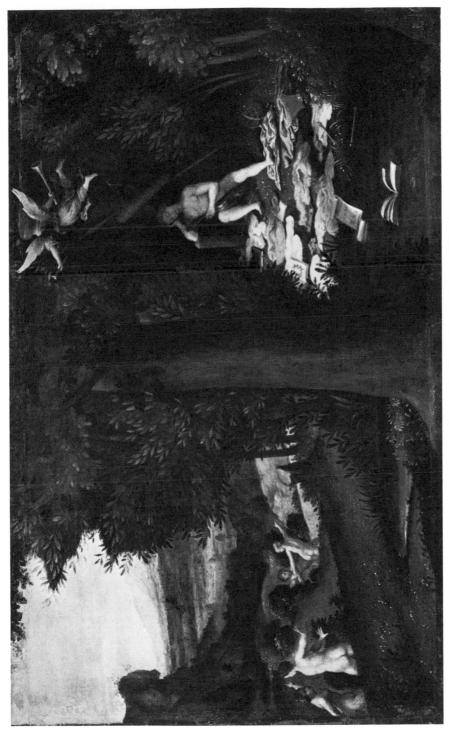

251. Lorenzo Lotto: *Sleeping Apollo*. Budapest, Museum of Fine Arts.

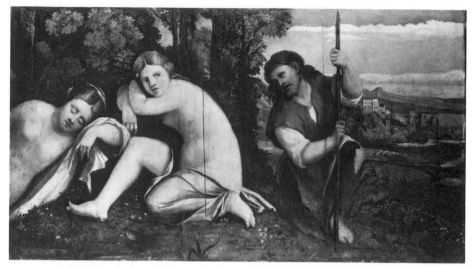

252. Venetian, early 16th century: *Cimone and Efigenia*. London, National Gallery.

253. Roman, 4th century: *Susanna and the Elders*. Rome, Catacomb of Pretextat.

254. Tintoretto: *Susanna and the Elders*. Vienna, Kunsthistorisches Museum.

255. Sassetta: Vainglory (detail from *St. Francis in Ecstasy*). Florence, Villa I Tatti.

256. Flemish: *Idleness*. Brussels, Bibliothèque Royale, ms. 11041, fol. 33v.

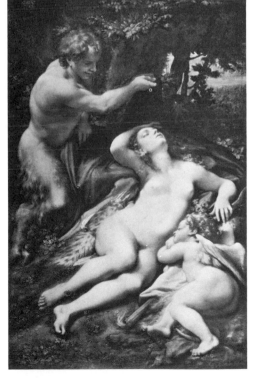

257. Correggio: *Terrestrial Venus*. Paris, Louvre.

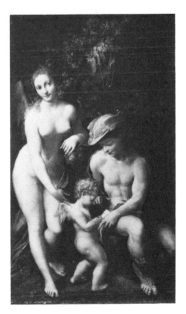

258. Correggio: *Celestial Venus*. London, National Gallery.

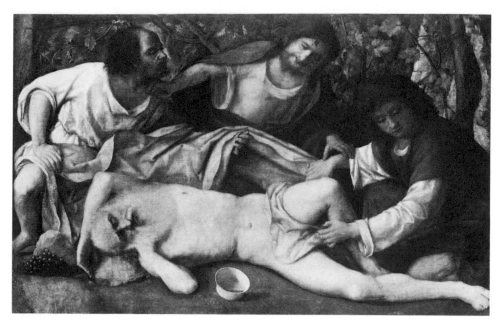

259. Giovanni Bellini: *Drunkenness of Noah*. Besançon, Musée.

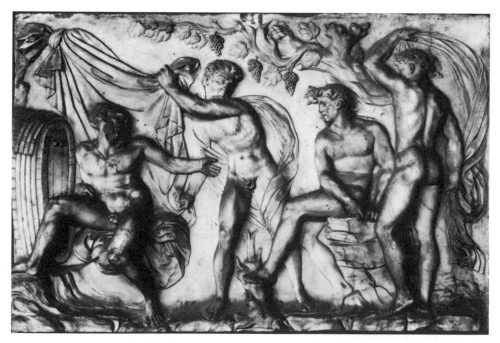

260. Baccio Bandinelli: *Drunkenness of Noah*. Florence, Museo nazionale.

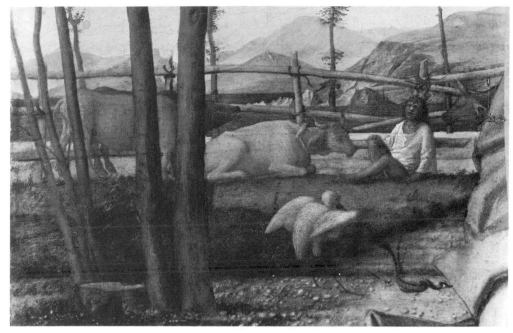

261. Giovanni Bellini: Detail of *Madonna*. London, National Gallery.

262. Byzantine, early 14th century: *Christ "Couched."* Mount Athos, Protaton.

263. Byzantine: Copy of 13th century *Madonna*. Mount Sinai.

264. Roman, *ca.* 1300: *Madonna*. Rome, Sta Maria in Ara Coeli.

265. Venetian, late 14th century:
Madonna with Sleeping Child.
Venice, Accademia.

266. Jacobello: *Madonna with Sleep-*
ing Child. Budapest, Museum of
Fine Arts.

268. Bartolomeo Vivarini, 1450: *Madonna with Sleeping Child.* Bologna, Pinacoteca.

267. Jacobello: *St. Anne with Sleeping Virgin.* Rome, Fabrizio Massimo Collection.

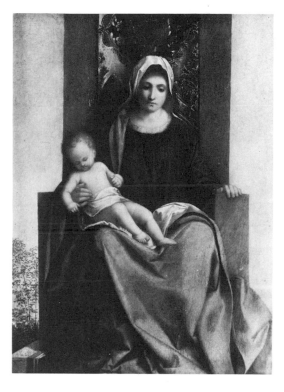

269. Giorgione: Madonna (detail). Castel-
franco, San Liberale.

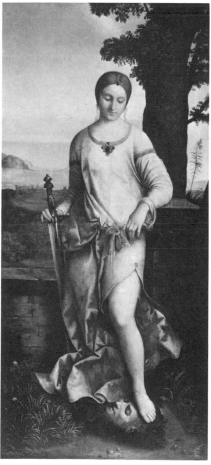

270. Giorgione: *Judith*. Leningrad, Hermitage.

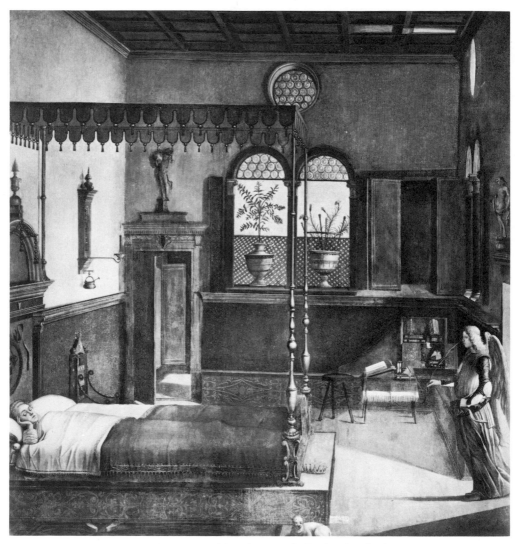

271. Carpaccio: *Vision of St. Ursula*. Venice, Accademia.

Index of Names, Places and Works of Art